WHO OWNS AMERICA?
WILL CHINA DOMINATE
U.S ECONOMY?

VAHAB AGHAI, PH.D.

To order additional copies of this book, contact:

www.hancockpress.com
www.amazon.com
www.barnesandnoble.com

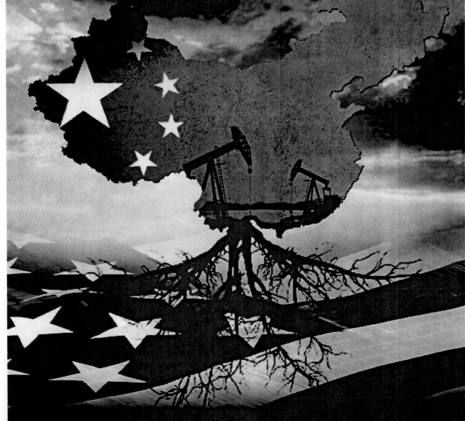

WHO OWNS AMERICA
WILL CHINA DOMINATE U.S. ECONOMY?

VAHAB AGHAI, Ph.D.

AUTHOR OF TERRORISIM, AN UNCONVENTIONAL CRIME

To my parents,
who brought me into this world to be who I am

Table of Contents

Preface

PART 4 Aspects of U.S. Economic Policy

PART 5 Aspects of Chinese Economic Policy

Preface

Who Owns America? is an analysis of one of the most monumental shifts of our time, the rapid emergence of China from agrarian nation to modern economic powerhouse. The book explores this topic from a broad range of perspectives, including traditional history, economic and statistical analysis, contemporary politics, and even futuristic speculation.

China had been the world's biggest economy for centuries when the Industrial Revolution propelled first Europe and then the United States into the lead. China began its return to the global stage in the 1990s as a manufacturer of low-end goods from toys to t-shirts. Soon other countries were slashing their costs to meet the "China price."

China's trade is still mostly low-end goods and commodities, while the United States competes at the upper end of the market. By a slim margin, the United States still trades more; but if the trends continue, China will push into the lead this year. That would be a remarkable feat for a country so poor that thirty years ago the average person had never even used a telephone.

China still lags behind American industry in innovation and in areas like automobile production, aerospace, computers, medicine, and pharmaceuticals. It has also been slow to build global alliances and flex its political muscle on a large scale, but that is changing. The country is beginning to push back in disputes over trade, exchange rates, and climate change. The United States is still the biggest importer, but China is gaining. According to AP, it was a bigger market than the United States for seventy-seven countries in 2011, up from twenty in 2000.

China is also becoming an investor. Its outbound investment for 2011 totaled

$67.6 billion. That figure is expected to improve rapidly. According to the Rhodium Group, projections indicate that by 2020, it will be $400 billion.

In closing, I would like to thank those who helped me in the preparation of this book: Marian Tapia for assistance in preparing supporting documents for the project, Kianoush for designing the cover to so aptly reflect the subject, and numerous friends for encouraging me to take on the project.

Vahab Aghai, Ph.D.

December 2012

PART 1 Two Nations Profiled

CHAPTER 1
Histories of the United States and China

United States

The United States of America is located on the North American continent and consists of fifty states and the District of Columbia. The country has a total area of 9,826,675 square kilometers. It shares borders with Canada on the north (8,893 km) and Mexico on the south (3,141 km). The east and west borders are defined by the Atlantic and the Pacific oceans respectively, with a total coastline of 19,924 kilometers (Central Intelligence Agency 2011).

The climate varies from tropical in Hawaii and Florida to arctic in Alaska, semiarid in the Great Plains west of the Mississippi River, and arid in the Southwest's Great Basin. The terrain varies as well, with hills and low mountains in the east, high mountains in the west, and a vast central plain in between. Alaska features a combination of rugged mountains and broad river valleys, while Hawaii is characterized by volcanic topography (Central Intelligence Agency 2011).

The lowest, hottest, and driest point in the United States is Death Valley, which is located in eastern California close to the border with Nevada. Part of the Mojave Desert, the valley sits 282 feet below sea level (U.S. Department of the Interior/National Park Service 2010). The highest point in the United States is Mount McKinley or, as the Athabascan natives called it, Denali (the High One). Located in Alaska's Danali National Park and Preserve, Mount McKinley stands at 20,320 feet above sea level and continues to grow as a result of the continuous compression and folding of the Pacific and North American tectonic plates (Department of Interior/National Park Service 2011).

The natural resources of the United States include copper, lead, molybdenum, phosphates, rare earth elements, uranium, bauxite, gold, iron, mercury, nickel, potash, silver, tungsten, zinc, petroleum, natural gas, and timber. The United States also has the world's largest coal reserves, with 491 billion short tons, and is the world's largest emitter of carbon dioxide from the burning of fossil fuels (Central Intelligence Agency 2011).

Society

U.S. population figures for the first decade of this century are as follows: in 2000, the United Stated had 282.3 million inhabitants; in 2001, 285.22 million; in 2002, 288.02 million; in 2003, 290.73 million; in 2004, 293.39 million; in 2005, 296.12 million; in 2006, 298.93 million; in 2007, 301.93 million; in 2008, 304.72 million; in 2009, 307.37 million; and in 2010, 310 million (International Monetary Fund 2011) It was estimated that by July 2011, the population of the United States would be 313,232,044 (Central Intelligence Agency 2011).

The racial makeup of the population of the United States is 79.96 percent Caucasian, 12.85 percent African-American, 4.43 percent Asian, 0.97 percent Amerindian and native Alaskan, 0.18 percent native Hawaiian and other Pacific islander, and 1.61 percent multiracial. In terms of religion, the breakdown is as follows: 51.3 percent Protestant, 23.9 percent Roman Catholic, 1.7 percent Mormon, 1.6 percent other Christian, 1.7 percent Jewish, 0.7 percent Buddhist, 0.6 percent Muslim, and 2.5 percent other or unspecified faith; 12.1 percent are unaffiliated, and 4 percent do not profess any religion (Central Intelligence Agency 2011).

U.S. population growth is at below-replacement levels, unless immigration is taken into account. Furthermore, the average age is on the rise, as the baby boomers move into their retirement years. Projected life expectancy for 2015 is 77.1 years for Caucasian men and 81.8 for Caucasian women;

while for African-American men, it is 71.4 years and for African-American women, 78.2. Infant mortality rates are higher among African-Americans than among Caucasians (U.S. Census Bureau, Statistical Abstract of the United States 2011).

The United States has no official language. The vast majority of the U.S. population (82.1 percent) speak English. Of the remainder, 10.7 percent speak Spanish; 3.8 percent, an Indo-European language; 2.7 percent, an Asian or Pacific Islander language; and 0.7 percent some other language. The literacy rate for the total population is 99 percent.

Government

The United States is a constitutionally based federal republic with a strong democratic tradition. Its capital is Washington, DC. It has several dependent territories: American Samoa, Baker Island, Guam, Howland Island, Jarvis Island, Johnston Atoll, Kingman Reef, the Midway Islands, Navassa Island, the Northern Mariana Islands, Palmyra Atoll, Puerto Rico, the Virgin Islands, and Wake Island.

The U.S. government is divided into three branches: the legislative branch which makes laws, the executive branch which implements laws, and the judicial branch which hears legal cases and appeals, and also reviews laws to verify their constitutionality. At the national and state levels, government operates under a legal system based on the English common law (the only exception is the state of Louisiana whose legal system is based on the Napoleonic Code of civil law).

History

Pre-Columbian Period

One of the earliest and best-known prehistoric cultures to occupy the North American continent was the Clovis culture. It produced a characteristic projectile point that was three to six inches long with fluted edges. When

14

inserted into a spear shaft, the Clovis point was an effective weapon for mammoth hunting. It is considered the first American technology (Goodyear 2012).

From the tenth to the fourteenth centuries A.D., an urban cluster of about 30,000 people lived near the Mississippi River. They were farmers who developed a highly intensive system of agriculture. They also manufactured high-quality flint hoes and traded throughout the Mississippi Valley. Archeologists called this Mississippian culture *Cahokia.* Cahokia was at the center of a trading system that linked hundreds of Indian settlements throughout the continent. Its remains provided evidence that a sophisticated way of living long predated the arrival of Europeans on the North American continent (Faragher et al. 1995).

The Anasazi were the farming culture of the Southwest. They lived in the Four Corners area where Arizona, New Mexico, Utah, and Colorado meet. They were forced to abandon the area in the late thirteenth century because of severe drought conditions and the invasion of Athapascan migrants who moved down from the subartic regions to the north. The Athapascans were the immediate ancestors of the Navajos and the Apaches (Faragher et al. 1995).

Colonial Period

At the time the first Europeans arrived, North America was occupied by more than 350 native societies speaking many different languages (Faragheret al. 1995). As Europeans first and then Americans spread across the continent, the cultures clashed and the names of Native Americans entered the annals of American history. They included Red Cloud *(Makhpiya Luta)*, a fierce warrior from the Oglala Lakota (Sioux) who fought for the rights to the Powder River country in northern Wyoming and southern Montana (1866); Sacajawea (*Agaidika,* or Salmon Eater), a Shoshone woman who in 1806

accompanied Meriwether Lewis and William Clark on their expedition to the western United Sates; Pontiac *(Obwandiyag)*, who defended the Great Lakes region of the United States from British troops in 1763; Geronimo *(Goyathlay,* or One Who Yawns), a Chiricahua Apache military leader who for more than twenty-five years (1860–1886) defended his people against U.S. encroachment on their tribal lands; Sitting Bull *(Tatanka Lyotake)*, a Hunkpapa Lakota medicine man who defeated Lt. Col. George Armstrong Custer at the Battle of Little Bighorn in 1876; and Sequoiah (known as George Guess), a scholar who invented the Cherokee syllabary (1821) (Frater 2007).

The first Europeans to set foot on what was to become the United States were the Spaniards who landed in Florida in 1539. Their attempts at conquest failed. In 1562, the French attempted to establish colonies in North America. They landed on Parris Island near present-day Beaufort, South Carolina (Faragher et al. 1995). The first permanent European settlement was St. Augustine, established in 1565 by the Spaniards in what is now Florida. Great Britain settled Jamestown, Virginia, in 1607. In 1620, a group of Separatists (a radical sect of Puritanism) sailed from England aboard a vessel called the Mayflower. The Pilgrims, as they were later called, landed in New England and established the Plymouth colony in Massachusetts (U.S. Department of State 2011). In 1624, Dutch settlers bought the island of Manhattan for $24 and named it New Amsterdam. In 1629, a second group of Puritans, facing increased persecution in England, immigrated to Massachusetts in what was called the Great Migration. This wealthier group founded the Salem colony, intending that it be ruled by their strict religious beliefs (Faragher et al. 1995).

The Massachusetts General Court was the governing body of all the Massachusetts settlements. The court was run by a member of the Puritan

Church, which ensured church control over both politics and religion in the colony. The court elected John Winthrop as governor (U.S. Department of State 2011). Because education was so important to Puritans, in 1647 Massachusetts required support of public schools for towns with fifty or more families (Faragher et al. 1995).

The strictness of the Puritans' beliefs led to disagreements among the colonists. In 1636, Roger Williams, a clergyman who objected to the seizure of Indian lands and supported the separation of church and state (U.S. Department of State 2011), purchased what is now Providence, Rhode Island, and founded the first American colony where church and state were completely separated and freedom of religion was allowed. Williams received a royal charter in 1663 that guaranteed the independence of Rhoda Island's government and freedom of religion. Other discontented colonists left Massachusetts to form new communities (Faragher et al. 1995).

In 1619, the first Africans arrived in Virginia. They were intended to be indentured servants who could eventually earn their freedom. However, that changed in the 1660s, when the demand for plantation labor in the southern colonies increased. From that point on, Africans were considered slaves and forced to serve for a lifetime (U.S. Department of State 2011).

On the other hand, the middle Atlantic colonies such Pennsylvania and New York had more diverse populations. They included Dutch, French, Danish, Norwegian, Swedish, English, Scottish, Irish, German, Polish, Bohemian, Portuguese, and Italian settlers (U.S. Department of State 2011).

In 1754, a battle at Fort Duquesne (Pittsburgh, Pennsylvania) between French regulars and Virginia militiamen commanded by George Washington marked the beginning of the Seven Years War, a war eventually won by England. In 1763, the Peace of Paris was signed; and France relinquished all of Canada, the Great Lakes, and the upper Mississippi Valley to England.

As discontent with royal authority over the American colonies grew, new local organizations emerged that supported an independence movement. Other colonists, however, tried to negotiate with George III; but the king had no interest in making concessions and instead ordered the imposition of the Coercive Acts. On February 9, 1775, the English Parliament declared Massachusetts to be in a state of rebellion. Four months later, George Washington was appointed commander-in-chief of the Continental Army. A year later, on July 4, 1776, Thomas Jefferson presented the Declaration of Independence for adoption by the Continental Congress. The declaration was followed by the Articles of Confederation on November 15, 1777. They designated Congress the sole authority of the new national government.

It wasn't until February 1783 that England officially declared an end to hostilities in America. On September 3, the Treaty of Paris was signed; and the American Revolutionary War officially ended on January 14, 1783, after the ratification of the Treaty of Paris. In 1789, George Washington was appointed as the first president of the United States. Two years later, the Bill of Rights (the first ten amendments to the Constitution) was ratified.

With nationhood came many new laws. One of the most important was an act prohibiting the importation of slaves (1807). It marked the beginning of the end for slavery. However, in 1830, the Indian Removal Act passed, ushering in the conquest of the West. In 1848, gold was discovered in California.

Modern Period

In 1861, the American Civil War began between the Confederate States of America, which supported Jefferson Davis, and the United States of America, which supported Abraham Lincoln (Faragher et al. 1995). On January 31, 1865, the House of Representatives passed the Thirteenth Amendment of the Constitution, which abolished slavery in America (A&E Television Networks 2011). In reaction, the following year the Ku Klux

Klan was founded. That same year, the first Civil Rights Act was passed by Congress. It declared blacks to be citizens and denied state governments the power to restrict their rights (U.S. Department of State 2011).

The entrance of the United States into World War I in 1917 began a new era for the nation, one in which the United States became more active in international affairs. In 1929, the Great Depression began. Four years later, Japan and Germany withdrew from League of Nations.

In 1939, Germany invaded Poland, beginning World War II; but it was not

19

until 1941, after the Japanese attack on Pearl Harbor, that the United States entered the war. The war lasted until 1945, ending in Europe after the Allies (Britain, France, Russia, and the United States) took Berlin, the German capital. The war in the Pacific ended a few months later when the United States dropped atomic bombs on the Japanese cities of Hiroshima and Nagasaki. The tactic avoided an all-out invasion of the island nation and was made possible by the fact that the Allies had broken the Japanese code. The Japanese never succeeded in breaking the U.S. code, however, because it was based on a difficult and obscure language—Navajo. During the war, about 400 Navajos served as "code talkers" for the U.S. Marines, decoding and transmitting messages in a fraction of the time it took machines to do it (Independence Hall Association 2011).

Two wartime trends continued to have repercussions long after hostilities had ceased. First, the United States ceased to be an isolationist nation in any sense of the word and became instead a recognized superpower. In 1945 it joined the United Nations and subsequently constituted the largest portion of UN forces participating in the Korean War (1950–1953). It later became the principal ally of South Vietnam in the Vietnam War (1961–75) and intervened at the request of Saudi Arabia when Iraq invaded Kuwait in the Gulf War (1991). Second, the policy of racial desegregation that was begun within the U.S. armed forces during and after World War II continued and spread outward into the society as a whole. After the Supreme Court declared racially segregated schools illegal (1954), the civil rights movement organized by Martin Luther King Jr. in the early 1960s sought to end segregation throughout the nation. As a result, Congress passed the Civil Rights Act of 1964 which made illegal discrimination based on race, color, religion, gender, or national origin.

In 1995, the Oklahoma City bombing became the first major recognized

incident of domestic terrorism in the United States. It was followed six years later by the September 11 terrorist attacks on the World Trade Center and the Pentagon. These incidents marked the beginning of an ongoing war against terrorism that led to long-term U.S. military operations in Iraq and Afghanistan beginning in 2003 (Independence Hall Association 2011).

China

China is a country that covers about 3.7 million square miles (U.S. Department of State 2010). It is located on the eastern part of the Asian continent. The largest country in Asia, it shares borders with many other countries and multiple bodies of water. To the east, it borders Korea, Korea Bay, the Yellow Sea, the East China Sea, and the South China Sea. To the north, it borders Mongolia; to the northeast, Russia; and to the northwest, Kazakhstan, Kyrgyzstan, and Tajikistan. To the west and southwest, it shares borders with Afghanistan, Pakistan, India, Nepal, Sikkim , and Bhutan; and to the south, it borders Myanmar, Vietnam, and Laos (Chinatouristmaps. com 2011).

China's terrain is composed of plains, deltas, hills, mountains, high plateaus, and deserts. Its climate is tropical in the south and subarctic in the north (U.S. Department of State 2010).

Society

Since 2000, China's population has grown at a slow and steady rate: in 2000, China had 1.267 billion inhabitants; in 2001, 1.276 billion; in 2002, 1.285 billion; in 2003, 1.292 billion; in 2004, 1.3 billion; in 2005, 1.31 billion; in 2006, 1.314 billion; in 2007, 1.321 billion; in 2008, 1.328 billion; in 2009, 1.335 billion; and in 2010, 1.341. It was estimated that by 2011 the population would be 1.348 billion (International Monetary Fund 2011). In July 2010, China estimated its growth rate to be 0.494 percent. Its infant mortality rate was estimated to be 16.51 deaths per1,000 live births, while

overall life expectancy was 74.51 years (72.54 years for males and 76.77 for females).

The Han are China's dominant racial group, accounting for 91.5 percent of the population. Zhuang, Manchu, Hui, Miao, Uyghur, Tujia, Yi, Mongol, Tibetan, Buyi, Dong, Yao, Korean, and other nationalities make up the remaining 8.5 percent of the population.

Officially China is an atheist nation; however, the Daoist (Taoist), Buddhist, Christian, and Muslim religions are practiced by portions of the Chinese population. China's literacy rate is high—93 percent for the total population. In 2009, it was estimated that the Chinese labor force was approximately 812.7 million. According to 2008 estimates, the breakdown by occupation was as follows: agriculture and forestry, 39.5 percent; services, 33.2 percent; and industry, 27.2 percent (U.S. Department of State 2010).

Because of overpopulation, China has passed strict laws regarding birth control. The 2002 Population and Family Planning Law and Policy permit one child per family, although in certain exceptional circumstances a second child may be allowed. Sanctions for failure to comply are mainly economic. Physical coercion is prohibited as a means to persuade people to opt for abortion or sterilization. However, instances of local officials using such methods to force people to meet birth limitation targets have been reported (U.S. Department of State 2010).

History

China's history goes back more than 5000 years. Its oldest dynasty, the Xia Dynasty, contributed greatly to the progress of Chinese civilization. That civilization produced one of the world's greatest educators, Confucius (551–479 BC), and scientists like Zhu Chongzhi (AD 425–500), famous for calculating both pi and the volume of a sphere (Ministry of Culture RR China 2003). A short list of the accomplishments of Chinese civilization

includes bronze craftsmanship, writing, metal coinage, the Great Wall, and the development of silk, steel, paper, ceramics, and block printing.

<u>Republican China</u>

On February 12, 1912, when the Qin Dynasty and the Qing Dynasty were replaced (U.S. Department of State 2010), the republic that Sun Yat-sen foresaw came into existence. There was no army, and Yuan Shikai, who led the parliament, made changes to the constitution and became a dictator. A new political party came into being in August 1912, founded by Song Jiaoren, one of Sun's associates. Called the Guomindang, or National People's Party/Nationalist Party, it unified a number of small political groups and became very popular. In the elections of February 1913, it won a majority of the seats in a new bicameral parliament. A month later, however, Yuan ordered Song's assassination. The murder stirred such discontent among the Chinese that by the summer of 1913 seven southern provinces had rebelled against Yuan. Nevertheless, in October an intimidated parliament elected Yuan president of the Republic of China, and the major powers recognized his government. Its international popularity grew when Yuan agreed to autonomy for Outer Mongolia and Xizang (Tibet) and then allowed partial control of the former by Russia and the latter by Britain. In November, Yuan ordered the Guomindang dissolved and its representatives removed from parliament. Eventually he suspended parliament and all provincial assemblies and promulgated a new constitution, under which he was proclaimed president for life. He then tried to reestablish the monarchy with himself as emperor, but failed in the face of popular resistance. Yuan died in June 1916 (Chaos at University of Maryland 2011).

During World War I, the Japanese seized German interests in Shandong Province. They also issued the so-called Twenty-One Demands, which would have effectively made Japan the protector of China. Beijing rejected

some of the terms, but allowed the Japanese to keep the Shandong territory and recognized Japanese authority over southern Manchuria and eastern Inner Mongolia. Two years later, however, China declared war on Germany in an effort to recover the territory it had lost to Japan and in 1918 secretly agreed with Japan to the terms regarding Shandong. After the Paris peace conference of 1919, China and Japan's secret agreement became known, and on May 4 of that year, student protesters staged massive demonstrations in Beijing. This action launched a movement to Westernize China and introduce socialism, which was ultimately implemented by Chinese communist leaders.

<u>People's Republic of China</u>

The People's Republic of China (PRC) was established on October 1, 1949, with its capital at Beijing (Chaos at University of Maryland 2011). The government was headed by Zhou Enlai, while the party was led by Mao Zedong. Mao referred to the republic as the "people's democratic dictatorship."

The new republic was divided into four social classes: workers, peasants, petite bourgeoisie, and national-capitalists—all of them led by the Chinese Communist Party (CCP). The party had 4.5 million members, of which 90 percent were peasant.

The PRC and the Soviet Union signed the Treaty of Friendship, Alliance, and Mutual Assistance in February 1950. China's new government was highly disciplined and put in place a program of national integration and reform, with moderate social and economic policies.

On June 28, 1950, the Agrarian Reform Law took effect. It redistributed farmland in the face of major opposition from landlords and wealthy peasants. Professionals and artists did not fare much better. University faculty members, scientists, other professional workers, artists, and writers

were forced to engage in self-criticism and public confession. Literature and other cultural pursuits were subject to approval by the CCP (Chaos at University of Maryland 2011).

During the Korean War (1950–53), some Chinese volunteers decided to aid the North Koreans. As a result, the UN declared China an aggressor nation and sanctioned a global embargo on the shipment of arms and war materiel to the country. The move also foreclosed any possibility of the PRC's replacing Nationalist China (Taiwan) as a member of the UN. In response, the PRC began a program of persecuting so-called enemies of the state— war criminals, traitors, bureaucratic capitalists, and counterrevolutionaries. Their main targets, however, were foreigners and Christian missionaries.

Between 1953 and 1957, the Chinese government began in earnest to transform the country's economy from a traditional to a command system. The period was "distinguished by efforts to achieve industrialization, collectivization of agriculture, and political centralization" (Chaos at University of Maryland 2011). A Five-Year Plan focused on the development of industry using the Soviet Union as a model, and in fact the Soviet Union provided technical and economic assistance.

The 1953 census had shown that China's population (then about 583 million) was becoming a major burden for the country. To meet its goals in the face of such population growth, the government began to collectivize agriculture, a transition that was 90 percent completed by the end of 1956. Furthermore, banks, industry, and trade were nationalized (private enterprise was practically eliminated).

In 1954, the National Peoples Congress promulgated the state constitution of 1954 and elected Mao president of the PRC. Liu Shaoqi was appointed chairman of the Standing Committee of the National Peoples Congress, and Zhou Enlai was made premier of the new State Council. In 1956, as part of

what was called the Hundred Flowers Campaign, cultural and intellectual figures were encouraged to participate in the new regime by expressing their thoughts on CCP rules and programs. By the following year, there was criticism and denunciation of political figures (Chaos at University of Maryland 2011).

Today China is still led by the Communist Party. Unfortunately, there continue to be well-documented reports of abuses of human rights that violate international norms. One of the best-known examples was the fiftieth anniversary of the Tibetan uprising. Observances of that occasion led to executions without due process, torture, and severe restrictions on the freedoms of speech, press, assembly, religion, and reproduction, to name a few.

In April 2009, the government presented the first National Rights Action Plan. Its goals were to be achieved within two years; however, the plan was never implemented (U.S. Department of State 2010).

Sino-British Joint Declaration

On December 19, 1984, the United Kingdom of Great Britain and Northern Ireland and the People's Republic of China signed the Sino-British Joint Declaration, which was an agreement dealing with how Hong Kong, for nearly 150 years a possession of Great Britain, would return to Chinese control. The document was the result of two years of negotiation dedicated to finding a way to maintain Hong Kong's prosperity and stability once it was no longer part of a democracy with a market economy.

Over the years there have been three treaties between Britain and China relating to Hong Kong, the Sino-British Joint Declaration being the third. The first was the Treaty of Nanking, signed in 1842 and ratified in 1843. It stipulated that Hong Kong Island was to be ceded in perpetuity to Britain. The second treaty was the Convention of Peking, signed in 1860. It specified

that the southern part of the Kowloon Peninsula and Stonecutters Island were to be ceded in perpetuity to the British. Furthermore, up to 92 percent of the total territory was to be leased to Britain for ninety-nine years, with an effective date of July 1, 1898.

In 1972, twenty-five years before the expiration of Britain's ninety-nine–year land leases, China informed the United Nations Special Committee that Hong Kong could not be included on the list of colonial territories covered by the Declaration on the Granting of Independence to Colonial Countries and Peoples because Hong Kong was China's "property" (Hong Kong Baptist University 1996). It had long been the Chinese government's position that Hong Kong was part of China and would simply revert to its previous status in 1997.

The approaching deadline began causing concern among Hong Kong's foreign investors and nationals, who were afraid the transition would cause instability and have negative economic consequences; so the British decided to explore options while there was still ample time. The negotiations began eighteen years before the expiration deadline. In March 1979, the Governor of Hong Kong visited Peking to examine options to resolve the issue, but the two governments could not reach an agreement. In 1982, they tried again, this time with some success. On September 24, 1982, the British prime minister Margaret Thatcher and the Chinese president Deng Xiaoping signed the following joint statement: "Today the leaders of both countries held far-reaching talks in a friendly atmosphere on the future of Hong Kong. Both leaders made clear their respective positions on the subject. They agreed to enter talks through diplomatic channels following the visit with the common aim of maintaining the stability and prosperity of Hong Kong" (BBC News 2008).

The second phase of the negotiations began on July 12, 1983, and consisted

of formal talks between delegations led by the British ambassador in Peking and a vice minister of the Chinese foreign ministry; the governor of Hong Kong served as a member of the British delegation. The British explained the administrative systems then in use in Hong Kong and the importance of continuity through the transition. The Chinese flatly rejected continuing any form of British administration after 1997. The British, after consulting with the governor of Hong Kong, proposed negotiations to discuss measures to replace the British administration in a way that would ensure long-lasting stability and prosperity in Hong Kong (Hong Kong Baptist University 1996).

By April 1984, China and Britain had concluded the initial negotiations, although with some unresolved points. It was apparent, however, that the sessions had been productive. From April 15 to April 18, the Secretary of State for Foreign and Commonwealth Affairs, Sir Geoffrey Howe, visited Peking; and the Chinese government and the British administration reviewed the options. After few more trips and intense negotiations, on August 1, 1984, Howe announced substantial progress toward a legally binding arrangement for the future of Hong Kong. He also announced that the British government would cease operations as administrator of Hong Kong, effective June 30, 1997. Thereafter the Sino-British Joint Liaison Group would operate in Hong-Kong as a consultant on the implementation of the agreement and a forum to exchange information. However, the group would not have any power or any involvement in the administration of Hong Kong. The group would start operations, effective the date of the legal agreement and continue until 2000, with meetings in Peking, London, and Hong Kong. Finally, after several more meetings, on September 18, 1984, negotiators on both sides approved the English and Chinese texts of the agreement and the associated Exchange of Memoranda. The delegations' leaders approved

the texts on September 26, 1984 (Hong Kong Baptist University 1996). Negotiations concluded on December 19, 1984, in Beijing with the signing of the legal agreement by the British and Chinese prime ministers. The agreement took effect on May 27, 1985, with the exchange of instruments of ratification. Thus concluded 155 years of British rule over Hong Kong (BBC News 2008). The agreement was registered with the United Nations on June 12, 1985 (People's Daily Online 2007).

Throughout the foregoing process, the British government took steps to ensure that any agreement would be acceptable to all parties—the people of Hong Kong, the British Parliament, and the Chinese government. All members of Hong Kong's Executive Council and the Governor's advisers were fully informed and consulted about the negotiations. The Unofficial Members of the Executive and Legislative Councils (UMELCO) provided crucial advice to the Governor and ministers regarding the best interests of the people of Hong Kong. The governor's and ministers' decisions were based on the UMELCO proposals from individuals and groups of people in Hong Kong and from opinions of the press who made specific proposals on what should be included in the agreement. In addition, members of the British Parliament were kept informed through visits and communication with on-site delegations (Hong Kong Baptist University 1996).

The formal, legally binding international agreement consisted of a joint declaration and three annexes. The joint declaration included acknowledgments by both the British and the Chinese governments that China would resume sovereignty over Hong Kong Island, the Kowloon Peninsula, and the New Territories, effective July 1, 1997, and the British acceptance thereof. The annexes spelled out details of the laws, administrative bodies, and land lease policies that would govern once Britain ceased operating as the administrator of Hong Kong: list

· *Annex I—Laws and policies for the Hong Kong Special Administrative Region (HKSAR).* Covers constitutional arrangements and government structure; laws; judicial system; public services; financial system; economic system and external economic relations; monetary system; shipping; civil aviation; culture and education; external relations; defense, security, and public order; rights and freedoms; right of abode, travel documents, and immigration. Stipulates that said laws and policies remain without modification for fifty years and that the socialist system of the Peoples Republic of China not be put into effect in the Hong Kong Special Administrative Region.

· *Annex II—Sino-British Joint Liaison Group.* Includes details pertaining to the establishment of the group, such as meeting locations, effective date, expiration date, and specific functions and limitations of the group.

· *Annex III—Land lease policies.* Stipulates land lease details for leases already issued by the Hong Kong government, leases to be issued under the Chinese government, some financial arrangements, and arrangements for the establishment of a joint land commission.

(Chinese Government's Official Portal 2007) </list>

From the start, the British government considered negotiation to be in the best interests of the people of Hong Kong. Britain's negotiators understood that the only alternative to the agreement was no agreement at all, which would likely have resulted in China's imposing the kind of economic system on Hong Kong that would have destroyed its stability and prosperity. The agreement, on the other hand, preserved the economic system, the legal system, and the body of laws already in place, which would allow Hong Kong to operate and administer its territory with a high degree of autonomy. Hong Kong could pass its own legislation, make its own decisions about its economy and its financial and trade policies, and participate in international

organizations and trade agreements.

A copy of the agreement was published in Hong Kong and circulated throughout the territories. An assessment office was established in Hong Kong under the supervision of a senior official of the Hong Kong government and monitored by Sir Patrick Nairne and Mr. Justice Simon Li. The office provided the British government with an analysis and assessment of opinion in Hong Kong (Hong Kong Baptist University 1996).

CHAPTER 2

China's Centralized Government

A *centralized government* can be defined as one that holds a monopoly over the provision of public goods and services throughout a nation (Dorn and Xi 1990). Note, however, that the term *centralized* refers to only the form of the government, not its nature (Zhou 2003).

By long tradition, China has been a centralized state. The country's first highly centralized government was established during the Qin Dynasty (221–207 BC). It successfully organized several public projects.

The emperors of the Han dynasty (206 BC–AD 220) were China's first politicians. They devised a system of governance that consisted of a mixture of feudal structure and central bureaucracy (Theobald 2000). The structure was that of an absolute monarchy (Zhou 2003). Territories were ruled by individual families until their lines died out, and the rest of the empire was ruled directly by the emperor.

The empire was divided into commanderies, each with a civil governor and a military governor. Commanderies, in turn, were divided into counties or districts, each managed by a civil magistrate and a military defender. The princedoms and marquisates were mostly autonomous and had their own political administration, with a counselor-delegate as head of government.

The central government was run by one or two chancellors, the greater commander, the censor-in-chief, and the imperial mentor. The latter three comprised the so-called grand counselors. The Imperial Board of Secretaries was in charge of imperial and central administrative tasks pertaining to imperial offerings and law enforcement, among other areas. The board was

run by nine courts under a chamberlain.

The Han dynasty system of central government and the Qin dynasty provided the foundation of the administrative structure that was used throughout the entire imperial history of China (Theobald 2000). However, centralized government in China reached its greatest heights during the Tang Dynasty (618–917 AD).

Many centuries later, the Communist Party of China, led by Mao Zedong, gained control of the country. *Communism* can be defined as a totalitarian system of government in which a single party controls the state-owned means of production and exercises absolute and total control over all aspects of life (Merriam-Webster 2012). Chinese communism (Maoism) was an interpretation of Marxist-Leninist communism that was derived from differences in ideology about peaceful coexistence between capitalists and communists (Chu et al. 2012). Under Mao, there was both a centralized government and a centralized financial system. Funds provided from the central government were mainly used for strategic and sectorial purposes (Wei 2000). After Mao's death, Deng Xiaoping developed *market socialism* (also known as *liberal socialism*), which has opened new economic opportunities for China (Chu and others 2012).

Today the Chinese Communist Party (CPP) still rules, although its role in the economy is declining. There is no doubt, however, that that role has greatly contributed to China's success. It has provided political stability and allowed its leaders to assertively formulate and implement economic policies. This, in turn, has generated conditions for investment that have attracted investors from all over the world.

The centralized government also supervises trade negotiations and controls the role of foreign capital in the economy (Columbus 2003). In short, China's government controls every aspect of the process. This is perhaps

not unexpected, since that government has had more than two thousand years of practice. It is, in fact, the longest-standing political system in the world (Sachs 2005).

The evolution of China's economy, however, made changes to its political system mandatory. A centralized economy was not the most effective vehicle for meeting the demands of reform (Dorn and Xi 1990). For example, during the 1970s, local governments collected all taxes and profits from state-owned enterprises and sent them to the central government. The central government then remitted funds to the local governments to subsidize their expenses, including social services (Chen and Song 2006). There were two major problems with this system. First, it was slow. This was a particular problem for large cities like Shanghai and Tianjin whose populations were growing rapidly, but whose economies could not because of centralized control over the local budget. Second, it tended to shortchange interior areas of the country vis-à-vis coastal areas. Both problems were rooted in differences in fiscal systems and investment structures from one region to another.

The solution was to implement a decentralized fiscal system. In 1994, local governments were given more control of their resources and their distribution. Township village enterprises (TVEs) were designated as main sources of economic growth and received financial incentives (Chen and Song 2006). As a result, local governments became more active in the promotion of economic development in their areas. Today local governments directly participate in the economy by providing favorable conditions for new enterprises. These conditions include identifying projects for development, resolving problems related to shortages of skilled labor, providing credit guarantees for indebted enterprises, improving infrastructure, opening overseas markets, fostering backbone enterprises, establishing enterprise

34

groups, and developing scale economies (UN ESCAP 2012).

Still, there have been some problems with the system reforms. The central government has attempted to increase investment in the interior regions, but some local communities have had difficulty matching the funds provided by the central government. Others have expressed discontent over uneven development resulting from different fiscal systems being used in different regions (Wei 2000).

In China's central government, the supreme administrative body is the State Council. Local governments must carry out the laws and regulations of the central government and adhere to its stipulations. The central government manages the administrative affairs of the whole country and makes macro-level decisions; the local governments manage local administrative affairs. However, the two have a unified leadership and decentralization of powers. The central government is mainly in charge of political and social stability, socio-economic issues of national concern, high technology, major infrastructure construction, important scientific and research institutes, and universities. The local government, in conjunction with the central government, is in charge of finance, economy and trade, legislation, education, scientific technologies, health, culture, sports, employment, personnel, and social welfare. The two levels of government have joint authority in the areas of banking, taxes, prices and the development of energy resources (UN ESCAP 2012).

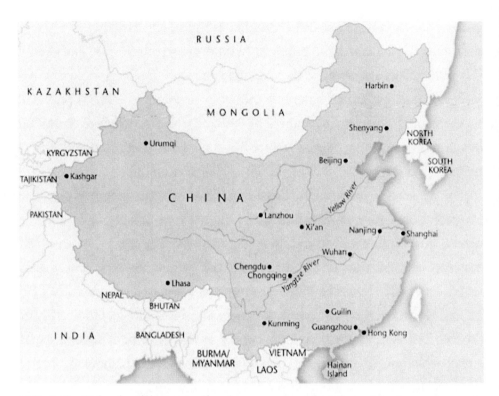

Officially China is still a centralized government; however, local governments have tried to implement their own rules, and many foreign companies comply with them rather than the central government's regulations (Hitt, Ireland, and Hoskisson 2009). Certainly, the economic reforms have contributed to decentralized investment as well as investment growth and structural changes in investment. State control has greatly been reduced since the implementation of the economic reforms, providing favorable policies to the coastal region and allowing local governments and enterprises to retain more profits and depreciation funds. Unfortunately, this new system has not worked equally well for all the provinces. The western region, for example, still heavily relies on the state budget and state-controlled banks (Wei 2000).

CHAPTER 3
Public Policy and Social Organization

United States
Public Policy

Public policy refers to a system of laws, regulatory measures, courses of action, and funding priorities related to a given topic and promulgated by a governmental entity or its representatives. It can also be defined as the organizing framework of purposes and rationales for government programs that deal with specified societal problems or the complex of programs enacted and implemented by government (Milakovich and Gordon 2009).

Government policies are meant to solve or cope with major social and economic problems. These policies are applied through a political process that is usually complicated and fragmented. As a result, they are often internally inconsistent and lack a centralized direction. Furthermore, it is next to impossible to predetermine policies for some problems, like those involving accidents, natural disasters, and acts of terror. Therefore, policies are more often the product of responses to particular circumstances or problems rather than the result of deliberate actions.

The complexity of public policy makes it difficult for the general public to understand. As a result, there is usually minimal support for public policies. Although a given policy might not be popular, it must have certain level of acceptability. However, the most acceptable policies may not be the most effective, and the most effective may not be acceptable.

There are five main public policy types: list

1. Distributive polices. These deliver large-scale services or benefits to certain individuals or groups in the population. Example: government loans to cover

private-sector losses.

2. Redistribution policies. These policies represent deliberate efforts by the government to shift wealth, income property, or rights from one group to another. They are very controversial and cause political conflicts. *Example:* affirmative action.

3. Regulatory policies. These policies promote restrictions on the freedom to act of those subject to regulations. They are intended to protect certain groups and are often enforced against businesses. Example: toy safety standards.

4. Self-regulatory policies. These represent a variation on regulation. They put certain professions or classes of people at an advantage or remove them from the government's power to regulate. Example: licensing of certain professions and occupations.

5. Privatization policies. These policies involve government's either joining with or yielding responsibility to private-sector enterprises to provide services previously managed and financed by public entities. This kind of arrangement is most often found at the local level, although other levels of government have shown growing interest in it.

Policymaking is a complex process that involves demands, public and private pressure, negotiations, and formal and informal decision making, all directed toward achieving or avoiding specific government action. Policymaking occurs in four stages. In the legislative stage, the basic legislation is drawn up, considered, and approved as law, a process that in the United States involves both the Congress and the president. In the second and third stages, an administrative agency provides detailed rules and regulations governing application of the law. The fourth stage is review, during which modifications are possible for legal, substantive, or political reasons. In the United States, this can involve the courts or Congress or

both.

Administrative involvement in subsequent stages of the policy process can assume a variety of forms, including the following: list

1. *Rule making.* This process is often delegated to administrative agencies by the Congress.

2. *Adjudication.* This is a quasi-judicial function involving the application of current laws or regulations to particular situations on a case-by-case basis.

3. *Law enforcement.* In an administrative context, this term refers to securing compliance with existing statutes and rules.

4. *Program operations.* This area deals with the administration of loans, grants, insurance, purchasing, services, or construction activities and constitutes a large part of agency impact on the policy process.

5. *Planning and analysis.* This process must define the operational goals of an organization, analyze alternative choices for resource distribution, and choose methods to achieve those goals over a specified time period.

6. *Program implementation.* This term refers to the set of activities directed toward putting a program into effect. Organization, interpretation, and application are the elements of program implementation (Milakovich and Gordon 2009). The public policy process has several steps:

1. *Problem identification* is the beginning of the public process, and demands action from the government to resolve a problem.

2. *Agenda building* consists of the discussion and consideration of options to solve a problem, a process that is based on three streams of information a problem stream, a policies stream, and a political stream.

3. *Policy formulation* is the process of problem solving.

4. *Policy adoption* is the acceptance of a policy.

5. *Budgeting* is a function of the executive branch and is a multifaceted process.

6. *Implementation* consists of the execution of the program that has been adopted by legislative, executive, or judicial order and requires organization and interpretation (Rushefsky 2008).

7. *Evaluation* is the process by which general judgments about quality, goal attainment, program effectiveness, impact, and costs can be determined. Its purpose is to determine the effectiveness of an implemented program. Furthermore, it can determine if a policy's effects are intended or unintended and its results beneficial for the population and the society (Theodulos and Kofinis 2004).

Supports and demands are the two inputs to a political system. *Support* is the overall support to a political system, while *demands* are requests for action. The two types of results are outputs and outcomes. *Outputs* are tangible and symbolic results of government decision, while the *outcomes* are the results of government outputs.

Social Organization

Social organization is the foundation of every society. It might vary from one society to another, but it is universal.

Social organization can be defined as the structure of social relations within a group and between groups and institutions (Dictionary.com 2011). A *social group* can be defined as two or more people who interact with each other and who recognize themselves as distinct social unit. Interacting with each other and sharing values and beliefs leads to solidarity among a group's members and other social systems (Stanford University 2011). A social group is considered one of the most stable and enduring units of society. Examples of social groups include families, political parties, and unions. Social classes, status groups, and crowds,

40

however, are different. They are called *quasi-groups* (Sociology Guide 2011).

A *social institution* is an established, complex, integrated set of social norms organized to preserve basic social values and to manage important group interests (Sociology Guide 2011). Social institutions provide order, coordination, and social change (Hunt and Colander 2008). They operate in five basic areas of life: determining kinship, providing for the legitimate use of power, regulating the distribution of goods and services, transmitting knowledge from one generation to the next, and regulating the relationship to the supernatural. In other words, the five basic social institutions are family, government, economy, education, and religion. They are found among all human groups. In the United States, these institutions are highly elaborated and distinct from one another (Sociology Guide 2011).

Social groups assign a role and a status to each group member. S*tatus* refers to a person's social position within the group, *role* to the part the person is expected to play, or fulfill, within the group. A *class* is considered a group of individuals with similar positions and similar political and economic interests within a stratified social system.

Social stratification is often compared to social inequality. The existence of social stratification indicates that inequality has been hardened or institutionalized through a system of social relationships that determines the rationale for and distribution of a society's rewards (Kerbo 2009). In the United States, achieved statuses are greatly encouraged, while ascribed statuses are rejected. This has generated the acceptance and encouragement of social class mobility (O'Neil 2008).

Social mobility may be defined as individual or group movement within a class system. Social mobility can occur vertically and horizontally when class systems are based on achievement (Kerbo 2009).

American society has been characterized by a relatively high degree of vertical social mobility. However, over the last thirty years that mobility has slowed and its extent varied based on rank in the class system and race. In the United States,

both ascriptive and achievement factors are important to social status; however, ascriptive factors have a heavier effect (Kerbo 2009).

Horizontal mobility refers to a change of occupation, or role, that does not involve any change of position in the social hierarchy. In other words, it is a change in position without a change in status. By contrast, *vertical mobility* refers to a change in the social position of an individual or a group. In other words, it is movement from one status to another. Other measures of social mobility track an individual's advancement over the course of his or her lifetime *(intra-generational mobility);* a family's advancement from parents to a child's adulthood *(inter-generational mobility)*; and forced gains or losses of status, usually of a group or class, based on permanent changes in the economy *(structural mobility)* (Sociology Guide 2011).

China

Public Policy

Napoleon Bonaparte once said, "Let China sleep. For when China wakes, it will shake the world." Today it is obvious that China is awake.

Before the twentieth century, China's history was shaped by dynastic cycles, long periods of rule by a single noble family. The cycle began with the seizure of power, proceeded with its growth, and concluded with its decline. According to ancestral wisdom, power was determined by the mandate of heaven; and public authority was exercised by the emperor and an elaborate bureaucracy in a highly centralized manner.

The last dynasty to rule was the Qing Dynasty, established during the seventeenth century. Its ancestral traditions and culture provided stability and prosperity for the China. However, by the nineteenth century the dynasty had weakened, and European countries sought control of the country (Wood 2011). The Qing Dynasty ended after a period of violent, chaotic change at the beginning of the twentieth century.

In 1911 China became a republic under the Western-educated Sun Yat-sen, who planned to run a democratic government. However, by the mid-1920s China was engulfed by a civil war between nationalist and communist factions. In 1949, a communist leader, Mao Zedong, took over the country; and a new regime contradictory to the traditional concepts of power began.

Mao ruled China for nearly thirty years, until 1976. Maoism was an idealistic political philosophy. Even though it endorsed centralized power exercised through the top leaders of the Communist Party, it stressed the importance of a close link to the masses of peasants to whom it required leaders to listen. Without that link, the legitimacy of the rulers was considered questionable.

Since Mao's death, the Politburo (which is the principal policy-making body and executive committee of the CCP) has been the legitimate source of power in China. Reputedly, however, the party is corrupt and irrelevant, with an authoritarian power over an increasingly market-based economy.

One of the party's main sources of power is the military, which is represented in the government by the Central Military Commission. In fact, political elites are mostly recruited from the military, and the head of the commission is often the most powerful leader in China.

China's political regime is categorized as authoritarian—all decisions are made by political elites and those who hold political power, with minimum participation by citizens. Leaders are recruited through their membership in the Communist Party, although nepotism greatly influences the selection. Although authoritarian, the regime still faces the challenge of how to manage effectively a large land and a large population from one centralized location.

The Chinese Communist Party is well organized throughout the country. In fact, the CCP is the largest political party in the world, with 82.6 million formal members as of December 2011 (China Today 2012); however, they make up only a small percentage of China's total population. Membership is solely for those who are

fully committed to the communist ideology and who are willing to devote their time and energy to party affairs.

Minority groups account for about 8 percent of China's population. There are fifty-five officially recognized minorities in the PRC, and the government has specific policies regarding them. The policies at once encourage economic development and suppress expression of dissent. At the core of this approach is the CCP's fear that geographic distance from population centers may encourage dissidents to seek independence or join with neighboring countries. Tibet is an example.

Prior to 1949, Chinese citizens were subjects of government but not participants in it. The CCP changed that situation by creating a relationship between Chinese citizens and their government, albeit an imperfect one. Nepotism is still very common in China's political process and influences the actions and beliefs of elites and citizens alike. However, in recent years, popular social movements that support democracy, religious beliefs, and community ties over nationalism have influenced Chinese politics and helped to define China's relationships with other countries (Gustafsson, Li, and Sicular 2008).

Most of the cadres of the Maoist era were peasants or factory workers; few were intellectuals or professionals. Since then the CCP has been led by technocrats, people with technical training who have climbed the ladder of the party bureaucracy. All seven members of the current Standing Committee have academic and professional backgrounds in technical fields. Less than 40 percent of party members come from the peasantry; however, this is still the largest single group within the CCP. The fastest-growing membership category consists of officials, intellectuals, technicians, and other professionals. Women make up about 20 percent of the membership, but only about 4 percent of the Central Committee (Gustafsson, Li, and Sicular 2008).

The CCP is organized hierarchically by governmental levels—village/township,

county, province, and nation. At the top of the system is the supreme leader, formerly called the chairman and now known as the general secretary. The party has its own constitution separate from the government's constitution (1982). The central bodies of the CCP are the National Party Congress, the Central Committee, the Politburo, and the Standing Committee.

The National Party Congress (NPC) has more than 200 delegates chosen primarily from congresses at lower levels of government. The NPC meets every five years and is unimportant in policymaking. Its real functions are to rubberstamp decisions made by party leaders and to elect members of the Central Committee.

The Central Committee has about 340 members who meet annually for about a week in what they called *plenums*. Central Committee members are in charge of carrying on the business of the National Party Congress between sessions. Because of its size and infrequent meetings, the Central Committee has only limited policymaking powers. However, it plays an important role in gathering the political elites and from them selecting the Politburo and the Standing Committee (Wood 2011).

The Politburo and the Standing Committee are the most powerful political organizations in the CCP structure. They are chosen by the Central Committee, and their decisions dictate government policies. The Politburo has twenty-four members; the Standing Committee has seven chosen from the Politburo membership. The Standing Committee holds secret meetings, and their membership reflects the balance of power among factions and the nepotism of different groups in policymaking (Wood 2011).

While China officially has a one-party system, the CCP does permit the existence of eight so-called democratic parties. Their membership, composed of businessmen and intellectuals, is about a half million and operates under the scrutiny of the CCP. These parties do not contest the CCP for control of the government; but they

do serve as advisors to the party leaders, and some even attain high government positions (Wood 2011).

Political issues are closely related to organizational matters. The structure, procedures, and staffing of a nation's bureaucracies will definitely influence its economic, social, and foreign policies (Harding 1981). The CCP came to power in 1949 and brought with it a vast assortment of theories and established practices of governmental and political organization. Having a long history of bureaucracy, Confucianism, and legalism and a socialism derived from Lenin and Stalin as forms of political organization, the transition was not easy. Indeed, it was fraught with ambiguities and contradictions.

The party's organizational system was complex and based on Chinese traditional theories, Soviet theories and practice, and the party's own revolutionary experience. During the last five centuries, Confucianism was the main administrative doctrine of the bureaucratic political management. The imperial government had a marked hierarchy of offices under the emperor, a formal system of ranks, and substantial structural differences. The Confucian principles of government were based on civil service examinations that most officials had to pass in order to enter government service. The examination, which was rigorous, stressed moral rectitude, personal abnegation, and service to society. Leninism used ideological education to ensure discipline, loyalty, and commitment. Confucianism and Leninism shared the ideology of routine criticism, self-criticism, and self-cultivation. Stalinism developed the "permanent purge," emphasizing that even after the seizure of power, the protection of the dictatorship of the proletariat against its enemies should continue; and so imprisonment, terror, and execution replaced the techniques of criticism and self-criticism. Stalinist ideology was an extreme form of internal remedialism. So the Chinese Communist Party followed the ideology of Stalin and proceeded with several purges to show dominance over others. The party implemented the Yenan technique, which was embodied in a set of documents based on the writings of Lenin and Stalin and the party's codifications thereof.

Furthermore, the CCP used mass campaigns to implement its policies (Harding 1981).

The CCP continues to be the policymaker and ruling force in China. Although the party has embarked on a path of economic reform since the late 1970s, China's economic success has brought with it a noticeable inequality among its citizens (Gustafsson, Li, and Sicular 2008).

Social Organization

Social organizations in China are composed of groups that perform independent activities in accordance with the constitution and the law. The subordinate units operate in cities and rural areas to serve and unite Chinese citizens. They are politically active and indispensable to coordinate social and public affairs and to safeguard the legitimate rights and interests of the people.

The following are the major social organizations or political parties in China:

· *All-China Federation of Trade Unions.* Supreme body uniting all local trade union and national industrial union organizations in China.

· *All-China Youth Federation.* Group dedicated to the interests of all youth organizations in China.

· *All-China Women's Federation.* Organization founded to unite women from all ethnic groups to fight for women's emancipation and to protect women's rights and interests in all areas, including politics, labor relations, property rights, and education among others.

· *All-China Federation of Industry and Commerce.* A nongovernmental chamber of commerce organized by people working in industry and commerce to promote mutual understanding between China and other countries and to develop mutual

exchanges (China Culture 2008).

In 1949 the Communist Party cadre became the new upper class. They manipulated and misused the ration system to gain access to better distributions of daily necessities and living space. In 1959 the landlord class was eliminated with land reforms, and peasants sold land to those wealthy enough to buy it. To prevent a new landlord class from emerging, a commune system was created. Peasants would work the land together. State workers were organized in similar units called *danweis*.

The increase in high school graduates and qualified middle class job candidates and the decrease in state industries made it difficult to get a position as a state worker. So the *hukou* system was implemented. It divided the population into urban and rural residents in order to facilitate the organization and distribution of state services through danweis and communes. Under this system, it was illegal to migrate from rural areas to the cities.

Then the Cultural Revolution (1966–76) occurred and changed the composition of society. Schools closed and young people were sent to the countryside learn from the peasants. By the 1970s the peasants were still the most illiterate, powerless, and poor people in China.

In the late 1970s, the *gaige kaifang* policy (also known as the reform and opening) was implemented. By 1984 the communes had disappeared and the danweis had laid off their workers; so peasants were forced to look for jobs in cities and in other regions.

By 1991 there were 113 million peasant workers. Two years later that number had increased to 145 million. By 2006 the number ranged from 150 to 220 million. Also known as migrant workers or floating population, they constitute the main body of the working class in China. This was the direct result of the reform and opening policy, which after 1979 allowed capitalist-owned enterprises to create jobs in China. The CCP adapted to the new system, and now cadres, party members,

and state professionals are the main body of the capitalist class. Higher education is limited—only about 5 percent of the population has an associate's degree (Yi 2005).

CHAPTER 4
Culture, Diversity, and Wealth

United States

Culture is the way of life that the people of a society follow. More specifically, it can be defined as the total pattern of human behavior and its products as embodied in thought, speech, action, and artifacts. It is the way of thinking and doing that is passed on from adults to children in their upbringing and can be thought of as the shared language, norms, and values of a society. Culture creates societies, and societies depend on culture (Hunt and Colander 2008).

Culture and Diversity

The United Sates is a multicultural society. The advantage of multiculturalism is that it incorporates diversity into a society and lets subgroups reverse their own history and view that history as a strong building block of the larger culture. The characteristics of every society are gradually shaped and changed over succeeding generations by innovations introduced by newcomers (Hunt and Colander 2008).

The great diversity of U.S. culture is derived in large part from immigration. Immigration has always been an important factor in U.S. history, viewed alternately as a point of pride and a social burden. For example, the Statue of Liberty proclaims the country's "open door" policy toward immigrants. In hard economic times, however, other views sometimes prevail. But as James M. Rubenstein (2008) notes, "In an economically integrated world; arguments such as 'if all immigrants were thrown out of the country, the unemployment rate would drop' or 'if all of the immigrants were cut off from public programs, then taxes would drop' have little scientific basis." Furthermore, in a culturally diverse world, such arguments are racist.

50

Culture is composed of several elements: social norms, institutions, technology, material products, and values. All societies have a *cultural universal,* which is an aspect of the culture that is found in all cultures. The United States has great diversity, and therefore greatly values freedom of choice with respect to both ideas and things. This makes life more complex and stressful.

The United States is an urban nation—or, to be more exact, an urban and suburban nation. The word *suburb* has different connotations for different people. For some, it means success, family life, and safety; while for others, it means cultural conformity, social isolation, and racism (Every Culture 2011).

During the nineteenth century, the suburbs became a haven for elites, while lower classes lived in the cities. Beginning in the early twentieth century, however, suburban living became affordable for working-class people and middle-class immigrants.

The prevailing political and economic views that have dominated the American way of life till now have been largely determined by the country's Anglo majority. For example, it has already been noted that the United States does not have an official national language. (English is the first unofficial language, followed by Spanish.) The question of whether English should be formally designated the nation's official language has been a source of tension between racial groups. Once settled in the country, immigrants are expected to adopt the American culture, including the English language. Speaking the language is one of the ways that nationalism and community solidarity are expressed in Americans' daily lives. It should be noted in this regard that the term *Americans* is used to describe white, middle-class people, while all other persons are identified by racial or ethnic background (e.g., African-Americans, Mexican-Americans).

As a response to the Great Depression, President Franklin Delano Roosevelt established a series of social programs called *New Deal* to serve as a cushion for the damaged economy. Today many of those programs are still in effect, including government-backed pension programs, bank deposit insurance, and unemployment benefits. Overall, Americans do not oppose these types of benefits.

The same cannot be said for general relief programs for the poor, or *welfare*. It is a basic tenet of American society that all citizens have equal and unlimited opportunity. If that is true, then arguably the only reason for being poor is laziness. As a result of this kind of reasoning, welfare programs often face cutbacks and the welfare laws have been reformed to require recipients to work to qualify for benefits (Adams and Goldbard 1995).

The United States continues to be less medically diverse than most other countries. Americans predominantly utilize the Western medical approach (i.e., biomedicine), which is characterized by the frequent use of invasive surgeries and drugs. However, many people combine such care with alternative approaches, such as homeopathic medicine, acupuncture, and chiropractic, often out of a need to cut costs. Health care services, insurance coverage, and drugs are disproportionately expensive in the United States and levels of patient satisfaction are not high. Nearly all other wealthy industrialized nations provide universal health care to their citizens; the United States alone does not. The U.S. health care delivery system is far from the best in the world (*New York Times* 2007).

Technology and science are important parts of the U.S. economy. Major areas of scientific research include medicine, energy, chemicals, weapons, aerospace technology, and communications, to name a few. The research expenses are covered by government agencies, universities, and private donations (Kerbo 2009).

Wealth Distribution

Substantial wealth gives power, influence, and independence to the one who possesses it. What is more, in the United States it can be transferred from generation to generation more easily than income, thanks to reductions in inheritance taxes made in 1982 and 2001, during the Reagan and George W. Bush administrations, respectively (Kerbo 2009).

In 2007, it was estimated that the upper class, or top 1 percent of the population, possessed 34.6 percent of all privately held wealth. The managerial, professional, and small business stratum, which comprised 19 percent of the population, possessed 50.5 percent of all private wealth. Taken together, those two sets of figures meant that a mere 20 percent of the population held 85 percent of the wealth. The remaining 15 percent of wealth was held by wage and salary workers, who accounted for the bottom 80 percent of the population (Domhoff 2011).

According to Domhoff (2011), a study by Norton and Ariely in 2010 indicated that Americans do not know how wealth is distributed in their country. The same study indicated that Americans would like to have a wealth distribution in which the top 20 percent own between 30 and 40 percent of privately held wealth.

Throughout U.S. history, records have indicated that wealth was concentrated in the top 1 percent of population, with minimal variations (Kerbo 2009). As already stated, wealth provides the power to influence political parties, lobbyists, or policy-making bodies. Furthermore, it can shape the general social environment to the benefit of the wealthy through the hiring of public relations firms or the making of donations to universities, museums, and similar institutions. Stock purchases and ownership can control corporations and their impact on society (Domhoff 2011).

China

In China, diversity is treated differently from the way it is in the United States. Many towns are recognized as autonomous counties or townships because they have large minority populations. Many of these townships have their own local dress, crafts, festivals, and other visible markers of ethnicity. The state allows (and in some ways encourages) such expressions of ethnic differences, as long they do not lead to separatism.

In the not-too-distant past, however, the government's approach was not so enlightened. During the Cultural Revolution (1966), the process was reversed as 12 million Han young people were transferred to state farms and rural villages, some inhabited by ethnic minorities. Tibetans have also been nearly reduced to a minority in their own land by such mass immigration, again at the instigation of the Chinese government.

Culture and Diversity

Diversity in China can also be observed in the country's leadership. Over time, China has moved away from leadership based on a single charismatic figure to a more collective form of leadership. This "fifth generation," as it is known, is the most diverse elite generation yet in terms of education, social class, political association, and career path. The leadership group is 11 percent female and about 89 percent Han. It also includes native representatives of the Tibet Autonomous Region. Even more importantly, thirty-five high-ranking fifth-generation leaders are not even members of the CCP. The class of 1982, which is the group of people who passed the most competitive college entrance examinations and graduated in 1982, will be significant members of the national leadership in the years to come. Currently, the class of 1982 accounts for164 leaders out of 398 college graduate members. Furthermore, 394 leaders received postgraduate degrees Fifth-generation leaders are not all technocrats; they are trained in a

broader range of disciplines, including economics, social sciences, and law. By contrast, there is a notable decrease in the power and influence of the technocrats, those who have degrees in engineering or natural sciences.

Another change from former generations is an increase in the number of foreign-educated leaders. China's political elite includes eighty-two members who were educated abroad.

Even though education is very important in the selection of leaders, patron-client ties and factionalism continue to influence political advancement more in the PRC. Still, checks and balances have increased since the fourth generation, and there is now a form of bipartisanship within the CCP—one party, two coalitions. One is the populist coalition (also referred to as Tuanpai), and the other is the elitist coalition. This bipartisanship, however, lacks transparency and legal sanction. Chinese authorities look for an "inner-party democracy" to establish checks and balances within the party. Obviously, the greater the diversity, the greater the difficulty in reaching agreements. This has become apparent in several debates on major issues such as the public health care system, financial reforms, and foreign trade. Although both coalitions demonstrate their solidarity and strength, both want to maintain the CCP's rule of China while continuing to improve China's status internationally.

The diversity in the leadership contributes to political pluralism, which makes for more dynamic decision making. Values usually differ, depending on the social background of each person; but in China, political leaders support the party's ideology and withhold their own opinions. Fifth generation leaders, however, are pragmatists. They are also less dogmatic than their predecessors and less ideologically confrontational regarding the United States. They have more sophisticated opinions on different (conceptual) political issues and are tolerant where sensitive issues are concerned. The

promotion of radicalism is not a priority for them. Although nationalism is rising in the China, it does not seem likely in the future that there will be a radical leader with a radical agenda. Generational differences will likely tend to reinforce diversity in values and how those values are perceived internationally (Li 2008).

Wealth

The wealth of China has increased greatly over the last thirty years. The economic boom has brought greater income and investment opportunities to the country. As a result, urban average real household net total wealth increased by 24 percent per annum in an eight-year period from 1995 to 2002.

On its face, such an improvement would seem to be a positive thing, but there were negatives associated with it for both the Chinese people and the CCP. To start, the economic benefits did not extend equally to all segments of the society. Most of the increase in wealth went to the economic and political elites of the country. Surveys indicated that households with above-average incomes accumulated more wealth than the poor. The latter accumulated some wealth, but much less and at much lower rates than the rich. For example, between 1995 and 1999, the rate of increase for the bottom-income households was 34 percent, while for the top-income households it was 166 percent. Comparable rates for the period between 1999 and 2002 were 111 percent and 346 percent, respectively. Statistics also demonstrated that savings were not being accumulated at the same rate for both groups (Meng 2007).

Two factors contributed to this disparity. First, the poor were largely dependent on income from labor (i.e., wages) rather than investment income or appreciation (i.e., unearned income). Generally, labor income and wage accounts are low in proportion to gross national income, and labor

elements take a low share in the distribution of enterprises. The wealthy, on the other hand, tended to have both earned and unearned income sources. As economic growth and reforms increased, the establishment of housing and other financial markets facilitated the rapid accumulation of wealth. As the principal authors of reform, high-level government and party officials (and their families) were particularly well situated to take advantage of both trends. For example, they were initially allowed to buy homes at heavily subsidized prices and in 2002 received a better allocation of housing and larger purchase price discounts. Since then, housing has appreciated so rapidly in urban China that it has become the principal factor in the accumulation of personal wealth and the disparity between bottom-income and top-income households.

The second factor that contributed to the disparity between rich and poor households was the undermining of the Chinese welfare system. China is in the process of changing that system to one in which the individual will have to provide for his own medical care, income in old age, and protection against other economic adversities. In the past, it was forbidden, unnecessary, and unrealistic for individuals to do this sort of thing because of extremely low wage levels. Private property, housing, or other capital did not exist. Moreover, every urban resident had a lifetime job, a full pension, lifetime free medical services, and free education for his or her children. However, as Communist central planning gave way to foreign trade and investment, state-owned enterprises shut down and laid off large numbers of employees, who then went to work in the private sector. The urban workforce employed in that sector swelled from 4 percent (with benefits) in 1986 to 67 percent (without benefits) in 2003.

For the CCP, the principal negative associated with China's increased

wealth was ideological: in many ways, that wealth undermined the socialist principles upon which the PRC was founded. For example, free (privately owned) enterprises in China have become more successful than state-controlled enterprises. The Chinese government has increasingly found itself running a system of state-controlled capitalism. In Chinese society, interest in accumulating wealth is growing; so is interest in preserving it through inheritance. To meet new economic realities, the Chinese welfare system is being redesigned along capitalist lines.

According to statistics, the main income growth in China occurred between 1995 and 1999, with an annual growth rate of 10.1 percent per annum; while the per capita net total wealth increased by 27 percent per annum during the same period, with an increase of 22 percent between 1999 and 2002. Housing wealth increased the fastest at a rate of 50 percent per annum from 1995 to 1999 and 19 percent from 1999 to 2002. Furthermore, all types of assets increased as well, indicating that per capita real net wealth grew faster than per capita real income.

Inequality did increase. The Gini coefficient of household per capita real income rose from 36 percent in 1995 to 38 percent in 1999 and to 40 percent in 2002. Except for housing, wealth inequality was most unequal during 1999; however, statistics indicate that inequality of total wealth fell between 1995 and 2002, mainly as a result of reduced inequality in housing. In any event, such figures should be read conservatively. Wealth distribution in China is complicated to classify because different inequality indices are used and provide varied answers.

Between 2008 and 2009, there was an estimated increase of about 50,000 millionaires with assets worth more than 10 million renminbi (up from 825,000 to 875,000), while people with assets exceeding 100 million increased from 51,000 to 55,000. Furthermore, there were about 2,000

billionaires with assets of more than 1 billion renminbi and more than 100 billionaires with assets of more than 10 billion renminbi. However, the average peasant earned less than $5,000 per annum (Lee 2010).

These statistics reinforce the fact that, while China's wealth has grown at a fast pace, there is still a major distribution difference between the rich and the poor. In addition, China's social welfare policies have benefited mainly urban residents; the programs have yet to reach the 737 million rural residents (Yunlong 2008). Zhang Monan (2010) attributes China's "difficulty in boosting domestic demand . . . to irrational primary and secondary distribution structures."

To solve these problems, the government has undertaken social welfare reforms in a wide variety of areas, including education, pensions, health care, housing, employment, and aid to rural residents and migrant workers. In 2009, for example, the Chinese government spent 293 billion yuan ($42.84 billion) to expand a number of social services. It increased public expenditures on rural mandatory education, raised the salaries of 12 million primary and secondary school teachers (using a performance-based system), and implemented a program for school building safety. Hospitalized childbirth was subsidized, and prenatal care and postpartum visits were provided, along with well-baby checkups from birth up to three years of age (Xinjua 2009). Finally there was China's low-income housing plan, according to David Cui, a bank strategist, one of the biggest peacetime wealth redistributions in the history of modern China (Weisenthal 2011).

Despite such efforts, economists have acknowledged that the lack of a social security system and health insurance will continue to be a burden for China's economy because it prevents people from spending freely, thereby keeping domestic demand low. To remedy the situation, there are plans to create and implement old-age pensions for the country's 130 million rural

migrant workers. In addition, in January 2009 China's State Council passed a medical reform projected to spend 850 billion yuan by 2011 to provide universal medical care for the whole population (Xinjua 2009). It is expected that by 2020, China will have invested 5.74 trillion yuan to enhance the whole social welfare system.

In 2008, about 219 million Chinese had pensions, 317 million had basic medical insurance, 124 million had unemployment insurance, 138 million had work injury insurance, and 91 million had childbirth insurance. Now with the increase in social services, according to Chinese experts, China will become a welfare state by 2049. The transition is planned to occur in three stages. In the first (2008–2012), a safety net will be created. In the second (2013–2020), welfare policies and measures will increase to make the social security network stable and sustainable. In the third (2020–2049), provisions will be improved to "build a socialist welfare society with Chinese characteristics." Economists believe that a mature Chinese welfare state will influence welfare state systems of other countries and set the standard for welfare states internationally (Stepan 2009).

CHAPTER 5
Poverty—Its Challenges and Solutions

United States

The United States has an open class system, which allows people to have social mobility. But social mobility can work both ways—it can either raise or lower the social and economical status of a person. Big gaps between social classes have always been a characteristic of capitalism; however, they are accentuated more when a nation goes through an economic crisis.

The United States is the largest economy in the world. It also has the greatest percentage of people living in poverty. The most recent economic crisis greatly impacted the middle and lower classes, making the gap between the upper class and the other classes larger than ever. Among developed nations, only Mexico has a greater number of poor.

In the United States, poverty rates have fluctuated throughout history. The U.S. poverty rate during the late 1950s was 22.4 percent, or 39.5 million people. The rate greatly decreased during the 1960s and by 1973 had dropped to 11.1 percent, or 22.9 million people. However, by the early 1980s the trend had reversed. In 1983, the poverty rate rose to 15.2 percent, or 35.3 million people. Between 1984 and 1992 the poverty rate remained above the 12.8 percent mark, and by 1993 it had increased to 15.1 percent, or 39.3 million people. By 2000, however, the rate had fallen substantially to 11.3 percent, or 31.1 million people (U.S. Census Bureau 2001). By 2004, it was up again to 12.7 percent, or 37 million people (The University of Michigan 2011). Then the rate began a series of modest declines. In 2005 it inched down to 12.6 percent, or about 37 million people (AARP 2006). In 2006, it

fell to 12.3 percent, or about 36.5 million people (U.S. Census Bureau 2007) and remained at that level throughout 2007 (U.S. Census Bureau 2008). In the following years, however, it would break all records.

In the summer of 2007, the United Stated suffered its worst economic crisis since the Great Depression. The crisis was ignited by the subprime mortgage market and then spread to prime mortgages, commercial real estate, corporate junk bonds, and other forms of debt. As a result, banks experienced major capital losses and drastically reduced lending. That spread the crisis to other markets (Moseley 2009), and soon what had been a national crisis became a global crisis.

The slowdown officially became a recession in December 2007. Soon it affected major corporations, governmental departments, and small businesses, Employers had few options but to reduce budgets to avoid a collapse. They started by reducing hours, then adjusted salaries, and eventually resorted to layoffs. Unemployment, already at 5 percent in late 2007, reached 7.8 percent by the end of 2008 (U.S. Bureau of Labor Statistics 2010).

Economists had predicted the increase in unemployment. Fourteen months after the onset of the recession, approximately 1.8 million Americans had lost their jobs in a period of three months, leaving a total of 11.6 million people unemployed (Kvaal and Furnas 2009). The outlook did not improve. By August 2009, the unemployment rate had increased to 9.7 percent; and by the end of September of the same year, about 15 million people were unemployed (Irons 2009). In October 2009, the United States experienced its highest unemployment rate in twenty-six years—10.2 percent (U.S. Bureau of Labor Statistics 2010).

These figures likely understated the problem. As the *Washington Times* pointed out in an article, "The unofficial unemployment rate begins with

the official rate and then adds in everyone else who should be working full time but is not, including those whose hours have been reduced from full time to part time, those who have become so discouraged they have given up looking for work and those who are 'marginally attached to the labor force.' " Tallying these figures suggests a rate as high as 20 percent" (Versace 2009).

That was a major blow to people in the middle and lower classes; and because unemployment and poverty have a positive correlation, it rapidly increased the national poverty rate. Not unexpectedly, evidence of negative, or downward, social mobility was pronounced. The reduction of income among formerly middle-class people moved them into the lower class. In addition, middle-class people who had work were willing to accept a reduction in salary or hours in order to safeguard their jobs, and the unemployed were willing to take bigger pay cuts to reenter the job market, although the chances of getting a job were slim.

The situation dragged people into an unfamiliar position, making them part of a group known to as "the new poor," middle-class people who were relying on public assistance for the first time in their lives and potentially for years to come (Goodman 2010). Experts acknowledge that every time there is a major economic crisis, before the economy recovers, some people will slip from middle to lower class; and for some of those, it might take longer to get back to their former status because there is a decreased demand for goods and employers are cutting payroll expenses by eliminating most of their full-time employees and shifting to part-time and temporary employees. Another factor that contributes to the difficulty of finding employment is the emigration of large companies to low-cost countries in Asia and Latin America; also, automation has cut 5.6 million jobs since 2000, which at some point provided lower-skilled workers a middle-class lifestyle (Goodman 2010).

Usually the sectors that aid economic recovery are the automobile, home-building, and banking industries. Unfortunately in this recession, those three were the ones most affected by current economic conditions. Moreover, the withholding of loans for small businesses and investment capital for new ventures prevented the creation of new jobs. A situation that was supposed to last for no more than a few months became a long-term crisis. Worst of all, for many people, being unemployed was only the beginning of their problems; it then led to foreclosure, the spending down of savings, increased credit card debt, and bankruptcy.

Traditionally, education has been a shield against long-term unemployment. With this recession, however, that has not been the case. Middle-class people, educated or not, are facing a new reality: they have to learn to live with a fraction of what used to be their incomes. Many have no option other than to rely on unemployment benefits, child support for single parents, financial help from parents or non-immediate family members, and state or local social services, including food banks. Their search for any kind of job is constant, but the opportunities are scarce. In some states there are hundreds, even thousands, of applicants for small numbers of positions. It has reached the point where job seekers must camp out overnight just to obtain and submit a job application. Unfortunately, this is not an uncommon situation around the country (Irons 2009).

The recession has also affected the formation of new businesses and the expansion of established enterprises. Both are being delayed until demand returns to normal levels. In addition, new businesses require new investors and creditors, which at this point is problematic because banks are limiting their loans and individual investors are not willing to take excessive risks. Obviously, the situation causes delays in establishing new businesses, which means in turn a prolonged economic recovery and a delay in the creation of

new jobs (Irons 2009).

For some existing businesses, loss of income has lead to the last resort— bankruptcy. In 2007, there were 28,322 business filings for bankruptcy. In 2008, there were 38,651 filings. In 2009, the number was 58,721 (United States Courts 2009), and in 2010 it was 56,282 (U.S. Courts 2011).

The story is the same for individuals. By the end of 2007, a total of 822,590 individuals had filed for bankruptcy. By the end of 2008, the figure was 1,074,225 bankruptcy filings; for 2009, it was 1,412,838 filings (U.S. Courts 2011). In March 2010, over 158,000 Americans filed for personal bankruptcy (Maierhofer 2010). Reports indicated that by the end of the year 1,536,799 individuals had filed, an increase of over hundred thousand cases. By the end of the first three quarters of 2011, reports indicated that 956,491 individuals had filed for bankruptcy, and 385 businesses had done the same (U.S. Courts 2011).

According to the Federal Reserve Chairman, Ben Bernanke, a full economic recovery will take years. The long-term effects go far beyond income and earnings; they can greatly affect a person's mental health and contribute to a gloomy future for children growing up in poverty (Irons 2009). Vanessa Wight, a demographer for the National Center for Children in Poverty, stated that it was expected that poverty rates would increase from 13.2 percent (39.8 million people) in 2008 to 15.8 percent (47.4 million people) in the months to come (Haq 2010).

There was, however, optimism among the economists. William Strauss, a senior economist at the Federal Reserve Bank of Chicago, took the fact that job creation increased in the first quarter of 2010 as an indication that the next six months would be suitable for hiring. To support his belief, he cited statistics that showed that in March 2010 employers created 162,000 jobs. In addition, he noted that there was a positive outlook for the financial,

insurance, real estate, and service industries. The same, however, was not true for the transportation, utilities, information, and communications industries. Acknowledging that optimism was not enough, Strauss added, "In order to achieve a full recovery, it is important to have new jobs, higher profit margins for companies, and higher salaries for the employees." Those jobs were not sufficient (Fredix 2010). Everyone knew the answer, but it was more complicated to implement it.

Vanessa Wight was not very far from the actual numbers. In 2008, just over 13.0 percent of the population lived in poverty. During 2009 that number increased to 14.3 percent, and by 2010 it had increased to 15.1 percent (U.S. Census Bureau 2011). The U.S. Census Bureau, using a more accurate method of measurement, revised the figure for 2010. The new method yielded a 16.0 percent figure instead of the 15.1 previously reported (Tavernise and Gebeloff 2011). That means about 49.1 million individuals lived in poverty during 2010 (Yen 2011). The poverty rate during 2010 was the highest since 1993 (The University of Michigan 2011).

The government, the experts, and the American people are aware of the key factors needed for a full recovery; however, it is complicated to revive an economy because it requires the correct strategies and time to recreate an economic flow. The benefits of the economic recovery will reach employers first; for the former middle class, recovery will come much later when they find secure, full-time jobs with salaries that allow them to cover their basic needs. Then they will be able to start the difficult journey to improve their economic circumstances, which eventually will move them back to their previous class status. Meanwhile, poverty increases in the United States.

China

China is a fast-growing economy that will soon officially replace the United States as the largest economy in the world. While the growing prosperity

of the country has not yet reached all sectors of the population, official statistics show that there has been a major reduction in the overall poverty rate since 1978.

The post-reform reduction of poverty in China can be divided into four phases.

· *1978–1985.* This phase coincided with general economic growth. The poverty rate dropped from 30.7 percent, or 250 million people, in 1978 to 14.8 percent, or 125 million people, by the end of 1985.

· *1986–1993.* This phase was rooted in prior economic reforms that disproportionately benefited those living in urban areas. The 1986 poverty reduction programs were implemented in rural areas to try to narrow the income gap. As a result, the poverty rate dropped to 8.8 percent, or 80 million people, by the end of 1992.

· *1994–2000.* The government launched the 8-7 Poverty Alleviation Plan, which focused on eliminating absolute poverty within seven years. By the end of 2000 the rate had dropped to 3.4 percent, 32.1 million people.

· *2001–2010.* In this period, the Development-Oriented Poverty Alleviation Program was implemented by the end of 2003. The absolute poverty population in China was 29 million, or 3.1 percent (Rural Survey Organization of National Bureau of Statistics, China 2004). By the end of 2009, about 35.97 million people, or 3.6 percent, of the rural population, lived below the poverty line (Zhu 2010)

Some experts take issue with the official statistics, which have shown a decrease in China's poverty rate from 30.7 percent (250 million people) in 1978 to 3.4 percent (32.1 million people) in 2000. Such dramatic reductions seem unrealistic. Other estimates have indicated that poverty in China was higher than the official rate to start with (Park and Wang 2002). For example, one source cited the International Monetary Fund as having reported that in

1981 China's poverty rate was more than 50 percent, that by 1991 it had dropped to 20 percent, and that by 2005 it had been reduced to 5 percent. However, the same article mentioned that China's *rural* poverty line is one of the lowest in the developing world (Ravallion and Walle 2008).

In November 2011, China raised its rural poverty line to 2,300 yuan a year, or 6.3 yuan per day, which is about one U.S. dollar. (Previously in rural areas, a person was classified as poor if his income was less than 55 cents per day [ET 2011]). The World Bank's global poverty standard is $1.25 per day in 2005 Purchasing Power Parity (PPP), which means that a person is poor if his

purchasing power is less than $1.25 a day in 2005 U.S. dollars (S.C. 2011). So even with China's latest increase, its rural poverty line still falls below the World Bank's poverty standard.

China considers a person poor if his income is less than $1.33 per day in 2005 PPP. The defining factor is the difference between income and savings. If a person can save, then he is not considered poor. However, the PPP estimates in China are biased. They are based on an international price comparison overseen by the World Bank, but carried out by China's National Bureau of Statistics (S.C. 2011). Moreover, this new standard would raise the officially impoverished population in China to over 128 million people, all of whom would be eligible for government antipoverty subsidies] (Reuters 2011).

The new threshold matches medium-ranked nations in the middle- and low-income tier of countries. According to a senior statistician in the Development Economics Research Group of the World Bank, the 2,300 annual income of Chinese farmers is about $1.80 a day. Based on a recent official survey, about 67.34 million rural people were moved out of poverty during the last decade. This means that only 2.8 percent of the population is considered poor. Reports indicate that about 26.88 million Chinese lived in poverty in 2010.

The World Bank recognizes the efforts of the Chinese government to eradicate poverty. Wang Yan stated that China would continue to improve conditions for the poor. One of the main goals of China's leaders is to alleviate poverty in the rural areas within the next ten years by narrowing the wealth gap (Rigby 2011).

According to the Chinese government, the newly classified poor will be entitled to benefits such as job training, discounted loans, and employment opportunities in government-funded rural infrastructure projects. Furthermore, one of the government's overall goals is to ensure that by 2020 every person in China will be able to feed and clothe himself (ET 2011).

Perhaps the estimates of poverty rates in China are unrealistic, but certainly

the Chinese government is being proactive in setting goals for itself. It is a fact that the poverty rates will increase, although if the government implements its promises, the quality of life for the poor will be better. China will continue to act on social issues in order to comply with the demands of the world market. The client's request, after all, must be fulfilled.

PART 2 Two Economies Profiled

CHAPTER 6
Recessions and Depressions in the United States and China

The Great Depression showed that recessions, large and small, are a recurring and distressing fact of the business cycle in all modern industrial economies. A *business cycle* is the combination of an expansion, or period of economic prosperity, and a recession, or period of economic decline. In other words, it is the ebb and flow of economic activity (Romer 2008).

United States

Since 1790, there have been forty-seven recessions in the United States Of those, seven have occurred in the last fifty years.

1960 Recession

During the 1960s, the United States experienced its longest uninterrupted period of economic expansion. It started in April 1960 and ended ten months later, in February 1961. Major businesses dominated the economy during the period, with the housing and computer industries superseding the manufacture of automobiles, chemicals, and electrical products.

The recession negatively impacted consumers and businesses alike (US History Project 2011). It was characterized by high unemployment, high inflation, and a declining gross domestic product (GDP). The growth rate of the nominal GDP was at or below zero during the downturn: in the second quarter, it was -2 percent; in the fourth quarter, -5 percent (Amadeo 2011). By May 1961, unemployment had reached 7.1 percent (Amadeo 2011).

According to Robert Dieli, the recession was caused by fiscal and monetary policies that were out of phase (Dieli 2011). To help the economy rebound, President John F. Kennedy implemented a recovery package that increased

government spending to improve GDP (ING-USA 2009).

1969–1970 Recession

The recession of 1969-1970 was so mild that there was some dispute as to whether it was a recession at all. It lasted only 11 months. During the first quarter, GDP was -7 percent; in the fourth quarter, -4.2 percent. By December 1970, unemployment had reached 6.1percent (Amadeo 2011).

According to Solomon Fabricant, in financial terms or by measures of real economic activity, the economic changes of 1969-1970 did not constitute a recession. However, based on GNP in constant prices, deflated personal income, industrial production, and employment, the economic changes over the period did constitute a recession. The severity overall was within limits of a recession, albeit a mild one (Fabricant 1972).

1973–1975 Recession

One of the longest and deepest U.S. recessions began in November 1973 and ended sixteen months later, in March 1975. It was characterized by weak economic growth and a simultaneous rise in both the inflation and unemployment rates (typically these two indicators move in opposite directions). The rate of contraction of GDP was 3 percent. There were three quarters of negative GDP: the third quarter of 1974 (-3.9 percent); the fourth quarter of 1974 (-1.6 percent); and the first quarter of 1975 (-4.8 percent). Technically, the recession ended in March 1975; however, in May 1975, unemployment reached a high of 9 percent (Amadeo 2011).

Multiple factors contributed to this recession—the excessive printing of money, wage-price controls, the oil shock, and a decline in productivity. The excessive printing of money created inflation. President Nixon instituted wage-price controls, which set salaries too high, forcing employers to lay off people. The recession was exacerbated by the 1973 oil shock. The price control policies implemented in 1971 to mask inflationary pressures instead

increased economic weakness both before and after the oil shock, preventing the economy from adjusting to market forces. Also, the regulatory attempt to hold down the price of oil contributed to shortages that were more costly than if prices had been allowed to rise freely.

Oil prices rose in nominal terms, from $2.60 per barrel in 1973 to $11.00 per barrel in 1975. Prices tripled, and the federal funds rate (the rate banks charge each other to use federal funds) increased 5 percent in a few months, causing a tightening of monetary policy. Real interest rates rose as well from below zero to 2–3 percent in a few months, producing an unsustainably low base. Lastly, the recession coincided with a decline in the growth of productivity that lasted twenty years (Labonte and Makinen 2002). The term that came to characterize this complex of factors and the recession itself was *stagflation*, which is persistent inflation, accompanied by stagnant consumer demand and relatively high unemployment (Merriam-Webster 2011).

1980–1982 Recession

At the time, the 1980-1982 recession was the deepest and longest of the post-war era. It was a so-called double-dip recession, consisting of two recessions interrupted by a two-quarter expansion. The first was from January 1980 to June 1980, the second from July 1981 to November 1982. It was also the first recession since the Great Depression to reach double-digit unemployment rates.

Two major factors contributed to the duration and intensity of this recession. The first was the oil embargo, which reduced U.S. oil supplies, thereby raising prices. The second was the effort by the Federal Reserve to combat inflation. The Fed, as it is called, increased interest rates, which reduced business spending.

Inflation reached 11.1percent on an annualized basis in the fourth quarter

of 1980. The contraction of GDP for January 1980 to June 1980 was 2.2 percent, with unemployment reaching 7.8 percent. The contraction of GDP for July 1981 to November 1982 was 2.9 percent, with unemployment reaching 10.8percent (Labonte and Makinen 2002). The recession caused six quarters of negative GDP. The second quarter of 1980 was the worst at -7.9 percent, which was the worst quarterly decline since the Great Depression. By November 1982, unemployment rose to 10.8 percent, which was the highest level of unemployment in any recession. The level remained above 10 percent for ten months (Amadeo 2011).

1990–1991 Recession

This recession lasted nine months, starting in July 1990 and ending in March 1991. It was the result of the savings and loan crisis of 1989, which led to the liquidation of numerous thrift institutions according to the terms of the Financial Institutions Reform, Recovery, and Enforcement Act of August 1989.

Another factor contributing to this recession was the Federal Reserve. In an effort to counteract rising inflation (from 2.2 percent in 1986 to 3.9 percent in 1990), the Fed tightened monetary policy between February 1988 and May 1989 in order to increase the federal funds rate. However, some of this increase had already been reversed by the time of the recession.

A third factor contributing to this recession was the Iraqi invasion of Kuwait, which caused another oil price shock. Crude oil prices rose from $15 per barrel in June 1990 to $33 per barrel in October 1990 (Labonte and Makinen 2002).

There was little or no fiscal easing, or government intervention, during this recession. The decline of inventories was smaller than usual. The contraction of GDP was 1.5 percent, with an unemployment rate of 7.8 percent fifteen months after the recession ended. The rise of unemployment was relatively

mild. The fourth quarter of 1990, GDP was -3.5 percent, and the first quarter of 1991 it was -2 percent (Amadeo 2011).

2001 Recession

The tenth post–World War II recession started in March 2001 and ended in November of the same year. This recession was caused by the Y2K scare, which created a boom and subsequent bust in on-line businesses. The economy began to show distress in mid-2000. Factors such as the falloff in industrial production since September 2000, the slump of the GDP between mid-2000 and mid-2001, and the 9/11 attacks also contributed. Oil prices rose to $34 per barrel by late 2000. There was easing of fiscal policy with a tax cut and the shift from a large budget surplus to a budget deficit. Because only investment spending was excessive, inflation remained low (Labonte and Makinen 2002). The federal funds rate was reduced from 6½ percent to 1¾ percent between January 3 and December 11, 2001. During the first quarter of 2001, GDP was -1.3 percent; during the third quarter, it was -1.1 percent. During the recession, unemployment increased to 5.7percent. However, as of June 2003, well after the end of the recession, it was up to 6 percent (Amadeo 2011).

2008–2009 Recession

The economy started to soar by mid-2007, characterized by loose monetary policy, global imbalances, misperception of risk, and lax financial regulation. The resulting recession (also called the Great Recession) is considered the worst and longest downturn since the Great Depression. It started in December 2007 and ended in June 2009, a period of 43 months.

The 2008-2009 recession was characterized by increased layoffs, a decline in consumer spending, and a banking crisis of global proportions (Verick and Islam 2010). At the root of the banking crisis was the subprime mortgage debacle. The subprime loan market was largely unregulated and driven by

78

greed. Years of lending to subprime and Alt-A borrowers (i.e., those having credit scores below prime but not subprime) fueled a housing boom that eventually collapsed as a result of balloon payments, increases in interest rates, and falling home values. By the end of the first eleven months of 2008, 1.9 million jobs had been lost (Albert 2008.)

From the beginning of the crisis until December 2008, the Federal Deposit Insurance Corporation (FDIC) took over twenty-seven banks (Verick and Islam 2010). GDP fell into negative numbers for five quarters: the first quarter of 2008 (-1.8 percent), the third quarter of 2008 (-3.7 percent), the fourth quarter of 2008 (-8.9 percent), the first quarter of 2009 (-6.7percent), and the second quarter of 2009 (-0.7 percent). The recession ended in the third quarter of 2009 when President Obama used an economic stimulus package to spur spending (Albert 2008).

Today, according to the *Washington Post,* Americans are earning less than they did thirteen years ago. The poverty rate has risen to 15.1 percent, which is the highest it has been since 1993 (Khimm 2011).

China

China's recessions are almost impossible to document and confirm. The country has almost certainly been affected by global recessions; however, in past years it has demonstrated its capacity to act promptly when facing economic challenges.

Global Recession of 1974-1975

In 1973 China entered into a contract with Japan, Western Europe, and the United States for the purchase of complete plants, transport equipment, and agricultural products, which were delivered in 1974. China bought them at high prices in a period of double-digit inflation. This led to a decrease in the international demand for Chinese products, which were overpriced, and ultimately caused a trade deficit of $1 billion in 1974 (Eckstein 1978).

1986 Recession

Some economists indicated that China's macroeconomic policies in 1985 led to lower demand and caused a loss of efficiency. The country also experienced a shortage of energy resources. In early 1986, net profit per 100 yuan of fixed assets declined by 3.7 yuan from 1985, reaching the lowest rate in those years. Labor productivity increased by only 2 percent. Realized profits also declined by about 10 percent. The size of deficits increased by 90 percent. In addition, the economic results of commercial enterprises shrank. Profits and taxes dropped faster than production, the industrial comparable cost of products rose, the quality of products declined, and the scope and scale of losses of enterprises increased. Reports indicated that growth was below the threshold rate. Moreover, the adoption of retrenchment policies reduced the efficiency of market forces on the marginal production of enterprises (Fewsmith 1994).

1998-2001 Recession

At the end of 1997, coal production had a surplus and entered a four-year recession. Prices gradually decreased, output decreased, and payments for coal sales remained in arrears. China's coal output shrank from 1.397 billion tons to 998 million tons in 2000. During this recession, government-owned mines laid off a large number of employees, new mine construction was postponed, and the government suspended matured debts from state-owned mines (Garnaut and Song, 2006).

Global Recession of 2008

Like other industrialized countries, China was affected by the 2008 recession. Its export trade was especially hard hit. Late in the year, however, the government implemented a financial stimulus package, including the moderating of credit. This produced a prompt and favorable outcome. By the end of 2009, the GDP growth rate was again at 8 percent. The fixed

80

investment in key manufacturing overcapacity and the maintenance of a fixed exchange rate for the renminbi in the face of the sinking U.S. dollar stimulated exports at the expense of Western economies, which also contributed to the recovery (Reuvid 2011).

Regardless of the plans implemented by the Chinese government, some economists still predicted that China's economic growth could fall as low as 5 to 7 percent. They expected this because of what they observed: the decrease in economic activity, inflation, and the losses in industrial output, exports, and investment over a period of several months. Taken together, those things constituted a recession whether it was called that or not.

During 2008, China's economic growth dropped to 9 percent from 13 percent the previous year. The government's target GDP growth per year is 8 percent, and usually that goal is surpassed. Andy Gilholm, a senior analyst, thinks that what matters is the number of successful companies, how many people can maintain their living standards, and the length of time weak economic conditions persist. Richard Herd, head China economist with the Organization for Economic Cooperation and Development, however, estimates that "every percentage-point decline in GDP growth costs two million jobs in China." According to economists, a clear definition of a Chinese recession is difficult because the official data are not as comprehensive as in Western economies. The only way to do such analysis is by basing calculations on estimates produced by private sector specialists (Wall Street Journal 2009).

The Chinese economy seems to have been less affected by past recessions in Western economies, but the future of the Chinese economy seems clearer. Dr. Marc Faber forecasts a recession for China as soon as 2012, mainly because of the global economic slowdown and the bursting of the economic growth bubble. This recession will directly affect the resource producers,

such as Canada and Brazil, and the global economy (Arabian Money 2011). His predictions are supported by the acceleration of the Chinese inflation rate to a thirty-seven–month high of 6.5 percent in July 2011, based mainly on surging food costs, which rose 14.8 percent. This worsens the global liquidity. In addition, the Producer Price Index (PPI) rose by 7.5 points during the same month, and prices of production materials rose 8.4 percent on a year-to-year basis (The Economic Times 2011).

Recessions and depression are necessary for the health of an economy. China's recessions are hard to identify because the factual information on which to base such a finding is often unavailable. However, it seems that the near future will not be as positive or promising as it is now.

CHAPTER 7
U.S. Trade Agreements

U.S. Foreign Trade

Since 1976, the United States has faced continual merchandise trade deficits of fluctuating amounts. This is a major concern for Congress because it leads to political pressure to open foreign markets, shield U.S. producers from foreign competition, and/or help them to improve their competency.

Recurring trade deficits have also resulted in a decline in the value of the dollar and turmoil in financial markets. This has caused a dearth of savings in the domestic economy and a reliance on capital imports to finance that deficit. The capital inflows offset the outflows of dollars used to pay for imports, and movements in the exchange rate help to balance the trade. When not balanced with capital inflows, rising trade deficits place negative pressure on the value of the dollar, which helps to shrink the deficit by making exports cheaper and imports more expensive. In addition, the increase in trade deficits diminishes domestic economic growth. The deficit in goods trade has increased from 1.9 percent in 1990 to 6.3 percent in 2005 (Nanto 2006).

American exports have been highly competitive worldwide, but the demand for imported products has been greater. In 2005, for example, U.S. exports of goods and services reached $1.28 trillion; however, U.S. imports were $1.99 trillion on a balance of payments (BoP) basis. During the same year, the U.S. merchandise trade deficit reached $766 billion on a census basis and $783 billion on a BoP basis. A surplus in services trade of $66 billion resulted in a deficit of $717 billion on goods and services for the year. In advanced technology products trade, the United States went from a surplus of $32.2 billion in 1997 to a deficit of $44.4 billion in 2005. During the latter year, the rate of imports from unaffiliated foreigners accounts was about 60 percent of all imported goods] (Nanto 2006).

By the first quarter of 2011, the trade deficit in goods and services was 23.5 percent worse than the year before. For August 2011, there was a deficit of $9.1 billion in advanced technology products. Exports had reached $177.6 billion and imports, $223.2 billion, resulting in a goods and services deficit

of $45.6 billion (U.S. Department of Commerce 2011).

Foreign Trade Zones (FTZs)

These zones were created to provide special customs procedures for U.S. plants engaged in international trade-related activities. The Foreign Trade Zones Board is composed of representatives of the U.S. Department of Commerce and Department of the Treasury.

Items may be imported into FTZs or produced in them. There is no limit on the time goods may be stored inside an FTZ, and certain merchandise held in FTZs may be exempted from state and local inventory taxes. Payment of the duty is deferred until the item is reimported for sale into the U.S. market (items produced in FTZs are exported duty free). This procedure is intended to put foreign producers on an equal footing with domestic producers.

FTZs are divided into general-purpose zones and subzones. General-purpose zones include public facilities that can be used by more than one firm, such as ports or industrial parks used by small to medium-sized businesses for warehousing, distribution, processing, and assembly purposes. Subzones are funded by general-purpose zones, but used by a single firm for manufacturing, processing, distribution, or warehousing that cannot be completed in a general-purpose zone. This procedures observed in both types of facilities do not apply to domestic industry or other domestic plants outside of zones. The U.S. Customs Service supervises all zone activity and ensures that all regulations are observed (MacLeod 2000).

American Trade Agreements with Other Countries

The United States is party to over dozen different trade agreements. These agreements are an important contributor to the economic growth of the country. The U.S. Trade Representative monitors the various agreements and enforces America's rights under them. What follows is a brief explanation of the trade agreements and the trade-related organizations that the United States is involved with, although this book will focus only on the agreements (International Trade Administration 2011).

World Trade Organization (WTO)

The United States is member of the World Trade Organization (WTO) and a signatory of the Marrakesh Agreement. The latter established the WTO and set out the rules relating to trade among its 154 members. In November 2001, the WTO members met in Doha, Qatar, and worked out

the Doha Development Agenda (DDA or Doha Round). It was the ninth round of multilateral trade negotiations since the end of World War II. The negotiations were intended to minimize trade barriers and increase development and opportunity in the areas of agriculture, industrial goods market access, services, trade facilitation, WTO rules, and economic growth and development (International Trade Administration 2011).

Trade and Investment Framework Agreement (TIFA)
TIFA provides a framework for governments to discuss and resolve trade and investment issues at an early stage. In addition, it identifies and works on capacity building, where appropriate (United States Trade Representative 2011).

Bilateral Investment Treaties (BITs)
BITs help to protect private investment, develop market-oriented policies in partner countries, and promote U.S. exports (United States Trade Representative 2011).

Free Trade Agreements (FTAs)
FTAs are based on the WTO Agreement. The United States has twelve free trade agreements with seventeen countries. Many FTAs are bilateral agreements, and others such as the North American Free Trade Agreement (NAFTA) and the Dominican Republic-Central America-United States Free Trade Agreement are multilateral (United States Trade Representative 2011).

The current FTA partner countries with the United States are Australia, Bahrain, Chile, Costa Rica, the Dominican Republic, El Salvador, Guatemala, Honduras, Jordan, Nicaragua (DR-CAFTA), Israel, Morocco, Canada, Mexico, Oman, Peru, and Singapore (United States Trade Representative 2011). According to the International Trade Administration, FTAs are the best way to open up foreign markets to U.S. exporters (International Trade Administration 2011).

North American Free Trade Agreement (NAFTA
NAFTA was signed in 1992 by Canada, the United States, and Mexico and went into effect on January 1, 1994. It established a free-trade zone in the Northern Hemisphere. The trade involved the lifting of tariffs on the majority of goods produced by the signatories to the agreement and the overall goal of eliminating the remaining barriers to cross-border investment

and the sale of goods and services among the three nations (Department of Homeland Security 2011).

Full implementation of the agreement began on January 1, 2008. The agreement eliminated the barriers to agricultural trade. In addition, many tariffs were eliminated, while others were gradually lifted over periods of five to fifteen years (United States Department of Agriculture 2011).

NAFTA is the world's largest free trade area, with a production of $17 trillion worth of goods and services. Trade has increased among the three countries. In 2009, U.S. goods and services traded with NAFTA totaled $1.6 trillion. Exports totaled $397 billion, while imports reached $438 billion with a deficit of $41 billion. Furthermore, in that same year it was reported that trade in services reached $99 billion with service exports of $63.8 billion and service imports of $35.5 billion, resulting in a surplus of $28.3 billion. Furthermore, for 2010, it was reported that goods exports totaled $412 billion, while goods imports reached $506 billion, resulting in a goods trade deficit of $94 billion (United States Trade Representative 2011).

According to NAFTA opponents, the agreement eliminated thousands of U.S. jobs; undermined democratic control of domestic policy making; and threatened health, environmental, and food safety standards. On the other hand, NAFTA supporters believed that it paved the way for better jobs in the United States and improvement in the lives of Mexican workers. The controversy resulted from a radical element in the implementation process of the agreement whereby each nation had to conform its laws to the treaty's requirements regardless of the will of its legislature (Public Citizen 2011).

Ultimately NAFTA led to the establishment in 2005 of the Free Trade Area of the Americas (FTAA), which includes thirty-four countries throughout the North, South, and Central America. The trade group operates exactly like NAFTA (although not all countries have FTAs with the United States). FTAA members are Antigua and Barbuda, Argentina, the Bahamas, Barbados, Belize, Bolivia, Brazil, Canada, Chine, Colombia, Costa Rica, Dominica, Dominican Republic, Ecuador, El Salvador, Grenada, Guatemala, Guyana, Haiti, Honduras, Jamaica, Mexico, Nicaragua, Panama, Paraguay, Peru, Saint Kitts and Nevis, Saint Lucia, Saint Vincent and the Grenadines, Suriname, Trinidad and Tobago, United States of America, Uruguay, and Venezuela (Free Trade Area of the Americas - FTAA 2006).

Dominican Republic-Central America-United States Free Trade Agreement (CAFTA-DR)

CAFTA-DR was put into effect in 2006. Its members are the United States, Costa Rica, the Dominican Republic, El Salvador, Guatemala, Honduras, and Nicaragua.

The purpose of CAFTA-DR was to liberalize trade in goods and services, but it also included areas such as telecommunications, electronic commerce, trade policy and practice transparency, and environmental protection. The agreement created new commercial opportunities for the United States and for the other participants promoted regional stability, economic integration, and development (International Trade Administration 2011). Under terms of the agreement, U.S. consumer and industrial goods exports were free of duty, and all other product tariffs were to be removed over a ten-year period. CAFTA-DR represented the fifteenth-largest U.S. export market in the world in 2010 and the third largest in Latin America after Mexico and Brazil. During 2010, the United States exported $24.2 billion in goods to the five Central American countries and the Dominican Republic. In the first five years after the implementation of the treaty, U.S. exports increased by 43 percent (export.gov, 2011).

United States-Australia Free Trade Agreement

This agreement took effect on January 1, 2005, and eliminated more than 99 percent of tariffs imposed on U.S. manufactured goods exported to Australia. All U.S. farm exports were also to be duty free. Other areas covered by the agreement included services, intellectual property, e-commerce, pharmaceuticals, and American investments. U.S. exports to Australia grew 11 percent in 2010 (export.gov, 2011).

United States-Bahrain Free Trade Agreement

This agreement was implemented on August 1, 2006, and with it the United States acquired its first free trade partner on the Arabian Peninsula and its third among Arab countries. Bahrain's service sector provides many business opportunities for American firms. In addition, the country is considered the banking center of the Middle East and, as a result of economic and political reforms, a model of economic growth in the region (export.gov 2011).

United States-Chile Free Trade Agreement

This agreement took effect in 2004, and 80 percent of U.S. consumer

and industrial goods exports to Chile became duty free. In addition, the agreement provided access to service suppliers and protection to U.S. investors and U.S. copyrights, trademarks, and patents registered in Chile (International Trade Administration, 2011). Chile also eased significant government procurements to U.S. bidders.

In 2008, the U.S. goods exports to Chile reached $12 billion, and in 2010 the Chilean economy grew by 5 percent. During the first seven years of the agreement, U.S. exports to Chile increased by 300 percent (export.gov, 2011).

United States-Israel Free Trade Area Agreement

This agreement took effect on January 1, 1995. Its purpose was the elimination of duties on manufactured goods, although there were still barriers to trade involving intellectual property rights, standards and technical regulations, and certain U.S. exports (export.gov, 2011). In addition, the process itself was unclear. So a new agreement was negotiated in 2004 and remained in effect through December 31, 2008, when it was extended through December 31, 2012.

The new agreement eliminates barriers to trade in services such as advertising, law, and consulting. In addition, it looks to elimination of all restrictions on government acquisitions. During 2010, U.S. exports to Israel grew to $11.3 billion from $2.5 billion in 1985 (United States Trade Representative 2011).

United States-Jordan Free Trade Agreement

This agreement took effect on December 17, 2001. It focused on eliminating duties and commercial barriers to bilateral trade in goods and services from the United States and Jordan. In addition, it included provisions concerning trade and labor, the environment, e-commerce, intellectual property, and procedural issues. The Department of Commerce's Market Access and Compliance Office examined this agreement to ensure proper compliance (United States Trade Representative 2011).

United States-Morocco Free Trade Agreement

In 1985, a bilateral investment treaty was signed between the United States and Morocco. The country's first free trade agreement with the United States took effect more than twenty years later, on January 1, 2006. The agreement focused on protecting enterprises, debt, concessions, contracts,

and intellectual property rights with the object of eliminating trade barriers. In 2009, the U.S. goods trade surplus with Morocco rose to $1.2 billion, with U.S. goods exports of $1.6 billion (United States Trade Representative 2011). Over 90 percent of U.S. consumer and industrial goods are imported duty free (export.gov 2011).

United States-Oman Free Trade Agreement

This agreement took effect on January 1, 2009. It focused on the area of trade in goods and services, where it eliminated most tariff and nontariff barriers. It also included protection for intellectual property rights, government procurement, labor, and the environment.

Oman has a bilateral deal of duty-free access for tariff lines that include almost all consumer and industrial goods and 87 percent of all agricultural products. The remaining tariffs are to be eliminated within ten years (export. gov 2011). Exports to Oman during 2010 reached $1.1 billion (United States Trade Representative 2011).

United States-Peru Trade Promotion Agreement (PTPA)

This agreement took effect on February 1, 2009. It eliminated tariffs and removed barriers to U.S. services, provided security for investors, and reinforced protection for intellectual property, workers, and the environment (United States Trade Representative 2011). At least 80 percent of the U.S. consumer and industrial goods exports are no longer subject to tariffs, and by 2019 the remaining 20 percent will be duty free. In the agricultural area, almost 90 percent of tariffs and duties on U.S. exports were eliminated, and the remaining 10 percent will be phased out by 2026 (export.gov 2011).

In 2009 it was reported that U.S. goods exports to Peru reached $4.8 billion. In the same year, Peru experienced a stable exchange rate, low inflation, low unemployment, and an economic growth rate of almost 10 percent (United States Trade Representative 2011).

United States-Singapore Free Trade Agreement

This agreement took effect on January 1, 2004, and looked to improve the bilateral relationship between the two countries. Overall the agreement protects intellectual property rights and the environment, and seeks to improve labor-management relations.

Trade with Singapore has improved U.S. competitiveness worldwide and opened up the Southeast Asian market, the world's largest (export.gov

2011). Tariffs were completely eliminated on U.S. goods, and increased access to the services and investment markets of both countries provided. U.S. goods exports to Singapore during 2009 reached $21.6 billion and by 2010 rose to $29 billion, making the nation the tenth-largest export market for the United States (United States Trade Representative 2011).

Pending Free Trade Agreements

There are three trade agreements approved by Congress, signed by President Barack Obama, and awaiting implementation dates.

<c>United States-South Korea Free Trade Agreement (KORUS FTA)</c>

On June 30, 2007, South Korea and the United States signed the KORUS FTA. More than four years later, on October 21, 2011, President Barak Obama, following approval by Congress, signed a new trade agreement with South Korea. That agreement went into effect on March 15, 2012, after the Korean National Assembly ratified it (United States Trade Representative 2012).

The new U.S.-Korean agreement is considered the largest trade deal since 1994, widening U.S. export access for service and consumer goods and supporting about 70,000 jobs in the United States. It is estimated that the reduction of Korean tariffs and tariff rate quotas (TRQs) on goods alone will add between $10 and $12 billion annually to the U.S. Gross Domestic Product and about $10 billion to the annual merchandise export total to Korea (United States Trade Representative 2011).

Under the terms of the agreement, about 95 percent of bilateral trade in consumer and industrial products will be duty free within the first five years, with the elimination of the remaining tariffs within ten years; while for agricultural products, the immediate elimination or phase out of tariffs and quotas will benefit U.S. exports, with all agricultural products becoming duty free. Services will also benefit from the agreement: it will provide easier market access commitments with better and more secure access for international delivery services. In addition, the financial services sector will benefit from better access to the Korean market.

United States-Colombia Trade Promotion Agreement

President Obama signed the trade agreement with Colombia on October 21, 2011. The agreement is seen as benefiting American jobs and both increasing U.S. exports and improving their competitiveness. Estimates

90

are that U.S. goods exports under the agreement will reach more than $1.1 billion and increase U.S. GDP by $2.5 billion (United States International Trade Commission 2011).

The agreement looks to facilitate the entrance of U.S. goods into Colombia's market. At least 80 percent of U.S. exports of consumer and industrial products are expected to be duty free immediately, and the remainder will be duty free within ten years. Moreover, the agreement will provide duty free tariff rate quotas (TRQs) on certain products, such as animal feeds and dairy products.

The trade agreement means more access to service markets, new opportunities for agriculture, increases in manufacturing and telecommunications exports, and better protection for intellectual property rights, labor rights, and the environment (United States Trade Representative 2011). It is expected that the agreement will become effective within the first half of 2012 (S.B. 2011).

United States-Panama Trade Promotion Agreement

President Obama signed the trade agreement with Panama on October 21, 2011. From the American perspective, the agreement focuses on increasing American jobs, expanding markets, and strengthening competitiveness.

The agreement will facilitate U.S. access to Panama's service market, prioritizing the following areas: financial, telecommunications, computers, distribution, express delivery, energy, and environmental and professional services. Over 87 percent of U.S. exports of consumer and industrial products will become duty free immediately, and the remaining tariffs will be phased out over the next ten years. Among the products benefiting immediately will be information technology equipment, agricultural and construction equipment, aircraft and parts, medical and scientific equipment, environmental products, pharmaceuticals, fertilizers, and agrochemicals. Overall half of current trade will become duty-free immediately, and the remaining tariffs will be phased out within fifteen years.

The agreement will provide better protection for intellectual property rights, labor rights, and the environment. It will also increase exports, open doors to U.S. investors, and expand opportunities in areas as disparate as agriculture and financial services (United States Trade Representative 2011). The agreement entered into force on October 31, 2012 (United States Trade Representaive 2012).

Domestic Trade Adjustment Assistance

As a result of prior trade agreements, the U.S. Congress and Preisdent Obama decided in 2009 to implement Trade Adjustment Assistance (TAA) to provide training and support to American workers who have been negatively affected by trade. Specifically, TAA is designed to help workers, farmers, and fishermen transition to alternative employment (United States Trade Representative 2011).

CHAPTER 8
China's Reforms

Over the last thirty years, China has been able to modify its economic system in a way that has led to a reformation at all levels of its society. Deng Xiaoping described this process as achieving overall prosperity by liberalizing and developing productivity, while at the same time eliminating exploitation and avoiding polarization. Furthermore, he added that "socialism is not able to survive without democracy" and that the CCP's objective was to "build a socialist democratic political system under the rule of law." This redefinition allowed the country to change direction to achieve a more prosperous society (Ji 2003).

Beginnings of Reform

December 1978 marked the beginning of a new era for China. That was the point at which the Chinese government recognized both the country's potential and the failure of Mao's centrally planned economy to achieve growth and prosperity. The country was far behind other Asian nations and the West both technologically and economically. To rectify this situation, the government implemented major economic reforms based on a revised form of communism, one that substantially increased the role of market mechanisms in the system and reduced government planning and direct control (U.S. Library of Congress 1987). "It encouraged the formation of rural enterprises and private businesses, liberalized foreign trade and investment, relaxed state control over some prices, and invested in industrial production and the education of its workforce" (Hu and Khan 1997).

The reforms were implemented gradually so that they could be tested in the Chinese environment and, if necessary, altered. Party leaders constantly

consulted to track the reforms, evaluate the their results, and analyze any problems. Like all major societal changes, the reforms produced political tensions and were often subject to mediation and debate, but all parties recognized the importance of reaching agreement in order to assure harmony on the reform agenda. Under Deng Xiaoping's leadership, a form of democratic centrism worked well to maintain the balance between the CCP's two political wings (Ji 2003).

The first economic reforms implemented in China were implemented between 1979 and 1984, and focused on revising China's foreign economic relations and agricultural system (U.S. Library of Congress 1987). Both individual enterprises and collectively owned and operated industrial and service enterprises were encouraged. Restrictions on foreign producers were greatly eased, and individual enterprises were allowed to engage in direct negotiations with foreign firms. Cooperation, trading, and credit arrangements with foreign firms were legalized so that China could enter international trade.

Once the various reforms were launched, there was an adjustment period between 1979 and 1981. During this time, problems were identified and imbalances in the economy corrected so that a well-planned modernization system could be put in place. The major goals of the adjustment process were (1) to expand exports rapidly; (2) to overcome key deficiencies in areas like transportation, communications, mining, steel production, and electric power generation; (3) to correct the imbalances between light and heavy industry; and (4) to increase agricultural production.

The adjustment period produced dramatic, positive changes in China's economy. Incomes increased. So did the availability of consumer goods. And the targeted sectors of the economy experienced strong rates of growth (Weiguang 2008).

Foreign Trade Reform

Meeting the new goals set by the government to make China a prosperous, industrialized nation required changes that a few decades earlier would have been unthinkable in Chinese society. To modernize its industry would mean initially at least importing foreign equipment and technology. It would also mean sending large numbers of Chinese students abroad to acquire special training and skills. To earn foreign exchange, the country would have to do everything from encouraging tourism to exporting arms. China would have to become a nation dependent on the world economy, and that flew in the face of the Maoist ideology of self-reliance. Conservative CCP members strongly resisted such reforms (U.S. Library of Congress 1987).

However, imports and exports are crucial to the economy of any modern nation. Before the reform period, China's imports and exports combined barely exceeded 10 percent of national income, but by 1986 that figure had risen to 35 percent. By the mid-1980s, trade restrictions had been eased and foreign investment had been legalized. Sole ownership by foreign investors had also become legal, although of questionable feasibility. At the domestic level, commerce had shifted from the government to the market, allowing and even encouraging private enterprises and free-market activities (U.S. Library of Congress 1987).

Agricultural Reform

The agricultural reforms of early 1980s ushered in a new era of productivity. The economic reform program in the rural areas of the country decollectivized agriculture. What replaced the communes was a government-initiated contract responsibility system based on individual households.

The collectivized system created by Mao was based on keeping grain production growing at the same pace as the population, in return for which farmers received a guaranteed low level of subsistence. This system hindered

rapid economic growth. As a result, something that started as a trial in the late 1970s became a nationwide reform. The administrators broke down the collective production teams, created contracts with individual households to work assigned portions of collective land, and expanded the variety of crops or livestock that could be produced (U.S. Library of Congress 1987). By the end of 1984, approximately 98 percent of all farm households were part of the contract responsibility system. "The goal of the contracting system was to increase efficiency in the use of resources and to tap peasant initiative" (U.S. Library of Congress 1987). The program succeeded in trials and was eventually implemented throughout the country. By the winter of 1982–83, all of the people's communes had vanished. They were replaced by a system of family-based farming that increased productivity, arable land, and peasant per capita income.

The benefits of this reform were obvious at the rural level. Income levels increased rapidly because of the increased prices paid by the state and the overall economic growth stimulated by the expansion of markets and the rediscovery of comparative advantage. The increased growth and efficiency were attributed to policies based on flexibility, autonomy, and market involvement (U.S. Library of Congress 1987). By 1985, it was a universal practice to pay taxes on profits and retain the balance. Furthermore, investment funds changed from government budget allocations without interest to required repayment of interest-bearing bank loans (Hu and Khan 1997).

Political Reform

Without doubt, these reforms benefited the Chinese economy, which began to grow steadily. Post-1978, China's real growth average was more than 9 percent, with some peak years reaching more than 13 percent. The per capita income nearly quadrupled in the fifteen-year period from 1982 to

1997 (Hu and Khan 1997).

Not everyone was happy about this turn of events, however. According to conservative CCP leaders, the economic reforms led to inequality among economic regions and produced a class of exploitative rich peasants. There were reports of peasant misbehavior, such as smuggling, embezzlement, and ostentatious displays of acquired wealth. In addition, health care access became a major issue (Kaye 2011). The conservatives pointed out problems like these, while the reformers focused on the benefits derived from the reform policies (U.S. Library of Congress 1987).

Conservatives were also concerned about the "corrosive" effects of Western culture on Chinese society. In response, in October 1983 the CCP initiated a national program to improve the party's organization and ideology. Its aim was to restore organizational norms, counteract corruption and the exercise of privilege, and enforce discipline in the course of implementing party reform programs. By the CCP's standards, the program succeeded in accomplishing its goal of preventing "cultural contamination" by rejecting radical advocacy of Western ideology (U.S. Library of Congress 1987).

Educational Reform

After the resumption of college entrance examinations in 1978, some 400,000 college students enrolled in universities. By 2007, higher education undergraduate and postgraduate enrollments reached 11.44 million; secondary and higher vocational education enrollments reached 20 million and 8.61 million, respectively (Weiguang 2008).

Education was always important for the Chinese population, but now, they are certain that education means a different quality of life. In the late 1970s, education was restructured to focus on supporting the economic development of the country. As the economy improved, the educational system diversified to fulfill the demands of a market-oriented society (Hannum 2009).

Health Care Reform

China's economic, social, and political systems are developing to fulfill the needs and demands of a rapidly changing society. New and modified reforms are still needed, as recent problems with food safety, contaminated consumer products, and public health monitoring systems attest. (China Daily 2009).

In 2009, the Chinese government implemented health care reform to eliminate the 7 to 15 percent fees that state-owned hospitals charged patients for drugs. Hospitals derive 50 percent of their income from the sale of drugs, and doctors' salaries are tied to the hospital earnings; therefore, doctors tended to prescribe more expensive medications rather than equally effective cheaper ones.

Under the new reform, the additional fees will now be covered by increased charges on health care services. Since those expenses are covered by basic medical insurance, patients will be left with lower bills. The new policy is in trials for three years in some hospitals (China Daily 2009).

Conclusion

China's economic progress over the last three decades has been undeniable. In 1978, China's total GDP was only 364.52 billion yuan, and its GDP per capita was only 381 yuan; by 2007, the country's total GDP was 24.66 trillion yuan, and the GDP per capita had reached 7869 yuan, 67.7 times more than in 1978, with an average annual growth of nearly 10 percent. In 1978, China's fiscal revenue was 113.2 billion yuan; by 2007, it had reached 5.13 trillion yuan, 45.3 times more than in 1978. By spring 2008, China was considered the fourth-largest economy in the world, with an average annual growth rate of nearly 14 percent. In 1978, the per capita disposable income of China's urban residents was 343 yuan; by 2007, it was 13,786 yuan. In 1978, the net per capita income of rural residents was 134 yuan; by 2007,

it had reached 4,140 yuan. In 1978, owning a car was a dream for virtually all Chinese; by 2007, car ownership had gone from almost zero to 15.22 million (Weiguang 2008).

China's success thus far can be credited to effective management of both its natural and human resources. Also, the Chinese people themselves deserve credit for having adjusted so well to economic reforms that fly in the face the existing socialist political system. Together these two trends have brought about gradual but steady change and, in the process, created a successful country that by May 2009 held almost 2 trillion U.S. dollars of foreign exchange reserves (Xinhua News Agency 2009). Now according to some experts, to continue its development as a nation, China must reform its political system to the same degree that it has reformed its economic system (Ji 2003).

CHAPTER 9
Twenty Years of U.S. and Chinese GDP

United States

The last time there was significant growth in the U.S. economy was in 2003. The economy grew steadily, and economists forecasted the continuation of good times.

During the third quarter of the year, the U.S. Gross Domestic Product (GDP) grew at a 7.2 percent annual rate after growing at a 3.3 percent pace during the second quarter. A 6.6 percent increase in consumer spending led the growth. This was the fastest pace since the third quarter of 1997. It was the result of tax relief that included child care tax credit checks and lower rates of income tax withholding. Final sales increased at a 7.8 percent pace in the third quarter, the strongest rate since the second quarter of 1978, with final sales increasing 16.7 percent. Home sales soared 20.4 percent. Investments in equipment and software increased by 15.4 percent, the strongest showing since the first quarter of 2000. In addition, exports outstripped imports 9.3 percent to 0.1 percent. The inflation rate rose to 1.7 percent from a 1 percent in the second quarter. Interest rates were maintained at the same level, something unseen since 1958 (Gongloff 2003).

During the same year the United States was responsible for more than 30 percent of the total world output, with a nominal GDP of $11 trillion and a per capita GDP of $37,839. Economists expected a big rise in real GDP for 2004. It was expected to be similar to the 7.2 of 1984, which was the third-highest growth rate post–World War II. Economists were excited about what seemed to be a remarkable year for the country (Smith 2004), although real GDP growth was only 6.4 percent. Nevertheless, in 2005 real GDP grew by

100

6.5 percent, which was the highest rate in twenty years.

By comparison, 2009 was the worst recent year with a real GDP contraction of -2.5 percent (Bureau of Economic Analysis 2011). Today the United States seems far removed from any possibility of reaching a growth rate above 7 percent anytime in the near future.

China

China has been in economic growth mode since 1979, easily surpassing the required growth rate of 7.2 percent envisioned by Deng Xiao-Ping. China's economic history varies greatly from that of the United States. For the past twenty-five years, China's economic growth has increased rapidly and steadily. Its economic output quadrupled in a twenty-one-year period. To meet the expectations set by Deng Xiao-Ping in 1979 required a 7.2 percent growth rate per year. Real economic growth exceeded 9 percent a year, and for the past fifteen years it has exceed more than 10 percent a year. In twenty-five years, there have been only two slowdowns—the first in 1989 and the second from 1993 to 1996 as result of inflation. During 1993 inflation was 14.7 percent, and in 1994 it reached 24.1 percent with a drastic falloff in 1997 to a 2.8 percent rate (Smith 2004). In 2003, as the result of a significant expansion in foreign trade, creation of about 8.59 million urban jobs, and the increase of personal income, Chinese GDP grew by 10 percent (China.org 2005). Economists forecast that the rapid growth of China was about to slow down, estimating GDP growth of 8.8 percent in 2004 and 7 percent in 2005 (Smith 2004). Surprisingly, China's GDP grew 10.1 percent in 2004 and 11.3 percent in 2005. It was not until 2008 that China's GDP slipped, although it remained above 9 percent. In 2008, GDP dropped to 9.6 percent from a 14.2 percent the year before. For 2009 it dropped to 9.2 percent; but for 2010, it recovered, reaching 10.3 percent (The World Bank 2011). Economists agree that China's prosperity will continue for a long

time to come(Smith 2004).

The International Monetary Fund estimated that for 2010, the value of total US GDP was $14.6 billion, while for China it was $5.7 billion (International Monetary Fund 2011). However, Arvind Subramanian calculated that the Chinese GDP had already surpassed that of the United States. He estimated that China's GDP during 2010 was about $14.8 trillion dollars. His calculations were based on the Penn World Tables, Version 7 (February 2011), purchasing power parity (PPP) estimates, which corrected biases leading to an upward revision for China's PPP-based GDP of about 27 percent for the year 2005. Subramanian used these corrected figures for computing his new estimates for China's PPP-based GDP per capita (Subramanian 2011).

According to Subramanian, China is already the world's biggest economy. Those who disagree with him believe that an economy's level cannot be based solely upon PPP. That said, in 2010 China clearly overtook Japan to become the world's second-largest economy according to market exchange rates.

The economic level of China will be determined only when accurate, comparable official numbers are made available and PPP is corrected (Pettis 2011). In the meantime, the fact is that if China is not already the biggest economy in the world, it very soon will be.

PART 3 **Trade Partners and Competitors**

Year	United States		China	
	Current-Dollar and "Real" GDP		GDP percent change from preceding period	
Year	GDP in billions of current dollars	GDP in billions of chained 2005 dollars	GDP in billions of current dollars	GDP in billions of chained 2005 dollars
1990	5,800.5	8,027.1	5.8	1.9
1991	5,992.1	8,008.3	3.3	-0.2
1992	6,342.3	8,280.0	5.8	3.4
1993	6,667.4	8,516.2	5.1	2.9
1994	7,085.2	8,863.1	6.3	4.1
1995	7,414.7	9,086.0	4.7	2.5
1996	7,838.5	9,425.8	5.7	3.7
1997	8,332.4	9,845.9	6.3	4.5
1998	8,793.5	10,274.7	5.5	4.4
1999	9,353.5	10,770.7	6.4	4.8
2000	9,951.5	11,216.4	6.4	4.1
2001	10,286.2	11,337.5	3.4	1.1
2002	10,642.3	11,543.1	3.5	1.8
2003	11,142.2	11,836.4	4.7	2.5
2004	11,853.3	12,246.9	6.4	3.5
2005	12,623.0	12,623.0	6.5	3.1
2006	13,377.2	12,958.5	6.0	2.7
2007	14,028.7	13,206.4	4.9	1.9
2008	14,291.5	13,161.9	1.9	-0.3
2009	13,939.0	12,703.1	-2.5	-3.5
2010	14,526.5	13,088.0	4.2	3.0

*Gross domestic product (GDP)

United States and China Annual Percentage GDP Growth in past 20 Years

United States and China Annual Percentage GDP Growth in past 20 Years

Year	Gross Domestic Product (GDP)				GDP based on PPP			General Government Revenue
	Constant prices	Current prices	Deflator	Per capita current prices	Valuation of country GDP	Per capita GDP	Share of world total	
Year	% change	U.S. dollar (billion)	Index	U.S. dollar (Units)	Current Int'l dollar (billion)	Current Int'l dollar (Units)	Percent	Percent of GDP
1991	9.210	409.165	103.090	353.268	1,028.740	888.200	4.163	16.858
1992	14.195	488.222	111.588	416.675	1,202.619	1,026.379	4.327	14.589
1993	14.003	613.223	128.457	517.414	1,401.315	1,182.375	4.836	13.613
1994	13.099	559.224	154.931	466.603	1,618.263	1,350.240	5.301	11.586
1995	10.900	727.947	176.213	601.008	1,832.035	1,512.566	5.679	10.718
1996	10.000	856.084	187.553	699.478	2,053.612	1,677.938	6.026	10.824
1997	9.300	952.649	190.391	770.590	2,284.225	1,847.690	6.335	11.421
1998	7.801	1,019.480	188.756	817.147	2,490.230	1,996.000	6.657	12.096
1999	7.599	1,083.284	186.388	861.212	2,718.230	2,161.524	6.918	13.085
2000	8.399	1,198.477	190.233	945.597	3,011.072	2,375.731	7.514	13.782
2001	8.292	1,324.814	194.152	1,038.036	3,334.418	2,612.627	7.581	15.106
2002	9.101	1,453.833	195.285	1,131.802	3,696.784	2,877.927	8.044	15.925
2003	10.101	1,640.961	200.201	1,269.828	4,157.855	3,217.456	8.548	16.155
2004	10.091	1,931.646	214.058	1,486.019	4,697.901	3,614.104	8.949	16.547
2005	11.290	2,256.919	222.489	1,726.054	5,364.259	4,102.495	9.405	17.218
2006	12.692	2,712.917	230.927	2,063.871	6,242.020	4,748.661	9.999	18.233
2007	14.141	3,494.235	248.501	2,644.563	7,337.638	5,553.390	10.756	19.797
2008	9.595	4,519.950	267.891	3,403.526	8,217.399	6,187.707	11.451	19.655
2009	9.096	4,984.731	266.247	3,734.608	9,046.990	6,778.091	12.556	20.021
**2010	10.456	5,745.133	275.696	4,282.894	10,084.369	7,517.717	13.267	19.413
**2011	9.589	6,422.276	284.678	4,763.873	11,195.363	8,304.422	13.984	19.820

*Gross Domestic Product (GDP) **Estimate
*Purchasing-Power-Parity (PPP)

(The World Bank, 2011)

United States Annual Current-Dollar and "Real" GDP
and
GDP Percent change from preceding period in past 20 Years
(Bureau of Economic Analysis, 2011)

	Gross Domestic Product (GDP)			GDP based on PPP			General Government Revenue	
	Constant prices	Current prices	Deflator	Per capita current prices	Valuation of country GDP	Per capita GDP	Share of world total	
Year	% change	U.S. dollar (Billion)	Index	U.S. dollar (Units)	Current Int'l dollar (Billion)	Current Int'l dollar (Units)	Percent	Percent of GDP
1991	-0.234	5,992.10	74.76	23,647.57	5,992.10	23,647.57	24.237	N/A
1992	3.393	6.342.30	76.532	24,699.63	6,342.30	24,699.63	22.806	N/A
1993	2.852	6,667.33	78.223	25,629.13	6,667.33	25,629.13	22.992	N/A
1994	4.074	7,085.15	79.872	26,906.53	7,085.15	26,906.53	23.198	N/A
1995	2.515	7,414.63	81.535	27,826.60	7,414.63	27,826.60	22.966	N/A
1996	3.741	7,838.48	83.088	29,076.55	7,838.48	29,076.55	22.986	N/A
1997	4.457	8,332.35	84.555	30,541.33	8,332.35	30,541.33	23.094	N/A
1998	4.355	8,793.48	85.51	31,857.84	8,793.48	31,857.84	23.492	N/A
1999	4.826	9,353.50	86.768	33,501.68	9,353.50	33,501.68	23.781	N/A
2000	4.139	9,951.48	86.647	35,251.93	9,951.48	35,251.93	23.627	N/A
2001	1.08	10,286.18	90.65	36,054.52	10,286.18	36,064.52	23.365	34.288
2002	1.814	10,642.30	92.117	36.949.99	10,642.30	36,949.99	23.137	31.831
2003	2.49	11,142.18	94.01	38,324.38	11.142.18	38,324.38	22.907	31.21
2004	3.573	11,867.75	96.77	40,450.62	11,867.75	40,450.62	22.607	31.462
2005	3.054	12,638.38	100	42,680.64	12,638.38	42.680.64	22.367	32.92
2006	2.673	13,398.93	103.257	44,822.96	13,398.93	44,822.96	21.876	33.758
2007	1.947	14,061.80	106.296	46,577.19	14,061.80	46,577.19	21.269	33.912
2008	0	14,369.08	108.619	47,155.32	14,369.08	47,155.32	20.758	32.383
2009	-2.633	14,119.05	109.615	45,934.47	14,119.05	45,934.47	20.422	30.37
**2010	2.639	14,624.18	110.617	47,131.95	14,624.18	47,131.95	20.218	30.324
**2011	2.313	15,157.29	112.058	48,387.29	15,157.29	48,387.29	19.884	31.498

*Gross domestic product (GDP) **Estimate
*Purchasing-Power-Parity (PPP)

(International Monetary Fund, 2011)

China's GDP in past 20 Years
(International Monetary Fund, 2011)**United States' GDP in past 20 Years**

CHAPTER 10
The Trade War Between the United States and China

The United States and China are (and for some time have been) rivals for the position of dominant trade market. As with any rivalry, there have been mutual accusations of unfair practices.

Recently the chairman of the House Ways and Means Committee, David Camp (R-MI), suggested implementing a law that would place duties on imports from countries with nonmarket economies (so-called NMEs) that subsidize their manufactured goods, allowing them to be sold abroad at less than cost, a practice called *dumping*. China is one such country (Bradsher 2011).

In November 2011, the Commerce Department investigated charges by American manufacturers of solar panels that China was engaging in dumping their solar panels in the United States. The manufacturers argued that the Chinese government had invested billions of dollars in the industry, directly subsidizing its production and distribution costs so that Chinese solar panels could undercut the prices of industrial competitors worldwide. One ostensible victim of such practices in the United States was Solyndra. The company received more than $500 million in federal loan guarantees, only to file later for bankruptcy. Despite such examples, environmentalists and at least one American trade group argued that any restrictions by the Commerce Department would negatively affect the adoption of clean energy technology and the creation of new jobs in the United States (Bradsher 2011).

However, American solar cell manufacturers believe that China is using unfair market strategies to gain a competitive advantage. During 2011,

107

China's share of worldwide solar panel production grew to more than half from almost zero five years earlier. That figure's growth just happens to coincide with major increases in solar wattage installed in the United States—more than 70 percent per year since 2008. China exports 95 percent of its solar panel production, and a large portion of that goes to the United States, where it has reduced the price of solar conversions. China has defended itself by accusing the U.S. government of trying to shift responsibility for its failures in clean energy development to Chinese solar cell companies (Bradsher 2011).

According to some experts, however, China has been subjected to a punitive calculation methodology used by the World Trade Organization, which China joined in 2001. The methodology is purportedly based on outdated information about prices, wages, and interest rates; and its use is slated to expire in December 2016. Furthermore, for twenty-two years, until 2007, the United States had a countervailing duty (CVD) law that was *not* applied to imports from other countries that were deemed NMEs. During that period, the Commerce Department was consistent: "If prices and other market signals were unreliable or fictitious in Country A for purposes of antidumping determinations, then they cannot be reliable or useable for purposes of measuring the benefits of subsidies in Country A in CVD cases" (Ikenson 2012). China has lost the majority of antidumping and antisubsidy cases because the Unites States categorizes it as a nonmarket economy and applies special rules that benefit the American industries in such situations (Bradsher 2011).

The Commerce Department issued its final determination in the antidumping investigation on October 10, 2012. The department imposed tariffs of 24 to 36 percent on solar panels imported from China. This decision was based on the conclusion that the Chinese manufacturers received government

subsidies and had dumped solar panels into the U.S. market for less than the cost of manufacturing and shipping (Bradsher, For Solar Panel Industry, a Volley of Trade Cases 2012).

The U.S. International Trade Commission (ITC) will issue a final determination in late November 2012 as to whether imports of solar cells from China materially injured or threatened material injury to the domestic industry. If the ITC determines that they did, then tariffs on cells made in China by Suntech would be 34.12 percent. Trina Solar would face tariffs of 35.87 percent, and tariffs for most others would be 34.79 percent. If enforced, these duties would likely have the effect of increasing costs for solar systems (China Global Trade 2012).

The president of the Chinese Renewable Energy Industries Association, Li Junfeng, advocates negotiation rather than conflict between the United States and China regarding solar power trade issues. He denies charges that the Chinese government provided billions of dollars in subsidies to the industry, asserting instead that the figure was no more than $10 million. (Bradsher 2011).

In fact, some experts believe that the solar sector has benefited from being globally integrated. The manufacturing of solar energy systems on a large scale by the world's leading solar industries in the United States, Japan, Germany, and China has reduced costs by over 50 percent since 2008. Utility companies, businesses, developers, and homeowners nationwide are opting for solar power. An increase in tariffs would lead to higher prices and reduced demand. Ultimately, it would cost an estimated 32,712 jobs in 2012; 40,593 by 2013; and 49,589 by 2014. In addition, it would put the 24,000 new jobs planned for 2012 and the $11 to $12 billion of solar projects in jeopardy.

In other words, if the United States imposes punitive tariffs, it will

unintentionally do great harm to its economy. It will reduce U.S. exports overseas and increase the price of solar cells. In addition, China will impose tariffs on American exports, specifically polysilicon which is the raw material of the semiconductor and solar industries (Pandya 2011) and in 2011 generated $670 million in U.S. exports. China is also likely to move some of its solar panel production to other Pacific Rim economies that have low-cost manufacturing hubs (Shah 2012).

Despite all of these predicted negative effects from imposing tariffs on China, on March 5, 2012, Congress passed the bill allowing the Commerce Department to apply nearly $5 billion in tariffs to imports from nonmarket economies, including China. According to John Thune (R-SD), a member of the Senate International Trade Subcommittee, this will "ensure that American job creators . . . have the ability to challenge unfair practices by our trading partners, including China and Vietnam." And the controversy continues (Morath 2012).

CHAPTER 11
U.S. and Chinese Trade Deficits

China

China, as it turns out, was not exempt from the effects of the global economic crisis. In February 2011, the country reported an unexpected trade deficit of $ 7.3 billion, caused by slowed growth in exports. Exports grew only 2.4 percent, while imports rose 19.4 percent (Zarathustra 2011).

China's central bank adviser Li Daokui and the government itself had in fact anticipated a reduction in the 2011 trade surplus. Likewise, David Cohen, head of Asian forecasting for Action Economics in Singapore, had concluded that 2011 would see a decline in the trade surplus, "perhaps to the $150 billion range from $180 billion [in] 2010." Cohen's caveat, however, was that any predictions should not be based solely on figures from around the Chinese New Year because that was typically the period of lowest activity. Other experts indicated that the main reason for the February 2011 deficit was higher costs for imported commodities. Bank of America-Merrill Lynch, for example, estimated that each $1 increase in oil prices per barrel might cause a reduction in China's annual trade surplus of $1.9 billion (Bloomberg News 2011).

During 2010, only March had shown a deficit ($7.24 billion). April had shown a slight recovery to a $1.68 billion surplus, while July had been the strongest month with a $28.7 billion surplus. In 2011, February had shown a deficit of $7.3 billion, the weakest monthly figure for the year. March had shown a slight recovery to $0.14 billion, while July's had been the strongest number—$31.5 billion. By contrast, the figures for the first three months of 2012 were $27.3 billion for January, a deficit of $31.5 billion for

February, and an unexpected recovery to a $5.4 billion surplus for March (Trade Economics 2012), the last surpassing the median projection of a $3.15 billion deficit (Bloomberg News 2012).

According to Xia Bin, an academic adviser to the central bank, this pattern of alternating surpluses and deficits is an indicator of China's new reality. Xia believes that China is at risk of running an annual trade deficit in 2012, largely as a result of the reduction in European and American demand for Chinese exports. If the country does, it will be the first time that has happened in two decades.

The obvious solution would be to replace foreign with domestic demand. To stimulate that demand, Xia has indicated that China would need a "very proactive" fiscal policy, including such measures as reforming the tax system and increasing wages (Tung 2011). (Indeed, Premier Wen Jiabao has proposed increasing wages by an average of 13 percent a year over a five-year period so that domestic consumption can increase [Bloomberg News 2012]).

By the end of 2011, the People's Bank of China had made credit more accessible to aid small businesses and pledged to improve its policies as necessary to stimulate economic growth. Further measures could include a cut in the banks' reserve ratios or interest rates.

With such changes in place, Xia expects that in 2012 China's economy will continue growing at between 8 and 9 percent annually, with prices rising between 2 and 3 percent. (Throughout 2011, annual inflation was elevated at 5.5 percent.) Moreover, Xia has predicted that "by 2020 the yuan will make up between 3 and 5 percent of the world's reserve currencies" (Tung 2011).

However, other experts take issue with Xia's principal conclusion that China

could be headed for its first annual trade deficit in decades in 2012. They believe that the country is not likely to experience such a deficit for years, unless exports collapse and the government's efforts to stimulate domestic demand fail to produce results fast enough.

Recently government efforts to ensure growth have focused on export tax rebates, in addition to helping exporters affected by rising costs and weak demand. Plans have also included stimulating imports and reducing the trade surplus. China's strategy is to counteract the reduction in exports to Europe by increasing its sales, not just in the domestic market, but to emerging markets as well. Tang Min from the Counselor's Office of the State Council has stated, "China can pursue a moderately loose fiscal policy as growth slows, yet can't substantially ease monetary policy because of inflation" (Bloomberg News 2012).

The unexpected $5.35 billion surplus reported in March 2012 might be an indicator that overseas demand is recovering, compensating for the slowdown in domestic demand. The trade figures support the views previously expressed by analysts who have predicted a sensitive economy with a "soft landing" for 2012.

The fact is that China is experiencing its fifth consecutive quarter of weak growth. For 2012, analysts forecast a growth rate of 8.3 percent, the slowest rate in a decade. Shanghai economist Zhou Hao has stated that "the market is quite pessimistic about China's economy" and added that he expects growth of 8.6 percent for the year.

The most recent data indicated import growth of only 5.3 percent in March compared with the economists' expectations of 9 percent, while February reported 39.6 percent. Exports grew 8.9 percent compared to an expected 7.2 percent, but the larger figure still represented a marked slowing from

February's 18.4 percent rate.

According to China's customs administration, the first quarter of 2012 showed total exports of $430.02 billion and imports of $429.35 billion—a surplus of $0.67 billion. China expects 2012 to show a trade surplus, although a smaller one than in 2011.

China's trade surplus has now diminished for three consecutive years. In 2008, the reported trade surplus was $296 billion. Then, in 2009, it slipped to $196 billion; in 2010, it fell to $183 billion; and in 2011, it hit $155 billion. Furthermore, the trade surplus as a share GDP fell from about 3 percent in 2010 to about 2 percent in 2011. Experts have indicated that the unexpected surplus of March 2012 does not guarantee stability, which opinion concerns investors because of the risk of recession in the EU and its effects on the China's export-oriented economy. Demand in export-oriented manufacturing has decreased about 30 to 40 percent in recent months (Edwards 2012).

United States

In December 2011, the U.S. trade deficit expanded. According to the Commerce Department, the gap increased from $47.1 billion in November to $48.8 billion in December. Rising demand for capital equipment produced overseas was in part responsible. For more than three years, such demand has set a record. The trend has been attributed to efforts to improve the job market, rebuild business inventories, and modernize industrial facilities. Jay Bryson, senior global economist at Wells Fargo Securities LLC, has predicted that the trade gap will rise to $49 billion.

For all of 2011, the trade deficit was $558 billion, the highest since 2008. Imports increased to $227.6 billion, while exports rose to $178.8 billion, yielding a trade deficit of $48.8 billion.

For its part, the U.S. economy expanded at a 2.8 percent annual rate during the fourth quarter of 2011. According to the Commerce Department, by the last three months of the year, the trade deficit had caused a drop in GDP of 0.11 percent. However, the trade gap with China had in fact decreased to $23.1 billion, and the gap with the European Union had effectively remained unchanged (i.e., exports to the EU grew to by 3.6 percent; imports from the EU, by 2.2 percent).

According to exporter Doug Oberhelman, the chairman and CEO of Caterpillar, Inc., U.S. exports will continue to grow. Even with positive figures, however, the trade deficit with China will remain significant. In fact, U.S. exports decreased 0.5 percent in January 2012, while imports decreased 15.3 percent compared to a year earlier (Chandra 2012).

CHAPTER 12
U.S. Debt and Who Holds It

The federal debt outstanding for fiscal year 2012 totaled $16.06 trillion. Of that amount $4.79 trillion was intragovernmental debt holdings and $11.27 trillion was held by the public.

Debt Breakdown by Type and Ownership

The $11.27 trillion of publicly held debt was divided into marketable and nonmarketable securities. The *marketable securities* totaled $10.75 trillion and included the following: Treasury bills (0.1 percent interest rate) $1.61 trillion; Treasury notes (2.0 percent interest rate) $7.11 trillion; Treasury bonds (5.4 percent interest rate) $1.19 trillion; and Treasury inflation-protected securities (TIPS) (1.4 percent interest rate) $807.47 billion. The *nonmarketable securities* (2.1 percent interest rate) totaled $539.4 billion and included the following: Domestic Series, $29.9 billion; Foreign Series $2.9 billion; State and Local Government Series $158 billion; U.S. Savings Securities, $183.6 billion; Government Account Series $163 billion; and Other $1.38 billion (U.S. Government Accountability Office 2012).

The intragovernmental debt holdings totaled $4.78 trillion and were owed to the following: Federal Old-Age and Survivor Insurance Trust Fund (SSA), $2.58 trillion; Civil Service Retirement and Disability Fund (OPM), $819 billion; Military retirement Fund (DOD), $376 billion; Federal Hospital Insurance Trust Fund (HHS), $228 billion; Federal Disability Insurance Trust Fund (SSA), $176 billion; Medicare-Eligible Retiree Health Care Fund (DOD), $132 billion; Federal Supplementary Medical Insurance Trust Funds (HHS), $69 billion; Nuclear Waste Disposed Fund (DOE), $49

billion; Postal Service Retiree Health Benefits Fund (OPM), $45 billion; Employees Life Insurance Fund (OPM), $41 billion; Deposit Insurance Fund (FDIC), $36 billion; Exchange Stabilization Fund (Treasury), $22.6 billion; Pension Benefit Guaranty Corporation (DOL), $21 billion; Employees Health Benefits Fund (OPM), $21 billion; Foreign Service Retirement and Disability Fund (DOS), $16.8 billion; Highway Trust Fund (DOT), $9.9 billion; Unemployment Trust fund (DOL), $20.6 billion; National Credit Union Share Insurance Fund (NCUA), $10.2 billion; Airport and Airway Trust Fund (DOT), $10.4 billion; and other programs and funds, $94.4 billion (U.S. Government Accountability Office 2012).

Interest expenses for fiscal year 2012, totaled $4.32 billion. Interest on debt held by the public was $245 billion, while interest on intragovernmental debt was $187 billion (U.S. Government Accountability Office 2012). For the period from October 1, 2012, through October 31, 2012, reported federal debt held by the public totaled $11.41 trillion; intragovernmental debt holdings totaled $4.84 trillion (TreasuryDirect 2012).

The most recent report indicates that by November 30, 2012, the total debt outstanding was $16.37 trillion, of which $11.55 trillion (or 70.58 percent) was held by the public and $4.81 trillion (or 29.42 percent) was intragovernmental holdings. The marketable portion of the public debt holdings totaled $11.03 trillion (or 66 percent), of which $11.01 trillion was held by the public and $19.5 billion was intragovernmental holdings. Treasury bills totaled $1.69 trillion; Treasury notes, $7.26 trillion; Treasury bonds, $1.2 trillion; and TIPS, $835 billion (TreasuryDirect 2012). Commercial Book-entry accounted for about $11 trillion (or 67.18 percent); Legacy Treasury Direct, for $10.1 billion (0.06 percent); Treasury Direct, for $19.11 billion (0.12 percent); Federal Financing Bank, for $7.11 billion (0.04 percent), Registered, for $62 million (0.06 percent); Bearer, for $96

million (U.S. Department of the Treasury, Bureau of the Public Debt 2012).

The nonmarketable portion of the public debt added up to $5.33 trillion (or about 32.60 percent), of which $539.99 billion was held by the public, while $4.8 trillion was intragovernmental holdings. Domestic Series totaled $29.99 billion held by the public; Foreign Series totaled $2.99 billion held by the public; State and Local Government Series totaled $158.86 billion held by the public; and United States Savings Securities totaled $183.18 billion held by the public; while Government Account Series totaled $4.95 trillion, of which $163.62 billion was held by the public and $4.79 trillion was intragovernmental holdings. Hope Bonds, which were intragovernmental holdings, totaled $494 million; and Others, which were also held by the public, totaled $1.33 billion (The Bureau of the Public Debt 2012). Of the nonmarketable, Savings Bonds accounted for $183.18 billion (1.12 percent); State and Local Government Series (SLGS), for $158.86 billion (0.97 percent); Government Account Series (GAS), for $4.96 trillion (30.30 percent); and Others, for $34.8 billion (0.21 percent) (U.S. Department of the Treasury, Bureau of the Public Debt 2012).

By June 2011, the grand total owed was $4.5 trillion (Defeat the Debt 2012). As of October 2012, which is the most recent report, the grand total owed to major foreign holders of Treasury securities was $5.48 trillion, of which for official was $3.9 trillion. Treasury bills accounted for $379.4 billion, while T-bonds and notes added $3.58 trillion (Department of the Treasury/Federal Reserve Board 2012).

The twelve major foreign holders of U.S. debt were China with $1.16 trillion; Japan with $1.13 trillion; the oil-exporting countries (i.e. Ecuador, Venezuela, Indonesia, Bahrain, Iraq, Kuwait, Oman, Qatar, Saudi Arabia, the United Arab Emirates, Algeria, Gabon, Libya, and Nigeria) with $266.2 billion; Brazil with $255.2 billion; the Caribbean banking centers (i.e., the

118

Bahamas, Bermuda, the Cayman Islands, the Netherlands Antilles, Panama, and the British Virgin Islands) with $258.4 billion; Taiwan with $201.6 billion; Switzerland with $194.4 billion; Russia with $165.4 billion; Hong Kong with $137.2 billion; Luxembourg with $139.4 billion; Belgium with $133.3 billion; and the United Kingdom with $117.3 billion (Department of the Treasury/Federal Reserve Board 2012).

The U.S. debt literally continues to grow every second. As of December 27, 2012, the federal debt holding by the public was $16.33 trillion. The intragovernmental debt holdings were $4.79 trillion. Combined they yielded a total national debt of $11.54 trillion (TreasuryDirect 2012)—a figure larger than the total economies of China, the United Kingdom, and Australia combined (Defeat the Debt 2012). About a third of that amount was owed to foreigners (the Bureau of the Public Debt 2012).

Interest Paid to China

Treasury notes are offered in auctions open to both foreign and domestic buyers. The maturities of notes are two, five, ten, twenty, or thirty years. The longer the term, the lower the interest rate. The thirty-year Treasury constant maturity series was discontinued on February 18, 2002, and reintroduced on February 9, 2006; while the twenty-year constant maturity series was discontinued at the end of 1986 and reinstated on October 1, 1993. Therefore, there are no twenty-year rates from January 1, 1987, through September 30, 1993 (U.S. Department of the Treasury 2011).

The majority of China's holdings are long term. By December 2000, China had a total of $60.3 billion in foreign holdings of U.S. securities. By the end of December 2001, that amount had risen to $78.6 billion. A year later, (December 2002), it was $118.4 billion. By the end of 2003, it had increased to $159 billion. By December 2004, it was $222.9 billion. By December 2005, the amount had reached $310 billion. In 2006, it closed

the year at $396.9 billion. By 2007, it was $477.6 billion. In 2008, China became the main foreign holder of U.S. securities.

Treasury Department figures (2011) set China's holdings for June 2008 at $535.1 billion and its holdings for December 2008 at $727.4 billion. By December 2009, the figure reported was $894.8 billion. By December 2010, it was $1.16 trillion. By September 2011, China held $1.15 trillion in Treasury securities (U.S. Department of the Treasury 2011). This figure included the most recent acquisition of $20.7 billion in U.S. notes and bonds (Kruger 2011).

Because the majority of China's holdings are long term, we will only consider the Daily Treasury Yield Curve Rates for the twenty-year constant maturity or, if the twenty-year constant maturity is not available, the thirty-year constant maturity. We will use the yield curve rate on the last day of the calendar year for the past twenty years to get an idea of how much the United States owes in interest to China and other foreign holders of U.S. debt (U.S. Department of the Treasury 2011).

To understand better how much China owns and how much it is paid in interest, it helps to have an idea of what the total outstanding public debt is. That figure is dived into two parts. The first is *debt held by the public,* which refers to all federal securities held by the institutions and individuals outside the U.S. government. The second part is *intragovernmental holdings,* which refers to government account series securities held by U.S. government trust funds, revolving funds, and special funds and federal financing bank securities (Bureau of the Public Debt 2011). According to the Bureau of Public Debt, as of December 27, 2012, the debt held by the public was $11.54 trillion, and the intragovernmental holdings were $4.79 trillion, which added up to a total outstanding public debt of $16.33 trillion. This figure changes every day (Bureau of the Public Debt 2012).

On April 14, 2011, Rep. J. Randy Forbes (R-VA) declared that, based on estimates made by the Congressional Budget Office (CBO) for the 2011 fiscal year and taking into consideration that China owned 12.1 percent of the debt held by the public at the end of February 2011 (Geiger and Fiske 2011), or $9.57 trillion (Bureau of the Public Debt 2011), the United States paid China $73.9 million per day in interest, or about $26.9 billion a year. The exact figure could not be established because the federal government does not make payments on weekends and holidays. In addition, debt payments vary according to the Treasury's note issue date (Geiger and Fiske 2011).

Based on the reports from the Department of the Treasury, by September 2012, China held about $1.15 trillion in Treasury bonds (U.S. Treasury Department 2012). This means that China owned about 7 percent of the total debt. However, if only the debt held by the public had been considered (which was about $11.27 trillion), then China owned about 10 percent of the total public debt. Therefore, Rep Forbes's estimates were correct. The United States paid nearly $74 million per day to China in interest.

Treasury Debt vs. Agency Debt

For the past forty years, the United States government has conducted a financial experiment: increasing agency debt relatively to Treasury debt (Pollock 2011). The two types of debt should not be confused. *Treasury debt* is debt issued by the Treasury and held by the public—by individuals, corporations, state or local governments, foreign governments, and other entities outside the U.S. government, not including the Federal Financing Bank (U.S. Department of Treasury, Bureau of Public Debt, 2011). *Agency debt* is debt issued by government agencies other than the Treasury (Tucker

2004). These include government-structured investment vehicles (SIVs) like Fannie Mae, Freddie Mac, the Federal Home Loan Bank, and the FHA/Ginnie Mae combination, all of which subsidize housing (Pollock 2011).

The federal government issues debt securities for two reasons. The first is to finance the federal deficit. The second is to provide an investment vehicle for government accounts (primarily trust funds like Social Security) that generate surpluses.

The Federal Reserve does not consider agency debt to be part of the total debt. However, agency debt is debt nonetheless and does increase interest rates on Treasury securities. That, in turn, increases the federal deficit (Pollock 2011).

Over the last forty years, the difference between the relative amounts of the two kinds of debt has shifted dramatically. In 1970, the Treasury debt was $290 billion, and the agency debt was $44 billion (15 percent of Treasuries). By 2006, the Treasury debt was $4.9 trillion, and the agency debt was $6.5 trillion (133 percent of Treasuries). By 2010, the Treasury debt was $9.4 trillion and the agency debt was $7.5 trillion (only 81 percent of Treasuries).

Joseph Gagnon, a Federal Reserve analyst, has suggested that "by taking $1.7 trillion in securities out of the market by Federal Reserve purchases, of which more than $1 trillion were purchases of agency securities, the interest rates on ten-year Treasuries were reduced by "somewhere between 30 and 100 basis points." According to Alex Pollock (2011), that the agency debt grew so much was the result of investors substituting agency debt for Treasuries in order to reduce the demand for Treasuries from its regular levels. Commercial banks provided another example. In 1970, commercial banks owned $63 billion in treasuries and $14 billion in agency securities; by 2006, they owned $95 billion in Treasuries and $1.14 trillion

in agency securities; by 2010, they owned $299 billion in Treasuries and $1.35 trillion in agency securities. Allegedly, this growth was attributed to trillions of dollars of agency securities being sold to investors worldwide. However, the two agencies, (Fannie and Freddie) had no explicit guarantee (i.e., insurance) and eventually experienced the kind of financial difficulties that launched the 2008 financial crisis.

To avoid such failures in the future, experts have suggested giving more attention to the Government Corporation Control Act. It deals with *mixed-ownership government corporations* like the Federal Home Loan bank. Although Fannie Mae and Freddie Mac are not expressly mentioned in the statute, they are considered to be part of the specified category and therefore subject to the act's provisions.

In order to control the debt of mixed-ownership government corporations, the Secretary of the Treasury is authorized to prescribe the following before such a corporation can issue obligations to the public: (1) the form, denomination, maturity, interest, rate, and conditions to which the obligations will be subject; (2) the way and time the obligations are issued; and (3) the price for which the obligations will be sold. In addition, the Revenue Act of 1992 contains the following vetoed statement: The Secretary of the Treasury must prepare an annual report and submit it to the Committee on Banking Housing and Urban Affairs of the Senate and the House of Representatives setting forth the impact of the issuance of guarantee of securities by government-related corporations on the rate of interest and amount of discount offered on obligations issued by the Secretary and the marketability of such obligations. Pollock (2011) recommends that this provision be implemented immediately to control agency debt and the possibility of significant losses (Pollock 2011).

CHAPTER 13
China's Total Trade Value

Over the years, China has become a strong nation, with rapid economic growth that has reached unthinkable rates. According to a 1996 projection by J. Rohwer, "If by 2025 China has raised the income of the average citizen to the level of the average Taiwanese in the mid-1990s, China's economy will be not only by far the biggest in the world, but [also] almost half again as big as America's [and] equal to some 75–80 percent of the . . . economies of the United States, Japan, and Western Europe put together. This would mark a radical change in the world's economic, business, and financial life."

Imports and Exports

China did not develop foreign trade policies that promoted rapid economic growth until 1978. After the new policies opened the nation to foreign investment, China rapidly reached an economic level similar to that of other major economic countries. Back in 1978, the total value of China's imports and exports was $20.6 billion, less than 1 percent of the world's total trade; among trading nations, the country ranked thirty-second. Today China has an open economy, with 80 million people employed as result of foreign trade (Trademark Southern Africa 2011).

China's trade surplus has been increasing for about twenty years and is the result of economic reforms that opened the country to foreign trade and provided preferential policies to attract foreign investment. Processing trade is the main form of foreign investment in China. The processing trade surplus is mainly supported by foreign-funded enterprises, which generate a greater proportion of surplus than other forms of ownership.

124

China will continue to be attractive to foreign investors for some time to come. The country offers abundant cheap labor, preferential investment policies, a stable political environment, and a relatively sound legal environment. As long as these conditions last, the growth will continue. In addition, China is a main destination for transferred manufacturing enterprises. The country serves as processor and manufacturer between East Asia, which is the supplier, and Europe and the United States, which are the developers and key markets (Zhongxiu and Jingying 2011).

Based on Chinese reports, virtually every year since 1990 China has run a global trade surplus. (The one exception was 1993, when a deficit of $11 billion was reported.) By 1998, China's surplus had reached $43.3 billion, only to decline to $ 22.6 billion by 2001. By 2004, it had recovered some of the ground it had lost, reaching $32.8 billion, and began a steep and steady rise. By 2005, it was $102 billion (Lum and Nanto 2006); by 2006, $123 billion; and by 2007, $262 billion (Lee 2008). Then the global financial crisis of 2008 struck. By 2009, China's global trade surplus had dropped to $196 billion (Winning and Yap 2010).

While China was running a streak of surpluses, trading partners like the United States were not. In 2005, the United States incurred a bilateral trade deficit with China of $201 billion (Lum and Nanto 2006), compared to $10 billion in 1990 (Morrison 2011). In 2003, China became the second-largest source of imports for the United States. By 2005, China's share of U.S. imports was 14.6 percent. Today the country is China's major overseas market.

China's Asian trading partners have become the major providers of precision machinery, electronic components, and raw materials for manufacturing (Lum and Nanto 2006). Furthermore, in 2005 China was the major consumer of Japanese and Southeast Asian goods (Lum and Nanto 2006).

Over the last thirty years, the value of trade between the United States and China has expanded substantially from $2 billion in 1979 to $457 billion in 2010 (Morrison 2011). By that year, the total value had reached $2.97 trillion, with an annual growth rate of 16.8 percent, 144 times more than in 1978. By the end of 2010, China was the world's largest exporter; it had been the world's second-largest importer since 2008 (Trademark Southern Africa 2011).

In 2010, China had trade surpluses with the world's two major economic centers, the United States and the European Union. The surplus with the United States had reached $181.3 billion, caused mainly by China's dynamic domestic economy. The figure amounted to 3.1 percent of China's GDP. The surplus with the European Union was $142.7 billion (Zhongxiu and Jingying 2011).

However, in 2010 China had trade deficits with Japan, the Association of Southeast Asian Nations (ASEAN), and Taiwan worth $227.6 billion (Zhongxiu and Jingying 2011). In addition, trade with Latin America, Africa, and members of the BRICS countries (Brazil, Russia, India, etc.) grew rapidly. From 2005 to 2010, it increased from 3.5 percent to 6.2 percent with Latin America, from 2.8 percent to 4.3 percent with Africa, and from 4.9 percent to 6.9 percent with the BRICS countries. China's total services trade value rose from $71.9 billion in 2001 to $362.4 billion in 2010. Moreover, as a developing country, China had granted major market access to the least-developed countries (LDCs) with whom it had diplomatic relations. According to Trademark Southern Africa (2011), "by July 2010, China had granted zero-tariff treatment to over 4,700 commodities from thirty-six LDCs" and was expected to continue that preferential treatment.

During 2010, processing trade maintained a steady increase in both imports and exports. In addition, general trade imports and exports showed rapid

growth. During the first half of 2010, the total value of China's general trade was $679.49 billion, which indicated the effectiveness of China's foreign trade strategies. It was reported that the proportion of China's trade surplus to the total trade sum in 2008 was 11.6 percent. In 2009 it decreased to 8.9 percent, and in 2010 it dropped to 6.2 percent (Zhongxiu Jingying 2011).

Furthermore, the U.S. merchandise trade deficit with China rose to $266 billion in 2008, dropped to $227 billion in 2009, and increased to $273 billion in 2010. During the latter year, it was reported that the bilateral merchandise trade was $457 billion. This deficit was the largest among U.S. trading partners. It was projected that for 2011, it could reach $301 billion (Morrison 2011).

Everything indicates that 2011 will also show some reduction, making China's foreign trade more balanced. Products that have a trade surplus are live animals used for food, beverages, and tobacco. Manufactured goods also have a surplus. Furthermore, the major part of the trade surplus is in the following sectors: communications equipment, computers and other electronic equipment, textiles and garments, footwear, leather goods, and fur products (Zhongxiu and Jingying 2011). China mainly imports iron and steel, oil and mineral fuels, machinery and equipment, plastics, optical and medical equipment, and organic chemicals (Trading Economics 2011).

While China, as already noted, is the second-largest trading partner of the United States, it is that country's third-largest export market and its main source of imports. China's other major trading partners are the European Union, Japan, Hong Kong, and South Korea. Until November 2011, exports of goods and services constituted 39.7 percent of China's GDP (Trading Economics 2011). However, during the last few weeks of August 2011, China's trade surplus showed difficulties as a result of the euro-zone crisis. China's trade surplus for September 2011 was $14.51 billion. It increased

to $17.03 billion in October and narrowed in November to $14.53 billion. November imports rose to 22.1 percent, a drop from the 28.7 percent reported in October (Back 2011).

According to Li Daokui, an adviser to China's central bank, China's trade surplus may disappear by 2013. Li stated, "It's possible for the renminbi to face depreciation pressure. If that time comes, let the market decide its fluctuation." The United States and twenty other nations have demanded that China allow its currency to trade more flexibly. These nations believe that unbalanced trade flows contributed to the global financial crisis of 2008 (Zhongxiu and Jingying 2011). During that crisis, China's foreign trade was among the first to stabilize. The Chinese government implemented several policies and measures to stimulate its economy, expand domestic demand, and stabilize imports and exports. In 2009, China increased its goods imports by 2.9 percent, the only country to do so among the world's major economies. This stimulated

the global economy. In its latest review of China's trade policy, the WTO stated that country has been a key factor in the recovery of the world's economy, thanks to its stimulating demand during the international financial crisis (Trademark Southern Africa 2011).

Li stated that for 2011, "China's trade surplus may report less than 1.6 percent of the GDP. Only the marketplace will have an answer for the demands of the U.S. and the other countries" (Ruan 2011). According to the Chinese government, China has a five-year plan for national economic and social development. It also has foreign trade policies that emphasize transforming trade modes and adjusting trade structure to promote balanced trade growth (Zhongxiu and Jingying 2011).

During the past six months, the yuan has appreciated 2.3 percent against the dollar. Experts predict that the yuan will appreciate 0.6 percent each

quarter in the first six months of 2012. In addition, according to the official reports, by October 2011, China's inflation rate had dropped to 5.5 percent. Li expects a drop in inflation to 2.8 percent for 2012. It is projected that for 2012, the Chinese economy will grow about 9 percent in 2012 (International Monetary Fund 2011). According to Li, if there is a risk that the rate of growth will drop below 6 percent, China would probably invest in public work projects. The central bank in its third-quarter monetary report stated that "while, inflation may continue to moderate, the foundation for price stability is not yet solid" (Ruan 2011).

As expected, China is facing economic challenges because of the international financial crisis. Only time and the market will determine whether the value of China's trade increases or declines. Its growth might slow, but that is far from stopping.

Foreign Direct Investment

Foreign direct investment (FDI) is an investment made to acquire a long-term interest in an enterprise operating outside of the economy of the investor. The investor's purpose is to gain an effective stake in the management of the enterprise. Only capital that is provided by the investor either directly or through other enterprises related to the investor should be classified as foreign direct investment.

FDI can take one of three forms: equity capital, reinvested earnings, or intra-company loans (International Monetary Fund 1993). *Equity capital* includes shares of companies located in countries foreign to that of the investor. *Reinvested earnings* are earnings not distributed to shareholders but reinvested in a company. *Intracompany loans* involve financial transactions between a parent company and its affiliates (Zhan 2006).

Because information on all of these components is not consistently or uniformly collected, FDI comparisons between countries are problematic.

For example, countries differ in the threshold value for foreign equity ownership that constitutes evidence of a direct investment relationship. It is suggested that a threshold of 10 percent of equity ownership is needed to qualify a person or entity as a foreign direct investor. However, data on the operations of transnational corporations (TNCs) show figures ranging between 10 and 50 percent. In addition, some countries do not specify a threshold point at all, but rely instead on other evidence, including assessments as to whether the investor has an effective voice in the foreign firm in which the equity stake is held (International Monetary Fund 1993).

Under Mao, the Chinese government opposed foreign investment and paid off all of its foreign loans by 1965. Two years after Mao's death, Deng Xiaoping promulgated new economic policies that included access to foreign trade and investment (Chinability 2011). Since 1979, FDI in China has grown rapidly, reaching a peak in the 1990s (Fung, Iizaka, and Tong 2002). The law on joint ventures, which granted foreign investment legal status in China, was adopted in 1979. The State Council also awarded rights of autonomy in foreign trade to Guangdong and Fujian provinces (Fung, Iizaka, and Tong 2002).

By the early 1980s, the first Special Economic Zones (SEZs) were established to attract direct investment from Hong Kong and other countries (Chinability 2011). SEZs are a useful tool as part of an overall strategy for increasing economic growth, industrial competitiveness, and foreign direct investment. They allow governments to develop and diversify exports while maintaining protective barriers, creating jobs, and experimenting with pilot programs and new policies and approaches. They also allow for more efficient supervision of enterprises, as government provides off-site infrastructure and environmental controls (The World Bank Group 2008).

Between 1982 and 1983, China modified its foreign investment laws and

by 1984 had increased access to foreign direct investment by expanding the number of SEZs in the country to fourteen. By 1985, twelve of the fourteen had been designated Technology Promotion Zones (TPZs) to expedite the movement of knowledge and technology from one organization or country to another via investment, licensing, or trade (Webfinance Inc. 2012). During that same year, development triangles were opened to foreign investors (Fung, Iizaka, and Tong 2002).

On October 11, 1986, China promulgated a number of significant regulations and provisions favorable to FDI inflow. They included preferential tax treatment for foreign joint ventures, the freedom to import materials and equipment, the right to retain and swap foreign exchange, and the simplification of the licensing process. Furthermore, additional tax benefits were made accessible to export-oriented joint ventures and those that advanced technology. Other benefits provided further autonomy of joint ventures, elimination of unfair local costs, and alternate ways for joint ventures to balance foreign exchange. Finally, the prices paid by state-owned enterprises were extended to foreign water, electricity, and transportation providers, as was access to interest-free renminbi loans (Fung, Iizaka, and Tong 2002).

In 1992, Deng Xiaoping encouraged a massive wave of foreign direct investment, which contributed to an increase in both the rate of GDP growth and inflation (Chinability 2011). The contracted FDI inflow to China grew from about $1.5 billion a year in the 1980s to more than $40 billion a year in 1999. Its share of total annual investment in fixed assets grew from 3.8 percent in 1981 to 12 percent in 1996. In addition, China's use of FDI grew from $0.5 billion to more than $40 billion a year (Fung, Iizaka, and Tong 2002).

On December 11, 2001, China became a member of the World Trade

Organization (WTO) (World Trade Organization 2011). Two years later the country was one of the most important FDI destinations in the world (Chinability 2011). In fact, during the early 2000s foreign direct investment in China accounted for a quarter to a third of total FDI inflow to developing countries. (Fung, Iizaka, and Tong 2002).

Foreign direct investment in China has continued to grow at a fast pace. For example, according to China's Ministry of Finance, the country's FDI inflow in August 2011 was 11.1 percent higher than in August 2010. Investment from abroad totaled $8.45 billion. From January to August 2011, investment increased 17.7 percent to $77.63 billion.

Numbers like these, along with a stable level of investment return, have encouraged companies to expand in China. For example, manufacturers of automobiles and construction and mining equipment have indicated a willingness to increase their investments in China within five years (Panckhurst 2011). Wen Jiabao has declared that China's economy will remain accessible to foreign investors and that the government will continue to encourage consumption to maintain growth.

The United States is one of the top ten nonfinancial FDI originators for China. In 2008 the United States invested $2.9 billion in the country. By 2009 that figure had grown to $ 3.6 billion, which represented a 21.5 year-on-year growth percentage (The US-China Business Council 2011).

China's foreign direct investment continues to grow with minimal limitations, making the Chinese economy one of the most stable in the world. Today, during what are difficult economic times for Europe and America, China "swims against the tide."

FDI inflows (US Dollars) bn 1990-2008		
Year	Contracted	Utilized
1990	6.6	3.5
1991	12.0	4.4
1992	58.1	11.0
1993	111.4	27.5
1994	82.7	33.8
1995	91.3	37.5
1996	73.3	41.7
1997	51.0	45.3
1998	52.1	45.5
1999	41.2	40.4
2000	64.2	42.1
2001	71.1	48.8
2002	84.8	55.0
2003	115.1	53.5
2004	153.5	60.6
2005		60.3
2006		63.0
2007		74.8
2008		92.4

(Chinability, 2011)

PART 4 Aspects of U.S. Economic Policy

Chapter 14

U.S. Economic Trends

In a *New York Times* article published in January 2012, Annie Lowrey considered whether the U.S. economy was really on the road to recovery. In 2010, President Obama had stated that his administration "would double U.S. exports in five years, helping to create 2 million jobs." As it turned out, two years later the administration was right on the mark.

Increasing exports have contributed greatly to the U.S. recovery, accounting for about half of the nation's economic growth since the depths of the recession. To achieve this result, the Obama administration, among other things, pressured China to increase the value of its currency and open its markets to U.S. businesses. In addition, the administration worked with U.S. companies looking to sell goods and services throughout the world. As a result, farm exports reached $137.4 billion in fiscal 2011 (ended September 30, 2011), showing an increase of 20 percent, or $22.5 billion. Sales of petroleum products also showed a remarkable increase of $90 billion, making fuels the single biggest export of the United States and making the country a net exporter of oil for the first time in sixty years. According to Commerce Department data, the value of U.S. exports is now about $180 billion a month, up from $140 billion per month in 2010. That represents a growth rate of about 16 percent annually, more than enough to double exports to $3.1 trillion by 2015.

For the past two years, export growth has mainly come from China, South Korea, Brazil, and India. Over the last decade, the sales of U.S. goods to China have increased fivefold, while exports to the rest of the world have

roughly doubled. Long-term trends seem favorable to the United States, as growing emerging-market economies move millions of consumers into the middle class. According to Lowrey's *New York Times* article (2012), the U.S. economy is where it should be.

Still, there are skeptics. Some economists and trade experts warn that the export success might soon diminish. Gary C. Hufbauer, a senior fellow at the Peterson Institute for International Economics, believes that about 90 percent of the increase is the result of macro trends. He added that the Obama administration's stimulus program reinforced domestic and global demand.

Trade experts pointed to other trends boosting exports since 2010. These included a global rebound from the depths of the recession and rising prices for commodities, such as cotton, wheat, and petroleum products. In fact, the starting point for the administration's five-year goal was when global trade volumes were near their recession-era lows. According to Andrew B. Bernard, this means that the rapid recovery has a lot to do with just getting back to the normal figures, which has a positive correlation with the rapid recovery of U.S. trading partners. For the last two years, the demand from developing countries has also helped to increase prices for commodities. Bernard added that 8 percent is a more realistic number than the 16 percent cited above for annual export growth postrecession.

Experts have indicated that after a global economic recession, it is typical for trade to return faster. In addition, it is expected that during 2012, factors such as the crisis in Europe will draw investors toward the dollar. This has brought the borrowing costs of the United States to near-record lows. However, U.S. exports are relatively more expensive, which might push developing economies to look for cheaper options.

In addition, there is a prospect of a global slowdown and an easing of

commodity prices. Europe is facing recession, and the International Monetary Fund and World Bank have warned that the emerging-market economies will likely slow down. Furthermore, according to the World Bank, a financial crisis in the euro zone could reduce global trade by more than 7 percent in 2012.

Michael J. Spence advises that overall "the main trend in 2012 will be volatility, with the preponderance of extreme macroeconomic risk on the downside," Europe being the global risk. In addition, he predicts two scenarios. The first is that "the United States will experience slow growth and high unemployment, without much action until after the presidential election, leaving the fiscal stabilization, growth, and employment largely unattended and structural adjustment in the hands of the private sector, without much public sector investment or support." The second scenario is that "the core euro zone begins to come apart, leading to sharply negative growth, then transmitted to the United States' fragile recovery and to the emerging economies by growth reduction, due to a sharp fall in external demand" (Spence 2011).

On the other hand, Ted Wieseman, an economist specializing in U.S. fixed-income markets, agrees with Lowrey. He sees the U.S. economy continuing on a good path, with slow growth in the vicinity of 2.25 percent for 2012, based on the *Global Forecast Snapshots: Outlook 2012, Policy Make or Break (November 27, 2011)* by Joachim Fels, Manoj Pradhan, and Spyros Andreopoulos. Among his reasons for optimism is a positive outlook for the housing market. The listed existing home inventory is at normal levels, and housing affordability is at its highest in historical records, with the average 30-year mortgage rate at 3.88 percent (third week of January 2012) and median prices down 25 percent over the past five years. This has stimulated home sales and housing construction, although financing is still difficult to

obtain as a result of the tightened lending and appraisal standards. Wieseman also cites job growth as a promising trend. Reports for December 2011 and January 2012 show that job growth averaged about 150,000 per month.

In November 2011, the Federal Open Market Committee (FOMC) forecasted GDP growth of 2.5 to 2.9 percent for 2012, 3 to 3.5 percent for 2013, and 3 to 3.9 percent for 2014. These optimistic predictions anticipated substantial fiscal tightening being implemented in the wake of the 2012 elections. Furthermore, the Fed forecasted a rate of 1.7 to 2 percent for private consumption expenditure (PCE) inflation and 5.2 to 6 percent for unemplyment (Wieseman 2012).

In January 2012, the FOMC stated that interest rates would stay at low levels until late 2014, revising their previous statement that this would be so until mid-2013. They also stated that the economy was growing moderately and labor market conditions had improved, although unemployment rates remained elevated. Private sector spending was growing, although business fixed investment had slowed. While the housing market remained slow, inflation had decreased and was expected to remain stable. The FOMC emphasized that global financial markets remained a risk factor in the economic outlook.

The FOMC expects economic growth over coming quarters to be modest, with the unemployment rate falling gradually and inflation remaining at or below levels consistent with the committee's dual mandate to foster maximum employment and price stability. The FOMC, in an effort to support a stronger economic recovery and maintain acceptable inflation levels, will try to maintain an open mind regarding monetary policy. Specifically, it intends to maintain the federal funds rate at 0 to 0.25 percent. In combination with low rates of resource utilization and a passive stance toward inflation over the medium term, this will contribute in a major way

to low levels for federal funds rates at least through late 2014. Furthermore, the committee is expected to extend the average maturity of its holdings of securities by continuing to reinvest principal payments from its holdings of agency debt and agency mortgage-backed securities in agency mortgage-backed securities and rolling over maturing Treasury securities at auction. The committee stated that it would constantly review and adjust as necessary the size and arrangement of its securities holdings in order to promote a stronger economic recovery (Bland 2012).

Wieseman, while positive, differs with the FOMC's growth projections. He forecasts GDP growth of only 2.25 percent for 2012 and 1.75 percent in 2013. The Treasury market will be secondarily on supply. In December 2012 Wieseman anticipates a 4 percent increase in durable goods orders, along with a rise in new home sales to an annual rate of 330,000. He expects the GDP for the fourth quarter of the year to be around 2.7 percent, with a GDP price deflator of around 0.5 percent (Wieseman 2012).

Other economists, however, accuse the central bank of manipulating U.S. economic statistics. According to Barry M. Ferguson, an investment advisor, the U.S. economy is far from healthy. Ferguson defines GDP as money supply multiplied by money velocity, and money velocity as "the number of times one dollar is used to purchase final goods and services relative to GDP." Money supply is derived from the M-2 data, which is the sum of all money deposited in banks. Based on a chart provided by the St. Louis Fed, the velocity of money is declining. This means that Americans are using a dollar less frequently to purchase final products and services, and that means that the economy is contracting and economic activity slowing. In other words, economic activity as measured by dollar turnover is declining. In fact, the money velocity rate of turnover is the slowest in over thirty years, which means the U.S. economy should be in recession. However, one

way to increase money velocity is to increase the money supply, something that the Fed has some control over through use of the printing press and the buying and selling of Treasuries. That, according to Ferguson, is what is happening. To achieve a positive GDP, the Fed is increasing the money supply to cover up the slowdown in money velocity (Fergunson 2012).

In January 2012, the reported unemployment rate was 8.5 percent, the lowest since February 2009. The Fed has been open to utilizing quantitative easing as part of a strategy to prevent another banking crisis, this one in response to Europe's long-term debt problems. Since the economic crisis began in 2008, the Fed has been in an open fiscal policy, which includes using low interest rates and $3 trillion in bond purchases in a continuous effort to stimulate the economy (Dunstan 2012).

CHAPTER 15
U.S. Exports

Worldwide the United States is the main nation involved in international trade and one of the top three exporters (Department of Commerce 2012). In November 2011, for example, U.S. exports were valued at about $177.8 billion, and the total figure for the year had already exceeded $1 trillion dollars.

The main exports of the United States are (1) *agricultural products* such as corn, wheat, soybeans, meats, and fruit; (2) *industrial supplies* such as fuel oil, organic chemicals, and plastic materials; (3) *consumer goods* such as medicines, musical instruments, furniture, and cookware; and (4) *capital goods* such as aircraft and aircraft parts, automobile parts, construction machinery, tractors, transistors, computers, and telecommunications equipment (Dorish 2010). The main export partners of the United States are Canada, the European Union, Mexico, China, and Japan (Department of Commerce 2012).

Exports in general have declined since the onset of the global recession in late 2008. However, in 2012 some improvement is expected (Department of Commerce 2012).

Agricultural Products

According to the U.S. Census Bureau (2011), agricultural product exports for 2010 totaled $115.81 billion. For the period of January to November 2011, exports of agricultural products totaled $124.57 billion (U.S. Department of Agriculture 2012). The five main destinations were China with $17.52 billion, Canada with $16.86 billion, Mexico with $14.59 billion, Japan with

$11.83 billion, and the European Union with $8.89 billion (U.S. Census Bureau 2011).

The most recent report provided by the U.S. Census Bureau put the year-to-date 2011 figure for foods, feeds, and beverages at $115.1 billion and broke down that total by commodity. Soybeans accounted for $15.86 billion; meat, poultry, etc. for $15.53 million; corn for $13.53 billion; wheat for $10.99 million; and other foods for $9.76 billion.

Industrial Supplies

Industrial supplies and materials for the same period accounted for $458.09 billion in exports. Petroleum products topped the list in this category, with $50.08 billion in exports, followed by fuel oil with $47.33 billion, organic chemicals with $35.98 billion, plastic materials with $33.06 billion, and nonmonetary gold with $30.46 billion.

That fuel in 2011 became one of the main exports of the United States, with a value of about $88 billion, was a major change. That total represented shipment of about 117 million gallons of gasoline, diesel, jet fuel, and other petroleum products per day. The growth in this sector came as a result of increases in prices per barrel of oil and per gallon of gasoline. Such increases lowered U.S. consumption of fuels, which in turn allowed refiners to sell more fuels to rapidly growing economies like those in Latin America (Phillip 2011).

Capital Goods

Capital goods can be defined as "goods devoted to producing other goods" (Investor Glossary (n.d.). It is the most varied category of U.S. exports. In 2011, the group (minus its automotive component) accounted for a year-to-date amount of $449.76 billion in trade. This total included $41.34 billion in industrial machines, $40.41 billion in semiconductors, $32.93 billion in telecommunications equipment, $32.08 billion in electric apparatus, and

$30.44 billion in civil aircraft (U.S. Department of Commerce 2012). There are other noteworthy inclusions beyond these.

The United States also exports agricultural equipment. This group of capital goods includes both farm field machinery used for producing crops and farmstead machinery used for raising livestock. In 2008, the United States exported $9.8 billion in agricultural equipment. Most of it was exported to industrialized market economies (International Trade Administration 2009). By the end of the second quarter of 2011, exports of agriculture equipment totaled $5.6 billion, and the major destinations for that period were Canada with $1.8 billion, Australia with $23 million, Mexico with $395 million, Germany with $260 million, and Brazil with $242 million (Association of Equipment Manufacturers [AEM] 2011).

Advanced technology products in recent years have been a major category of capital goods exports. From January to November 2011, this group accounted for a total of $260.51 billion in trade, including products for use in the following areas: information and communications ($81.15 billion), aerospace ($80.17 billion), electronics ($39.92 billion), and life science ($26.37 billion). The main destinations of these products were China with $117.85 billion, the European Union countries with a total of $68.28 billion, Mexico with $43.77 billion, Japan with $ 23.243 billion, Taiwan with $17.37 billion, and Korea with $16.15 billion (U.S. Department of Commerce 2012).

Of particular interest in the immediately preceding figures is the one for aerospace exports. The United States exports both civil and military aerospace products. The top export markets for such products are France, China, Japan, the United Kingdom, and Germany; but markets such as India, Saudi Arabia, Israel, and Indonesia have been showing growth. The U.S. aerospace industry is split evenly between the civil and military

sectors. When it comes to exports, however, the civil sector dominates. Since 2005, over 85 percent of all U.S. aerospace exports have consisted of civil products. This is a direct result of strict U.S. export policies put in place in the late 1990s. These have negatively impacted the ability of U.S. satellite manufacturers to sell their products abroad (International Trade Administration 2011).

The automotive component of capital goods, omitted from the figures discussed thus far, adds fully 25 percent to the capital goods export total. The category consists of vehicles, parts, and sometimes engines.

In 2010, the United States exported 2,233,230 vehicles. Light vehicles were exported to almost 200 countries, including Canada ($17 billion), Germany ($3.6 billion), Saudi Arabia ($2.95 billion), China ($2.91 billion), Mexico ($2.8 billion), Korea ($313 million), Chile ($360 million), Russia ($106 million), the United Arab Emirates ($1 billion), Kuwait ($707 million), and Qatar ($239 million) (International Trade Administration 2011).

During the same year, U.S. worldwide automotive parts exports increased 36.2 percent to $58.1 billion, compared to $42.7 billion in 2009. According to the Commerce Department, 84 percent of those exports were shipped to Canada ($25.8 billion), Mexico ($17.4 billion), the European Union ($4.48 billion), and Japan ($1.31 billion). U.S. auto parts exports to China increased to $1.5 billion. The U.S. original equipment (OE) parts market during 2009 was $103.7 billion and increased to $141.5 billion in 2010. As of 2010, the United States remained the second-largest exporter of auto parts (U.S. Department of Commerce 2011).

In 2011, exports of motor vehicles and parts totaled $126.97 billion year to date, with passenger cars accounting for $43.08 billion; trucks, buses, and special-purpose vehicles accounting for $22.06 billion; and parts accounting for $61.82 billion. The main destination was Canada with a total of $51.17

billion in U.S. automotive exports (i.e., $11.42 billion in passenger cars; $13.47 billion in trucks, buses, and special-purpose vehicles; and $26.29 billion in parts). Mexico was the second most frequent destination for U.S. passenger car exports, with a total of $23.27 billion, of which $19.48 billion was parts. Germany was the third main destination on the list, with a total of $6.88 billion in U.S. automotive exports (U.S. Department of Commerce 2012).

It is expected that global automotive production and sales will remain weak for several years, with only gradual improvement. Despite the declines in production and employment, however, automotive manufacturers and suppliers still account directly and indirectly for more jobs than any other manufacturing sector (U.S. Department of Commerce 2011).

Consumer Goods

Consumer goods accounted for $161.51 billion in exports January to September 2012. Pharmaceuticals led the category, with $41.91 billion exported; followed by other household goods with $18.7 billion; gem diamonds with $17.7 million; toys, games, and sporting goods with $9.56 billion; toiletries and cosmetics with $8.99 billion; and other goods with $50.27 billion (U.S. Department of Commerce 2012).

In March 2011, the value of U.S. exports of goods and services reached $124.9 billion and $47.7 billion, respectively. These figures reflected the highest increase on record. U.S. goods and services exports for the first quarter of 2011 increased to $505.2 billion compared to the first quarter of 2010, when they totaled only $439.6 billion—a 15 percent increase (International Trade Administration 2011).

Export Destinations

The main destinations cited in the Commerce Department's 2011 year-to-date report on U.S. exports were as follows: *North America* accounted for

a total of $439.51 billion in U.S. exports, of which $258.27 billion went to Canada and $181.23 billion went to Mexico. *Europe* received a total of $300.27 billion in U.S. exports, of which $245.83 million went to the European Union and $189.48 billion went to the (smaller) Euro Area. The *Pacific Rim countries* received a total of $336.32 billion in U.S. exports, of which $94.17 million went to China and $60.78 billion went to Japan. The *newly industrialized countries (NICS)* received a total of $125.58 billion in U.S. exports, of which $39.54 billion went to South Korea and $33.71 billion went to Hong Kong. *South and Central America* received a total of $154.26 billion in U.S. exports, $39.56 billion of which went to Brazil. The *Organization of Petroleum Exporting Countries (OPEC)* received a total of $58 billion in U.S. exports, of which $12.3 million went to Saudi Arabia. *Africa* received a total of $29.87 billion in U.S. exports, $6.72 billion of which went to South Africa. *India* received a total of $19.66 billion in U.S. exports, making it also a main destination (U.S. Department of Commerce 2012).

CHAPTER 16
Is Outsourcing Damaging the U.S. Economy?

Outsourcing is a practice used by companies to reduce costs by transferring portions of work to outside suppliers rather than completing it internally (Investopedia 2012). This practice is not new. In the early nineteenth century, Great Britain decided to adopt it. Initially, British mill owners imported cotton from the United States, produced fabric in Great Britain, and exported it to India, then its colony. The British kept about 80 percent of the gain from the exports. Later, the mill owners decided that they could grow the cotton and manufacture the fabric in India, supposedly saving on wages and shipping expenses. It looked like the perfect plan until the monetary gains to Great Britain fell to 15 to 20 percent, while India retained 80 percent (Hassan 2008). Similarly, U.S. companies established facilities abroad during the 1970s and 1980s in response to heightened competition from Japanese and European multinational corporations (Levine 2011).

Outsourcing has become a major concern in the United States, not only for workers, but also for policymakers, because it has affected unemployment rates in the country. These exceeded 9 percent well after the end of the June 2009 recession. The jobs that were outsourced at first were blue-collar, like textile mill and auto assembly line jobs; but later (in the early 2000s), white-collar positions, like IT and IT-enabled jobs, suffered the same fate (Levine 2011).

Developing nations that offer cheap and skilled labor, low taxes, and flexible administrative requirements have been a magnet drawing U.S. companies to take their businesses abroad (Mohr 2012). According to Forrester Research, Inc., it is expected that by 2015 a total of 3.4 million service sector jobs will

have been outsourced from the United States (Levine 2011). This amounts to about 300,000 jobs lost per year (Hassan 2008). This will definitely not benefit American industry in the long run. It could take decades before developing countries reach the point where they have to increase wages dramatically.

Furthermore, low-skilled jobs are not the only ones being outsourced. American companies established in developing economies have increased their openings for accountants, engineers, and IT specialists. Abroad these jobs are compensated at a lower rate than in the United States. This trend is prejudicial to American industry because it is very difficult to regain outsourced jobs once lost. What is more, because there are now fewer domestic job openings in the affected careers, in the future there will be fewer students majoring in those fields in colleges and graduate schools.

Another area in which the United States is losing ground because of outsourcing is manufacturing capacity. Every time a U.S. factory closes down, the country loses industrial infrastructure (Mohr 2012). Companies are moving to countries that offer significant incentives, such as Germany. If those companies ever return home, however, it will take years to develop the manufacturing equipment and to train the engineers they would need.

Even if such companies remain abroad, however, they are at risk. Should the United States embark on a trade war with the countries to which they have relocated, those governments might levy tariffs on foreign companies or on their goods and products crossing the border. If diplomatic relations between the two countries break down or if a country falls into economic decline, that might cost investors in international markets their portfolios (Mohr 2012).

Some supporters of outsourcing believe that it will open opportunities for more Americans to hold jobs at higher levels and offer substantial gains to

the U.S. economy by providing cheaper imports. They also believe that it will increase U.S. trade by creating jobs in developing countries, thereby improving their economies to the point that they will be able to buy U.S. products and pay back any U.S. loans that they may have (Hassan 2008). Opponents argue that outsourcing contributes to higher unemployment and higher levels of poverty because outsourced jobs are lost forever.

The University of California-Santa Cruz conducted a study to test the theory that outsourcing jobs greatly affects the national economy. The study found that "in the labor-intensive industries such as leather, textiles, footwear, and clothing, about one-third of displaced workers could not find reemployment within a three-year period, and of those who did, about half . . . experienced a cut in their wages of at least 15 percent." Other effects documented by the study also suggested that outsourcing results in a loss of income to local, state, and federal governments as a result lower payroll tax receipts, lower levels of contributions to Social Security and Medicare, and reduced revenues from sales taxes and similar levies (Hassan 2008).

The fact is that manufacturing jobs do have a major effect on the national economy, and the majority of outsourced jobs are of this type. Outsourcing benefits investors, shareholders, and consumers in the United States; but it damages the economy (Hassan 2008).

According to research conducted by Jensen and Kletzer, two economists specializing in outsourcing, at least 60 percent of workers are at risk of being outsourced. The figure includes individuals working in the fields of computer science and mathematics; law; life, physical, and social sciences; business and financial operations; and architecture and engineering. The Bureau of Labor Statistics (BLS) estimates that out of 515 occupations, about 160 lend themselves to outsourcing; however, there are 33 service-providing occupations that are at a greater risk. Occupations in office and

administrative support and in professional and related occupations, such as computer operators, programmers, and support specialists, are part of this list (Levine 2011).

Blinder and Krueger have utilized three alternative survey methods to determine which jobs are most at risk of outsourcing. Their results indicate that "about one in four U.S. jobs are outsourceable" (Levine 2011). In 2009, Blinder created a chart listing occupations and their level of "offshorability." The most vulnerable were in fields like computer programming and systems analysis, telemarketing, bookkeeping, accounting, and auditing. The next most vulnerable included jobs in computer software engineering, accounting, machine operation, assembly and production, and bill and account collection. Third most vulnerable on the list were jobs in general operations management; stock and order filling; and shipping, receiving, and traffic. The fields at less risk were business operation, health and safety, music, photography, and postal service (Levine 2011). Based on Blinder's chart, most of the occupations in the United States are at risk of outsourcing. This conclusion was of so much concern to three U.S. Congressmen—Rep. Jerry McNerney (D-CA), Rep. Gary Peters (D-MI), and Rep. Tim Bishop (D-NY)—that on January 31, 2012, they introduced the Outsourcing Accountability Act of 2012, which amends the Securities Exchange Act of 1934. Under current law, it was complicated to determine if corporations that received tax incentives were in fact creating new jobs in U.S. territory or in other countries. (Estimates indicated, for example, that from 2000 to 2009, multinational corporations cut 2.9 million U.S. jobs and created 2.4 million jobs in other countries.) The Outsourcing Accountability Act requires large corporations with annual revenues of $1 billion or more to disclose how many of their employees are domestic and how many are abroad, including the percentage change from the previous year. The act

represents an effort to make corporate outsourcing practices transparent and contributes to clarifying tax ambiguities that contribute to job outsourcing. Now, by having more control over corporate operations, people in the United States will have a greater chance of finding good, well-paid jobs.

Workers, however, are not the only ones to benefit from transparency in outsourcing. Investors will benefit as well because they will know how and where their money is invested. Such information can now be used in making investment decisions (U.S. House of Representatives 2012).

It seems that things for outsourced companies are already changing. According to Harold Sirkin, Michael Zinser, and Douglas Hohner, experts from a leading management and consulting group, "outsourcing manufacturing in China is not as cheap as it used to be." This will lead some companies to return their operations to the United States. In the last few decades, labor was cheaper for American companies in China. (According to a BCG report, it was less than $1 per hour.) Now the situation is different. Labor costs, shipping, and fuel expenses have all increased greatly. The massive creation of new factories throughout China has led to a greater demand for workers, along with higher wages, because companies have to compete for the most skilled prospects. Estimates indicate that "by 2015, it will be only about 10 percent cheaper to manufacture in China." Sirkin has stated that "the average Chinese worker is about a quarter as productive as the average U.S. worker." It is estimated that, with the return of companies that outsourced jobs, there is the potential to create about two to three million jobs in the United States.

The United States is already seeing the return of some of American companies. Bruce Cochrane, the owner of Lincolnton Furniture in Lincolnton, North Carolina, decided to return to the United States after fifteen years of operation in Asia, moved by the great demand for American products in

Asia. Other examples are Sleek Audio, which moved from China back to Florida, and Ford Motor Company, which will be bringing 2,000 jobs back from China as well. According to Sirkin, this is a positive scenario for the economy, despite the lower-than-before wages (Deb 2012).

With the new policies and the return of companies, the United States has a chance to recover some of its outsourced jobs. Financial, political, and even social factors will influence the future of outsourcing.

CHAPTER 17
U.S. Addiction to Debt

Increasingly the United States is seen abroad as a plutocratic country with major trade and budget deficits, a tax system that favors the wealthy, immoderate military expenditures, and a tendency to contract debt (Elliott 2011). Its hold on the title of the world's greatest economy has been slipping, as has the admiration and respect of other countries. All of these factors have led to a national and international economic crisis.

Experts indicate that the United States lives in a bubble, one that sooner or later will burst, leaving the country in an even worse economic situation. The country has the option of seeking help from the International Monetary Fund (IMF), but that would be almost unthinkable given the nation's status as the world's only superpower (Elliott 2011).

Financial instability and debt problems are not anything new for the United States. According to Chris Mayer, an editor at Agora Financial in Baltimore, Maryland, the United States has already defaulted on its financial obligations five times. The first was in 1779 when, as a newly declared nation, it was unable to redeem its currency during the Revolutionary War. In 1782, it defaulted on loans secured to finance that war. It happened again in 1862 during the Civil War when it failed to redeem dollars for gold. In 1934, during the Great Depression, it defaulted on the loans used to finance World War I, and in 1979, it defaulted on small bills by not paying on time. According to Mayer, all of these defaults, except for the one in 1979, resulted in a significant loss of purchasing power.

For the last twenty years, U.S. policymakers have been in denial. Believing

that the United States was somehow an exception to the rules of economics, they have consistently opted for the easiest ways to solve the nation's economic problems.

Consider the dot-com bubble. It started during the mid-1990s with the stock market soaring on technology and Internet stocks, a deluge of initial public offerings (IPOs), and ever-increasing stock prices. Everyone believed that the Internet was the wave of the future that would bring endless growth, but the wave did not last long. Between 2000 and 2001, overvalued stocks along with an excess of private-sector debt caused the stock market to crash (The Investor's Journal 2011).

Alan Greenspan, then chairman of the U.S. Federal Reserve Board, presided over the financial market boom (Elliott 2011). Greenspan's solution to the dotcom crisis was to greatly reduce interest rates, moved as he was by his great scorn for regulation. Years later, these two views were the leading cause of the mortgage crisis. Greenspan admitted that he was wrong to believe that financial institutions could regulate themselves (Time Magazine 2012). The second Bush administration, which inherited a solid economy and a budget surplus from the Clinton administration, lost both by financing two wars, cutting taxes for the wealthy, and setting the subprime mortgage crisis in motion. Just before the Bush presidency ended, the bubble burst. In an effort to stabilize the economy, interest rates were reduced to ease consumer lending, but it was not enough to stop the slide into a recession so severe that it bordered on depression. The Obama administration cut taxes and increased government spending, which avoided another Great Depression but left the economy fragile.

Still, there are those who believe that the situation is not as dire as it seems. According to Nick Parsons of the National Australia Bank, the United States as a country is not in the same situation as, for example, Greece; although

154

individual states, counties, and cities across the nation are. He notes that such places have "higher levels of personal indebtedness, public spending that has exceeded income by a considerable margin, and . . . high rates of unemployment." Parsons believes that the difference between Europe and the United States is that Europe relies on Germany and the United States relies on China (Elliott 2011).

In early 2009, the Obama administration faced a budget deficit projected to climb to $1.2 trillion and an economic dilemma: slashing the deficit either by raising taxes or eliminating government programs would further weaken the economy. In July 2011, IMF estimates suggested fiscal consolidation with contractionary effects on private domestic demand and GDP; in other words, "the IMF found that a fiscal consolidation amounting to 1 percent of GDP would reduce private consumption by 0.75 percent over the following two years, while GDP would drop by 0.62 percent" (Elliott 2012). Economists warned that increasing taxes and reducing spending at the wrong time could do more damage to demand, leaving a deeper recession and bigger deficits. According to Elliott (2011), the only way to get out of this situation is by recognizing that high levels of public borrowing are a reflection of deeper problems at the private level, including the debt addiction on the part of the public. Genuine improvements in productivity and real wage growth will come only with the implementation of realistic and concrete policies designed to reduce unemployment, augment economic productive capacity, and reduce deficits.

The economic health of the United States is a reflection of easy credit and bad financial habits of both consumers and government. In fact, according to Federal Reserve data, by the end of 2010 total U.S. household debt and the federal debt ceiling were quite similar—about $13.4 trillion. The U.S. federal debt can be compared to consumer debt. The difference is that the

federal government does not owe money to credit card companies, but to millions of individuals, pension funds, and foreign central banks. If a consumer reaches his credit limit, most likely the lender will lower the credit limit and/or close the account and demand payment in full. However, if the government reaches the debt ceiling, or the amount that the government can borrow, the Congress just raises the limit so that the government can avoid defaulting on its financial obligations (Grant 2011).

China is the largest foreign holder of U.S. debt. In August 2011, after Standard & Poor's downgraded America's long-term debt to AA+, the Chinese government expressed in strongest terms its reservations about America's economic policies. The Chinese government stated that the United States needed to "quit its addiction to debt and . . . live within its limits." In addition, China called upon the United States to "reduce its enormous military expenditures and its bloated social welfare" programs (Barboza 2011).

China's reservations were soundly based. By the end of 2010, China had about $3 trillion in foreign exchange reserves. Of that amount, about $1.16 trillion was in U.S. securities (Macedonian International News Agency 2011). China decided to invest in U.S. Treasury bonds mainly because the American bond market was considered the safest and most liquid in the world. In fact, there were and still are few places to invest other than the United States (this would be true even if the United States were to devaluate its currency). Therefore, China really has no option other than to continue buying U.S. Treasuries. If it refrains from doing so, the dollar would weaken and U.S. borrowing costs would increase abruptly. However, this seems an unlikely scenario because such action on China's part would devalue its existing holdings of U.S. debt. Therefore, until China finds alternatives, it will continue to be the largest buyer of U.S. Treasuries. However, China has

requested international supervision of the U.S. dollar and a new stable and secured global reserve currency as an option to prevent an economic crisis caused by a single country (Barboza 2011).

If China is publicly suggesting such solutions, it means that the country is asserting its power over the United States. And why not? While the outlook for the American economy is gloomy, the Chinese economy has become the world's second largest with an annual growth rate of nearly 9 percent. It has also become the world's largest foreign exchange holder (Barboza 2011).

If the U.S. government does not change its financial habits, eventually foreign investors will demand higher interest rates, which would be an additional burden on the American economy (Grant 2011). Christine Lagarde of the IMF has suggested that the United States take steps to prevent future bubbles. If the United States wants a truly healthy economy, it needs to enter rehab before it becomes the new Japan (Elliott 2011).

CHAPTER 18
Is the United States Bankrupt?

Many experts believe that the United States would never default on its debts or that the possibility is much lower than, say, Japan's doing so or some other developed country's doing so. Why? There are a variety of answers: Because the country's long-term nominal interest rates are historically low. Because the dollar is the world's reserve currency. Because other countries have a great demand for U.S. Treasuries.

A country goes bankrupt when its technology, preferences, and openness to international trade are not in harmony with the demands of international trade. Therefore, a general equilibrium is needed to prevent a bankruptcy. Governments rely on official debt reports to measure fiscal solvency. The best way to calculate a country's solvency is by examining "the lifetime fiscal burdens facing current and future generations. If these burdens exceed the resources of those generations or are at their limits, this is an indication that the country's policies will be unsustainable and could lead the nation to bankruptcy" (Kotlikoff L. J. 2006).

It is uncertain whether the United States fits this description; however, there is enough evidence to suggest that it might. In 2005, Gokhale and Smetters published an analysis of the country's "fiscal gap." It measured the difference between all future government expenditures (including debt service) and all future receipts. The results indicated a fiscal gap of $65.9 trillion; this was more than five times the U.S. GDP and almost twice the national wealth. The suggested solution was an immediate and permanent doubling of personal and corporate income taxes, a permanent two-thirds cut in Social Security and Medicare benefits, or a cut in federal discretionary

spending of 143 percent. The most alarming feature of the analysis was the omission of the value of contingent government liabilities.

As is well known, from 2005 to the present, conditions worsened. The Bush administration expanded discretionary spending, but did not create any new revenue sources. In fact, the administration based its conclusions on outdated reports and budgets, and both political parties went along with that (Kotlikoff L. J. 2006).

According to Laurence J. Kotlikoff (2006), productivity growth would be a more realistic way to alleviate such fiscal problems. Arguably, it would translate into higher wage growth, an expanded tax base, and limited requisite tax hikes. Even so, there would be no guarantee that it would raise net resources.

The reason is that some government expenditures are explicitly indexed to productivity and others are not. According to Kotlikoff, to save the United States from bankruptcy, the government needs to simplify its tax, health care, retirement, and financial systems. He made his recommendations based on the 2010 International Monetary Fund report that said of U.S. fiscal policy that "a larger-than-budgeted adjustment would be required to stabilize [the] debt-to-GDP ratio. . . . To close the fiscal gap [would] require a permanent annual fiscal adjustment equal to about 14 percent of U.S. GDP." This would mean an immediate and permanent doubling of personal and corporate income taxes and a reduction of payroll and Federal Insurance Contribution Act (FICA) taxes. The tax increment would result in a surplus of about 5 percent of GDP during 2010. Based on the CBO's report, Kotlikoff estimated a fiscal gap of about $202 trillion for 2010, largely the result of 78 million baby boomers collecting benefits that will exceed per-capita GDP. The solutions to this problem would be anything but popular: major benefit cuts, major tax increases, or the massive printing

of money to cover the bills. The scenario seems even worse than Greece's because the solutions will bring increased poverty, taxes, interest rates, and consumer prices (Kotlikoff L. 2010).

Other experts disagree with Kotlikoff and assure that the United States is not going bankrupt. According to Richard Duncan, government debt has increased by $4 trillion to a total of $15 trillion, while government as a percentage of GDP grew 99 percent by the end of 2011. He compares this with the current 230 percent of Japan. He explains that "spending on Income Security" in the United States jumped $231 billion, or 63 percent. Medical spending increased by $111 billion, or 30 percent. Social Security outlays increased $145 billion, or 25 percent. Military spending increased $155 billion, or 28 percent. And all of these between 2007 and 2011 (Duncan 2012).

In 2011, the United States spent $700 billion on defense—19.5 percent of total government spending. Non-defense discretionary spending was about 18 percent of the total government spending. Official reports indicate that the budget deficit for 2012 is projected to drop to $1.1 trillion, or 7 percent of GDP; for 2013 it will drop to $585 billion, or 3.7 percent; and for 2014 it will drop to $345 billion, or 1.5 percent. If this happens, there will be a severe worldwide recession. Social Security taxes paid by employees will increase by about 44 percent. However, there is a high probability that the U.S. budget deficit will continue at about $1 trillion, because Congress will increase government spending and extend tax cuts. This will prevent the U.S. economy from collapsing. Optimistically, Duncan predicts that the United States economy has about ten more years, at which point it will collapse, marking the beginning of a new world—one without the United States (Duncan 2012).

CHAPTER 19
Sustainable Capitalism

Sustainable capitalism can be defined as the framework that seeks to maximize long-term economic value creation by reforming markets to address real needs while considering all costs and integrating environmental, social, and governmental metrics into the decision-making process; in addition, it applies to the entire investment value chain from entrepreneurial ventures to publicly traded companies, from investors to late-stage growth-oriented opportunities, from company employees to CEOs, from activists to policymakers and standard setters. It goes beyond borders, industries, forms of ownership, asset classes, and stakeholders (Generation Investment Management LLP 2012).

Capitalism has more strengths than any other economic system. It effectively organizes economic activity, distributes resources, and manages supply and demand. It has higher levels of freedom and self-governance than any comparable system and motivates people to innovate and work hard for a better reward. It is so flexible that it can be adapted to the needs of different countries (e.g., the United States and China) (Generation Investment Management LLP 2012).

However, there is no such thing as an economic system without faults. Nicolas Sarkozy, the former French prime minister, emphasized that the most recent global economic crisis was attributable to an excess of confidence in capitalism, and he concluded that "capitalist economies should never have been allowed to function without strict government oversight and regulation."

Capitalism has faced several crises in which the government has intervened, which has raised the question of whether capitalism is in fact a sustainable system. According to John Ikerd, "the sustainability of capitalism or any other economic system depends on its ability to meet the needs of the present without diminishing the opportunities for the future." Ikerd, for example, emphasizes that the growth of 2000 was nothing more than the result of unethical financial practices that promoted irresponsible borrowing and spending. He condemns economic growth founded on weak and unstable sources as unsustainable.

Over the last thirty years, the United States has not focused on some important parts of the economy. By failing to address issues related to energy resources and global climate change, it has put at risk the future of natural resources. There have also been social consequences. Alan Greenspan, former chairman of the Federal Reserve Board, has stated that inequality between the wealthy and the rest of the U.S. population is growing at such a fast pace that the stability of democratic capitalism might be at risk. A sustainable economy must be founded on the responsible use of both natural and human resources and for the future as well as the present. However, the United States is an instant-gratification society that prefers loans and interest payments to saving and buying in the future. Ikerd believes that this, too, is unsustainable (Ikerd).

A sustainable economy must renew and regenerate at least as much as it extracts and exploits, which is not the case with the United States (Ikerd). Furthermore, it is believed that by 2020, maintaining sustainable capitalism will require a combination of "independent, collaborative, and voluntary actions by companies, investors, government, and civil society" (Generation Investment Management LLP 2012).

Companies will derive multiple benefits from embracing sustainability, from

an improvement in competitive position to a reduction in waste, an increase in energy efficiency, an improvement in human-capital practices, and the chance to achieve higher compliance standards. This, in turn, will reduce costs, improve operations, induce innovation, and enhance profitability.

Investors also play an important role in the sustainability of a nation. Today's investors are focused exclusively on the short term and tend to forget the real value of business. Short-term returns damage both the planet and the society, and ultimately reduce returns for investors. A study by Eccles, Ioannou, and Serafeim indicates that sustainable companies outperform non-sustainable companies. Results indicated that US$1 invested in a value-weighted portfolio of sustainable firms at the beginning of 1993 would have grown to US$22.60 by the end of 2010. By contrast, US$1 invested in a value-weighted portfolio of unsustainable firms at the beginning of 1993 would have grown to US$15.40 by the end of 2010. The difference in annual abnormal stock-market performance, after taking into account four risk factors (i.e., market, size, book-to-market, and momentum) was 4.8 percent. Moreover, the study found that the portfolio of sustainable firms exhibited less volatile performance relative to the portfolio of unsustainable firms. This empirical evidence suggests that investors who spend resources identifying companies that embed sustainability in their strategy can earn substantial returns while experiencing low volatility" (Generation Investment Management LLP 2012).

One of the main barriers to a business's adopting sustainability is focusing on short-term financial results. According to Lester Lave, an environmental economist at Carnegie Mellon University, companies that are focused on an annual return of at least 40 percent (the average is about 12 percent) are not open to investing in energy efficiency, which will produce higher returns in the long run. Lave agrees that markets based on short-term returns

have deleterious effects, like increasing the gap between rich and poor and augmenting the volatility of the global financial market (Gies 2012).

To be sustainable, capitalism needs to change to meet the demands of contemporary society, or it faces major failure (Ikerd). Al Gore and David Blood, in their 2011 paper A Manifesto for Sustainable Capitalism suggested that capitalism can become as sustainable as it once was by embracing the following five strategies: <list>

1. *Identify and incorporate risks from stranded assets.* These could be high-carbon assets such as coal-fired power plants that become prohibitively expensive to use because of incentives to cut carbon dioxide emissions. An accurate price—one that addresses the use of coal's true cost to society—would dramatically change the costs of such resources.

2. *Mandate integrated reporting.* This method of accounting requires companies to include environmental, social, and labor performance along with financial results. The practice is currently voluntary.

3. *End the default practice of issuing quarterly earnings guidance.* This practice gives executives and investors incentives to make decisions based on short-term profits rather than longer-term objectives.

4. *Align compensation structures with long-term sustainable performance.* Senior managers should not receive bonuses automatically or for turning in quarterly profits. Rather, their compensation should be tied to longer-term objectives, including environmental and social goals.

5. *Encourage long-term investing with loyalty-driven securities.* Such securities would only pay off when investors hold them for several years, giving them a longer-term investment in a company's success" (Gies 2012).

Modern capitalism is in an economic and ecological crisis. The pillars

of capitalism—private ownership and free markets—have been greatly affected by the financial crises (Future Generations Party). In the worst cases, government has ended up being the lifesaver of unsustainable companies and their investors. Now government must focus on the implementation of sustainability initiatives, which will improve job creation and retention, property values, community revitalization, business attraction, and cost savings for individuals and businesses. It is also imperative for government to develop key infrastructure and a policy framework that fosters both public-private partnerships and the creation of regulations to monitor their sustainability. Finally, government being the major company, it needs to operate under the same sustainability principles as private enterprises and be cautious about the management of both financial and environmental/social/governance (ESG) resources. This will lead to a steady overall growth.

Civil society is a central part of sustainable capitalism. Through campaigns, lobbying, and partnership with the private sector, nongovernmental organizations (NGOs) must encourage investors, companies, regulators, and policymakers to adopt sustainable capitalism. NGOs must also demand transparency and focus on sustainable consumption (Generation Investment Management LLP 2012).

It is imperative for the U.S. government to take action in the marketplace. However, an economic rescue plan focused on boosting consumption will only expedite environmental degradation. Capitalism is at risk because of the unmeasured pursuit of profits and growth. Instead of providing short-term solutions like stimulus packages, government needs to directly supervise the American companies and banks that have proved to be incapable of properly managing themselves. Companies and investors both urgently need to conduct business according to the following principles of

sustainable capitalism:<list>

· Accept that markets will be regulated and that some limits may be imposed on private property and patent protection.

· Adopt a long-term sustainable vision rather than short-term exploitation for quick profits.

· Renounce the notion of constant expansion and growth. Encourage the concept of a steady state economy, which emphasizes qualitative economic development, not quantitative economic growth.

· Restrain consumption rates that simply fuel growth. Discourage marketing media attempts to persuade people to borrow and spend recklessly.

· Reduce unnecessary production and eliminate planned obsolescence. Produce durable products for human needs and not for corporate profits.

· Curb resource depletion and focus on conservation, recycling, and renewable technologies.

· Revise statistical accounting systems, such as GDP, so that they reflect externalities like pollution and public health.

· Ensure that the marketplace fairly allocates resources and products. There is enough land, water, air, minerals, food, and money for all to share equitably.

· Preserve the notion of creative entrepreneurship and innovation, but restrain self-interest and control income disparities. Environmental waste is a function of wealth.

· Review the practice of free trade and its global environmental effects.

· Modify the terminology of economic theory and business practice. Future generations will view terms like *maximizing profits, toxic assets, robust growth,* and *consumer confidence* with both incredulity and anger.

· Recognize the importance of a progressive taxation system. Abandon pleas for tax cuts, and discourage offshore tax havens.

· Control excessive profit and compensation levels in all enterprises. The earnings of the top executives in North America are 350 times the average worker's wage.

· Encourage an equitable distribution of wealth in society. In the United States, the top 5 percent of the population controls 70 percent of the assets.

· Do not promote the privatization of basic human rights, such as water.

· Encourage governments to eliminate subsidies and introduce true-cost pricing for resources.

· Refocus the stock market on its traditional role of raising investment capital for development projects. Discourage the increasingly prevalent casino capitalism mentality (Future Generations Party).

Capitalism will only be revived by adopting an ideology of sustainability. Focusing on long-term results will bring balance between economic growth and the environment. Until then, capitalism—specifically, U.S. capitalism—will be unsustainable.

CHAPTER 20

Billions Wasted in Afghanistan

The current war in Afghanistan is the longest in U.S. history—now over ten years. The cost reflects all those years. Since 2001, the U.S. government has expended $522,151,508,850 on the conflict—and counting (the figure changes every second) (National Priorities Project 2012). Most Americans now believe that the conflict has been a waste of time, lives, and money. The U.S. soldiers fighting there are tired of both the multiple deployments and hostile environment in the country. And now, after almost eleven years, even the majority of experts feel that the U.S. presence in Afghanistan has become a negative for both countries.

Begun by the (George W.) Bush administration, the Afghanistan conflict was later dubbed "the right war" (as opposed to the "wrong" war in Iraq) by Barack Obama when he was a presidential candidate. Today some experts call it Obama's war; and President Obama himself, now once again a candidate, appears ready to declare victory and leave.

The fact is that at no time in over a decade of war has the United States ever controlled even half of Afghanistan, nor has it won the hearts and minds of the Afghan people. Nothing is more indicative of the latter than the series of incidents, ranging from embarrassing to outrageous to utterly tragic, that have recently made headlines around the world. One such incident involved NATO forces burning copies of the Quran. Another involved U.S. soldiers urinating on the bodies of militants. Both incidents gave the impression to many Afghans that U.S. troops were stationed in the country to humiliate the Afghan people and disrespect their faith (Kahn 2012). The most recent

incident, however, went far beyond humiliation and disrespect. A U.S. sergeant killed sixteen civilians—four men, three women, and nine children (four of the latter, girls under the age of 6). Afterward eleven of the sixteen bodies were set on fire (Shah and Bowley 2012). Such carnage is beyond defense in any conflict. Nonetheless, defense officials indicated that possible factors affecting the accused soldier were a fourth deployment, extremely high daily stress levels, traumatic brain injury, and alcohol. It did not help either local or international opinion that the soldier was promptly removed from the country and returned to the United States for further investigation and legal proceedings.

Such incidents belie Western claims of bringing freedom and democracy to Afghanistan, as does the mounting civilian casualty count. Researchers at Brown University's Watson Institute for International Studies estimate that there have been between 12,423 and 14,701 civilian deaths in Afghanistan from October 2001 through June 2011 (Crawford 2011). In fact, the civilian casualties of the war are greater than those suffered when the country was under Taliban control (Watson Institute 2011). The numbers reported by the United Nations Mission in Afghanistan (UNAMA) are arguably even higher. According to its estimates, civilian casualties for the last five years alone were as follows: 929 in 2006; 1,523 in 2007; 2,118 in 2008; 2,412 in 2009; 2,790 in 2010; and 3,021 in 2011 (UNAMA 2012), for a total of 12,793. Casualties for the first half of 2011 were the highest in a decade (Rogers and Sedghi 2012).

Such figures demonstrate one way in which the Afghan war effort has gone awry. There are others. Originally U.S. and NATO forces were supposed to help Afghanistan establish both a national army and local police forces. Instead the United States and NATO focused on creating military bases to protect their own forces and equipment. They forgot to invest in

Afghan society and political integration. As a result, the Afghan army and the police remain weak institutions, and the government is plagued by rampant corruption and assassination. Now all of these collective failures are affecting perceptions of the United States and U.S. investment in the country. Afghans see the United States as an occupying power that covets their natural resources, denigrates their culture, and increases animosity between ethnic groups (Khan 2012).

In the meantime, in the United States there is little political interest and even less public interest in non-American casualties and war damage. This kind of attitude could do great harm in the future to U.S. relations with Afghanistan, other countries, and the worldwide Muslim community. It is imperative for Americans to understand that not only *their* money has been wasted in Afghanistan and not only *their* lives and interests have been damaged (Tirman 2012). According to the Afghan Ministry of Public Health, in 2009, two-thirds of Afghans had mental health issues. Furthermore, Afghans face a number of other huge problems such as poor sanitation, malnutrition, reduced access to health care, and environmental degradation—all of which have been aggravated by the current war (Watson Institute 2011).

The fact is that the Afghanistan war has been a failure marked by an inexcusable loss of lives and resources; and like other wars fought in the so-called graveyard of empires, it is a war that cannot be won. There is no doubt that now the United States must withdraw, but it cannot simply walk away from the tremendous amount of damage that has been done to both the country and its people (Seervai 2012).

The withdrawal must be accomplished in a deliberate and methodical way. According to Shanoor Seervai, a rushed withdrawal would be dangerous for Afghanistan and its neighboring countries. David Cameron, the British prime minister, and White House officials believe that leaving prior 2014

would be risky for Afghanistan because the Afghan National Security Force (ANSF) will be not be ready to provide for the security of the country. As a result of the killings in the area of Panjwai on March 15, 2012, the Taliban suspended peace talks with the Americans. This means that pulling out too soon would leave Afghanistan worse off than in 2001. Leaving early would also increase instability in Pakistan, because the Taliban controls the Afghan-Pakistani border and might seek revenge on Pakistan and other nearby countries (Seervai 2012).

In April 2012, the United States and Afghanistan agreed that a U.S. military presence would remain in Afghanistan to support its "transition to transformation" from 2015 through 2024 (Khan 2012). Although the negotiated agreement is not finalized (i.e., it needs signatures from Washington, the Afghan parliament, and President Hamid Karzai), it does offer the most effective route to withdrawal for U.S. and NATO troops with the least damage possible to Afghanistan. The U.S. and NATO military presence could discourage any plans by the Taliban to take over Afghanistan again. It will also give Afghan citizens confidence that their government is capable of protecting their society and encourage participation in the 2014 elections.

According to an article in the *Washington Post,* after the withdrawal, Afghanistan will need economic support for its special forces, in addition to long-term air support and military training to respond to emergencies. The United States has committed to providing support in all of these areas (*Washington Post* 2012). It has also pledged about $1.8 billion per year for military and police (Riegert 2012).

According to the Afghan national security adviser, Rangin Dadfar Spanta, this agreement is a strong foundation for the security and development of Afghanistan, the region, and the world. Ryan C. Crocker, a U.S. ambassador,

stated that the agreement was the commitment of the United States to help Afghanistan to become a "unified, democratic, stable, and secure state" (*New York Times* 2012).

In August 2011, some of Afghanistan's neighbors, such as Pakistan, expressed discontent with the agreement. Also, a senior member of Hamid Karzai's peace council noted that the agreement would likely nullify any attempts at negotiations with the Taliban (Farmer 2011).

Vahab Aghai, Ph.D

PART 5 Aspects of Chinese Economic Policy

CHAPTER 21

Chinese Economic Trends

In previous years, China has seemed invulnerable to the effects of the global economic crisis. However, 2012 may be a different story.

Even though China's GDP grew 8.9 percent in the last three months of 2011 compared to the same period in 2010, it was the fourth straight quarter of slower growth and the weakest point since the third quarter of 2009. During the last two months of 2011 and the first month of 2012, there were reports of a manufacturing slowdown in China. China closed 2011 with a Purchasing Managers Index number of 48.7. (Any PMI below 50 is considered an indicator of a slowing economy.) To encourage lending, China's central bank reduced bank reserve requirements for the first time since 2008. According to the government's data, home prices fell in fifty-two out of seventy cities in the month of November. In addition, China reported the smallest gains in overseas sales and imports in two years. Estimates from UBS AG, Nomura Holdings, Inc., and Société Générale, SA, indicated that by the end of the first quarter of 2012, growth would be below 8 percent as a result of the continuing slowdown in export demand and the government's policies on housing costs.

In January 2012, the Chinese government continued with its plan to adjust policies to support growth. This time the central bank allowed the five biggest lenders to increase first-quarter credit by a maximum of about 5 percent compared to 2011. In addition, the banking regulator indicated that a plan to relax capital requirements was under consideration (Shedlock 2012).

Yukon Huang, a Senior Associate at the Carnegie Endowment for International Peace, agrees with this approach, noting that China will likely shift to a slower growth trajectory with the anointment of its fifth generation. He expects growth to be around 8 percent, which will reduce policy options, but might benefit China and the rest of the world. Huang believes that if China becomes consumption oriented, it will ease global trade tensions. Furthermore, with weak financial institutions and its infrastructure-led growth model under attack, the country might not be able to achieve its goals (Huang 2011).

John Ross, a professor at Antai College of Economics and Management, has a very different viewpoint. He believes that since 2007 China, based on actual effective demand, has contributed 33.4 percent of global market growth, more than four times that of the United States, which contributed only 8.1 percent. In addition, during the first three quarters of 2011, China's market expanded by over $1 trillion, approximately twice that of the U.S. market. There is no other economy with a higher market/global aggregate demand expansion than China (Ross 2012).

Ross is so sure that China will continue its market growth at the same level during 2012 because developing economies currently dominate global economic growth and are China's largest trading partners. In the period between 2007 and 2010, developing economies accounted for 78.6 percent of world market growth, while developed economies accounted for only 21.4 percent. Also, the BRICS nations (Brazil, Russia, India, China, etc.) or China and Latin America were the greatest contributors of world market/effective demand expansion. According to Ross, "Either of these two groups contributed more than twice [the] market expansion [of] the developed countries."

Another argument that Ross makes in support of China's continued market growth is that as "China's economy becomes larger, a similar percentage of yearly growth necessarily turns into an increasingly large annual absolute market increase." In other words, the absolute market adjusts to the growth. In 2008, China's economy

expanded by 2.3 trillion RMB; in 2009, by 2.4 trillion RMB; and in 2010, by 3.1 trillion RMB. Furthermore, Ross notes that the expansion of China's position in the world market is underestimated because actual sales use real money, which is affected by exchange rates and inflation. In 2009, China froze the renminbi's exchange rate and reported an economic expansion of $469 billion. In 2010, China allowed the exchange rate to rise and reported economic growth of $935 billion. Ross is sure that for 2011 the figure reported will be over $1 trillion.

In recent years, developing countries have accounted for the lion's share of global market expansion. China has accounted for 33.4 percent, Latin America for 17.3 percent, South Asia for 8 percent, East Asia (excluding China) for 7 percent, the Middle East and North Africa for 6.1 percent, developing countries in Europe and Central Asia for 4.5 percent, and sub–Saharan Africa for 2.1 percent. Altogether developing economies accounted for 78.6 percent of global market expansion. On the other hand, Japan (with the drastic rise in the yen's exchange rate) accounted for 14.9 percent and the United States, 8.2 percent, while the share of the developed European economies declined to 9.2 percent (Ross 2012).

Ross believes that the figures for 2012 will be similar. He states, "Developed European economies will continue to be in bad shape, suffering a recession, possibly worsened by a low euro exchange rate. Again, the growth of world economy will be primarily due to developing economies." The large developing economies will grow more slowly than in the recent past, but still faster than developed ones. China is likely to grow by at least 7–8 percent in real terms, with an expansion of its market reaching 12–15 percent in dollar terms. Furthermore, the BRICS economies will continue as leading contributors to world growth (Ross 2012).

The economies of developing nations directly affect China because they are China's major trade partners, representing 54 percent of its total trade—49 percent of exports and 60 percent of imports. Another factor contributing to China's growth

is declining inflation, which "allows [for] domestic economic loosening/stimulus" (Ross 2012). The combination of domestic and international factors, including the gloomy outlook for Europe and slow growth in the United States, indicates that China's economy will expand largely based on the contributions of the developing economies (Ross 2012).

Overall then, the indications of damage to China's economy are real. The country's growth has definitely slowed, but it has not stopped. What has ended for the time being is the cycle of rapid growth. Otherwise, China's economy remains largely untouched by the global economic crisis.

CHAPTER 22
China's Exports

Exports have been one of the main pillars of China's rapid economic growth for almost thirty years. It is estimated that about 10,500 jobs are created for every $100 million of goods exported. Exports of goods and services constitute 39.7 percent of China's GDP. The country's main exports are office machines, data processing equipment, telecommunications equipment, electrical machinery, apparel, and clothing. China's main export markets are the European Union, the United States, Hong Kong, Japan, and South Korea (Trading Economics 2012).

In 2007, China's main export market was the European Union with $250 billion worth of exports, followed by the United States with $233 billion and Hong Kong with $184 billion. Together they constituted 54.3 percent of China's total exports. Other important markets were Japan, the Association of Southeast Asian Nations (ASEAN), South Korea, Russia, India, Taiwan, and Canada (starmass 2011). As of 2009, the value of shipments from China to Africa, Latin America, and the Middle East were about $192 billion over a five-year period. In 2009, China became the world's largest exporter to the Middle East (Simpfendorfer 2009).

In 2010, the main Chinese exports were electrical machinery and equipment, power-generation equipment, apparel, iron and steel, optics and medical equipment, furniture, inorganic and organic chemicals, ships and boats, vehicles (excluding rail), and footwear. China's top export markets were the United States with $283.3 billion worth of goods, Hong Kong with $218.3 billion, Japan with $121.1 billion, South Korea with $68.8 billion,

Germany with $68.0 billion, the Netherlands with $49.7 billion, India with $40.9 billion, the United Kingdom with $38.8 billion, Singapore with $32.3 billion, and Italy with $31.1 billion (The US-China Business Council 2012). China's exports have increased to other regions besides America and the European Union. It is common to see a greater number of Asian, African, and Middle Eastern countries among China's fifty main export destinations (The Middle East Information Network 2012). Equipment and machinery are among the main products aimed to markets in India, the Middle East, and South America (Blommberg News 2012).

Originally, the Middle East was considered to include the following twenty-one countries: Algeria, Bahrain, Egypt, Iraq, Israel, Jordan, Kuwait, Lebanon, Libya, Morocco, Oman, Palestine, Qatar, Saudi Arabia, Sudan, Syria, Tunisia, Turkey, the United Arab Emirates, and Yemen (The Middle East Information Network 2012). In the mid-1990s, the region was geopolitically redefined to include Afghanistan, Algeria, Armenia, Azerbaijan, Comoros, Djibouti, Eritrea, Georgia, Kazakshtan, Kyrgyzstan, Libya, Mauritania, Morocco, Pakistan, Somalia, Sudan, Taijikistan, Tunisia, Turkmenistan, Uzbekistan, and Western Sahara (International Monetary Fund 2012). This larger region, now described as the Greater Middle East, has become one of China's main export destinations (DG Trade Statistics 2012).

In 2010, fifteen Middle Eastern countries ranked among China's top fifty export destinations. They were (in order of approximate value of Chinese exports received) as follows: the United Arab Emirates ($211.57 billion), Turkey ($119 billion), Saudi Arabia ($103.58 billion), Kazakhstan ($92.27 billion), Pakistan ($69.07 billion), Egypt ($60.11 billion), Ukraine ($55.34 billion), Israel ($50.18 billion), Kyrgyz Republic ($40.51 billion), Algeria ($39.82 billion), Iraq ($35.92 billion), Morocco ($24.74 billion), Syria ($24.36 billion), and Libya ($20.56 billion) (DG Trade Statistics 2012).

In the same year, the following Asian countries were among the top fifty destinations for China's exports: Hong Kong ($2.17 trillion), Japan ($1.19 trillion), South Korea ($683.02 billion), India ($406.07 billion), Singapore ($320.26 billion), Russia ($294.23 billion), Malaysia ($236.45 billion), Vietnam ($229.37 billion), Indonesia ($218.54 billion, Thailand ($196.33 billion), the Philippines ($114.86 billion, Bangladesh ($67.43 billion, Ukraine ($55.27 billion), Myanmar ($34.45 billion, New Zealand ($27.4 billion), North Korea ($22.69 billion), and Macao ($21.23 billion) (DG Trade Statistics 2012).

The following African nations were also part of the list: South Africa ($107.26 billion), Nigeria ($66.59 billion), Liberia ($43.31 billion), Benin ($22.63 billion), and Angola ($19.81 billion) (DG Trade Statistics 2012).

In 2011, Europe, the United States, and Japan accounted for 48 percent of China's total exports. However, Louis Kuijs, an economist at the Global Institute in Hong Kong, has noted that developing countries are China's main export destinations. Other analysts have provided the reason, indicating that China's brand has an advantage over other international brands in this market because the country's technology, product levels, and lower prices are more suitable for developing nations (Blommberg News 2012).

In 2011, China's main export markets were the United States with $324.49 billion worth of exports, Hong Kong with $267.91 billion, Japan with $148.43 billion, South Korea with $82.95 billion, Germany with $76.46 billion, the Netherlands with $59.51 billion, India with $50.55 billion, the United Kingdom with $44.13 billion, Russia with $38.93 billion, and Singapore with $35.46 billion (Hong Kong Trade Development Council 2012). Overall the European Union imported $172.16 billion worth of Chinese goods and services (European Commission 2012)

Despite a slower pace, China still reported continuing growth for the first

months of 2012. The first two months of the year, exports to the United States were $17.13 billion (U.S. Census Bureau 2012),

For January 2012, China reported export destinations and values as follows: Hong Kong ($17,083,547); Indonesia ($13,505,202); Japan ($12,269,859); South Korea ($7,380,511); Germany ($5,849,747); the Netherlands ($4,552,297); India ($3,734,870); the United Kingdom ($3,685,896); Russia ($3,199,807); Australia ($3,102,024); Singapore ($2,806,049); Brazil ($2,635,012); France ($2,518,119); Italy ($2,437,076); Canada ($2,235,590); Malaysia ($2,164,636); Thailand ($2,159,226); Taiwan ($2,070,235); Vietnam ($1,949,263); the Philippines ($1,183,126); South Africa ($1,164,560); and New Zealand ($356,286) (ETCN 2012). China's total exports for March 2012 were reported to be $165.7 billion (Trading Economics 2012).

Some analysts estimate that by 2020 world trade could total $35 trillion. China's exports to Europe would be worth over $1 trillion; intra-regional European trade, over $7 trillion; and Asian trade, about $5 trillion. European exports to Africa and the Middle East would be about 50 percent greater than exports to the United States, and Europe itself would be the most important market for sub-Saharan Africa's exports (Ernst & Young 2012).

The Asian-Pacific region would have the fastest growth in global trade, and that growth would extend beyond Asia to the Middle East and Africa. This would cause a shift in the preferred geographic locations for companies. China would experience pressure from lower-cost/lower-wage countries and risk losing its competitive advantage more quickly than expected. The fastest-growing trade route would be the one between India and China, with exports to India from China at about 18.5 percent per year. The Asian Pacific region would continue to be competitive; China and India would continue to be the rapid-growth markets; and together they would comprise the main

global trade markets, superseding the United States and the European Union (Ernst & Young 2012).

<cn>CHAPTER 23</cn>
<ct>China's Currency</ct>

On April 14, 2012, China's central bank announced the first widening of the yuan's trading band since 2007 (Bloomberg News 2012). Two days later, the People's Bank of China widened the yuan's daily trading band against the U.S. dollar to 1 percent above and below a daily reference exchange rate, from a previous 0.5 percent. The last time China expanded the dollar/ yuan trading band was in May 2007 at 0.3 percent (Zhang 2012). At present, the worst currency performers against the dollar in Asia are the Indonesian rupiah, the Japanese yen, and the Chinese yuan.

This action encouraged confidence in the strength of the economy and a soft landing. According to Zhou Xiaochuan, the central bank governor, flexibility of the yuan can help to control inflation and sustain an economy that it is estimated to grow about 8.2 percent in 2012. Investors, suppliers, and foreign companies eyeing the Chinese market are alert to the risks from a cooling property market and weakness in exports resulting from European economies imposing austerity measures. Despite moderate growth in the first quarter of 2012, American companies such as Apple and Ford Motor are contemplating expanding plants in China. Shane Oliver, a Sydney-based head of investment strategy, commented, "In 2008, China linked the yuan back to the dollar, and now they are widening the band. This indicates that they are more confident that the major manufacturers in the coast of China will not be adversely affected."

The Chinese government is doing everything possible to avoid a deeper

growth slide during the process of transferring power to younger leaders. Some analysts believe that "the yuan move suggests that 'reformers' are driving policy," [while others believe that] "a resumption of accelerated reforms is gathering momentum" (Bloomberg News 2012).

China has a five-year plan for 2010 through 2015 that requires officials to slacken controls on capital flows as the nation shifts to a convertible currency. The new rules for yuan trading follow increases in quotas for foreigners buying stocks and bonds in China and in the amount of yuan held in the exterior that can be invested locally.

The Obama administration believes that China has been keeping the exchange rate artificially low and that now, even though the Chinese government is in process of correcting it, neither the change nor its pace is sufficient. The exchange rate affects American manufacturers and contributes to a U.S. trade deficit with China that rose 8 percent to $295 billion during 2011 (Bloomberg News 2012).

In September 2011, the IMF estimated surpluses of 0.86 percent in 2015 and 0.93 percent of gross domestic product for 2016. However, on April 17, 2012, the IMF changed its projections to 0.42 percent for 2015 and 0.51 percent for 2016 (International Monetary Fund 2012).

According to Christine Lagarde, managing director of the IMF, the widening of the yuan band is positive because it shows that China is committed to "rebalancing its economy towards domestic consumption, allowing the market forces to play a greater role in determining the level of the exchange rate." Economists in Hong Kong agree with Lagarde. According to Wang Tao, this is positive for the economy, because greater currency flexibility increases "the independence of monetary policy" (Bloomberg News 2012). Washington concurs; according to U.S. Treasury Secretary Timothy F. Geithner, the widening of the yuan band is a significant and promising

indication of China's commitment to depend less on external demand and begin the lengthy process that will lead to exchange rate changes (Katz 2012). According to Shen Danyang, Ministry of Commerce, China's action to widen the yuan trading band is a crucial step in its exchange rate reform. As a result of the band widening, the yuan's value will become a little less predictable. In addition, exporters might experience difficulty in controlling foreign exchange risks (Zhang 2012). However, many exporters in China embrace the decision to widen the yuan's trading band. They feel confident in their ability to handle independent pricing and risk management, because currency is a common risk in their field. Now, their businesses will have to adapt to the market. Exporters also believe that this will help export-oriented companies promote their competitiveness potential. They would willingly make the necessary changes, such as cutting the cost of exports, to adapt to the new market.

While most experts perceive the change as positive, small- and medium-sized companies have concerns because they face "two-way fluctuations." They do not feel ready for a market-based exchange rate. Some analysts agree with them, because the wider trading band does involve risks as well as opportunities.

Export companies will most likely benefit from the yuan's depreciation, although they will have to pay for the cost of exchange rate fluctuations when the yuan rises. However, the yuan's exchange rate is expected to remain stable and its depreciation to be minimal. Some exporters are taking precautions and making deals with banks to stabilize the trading exchange rate with customers for a certain period of time (usually a year). Others believe that banks should be more proactive and develop financial options to aid companies that might face exchange rate issues. It is expected that the government will issue warnings against potential risks so that companies

will have time to cope with the change (Xinhua 2012).

Economist Andy Xie believes that the widening of the yuan trade band against the U.S. dollar "will not lead to faster appreciation of the currency in the coming months; to think that is erroneous." The move was a reaction to deal with the almost decade-long pressure from the United States to demonstrate that the yuan is not undervalued. The United States argued that China had an unfair trade advantage that led to the loss of millions of U.S. factory jobs. Another expert, Arjuna Mahendran, believes that the move could result in either appreciation or depreciation of the currency against the dollar (CNBC 2012).

CHAPTER 24
China's Inflation

In March 2012, China's inflation unexpectedly accelerated as a consequence of a rise in food prices. In the United States, the Producer Price Index (PPI), which is a leading indicator of consumer inflation (Bloomberg 2012), fell 0.3 percent compared to 2011, raising concerns about weak demand. Based on this figure, analysts suggested that China's inflation would moderate in the coming months.

Everything indicates that China will meet its 2012 inflation target of 4 percent. Tim Condon, head of Asian economic research at ING, is confident that even with the figures reported in March, China will reduce its rate of inflation. Since this would be the first reduction since November 2009, economists forecasted that annual consumer inflation would be about 3.3 percent, with prices easing to about 0.2 percent compared with February's 3.2 percent (Qing et al. 2012) and a rise in food prices to 6.2 percent. According to the National Bureau of Statistics, China's consumer prices rose 3.6 percent compared to 2011, while food-related costs gained 7.5 percent (Bloomberg 2012). This was in line with the expectations of a number of economists.

Ren Xianfang, an analyst at IHS Global Insight in Beijing, stated that the main concern is the PPI. Since the last quarter of 2011, it has dropped to near-deflationary levels, a fact that will have consequences for China's economic recovery. During the first quarter of 2012, the economy grew only 8.3 percent, the slowest pace in nearly three years. In addition, as exports decreased and rigid credit conditions discouraged local demand, China was at risk of experiencing its weakest full year of growth in a decade (Qing et al. 2012). Data indicated that food prices, which are the main contributor to

inflation, were volatile. Some key products that recently rose in price were vegetables and fuel (Bloomberg 2012).

However, according to Li Wei, an economist in Shanghai, some prices have decreased month-to-month, indicating that the inflation is short term. Other analysts expect strain in prices for the rest of 2012. For example, a major vegetable wholesaler in Beijing stated that prices had to be increased to cover rising labor costs and smaller crops resulting from bad weather and less planting following losses from the previous year. Jeremy Stevens, an economist at Standard Bank, expects that overall food inflation will continue to be moderate—an average 9 percent in March, down from 9.9 percent the previous month (Qing et al. 2012).

Considering these circumstances, Premier Wen Jiabao stated they were a reminder that inflation could rebound, even if price increases stayed below the expected 4 percent. Yao Wei, a Hong Kong–based economist with Société Générale, stated that inflation might decelerate during the second quarter of 2012 as a result of higher bases of comparison during the same period of 2011. Yao concluded that there was a possibility of a reserve ratio cut for April 2012, but not a reduction in interest rates. In February 2012, in an effort to increase liquidity in the banking system, the People's Bank of China did in fact reduce lenders' reserve requirements for the second time in three months (Bloomberg 2012).

A Reuters poll of economists had indicated that "China could reduce banks' reserve requirement ratios (RRR) by another 150 basis points before December to 19 percent to induce banks to increase their lending" (Qing et al. 2012). Although there was optimism about a rebound in the second half of 2012 (Qing et al. 2012), analysts in a Bloomberg News survey agreed that "banks' reserve requirements will drop in 2012 with some of the analysts expecting lower benchmark borrowing costs."

Liu Li-Gang, a head economist, disagrees with this view. She stated that "the central bank is cautious in its policy position. In addition, [since] the most recent report reduces the urgency to lower the reserve requirements in the short term, any cut will be postponed until May or June" (Qing et al. 2012). In addition, there is optimism that growth may recover between 8.9 and 9 percent during the second quarter of 2012, as the demand from the United States and Europe increases. According to the People's Bank of China governor, Zhou Xiaochuan, the Chinese government is looking for alternatives to avoid a rebound in consumer prices. They expect to change the way prices are set, especially for electricity and fuel, and concluded that the ultimate goal is to reduce inflation gradually, which will contribute to a "soft landing" (Bloomberg 2012).

CHAPTER 25

China's Economic Growth)

Since the late 1970s, China has grown rapidly. Its growth was particularly dramatic during the 1990s. The country encouraged the formation of rural enterprises and private businesses, opened up to foreign trade and investment, eased state control on some prices, and invested in industrial production and education for its workforce.

Capital investment has aided the country's production. Prior to the economic reforms, between 1953 and 1972, China's productivity increased at an annual rate of 1.1 percent. After the reforms, between 1979 and 1994, it increased at an annual rate of 3.9 percent. During the first fourteen years of economic reform, the output of state-owned enterprises declined to 40 percent from 56 percent. On the other hand, the share of collective enterprises increased to 50 percent from 42 percent, and the share from private business and joint ventures rose from 2 to 10 percent.

"With the economic reforms, also came the liberty for enterprise managers to set their own production goals; they were able to sell some products in the private market at competitive prices, grant bonuses to good workers, [and] fire ineffectual ones. Furthermore, the Chinese government granted them a portion of the firm's earnings for future investment and facilitated the establishment of private ownership of production. These companies created jobs, developed wanted consumer products, earned important hard currency through foreign trade, [and] paid state taxes" (Hu and Khan 1997). The economic incentives such enterprises were given worked because managers and private owners were willing to increase their production if they were

entitled to more profit.

Foreign direct investment has been another major factor contributing to China's economic transformation. FDI increased from almost nonexistent before 1978 to nearly US$100 billion in 1994 (Hu and Khan 1997) and by the end of 2011 had reached US$116 billion. In January 2012, the Chinese Commerce Ministry set a goal of attracting an average of $120 billion of FDI in each of the next four years (Reuters 2012).

Before such reforms were implemented in 1978, China's annual growth rate was about 6 percent. Afterwards, average real growth was more than 9 percent a year, and sometimes reached more than 13 percent. In the fifteen years from 1982 to 1997, per capita income nearly quadrupled. By 1997, many experts predicted that China would be the largest economy in the world by the year 2017.

The main reasons for this rapid growth were factors like capital accumulation and increased productivity. According to Hu and Khan (1997), "during 1979–94, productivity gains accounted for more than 42 percent of China's growth and by the early 1990s had overtaken capital as the most significant source of that growth." However, it should be noted that deriving internationally comparable data on the Chinese economy is complicated by variations in how the figures are reported and interpreted by analysts (Hu and Khan 1997).

Some people compare China's economic growth with that of Japan during the 1970s. The second-largest economy in the world, Japan used its political system and economic structure to implement policies favoring progress. In addition, whenever there were new initiatives, they were always supported with minimal obstacles (Komo 2011).

In October 2011, China became the second-largest economy in the world. By that time, the country was already known as both the world's largest

vehicle market and largest vehicle manufacturer, and was considered one of the world's largest consumers of luxury goods. It had wealth and a modern infrastructure.

Despite such gains, however, China is still very much a developing country. Many of its citizens have not been touched by its phenomenal economic progress. Even Prime Minister Wen Jiabao has admitted that "the country needs to pursue a more 'balanced' growth," adding that the growth of the last thirty years had "left China with a weak economic foundation and uneven development." The latter has manifested itself in citizen complaints about the increasing unaffordability of food, health care, and housing.

Other signs of the strain of rapid growth have become apparent in China's economy. By the third quarter of 2011, China's rate of GDP growth had fallen to 9.1 percent from 9.5 percent the previous quarter. This was the slowest pace in nearly two years (National Bureau of Statistics China 2011). By October 2011, the rate of inflation had risen to about 6.5 percent, largely as a consequence of the government's $568 billion stimulus program, which had been undertaken in 2009 in response to the global economic crisis (The Sunday Independent 2011). During the fourth quarter of 2011, China's economy grew at its slowest pace since the second quarter of 2009—8.9 percent. Gross domestic output grew only 2 percent from the previous quarter. Net exports decreased, while consumption increased. By December 2011, the growth in property investment had decreased to 12.3 percent, marking a drastic slowdown from the previous month's 20.2 percent. (Housing investment is expected to continue to decrease during 2012 as a consequence of action taken by the government to reduce housing prices and avoid a housing bubble.) Finally, during the last two months of 2011, foreign direct investment dropped 12.7 percent compared to the previous year's levels, indicating that China's economy is not immune

to the effects of the global economic crisis. Taken together, all of these negative indicators during 2011 suggest, according to some economists, that the underlying momentum of China's economy is slowing faster than the data implies (Reuters 2012).

Despite less-than-favorable current economic conditions, however, indications are that China will continue growing, albeit at a slower pace. Since the 1990s, the country has been and most likely will continue to be the most accelerated economy in the world.

CHAPTER 26
China's Acquisitions

Any business acquisitions by Chinese firms or the Chinese government are always carefully monitored by developed nations. The most recent transaction involved a bankrupt dairy farm group in New Zealand. For some, it signaled China's intent to gain control over food production around the world.

New Zealand's government approved the transaction after twelve months of deliberation. The sixteen-property Crafar Farms group was sold to Shanghai Pengxin, a Chinese corporation, for $170 million.

New Zealand is the first developed nation to sign a free trade agreement with China. It is also the world largest exporter of dairy products, which may explain why in some quarters the sale was taken as "a selling out to foreign interests." Some believe that the Chinese investors are trying to obtain productive farmland to secure their own food supplies. Producing farmland with access to water has become the new target for many governments because of increasing populations and declining resources. According to Russel Norman, the co-leader of New Zealand's Green Party of Aotearoa, "the Chinese government has embarked upon a strategy of encouraging Chinese companies to purchase farmland throughout the world." Others view the transaction as a win for both parties. They believe that the government cannot turn away investors just because they are foreigners and accuse opponents of the transaction of xenophobia (Sands 2012).

According to *Forbes*, China is capable of acquiring anything because it has the means to do so. By the end of September 2011, China's foreign currency

reserves had grown to $3.2 trillion. Those reserves are mostly in dollars, but China has recently diversified into euros, gold, natural resources, and the sovereign debt of other countries like Australia and Japan (Czaja 2012). It seems, however, that China is interested in more than just farmland. According to *USA Today,* in May 2012, the Federal Reserve approved the selling of an American bank to the Industrial and Commerce Bank of China, which is the largest Chinese bank and one in which the Chinese government owns a 70.7 percent interest. According to Treasury Secretary Timothy Geithner, the transaction was approved because it offered "greater opportunities for U.S. workers and companies."

Recently, Chinese investors have obtained stakes in a Guinean iron ore mine, Canada's oil sands, oil fields in Angola and Uganda, a coal-bed methane gas company in Australia, and an oil company in Argentina. In addition, it is interested in Canada's Potash Corporation, which has triggered some concerns over control of the global fertilizer market (Czaja 2012).

According to the Heritage Foundation, China's rapidly increasing investments throughout the world are evidence that the country wants to expand its domains worldwide. From 2005 through 2011, there were at least 500 transactions (failed and successful), which added up to over $100 million and covered a broad range of fields—technology, metals, chemicals, agriculture, real estate, energy, power, transportation, and banking.

The Western Hemisphere is China's major locus for investment, accounting for $95.2 billion and including Brazil ($25.7 billion), Canada ($17.2 billion), and Argentina ($11.7 billion) as main investment sites. Sub-Saharan Africa accounts for $77.1 billion and includes Nigeria ($18.8 billion), South Africa ($8.2 billion), and the Democratic Republic of the Congo ($7.8 billion) as major investment sites. East Asia accounts for $66.7 billion and includes Indonesia ($23.3 billion), Vietnam ($8.8 billion), and

Singapore ($7.7 billion) as main investment sites. West Asia accounts for $66.8 billion and includes Iran ($17.2 billion), Kazakhstan ($12.3 billion), and the Russian Federation ($11.4 billion) as main investment sites. Europe accounts for $60.3 billion and includes Britain ($11.9 billion), France ($8.2 billion), and Switzerland ($7.3 billion) as main investment sites. The Arab world accounts for $52.7 billion and includes Saudi Arabia ($11.4 billion), Algeria ($10.5 billion), and the United Arab Emirates ($8.2 billion) as main investment sites. Australia accounts for $45.3 billion and the United States, for $42 billion (Scissors 2012).

Through these investments, China is securing energy supplies, food sources, and trading partners throughout the world. Given its monetary reserves and the needs of its population, it is a trend that is not likely to stop anytime soon.

China engages in two types of foreign direct investment in the United States. One form involves private Chinese companies investing in smaller U.S. firms. The other form involves the Chinese government itself using sovereign wealth funds (SWFs) to purchase stakes in major American companies.

Sovereign wealth funds are government investment funds, consisting usually of foreign currencies, that allow governments to invest abroad for profit. In the United States, they can do so in a number of ways. As already noted, they can buy a stake in a company. They can also buy the company itself. They can purchase U.S. Treasuries, or they can convert Treasuries into shares of U.S. corporate stock. They can have state-owned companies do all of those things instead.

China's sovereign wealth fund was managed by the Chinese Investment Corporation (CIC), which did not perform well. After a number of failed transactions, the Chinese government hired international fund managers

(e.g., the American private equity firm of JC Flowers) to manage its investments in global equity markets (UCLA Asian American Studies Center 2009).

Typically, the United States imports Chinese goods and pays for them in dollars. China then invests those dollars in U.S. Treasuries so that the United States can buy more goods. In effect, China is lending the United States the money to buy its products. In this way, by mid-2009, China had accumulated $2.2 trillion in U.S.Treasuries and other foreign paper. As a result, it has been less interested in acquiring more (Blodget 2009). Now China, one of the major creditors of the United States, wants to acquire hard assets like companies, land, and natural resources. Indeed, experts believe that foreign governments in general are highly interested in purchasing U.S. public assets, such as electrical power grids, railways, and toll roads (Long 2011).

The instability of the U.S. economy makes smaller companies the perfect target for foreign investors. These days it is common for private Chinese investors to buy auto-parts plants or printing-plate factories. These kinds of acquisitions cause little concern. However, any attempt to acquire energy, information technology, or security companies by investors linked to the Chinese government arouses great concern about possible motives. In 2005, for example, Congress opposed the selling of Unocal Corporation to the China National Offshore Oil Corporation (CNOOC). The objection at the time was that the purchase was not a free-market transaction. In 2007, Hai'er, a Chinese appliance maker, tried to buy Maytag. Again foreign ownership concerns halted the transaction. In 2007 and 2008, the partnership between Bain Capital Partners, a U.S. firm, and Huawei's, a Chinese firm, to buy out an American company that produced anti-hacking security systems for computers also failed. The problem was a lack of transparency as to who

actually owned Huawei. According to the Rand Corporation, Huawei was directly linked to the Chinese military, a finding that created great anxiety among U.S. lawmakers. On the other hand, Lenovo, a Chinese firm in which the Chinese government held a 28 percent interest, was allowed to purchase IBM's PC division in 2005 (UCLA Asian American Studies Center 2009).

According to the Chinese government, the only reasons for it to invest in the U.S. energy and mineral sectors is to secure resource imports for China's development, to encourage outflows of capital from China to relieve some of the pressure on the RMB, and to reduce excess liquidity which stimulates inflation. So, after failing in the effort to obtain U.S. infrastructure, China turned to countries not considered "friendly" to the United States. China now has assets in Australia, Brazil, Venezuela, Ecuador, and sixteen other countries. In the end, if the U.S. economy continues to struggle, it is expected that the United States will also allow Chinese investors to invest in U.S. infrastructure (UCLA Asian American Studies Center 2009).

Some American experts disagree with these conclusions, however. They believe that the true intentions of the Chinese govenrment are not the ones represented above. China, they claim, is using its wealth strategically by helping Chinese state-owned enterprises to buy up the economic assets of the United States. For example, the Chinese are involved in buying land in Toledo, Ohio, (The American Dream 2011) and wind-power energy that generates assets worth around $1.65 billion. As evidence, these experts point to the fact that China already has such a presence in the Phillippines, Brazil, and Portugal (Xu and Durfee 2012).

Chen Deming, China's commerce minister, has stated that his country was was unwilling to continue taking U.S. government debt. By 2011, China owned $3.2 trillion in foreign currency reserves and was ready to invest in U.S. infrastructure. According to Reuters, the Obama administration

encouraged such investment. In a meeting in 2010 with Chinese CEOs and the Chinese President, Hu Jintao, President Obama stated, "The United States is open for investment and would welcome it."

China would start as a passive investor. What that meant, according to Cate Long (2011), was that China would invest in U.S. infrastructure indirectly, by acquiring municipal or corporate bonds issued to fund water and sewer systems and other infrastructure assets. Direct ownernship through public or private partnership was not recommended at the time for national security reasons. As Long summarized the situation, because of the great demand from corporations and investors worldwide, the United States had the opportunity to structure and limit participation in the U.S. system.

It is a fact then that Chinese investors do face major difficulties investing in certain sectors of the U.S. economy, mostly as a result of protectionist pressure being exerted by American politicians (UCLA Asian American Studies Center 2009). However, the United States is already at the stage where it needs Chinese investment to improve and maintain its infrastructure, among other things.

CHAPTER 27
China and North Korea

China and North Korea share a border and a common historical and ideological background. Historically, China has been a strong ally to North Korea and its largest trading partner, the major supplier of food, arms, and energy.

When North Korea has faced the imposition of international economic sanctions, China has opposed them; that is, until North Korea conducted its first nuclear weapons test in October 2006. China was not pleased with this turn of events, and when the second test occurred in May 2009, China did agree to stricter sanctions (Bajoria 2010).

More recently, China's willingness to stand by North Korea was tested when that nation announced the planned launch of a rocket, ostensibly to put a global positioning satellite into orbit. Other nations pronounced that explanation a pretext for testing a ballistic missile capable of reaching the continental United States (Buckley, Chinese President Hu lauds North Korea ties 2012). Despite international disapproval of the launch (and the possibility of a third nuclear weapons test), Chinese president Hu Jintao expressed his willingness to strengthen relations with North Korea and its new leader, Kim Jong-un. Hu stated that it was fundamental for China as a nation and a formal policy of China's Communist Party and government to continue the consolidation and developing of harmonious relations with North Korea (Buckley, Chinese President Hu lauds North Korea ties, 2012).

That said, China did join other countries in condemning the North Korean rocket launch, which occurred on April 13, 2012, and failed spectacularly. China also warned North Korea of consequences if another nuclear test were to be conducted; however, China has not supported the imposition of harsher sanctions on North Korea in this regard (Buckley, Chinese President Hu lauds North Korea ties, 2012).

Satellite images now show that North Korea is continuing activity at a facility where it has staged previous nuclear tests (Buckley, China lauds North Korea friendship, 2012). Hu has stated that "China and North Korea should join forces to protect the lasting peace of northeast Asia" (Buckley, Chinese President Hu lauds North Korea ties, 2012). Despite Hu's pronouncements, however, some of the equipment in use at the test site appears to be of Chinese design and manufacture. If, as is suspected, Chinese firms provided and transported such equipment to the site, that would be a violation of U.N. sanctions. According to a U.S. State Department spokesperson, "China has

provided repeated assurances that it's complying fully with U.N. sanctions." However, an Asia expert stated that North Korean trading companies operate freely in China, and there are some Chinese banks that facilitate such transactions (Royce 2012).

Indeed, reports indicate that during the first quarter of 2012, commerce between China and North Korea reached a record high—between $1.3 and $1.6 billion. China's imports from North Korea were valued at about $570 million; its exports to North Korea, at about $800 million (arirang.co.kr 2012)

According to Adam Segal, a Council on Foreign Relations Senior Fellow, China will never completely turn its back on North Korea, because it is not in China's interest to do so. North Korea serves as buffer between China and American and Japanese troops. Trade with North Korea provides economic benefits. Finally, China is not interested in precipitating North Korea's collapse, because that would increase the flow of refugees into China. China may share certain security concerns (like those about nuclear weapons) with the United States, but overall it has more in common with North Korea and sees that nation as essential to its stability and security (Bajoria 2010).

PART 6 Crises to Come

CHAPTER 28
Does Europe Need Help from China?

Not long ago, China was a developing country with a weak economy. Today China is still a developing country, but it has a strong economy and has become a strong nation with economic power similar to that of the United States and the European Union.

Trade has been the driving force behind this transformation. Since the reforms began in 1978, trade has become one of the main sources of wealth for China and has changed the country's situation dramatically. China has evolved from "factory of the world" to "major market of the world." This has obligated consumer-oriented businesses to develop a China strategy. Companies looking to sell their products in China now must adapt those products to the needs and desires of China's consumers (Whitney 2006).

Throughout this evolution, the European Union has been an important trading partner for China. In the 1980s, the European Union had trade surpluses with China. By 2002, China was the EU's third-largest trading partner. By 2008, the European Union had become China's main trading partner and an important provider of investment and technologies. However, the rapid increase in China's economic power has turned the tables in that nation's favor. It now has continuous trade surpluses with the European Union (Gosset 2012).

China has clear expectations of its trade relationships: they must be sustainable and beneficial. What's more, the country is firmly focused on continuing its development. That could result in conflicts about China's global responsibilities—social, economic, and environmental (Zhongping

204

2009)

In 2011, the European Union suffered the worst debt crisis in its history, one that threatened the economic stability of multiple EU members and the EU's common currency, the euro. The euro was established in Maastricht in 1992. Before joining the currency, member states had to agree to abide by a number of provisions related to budget deficits, inflation, interest rates, and other monetary considerations. Three member nations—the United Kingdom, Sweden, and Denmark—decided not to join. The currency officially came into existence on January 1, 1999.

In December 2008, in reaction to the global financial crisis, EU leaders agreed on a 200 billion-euro stimulus plan to boost European growth. In April 2009, the European Union demanded that France, Spain, the Irish Republic, and Greece reduce their budget deficits. By December, Greece had a debt of 113 percent of GDP. By February 2010, Portugal, Ireland, and Spain were facing concerns about their debt levels. In an effort to save its indebted members, the European Union approved emergency loans, bailout funds, and safety-net plans. On August 7, 2011, the European Central Bank announced the purchase of Italian and Spanish government bonds in an effort to reduce the borrowing costs the two nations. During the fall of 2011, the European Commission predicted that economic growth in the euro zone in the second half of the year would be only 0.2 percent. Furthermore, the IMF warned that the euro zone countries were "entering a dangerous new phase" and noted that growth in the EU's private sector had shown a reduction for the first time in two years. The crisis seemed to spread rapidly and uncontrollably. By the end of 2011, euro zone members appeared ready to create and implement new budgetary rules to halt it (BBC News 2011).

All indications are that Europe is heading for recession. According to some economists, recovery will depend in part on the EU's further opening up to

Chinese investment. For example, allowing greater investment by Chinese companies could help to stimulate the European economy by creating jobs (Xinhua 2011). Allowing China to buy European bonds would allow that country to export much needed capital to Europe. As a consequence, however, domestic European industries would be forced to compete with Chinese goods, and Europe would run a current-account deficit with China. Economists who support such policies emphasize that today the way to grow an economy is by running a capital-account deficit with the rest of the world and by exporting, not importing, capital (Mattich 2011).

Other economists disagree. They believe that since the problem is rooted in imbalances within the euro zone (Mattich 2011), China cannot be used as a lifesaver, because China itself is being affected by the European crisis. Chinese exports to the European Union have decreased, and European banks are more hesitant to finance shipments of European buyers. The latter is a burden because Chinese exporters take only letters of credit issued by Western banks. This is a clear indication that China is being cautious about the effects of the European crisis on its economy (Peaple 2011). Clearly Europe needs a radical change to recover from the crisis. That change should include "a new fiscal compact aimed at stronger budgetary discipline and closer coordination of economic policies" (Fedyashin 2012).

Today, China and the European Union exist in a state of codependency. The European Union needs investment from China to save its economy, and China needs Europe to continue its economic growth. Of the two nations, however, Europe is clearly in more desperate straights and has the greater need for its trading partner.

CHAPTER 29
Will China Face an Economic Crisis?

According to some experts, China's is the most active economy in the world. In 2010, China had an average annual GDP growth rate of 9.6 percent (Ran 2011). For 2011, the comparable figure was about 9.2 percent (Elliott 2012). The continuous growth of GDP and optimism regarding domestic demand have spurred the development of online marketing and e-commerce in China and made them an important part of the nation's economic growth. Reports indicated that by June 2010, there were approximately 20,700 registered websites devoted to e-commerce. By the end of the year, China had the largest number of Internet users in the world (about 400 million [Ran 2011]) and approximately 47 million mobile users with 3G-enabled mobiles, both of which further increased online shopping. China's cross-border trade, small and medium-sized businesses (SMBs), and online payment industry generated about US$160.1 billion. Its e-commerce sales produced US$713.3 billion, with a trading source utilizes volume of about US$81.3 billion, and accounted for about 3.3 percent of China's overall retail sales. By the end of 2011, China had 505 million Internet users (Phneah 2012), and its SMBs had produced online sales revenues of nearly US$2.08 billion (Phneah 2012).

Regardless of the shortcomings of Chinese laws pertaining e-commerce, the government has recently promulgated its twelfth five-year plan report (2011–2015), stating its goal of reaching a value of online shopping of US$2.86 trillion by 2015. According to China's Ministry of Industry and Information Technology, this goal is realistic, given "the fast-developing

mobile Internet, cross-border trade, [and] growth in the . . . SMB sector and online payment industry" (Phneah 2012). It also resonates with the country's culture, one in which the consumer's priority is price and there is a strong tendency toward collective behavior (Ran 2011). The value of online trading among Chinese businesses is expected to be over 50 percent of all such purchases in the country. China is expected to be the world's most valuable e-commerce economy (Phneah 2012).

E-commerce took root in China while the world was in financial crisis. The new sector had opportunities other sectors did not because of its low operating costs and lack of reliance on venture capital. Chinese Vice Minister Jiang Yaoping stated that e-commerce brought many benefits, including reduction of materials, employees, and overall costs. Internet analyst Andrew Collier has stated that e-commerce is gradually replacing the traditional way of doing business because of the flexibility it offers (Article Snatch 2011).

China's government is very optimistic about its economic growth. A report entitled *China 2030,* by the World Bank and China's Development Research Center of the State Council (DRC), projects that China will have GDP growth of 8.6 percent for 2011–2015, 7.0 percent for 2016–2020, 5.9 percent for 2021–2025, and 5.0 percent for 2026–2030. These projections were based on China's having steady reforms and no major shocks. Based on growth accounting models, by 2020 China will be growing at about 6.5 percent annually on average. In addition, current domestic consumption, which is at present about $3.5 trillion, is expected to reach about $13 trillion by 2020. This seems unrealistic, although not impossible (Rosen 2012).

Other experts agree with Rosen. They do not share the government's optimistic expectations. Analysts in London believe that China will have a rough time economically in 2012. Albert Edwards, head of strategy at Société Générale, predicts a drastic slowdown in China's economic activity

during this year. According to Edwards, China's rapid emergence from the 2008–2009 economic crisis was the result of a massive reflationary package from the Chinese government, a stimulus that the country will be unable to afford a second time. Domestic demand and e-commerce might increase, but not sufficiently or rapidly enough to make up for the losses in exports, which will widen China's trade deficit. This situation will also make China susceptible to the consequences of a double-dip recession in the West and a cooling of the property market at home. Edward Chancellor, a historian, states that China is following a pattern similar to that of previous "manias and bubbles in history," one that includes an assumed growth story, easy money, credit expansion, investment booms, misallocation of capital, and conspicuous consumption. According to 469 global experts, chronic problems with government finances and severe income inequality are China's major risks over the next few decades, threatening global growth, which might also be negatively impacted by systemic financial as well as food and water crises (Elliott 2012).

The truth is that China's trade sector is facing great challenges. In January 2012, it had a trade surplus of $27.3 billion; however, in February, it ran a trade deficit of $31.5 billion, resulting in a negative balance of trade of $4.25 billion for the two-month period. The first two months of the previous year (2011) had shown a trade deficit of less than a quarter of that amount—$890 million. Until then, that deficit had been the largest monthly deficit in the country's history. For January and February, exports rose 6.9 percent; imports, 7.7 percent—a big difference from China's usual double-digit increases (Davis and Back 2012).

China is also facing slower growth in other areas. Vehicle sales, including trucks and buses, dropped 6 percent in the first two months of 2012 compared to the same period the previous year; foreign automobile makers expected

a second year of single-digit growth. Industrial production registered 11.4 percent growth compared to 12.8 percent in December 2011. Retail sales reported a slowdown, dropping to 4.7 percent compared to 18.1 percent in December 2011. Property sales also fell off, and inflation dropped more rapidly than expected. In February, consumer prices rose only 3.2 percent compared to 4.5 percent in January of this year (Hui 2012). Although China's economy has not shown a quarter where GDP decreased since early 2009, Qu Hongbin, an Asia economist for HSBC, forecasts GDP growth of 8 percent for the first quarter of 2012, 0.6 higher than what J.P. Morgan predicted (Davis and Back 2012).

Demand was also weak during the first two months of the year. Exports to the European Union, China's largest trading partner, declined by 1.1 percent compared with the same period in 2011. Trade with the United States during the fourth quarter of 2011 accounted for 17.4 percent of total exports; for January and February 2012, that figure fell to 14.9 percent.

China itself does not rely as heavily on foreign trade as it did before. The country now faces new financial challenges, such as reducing the relative appreciation of the yuan against the dollar. (Davis and Back 2012).

The Chinese government has acted to stabilize growth. Wen Jiabao, the Premier of the State Council, has reduced China's growth target from the original 8 percent set in 2005 to 7.5 percent. Furthermore, it is expected that China's central bank will cut the reserve requirements for banks so that they can increase lending, a strategy that has been utilized twice since late 2011. There is a great deal of caution about cutting interest rates because it could generate disproportionate increases in the building of luxury apartments, which could in turn trigger a housing bubble (Davis and Back 2012).

A report by the Tsinghua University points out the contradictions of Chinese society and demands more aggressive political action to fix the situation. It

asserts that "China is caught between the extremes of misguided socialism and crony capitalism;" and if it cannot achieve a breakthrough over the next five years, it is at a great risk of collapse (Chunshan 2012).

Most experts agree that China will be an economic superpower, with great influence worldwide. Richard Daniels, however, has a different opinion. He believes that China is an unsustainable economic system. To defend his position, he argues, "If numbers do not add up, it does not matter . . . how big your economy might be or how fast it is growing or how heavy a role the state plays."

China has several numbers that don't add up. One of the main reasons is that China's state capitalism temporally increases economic growth, only to have it subsequently crash. It is the same system used by Japan and South Korea, and both countries faced an economic crisis using it—Japan in the early 1990s and South Korean in 1997–1998. The main problem is that prices cannot be fixed indefinitely. China is indulging in the same excesses as Japan and South Korea. Currently, China has a level of investment of nearly 50 percent of GDP, although the country is not yet done with the process of urbanization and industrialization. China needs to invest more in infrastructure and increase consumption; at the same time, the country needs to reduce fixed investment and net exports as a share of GDP. Moreover, China's real estate market is overbuilding, both literally and figuratively. (Consider the real estate agent who offered a free BMW to anyone willing to buy a luxury apartment, and this at a time when there is not nearly enough housing for low-income families.) Another weakness is that the majority of the investment is financed through loans. As a consequence, debt levels are rising rapidly. According to Fitch, the rating agency, bank credit in China in 2011 was about 185 percent of the country's GDP, an increase of 56 percent in three years. Daniels believes that if the Chinese government redirects the

economy, it could prevent a collapse. The problem is that the government is not doing anything fast enough, mainly because it is fearful of an economic slowdown or a reduction in growth. Overall, China's government is not setting prices correctly, which leads to investors' acting based on the wrong price signals (Daniels 2012).

CHAPTER 30
Will the World Economy Falter in the Next Decade?

Some experts assert that in the near future there will be a shift in economic power from the developed economies of the world to the emerging economies. This shift is predicted to occur as a result of both the global financial crisis and the ability of the emerging economies to take advantage of the opportunities it presents (Salomon 2011).

China, India, and other emerging markets like Latin America and Africa are catching up to the developed world at a faster pace than anticipated. Experts project that if emerging markets keep growing at a pace of 3 percent per year faster than the United States, by 2030 they will produce two-thirds of the world's output. In 2011, the four leading emerging nations in this regard—China, India, Indonesia, and Brazil—contributed two-fifths of global GDP, measured at purchasing-power parity (PPP); while the combined contribution of the United States and the European Union fell to less than a quarter. Such shifts in economic power are normal among nations. That they will occur sooner rather than later, however, is uncertain because the emerging economies will also face economic challenges over the next decade or two. The fact is that it is easy for emerging economies to grow to certain level, but difficult to surpass developed economies (Salomon 2011). In order to have access to markets, basic resources, and advanced technologies, emerging nations are buying firms in developed nations. The main developed markets of these emerging economies are the United States, Britain, Canada, and Australia. Often, emerging economies try to avoid their fragile home markets. Instead they prefer the slow but sure investment climate of the developed economies because the regulations, tax laws, and

courts are more flexible. In addition, a corporate presence in developed economies allows greater access to financing (Salomon 2011).

According to John O'Sullivan, "The IMF forecasts that emerging economies, as a whole, will grow by around 4 percentage points more than the rich world during 2011 and 2012." This means that by 2013 emerging markets will produce more than half of global output, measured at PPP. One of the reasons behind such predictions is that investors expect a collapse in the developed economies, while they are confident about the emerging ones. Investors base such views on the fact that the developed nations are saddled with debt (both governmental and personal) and outdated financial laws, while the emerging economies have populations that are saving and modernized financial laws (O'Sullivan 2011).

The rise of emerging nations is not a new phenomenon. During the 1700s, the world's biggest economy (and leader in cotton production) was India, followed by China. In part, this was a function of the large populations of these two countries, population being one of the key factors of production. Britain's economy doubled in size in thirty-two years during the mid-1800s. During approximately the same period (the 1870s), the U.S. economy doubled in seventeen years. In recent years, both China and India have doubled their economies in less than a decade (O'Sullivan 2011).

The truth is that developed nations fear direct competition for (among other things) geopolitical supremacy, oil and raw materials, currency values, and military power. In addition, they have a well-founded concern about losing jobs to lower-cost suppliers in the emerging nations of the world. For their part, emerging nations fear a slowdown in the world economy. That would mean less demand from the developed economies and hence lower exports. This would force emerging nations to rely on their own internal markets, which would not be as profitable. Such economic conditions would also

increase the risk of overspending (both consumer or government), overuse of credit, and inflation. To summarize then, emerging nations are threatened by sudden economic slowdowns, and experts agree that they have a minimal chance of sustaining rapid growth long term. Developed nations, on the other hand, must deal with economic decline, as experts agree that "no country (or group of countries) . . . stays on top forever" (O'Sullivan 2011). There is a shift coming then in economic power, but it will not occur rapidly because nations worldwide are suffering the consequences of two economic crises—first the one in the United States and more recently the one in the euro zone. The economist Nouriel Roubini, who predicted the financial crisis of 2008, now forecasts a decade of global economic struggles. Roubini agrees with the IMF that the U.S. economy is weakening, that "it will grow by 1.7 to1.8 percent during 2012, [and that] unemployment will remain high." What is more, he believes that the country's inability to manage its fiscal problems is creating uncertainty elsewhere, particularly in the euro zone and the Middle East. The European Union must, in his view, develop a specific and effective plan to control the spread of its debt crisis and restore trust in the euro. The possibility of a conflict with Iran that involves Israel and/or the United States is even more troubling. In Roubini's opinion, it could cause oil prices to rise to $150 per barrel and might even trigger a global recession (MSNBC 2012).

Roubini does not lay all of the blame on the United States, however. He believes that China is also contributing to the uncertainty by virtue of its unbalanced growth. He considers an economy that mainly depends on exports, fixed investments, and high savings with minimal consumption to be unsustainable. Finally and more broadly, he cites unemployment and economic insecurity as well as greater inequality between rich and poor as general conditions contributing to a global crisis (MSNBC 2012).

What Roubini is describing is overall financial fragility. He states, "There is a huge amount of uncertainty—macro, financial, fiscal, sovereign, banking, regulatory, taxation, geopolitical, political, and policy." The fragility of the developed economies will, in his opinion, bring a recovery that is "U-shaped . . . rather than a V-shaped," lasting between three to five years as a result of high debt levels. Indeed, the recovery process might take up to ten years, during which time the global economy would continue to suffer. To lessen the possibility of such a protracted recovery, Roubini suggests, among other things, that investments need to be redirected from less productive sectors such as real estate to more productive ones such as human capital, structure, technology, and innovation (MSNBC 2012).

CHAPTER 31
Is the United States Committing Superpower Suicide?

David Ignatius, an opinion writer for the *Washington Post,* recently addressed the issue of declining American power. Ignatius believes that until now the issue has been largely the province of scholars, but that it should be at the forefront of presidential debates. He would like to hear presidential candidates discuss questions like these: Is America's position in the world eroding? If so, can the United States bounce back, and what is the right recovery strategy? Or will the liberal international order we've known since 1945 give way to something different and disorderly, no matter what we do? Three writers with different opinions have suggested some answers.

Robert Kagan of the Brookings Institution believes that the United States is just as strong as it has ever been; however, other experts disagree. They doubt that the United States has the resources to secure its power in future conflicts. Kagan asserts that the United States is fully capable of doing so, although he recognizes that there is an imminent threat from the growing power of China. Those who doubt U.S. capabilities, he asserts, have an idealized notion of a United States that did whatever it pleased. That, Kagan believes, is a United States that never existed (Amanpour and others 2012).

Kagan believes that a good alternative to U.S. leadership does not exist; that if the United States agrees to the demands from developing economies—specifically, China—it would be predisposing itself to superpower suicide. Furthermore, Kagan states that things would be far worse if the United States were to lose its superpower status, because "the liberal order cannot survive without U.S. power, hard and soft." The end of American superpower would have a domino effect on other nations, causing a decline in the world order. Kagan believes that the United States would be replaced by another form of order, with different ideologies reflecting those powers' interests, or it might just be a total chaos.

John Ikenberry, from Princeton, believes that there is an excess of fear and uncertainty, when in fact the global order is more stable than others think. According to Ikenberry, the strength of the United States derives from the network of institutions it helped to create after the end of World War

218

II—the United Nations, the World Bank, and NATO, to name a few. He firmly believes that the United States is strong because it can count on the support of all these institutions throughout the world that reflect the values of capitalism and democracy. Ikenberry concludes by stating that regardless of the challenges the United States faces, it will remain a superpower. His only caveat is that the country must maintain its network of alliances and partnerships.

Charles Kupchan, from Georgetown University, believes that the world is already facing a "global turn" and that this will benefit the United States and the Western world; however, what the Western world visualizes for the future differs from what China, Iran, Turkey, and Russia envision. "The world," he explains, "is barreling toward not just multipolarity, but also multiple versions of modernity." He notes that even if democracy is adopted, each place will adapt it to fulfill its own interests. He concludes that the best strategy to deal with this is for each nation to focus on its own economic and political strengths.

Ignatius believes that the Obama administration is following the path described by Kupchan, that the administration aims to adapt American power to an evolving world rather than to rebuild the nation's original primacy. Ignatius cites the administration's expressed need for a multipolar world, even as it has considered exercising unilateral power (Ignatius 2012). Other analysts believe that the world is moving into a post-American era. Whether it is or not, according to Fareed Zakaria, depends on how the United States manages some key factors that determine economic and social success. In the twenty-first century, two of the most important of these are *innovation* and *energy*. The superpower nation must be able to renew ideas constantly in conjunction with more effective production and energy usage techniques.

China, for example, has the factors necessary to be successful in the twentieth century (i.e., cheap labor and a large amount of capital); and succeed it has, as factory to the world. However, the country is not known for being a generator of new ideas, and it struggles with energy issues, both factors deemed essential to twenty-first-century success. But China is showing improvement. It has become a leader in clean technology (i.e., solar and wind) and is targeting higher education and looking to develop research labs.

On the other hand, the United States has all the elements to continue to be a superpower in the twenty-first century. It has innovative and research-oriented companies, a stable university system, a dynamic capital market, and a flexible and diverse society. What it lacks is a political system that can control, organize, and implement all of these elements. American still lacks an effective energy policy, an immigration policy, an economic policy focused on growth and jobs, and a budget-deficit policy. Why? Because American political parties are busy focusing on their own interests rather than the country's, and *that* is the factor most likely to make this century the post-American era (Zakaria 2011).

Vahab Aghai, Ph.D

PART 7 The Future

CHAPTER 32

Is China an Emerging Superpower?

China is an emerging superpower in every sense of the word. The country is already considered a regional power in Asia, and its global influence is growing through its economic ties to Africa, Latin America, and Europe.

Some experts believe that a true global power must exercise both economic and military power worldwide. Lawrece Saenz, a senior lecturer at the School of Oriental and African Studies in London, asserts that China will be a superpower when it takes over Taiwan. According to Saenz, at present China would lose in a war with the United States, but within twenty years that will not be the case. Alexander Neill, a senior Asia research fellow at the Royal United Services Institute (RUSI), says that China will be a superpower when militarily it can challenge the United States and has the ability to deploy worldwide in defense of its interests. However, according to Gen. Chen Bingde, a military leader, his country does not have the intention to become a military superpower; and China's defense minister, Gen. Liang Guanglie, has stated that "to judge whether a country is a threat to world peace, the key is not to look at how strong its economy or military is, but the policy it pursues." Some experts find statements like the last two to be incongruous because they are not in accord with the facts on the ground. For example, in 2010 the Chinese government set its defense spending at about $80 billion; the U.S. Defense Department estimated that the total was nearly double that amount, or about $150 billion. In addition, in 2011 there were military projects ongoing, such as the construction of China's first aircraft carrier and the possession of a latest-generation fighter (the J-20) that has the radar-evading capability of a fifth-generation fighter like the F-22 or the

F-35. The J-20 is expected to be operational by 2017; however, China can deploy it earlier by making some modifications, if they wish.

To be a superpower, a nation needs both military and economic power. China is already an economic superpower according to Saenz and, taking into consideration that many experts estimate that China's economy will surpass that of the United States by 2021, everything indicates that China is not far from becoming a superpower. According to Yao Yang, director of the China Center for Economic Reform at Peking University, if the two economies grow—China by 8 percent and the United States by 3 percent in real terms, China with an inflation rate of 3.6 percent and U.S. with 2 percent—and the renminbi's value increases against the dollar by 3 percent per year, then China would be the largest economy by 2021 (Shaikh 2011).

A nation's technological achievements say something about its superpower status, and according to Jack Schoefield, China will dominate that field as well for many years to come. Being the second-largest economy, China is already sending signals of its long-term plans: the $40 billion Beijing Olympics, the $45 billion Shanghai Expo, and the country's first astronaut in the space. Now China is focused on the development of its infrastructure. It has already built the three Gorges Dam, relocating 1.24 million people. Future plans call for building fifty new airports by 2016 (one of them a mega-construction about the size of Bermuda), the 128-storey Shanghai Tower (which would be the world's second-tallest building), the world's biggest wind farm; the world's longest cross-sea bridge, and the fastest railway, running at 280 miles per hour.

China has no shortage of population. According to the 2010 census, its population grew to 1.34 billion, surpassing the United States by 1 billion. In addition, China's GDP has been growing for the last three decades at an average of 10 percent a year, except for 2009 when it slipped to 9.2 percent.

During this same period, the United States and Europe reported declines. According to Jin Liqun, chairman of the China Investment Corporation, the Western world's problems are the result of a welfare society.

In present day China, the Communist Party is combining ultra-capitalist economics with authoritarian politics in an effort to raise living standards for the population as a whole. Furthermore, China's twelfth five-year plan (2011-2015) is now shifting from production to consumption. Indeed, the Chinese will soon be the world's major consumers. They already constitute the biggest market for PCs, phones, and cars and are the largest number of Internet users.

To be more successful commercially, however, China will need to develop and manufacture its own world-class products. The country is facing an increase in production costs. China has the third-highest labor costs among the emerging nations of Asia. This has produced some emigration of corporations to cheaper places, such as Vietnam, Cambodia, and Laos; however, China's upgrading of its infrastructure and technology, combined with its promising local market and growing middle class, are reasons enough for most manufacturers to stay put. Some experts believe that three out of five Chinese technology companies will develop global brands over the next five years. Lenovo, which took over IBM, is a case in point. Still, China faces some serious obstacles. Its population growth is slowing (as planned) to 7 or 8 percent per year, and wages are increasing faster than GDP. In addition, the collapse of the Euro or other global financial crises could affect China's economy because it depends so heavily on exports. (Schofield 2012).

Other experts believe that China will become a superpower in the not-too-distant future. They foresee two possible routes, or scenarios, leading to this eventuality:

1. Trans-Pacific Alliance. China has become the largest economy in the world, due to a close trans-Pacific alliance with the US. Its wealth is mainly derived from their cheap consumer goods that are mainly sold to the United States and the Far East; but the price for its wealth is high. Chinese CO_2 emissions are now higher than the emissions of all other nations combined. Per capita emissions have soared even above the levels of the United States. As droughts, floods, and food shortages increasingly ravage the planet, billions of people perceive Beijing as the main culprit behind climate change. More than 100 nations, including the EU, have formed an official alliance against "Chimerica," as the two superpowers threaten to destroy the biosphere. There are warnings of an impending "climate war."

2. Eurasian Alliance. China has become the largest economy in the world, due to a close Eurasian partnership with the EU and India. The People's Republic mainly generates its wealth by developing and exporting green technologies. In collaboration with the EU, Beijing has put in place rules against excessive indebtedness, which apply both to financial and "ecological" debts. The cost to the environment is now integrated into how Eurasian nations calculate their gross domestic products. CO_2 emissions are beginning to decline around the world, except in the United States. The former superpower is culturally incapable of modernizing itself ecologically and is losing its power due to its addiction to cheap oil. Eurasia has become the new superpower, with China as the dominant force (SPIEGELnet GmbH 2011).

The first route, a trans-Pacific alliance with the United States, is the faster. It would bring new coal-fired power plants, larger automobiles, and a construction boom, leaving behind energy efficiency; in other words, China

would adopt the traditional American way of life. As just one consequence, this route would likely bring climate changes that could threaten China's and America's food security. The Eurasian alliance, on the other hand, would benefit both sides because both are already massively investing in renewable energy, public transportation, and cars powered by eco-electricity. However, it would mean that growth would not proceed on the fast track (SPIEGELnet GmbH 2011).

China already has some of the key qualifications to become a superpower. It is influential in shaping foreign policy, mainly through the UN. In 2011, China announced its interest in becoming part of a legally binding global agreement limiting CO_2 emissions. It also has growing military power and a strong presence abroad (in Africa, for example). China has even offered to help with the European Union financial crisis. Whichever route China chooses to become a superpower, clearly the first steps have been taken.

CHAPTER 33
China: Powerhouse of the World Economy?

China's economy has grown enormously over the last thirty-three years, and everything indicates that that growth will continue. Today China's is the second-largest economy in the world and in the near future will likely replace the United States as the largest. It is an economic powerhouse and, as such, an object of interest to the global community.

China's economic growth is not a coincidence or a matter of luck, but rather the result of the country's having two kinds of financial institutions—formal and informal. The formal sector includes banks and similar financial institutions. It is heavily regulated by government and used as an instrument of government policy. The main policy purpose served is to act as the key player in trade, exchange-rate, and inflation-fighting strategies. The informal sector of financial institutions includes credit clubs, curb markets, and extended families. These function without government regulation and deliver credit to the emerging parts of the economy. This kind of dual financial system is common in Asian countries (Rohwer 1996).

According to Jim Rohwer (1996), "One of the major mistakes committed by the poor economies, specifically Africa and Latin America, is to keep their exchange rates overvalued against major economies, especially the U.S. dollar. This practice discourages the developing country's manufacturers from exporting and diminishes the important price signals, and marketing and technological information offered by the world market. East Asia's countries did the opposite; they strived to keep their exchange rates slightly undervalued against the dollar as a way of promoting exports and economic growth."

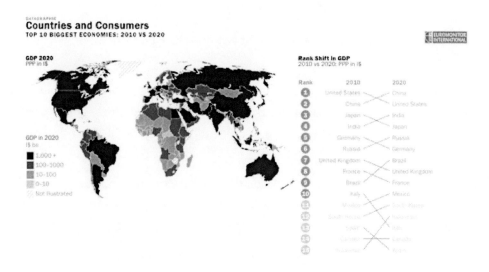

China's rapid and steady economic growth since 1979 suggests that the country has had a well-planned strategy to continue its economic success regardless of the state of the global economy. Certainly for the last decade, everything has indicated that China would soon be the economic powerhouse of the world. Indeed Gallup, Inc., reported that even Americans named China as the world's coming economic powerhouse, based on the consistent economic growth of that country and the economic crisis facing the United States in February 2008 (Saad 2009). By 2010, with the American economy stagnating, some financial experts believed that China could achieve powerhouse status within a year.

When China attains that status also depends on how it is measured. In purely dollar terms, for example, it would take China about another ten years to surpass U.S. output. In terms of the global economy, China could account for almost 25 percent by 2020 (Gardner 2010). Based on IMF statistics, the Chinese economy is expected to grow to $19 trillion by 2016, while the U.S. economy is expected to reach $18.8 trillion (Finance Twitter 2011). At that

point, the IMF predictions indicate that the United States would account for 15 percent of the world economy and Western Europe, 13 percent. Economist Bart van Ark has stated that only inflation or asset bubbles could slow down China's rapidly growing economy. Few projections push China's ascendancy to economic leadership in the world out past 2025 or 2030.

Certainly China is already a trading powerhouse, a nation that has modified regulations to adapt to international norms, created millions of jobs for other economies, and opened up hundreds of different areas of the service sector. In addition, foreign companies have benefited from doing business in China for a decade. Nearly 350,000 foreign-funded companies have been established in the country, generating profits of $261.7 billion. Furthermore, Chinese imports have saved American and European consumers thousands of dollars (Xinhua 2011).

An economy, however, is like a roller coaster; and China's economy is now facing some obstacles. During the third quarter of 2011, it decelerated to its weakest pace in more than two years. This made it more vulnerable to a severe decline should the euro zone debt crisis worsen or the U.S. economy slip back into recession. Because of a reduction in global demand, the first three quarters of 2011 saw a decline in Chinese exports (although September showed some recovery). According to the spokesman at the National Bureau of Statistics, Sheng Laiyun, this was just a minor reduction in economic growth. The Chinese economy was still stable and would continue to grow fast (Reuters 2011).

Despite the conclusions of Sheng Laiyun, indications are that China is facing some real issues with its economy. According to HSBC Index reports, the Chinese Purchasing Managers' Index for November 2011 dropped from 51 to 48.1. In addition, there was a decline in the factory sector caused by weakness in domestic consumption. In October 2011, inflation declined,

real estate prices collapsed, and car sales fell. The reaction was swift: the People's Bank of China (PBOC), which is the country's central bank, cut its required reserve ratio for twenty cooperative banks to 16 percent. China's fast-growing economy had hit a bump in the road.

Experts believe that this time China will have difficulty creating growth during a period of external crisis because conditions have changed. In the past, demand from developed countries was strong. Now European demand has declined, and American consumers, the usual engine of global growth, are not spending as before. Therefore, exports will not be a strong contributor to the Chinese economy.

China does not have many options to stabilize its economy. Since interest rates on bank deposits are below the inflation level, the central bank cannot lower benchmark rates without triggering an outflow of deposits from commercial banks. Reserve requirements cannot be reduced because commercial banks already have high levels of questionable loans on their books, a result of government decontrol of lending practices. China could use a portion of its $3.2 trillion of foreign reserves to recapitalize the banks, but this would increase the risk of insolvency for the central bank. Furthermore, China's money supply has already been expanded to enormous levels. "China's M2, which is a key economic indicator used to forecast inflation, was 34 percent larger than America's by the end of October 2011. Today's high rates of inflation are the result of the rapid increase of China's money supply over the last three years. The Bureau of National Statistics indicated that the real level of inflation is more than twice the official figure" (Chang 2011).

The only real option that China has is to buy GDP growth with direct spending or "tidal wave investing," but with several unviable projects, China has very limited ways to stimulate investors to invest. Analysts believe that China will employ the strategies used by Japan. Those strategies produced

recession and recession-like stagnation in Japan; but analysts believe that China is different, that the same strategies could generate decades of growth in that country.

China has a debt-to-GDP ratio of about 89 percent. Experts have concluded that the Chinese economy has reached its limits (Chang 2011).

Kirk Elliott, an economist, discussed the future of China as part of a webinar for World Net Daily. Elliott stated that China could be facing "an economic tsunami" in the near future. His predictions were based on the following factors: <list>

· *Debt.* China's debt is about $36 trillion yuan (or US$5.68 trillion). This is only about one-third of the total U.S. debt. What makes China's total more problematic is an underlying difference: U.S. per capita national income is $47,140; the comparable figure for China's is $4,260, less than one-tenth of the U.S. amount. In order to be at the same level, China's total debt should be about US$1.5 trillion.

· *Inflation.* China's official inflation rate is 6.2 percent, which is much lower than the unofficial and far more accurate rate of 16 percent. (By comparison, the official U.S. rate of inflation is 3 percent, with an unofficial figure of between 10 and 13 percent.) Double-digit inflation increases the cost of living, pressure for higher wages, and ultimately the prices of exported goods. In addition, central banks around the world are printing money on a massive scale in an effort to stimulate liquidity and spending. All of this suggests that the world could be in the first stages of an inflationary cycle of unprecedented proportions—global hyperinflation.

· *Excess capacity.* In China, the excess capacity in the economy and private consumption is only 30 percent of economic activity. That means that China's population cannot consume the excess capacity. Excess capacity is an indicator of a global economic slowdown. A global recession would

definitely affect the Chinese economy, because it depends so heavily on the world's demand for goods.

· *Taxes.* Chinese taxes on business, direct or indirect, are 70 percent of earnings. The individual tax rate is 81.6 percent. According to Elliott, a country cannot remain strong or viable with such high tax rates.
</list>

Elliott believes that the Chinese population will eventually revolt in protest and concluded with the following statement: "There is an economic tsunami about to engulf China, and because of the size of China's economy and its manufacturing might, the impact of the tsunami will be felt far and wide. The United States will feel it in the form of inflationary pressures that it cannot afford right now. Periphery countries to China may feel its military might or cower to political pressure as governments that run out of money start to do irrational things (look at the United States, or Greece, or the European Union)" (Elliott 2011).

Elliott's point of view is valid. Taking into consideration the latest reports, it seems that China has become *an* economic powerhouse, but it will take more than a couple of years for it to become *the* world's economic powerhouse.

CHAPTER 34
Other BRICS Economies

Brazil

The Federative Republic of Brazil is located on the easternmost portion of the South American continent. Its Atlantic Ocean coastline measures 7,491 kilometers. The country shares borders with Argentina, Bolivia, Colombia, French Guiana, Guyana, Paraguay, Peru, Suriname, Uruguay, and Venezuela. Brazil is the largest country in South America, covering an area of 8,514,877 square kilometers. Its terrain is mostly flat to rolling lowlands in the north; the rest of the country consists of some plains, hills, mountains, and a narrow coastal belt (CIA 2012).

Brazil is rich in natural resources. These include bauxite, gold, iron ore, manganese, nickel, phosphates, platinum, tin, rare earth elements, uranium, petroleum, hydropower, and timber. Only 6.3 percent of its land is arable, and only 0.89 percent is utilized for permanent crops; 92.18 percent is put to other uses (CIA 2012).

Brazil's weather is mostly tropical, although it is temperate in the south. Recurring droughts in the northeast and floods and occasional frost in the south are the main natural hazards. Brazil faces a number of significant environmental issues: deforestation in the Amazon Basin, illegal wildlife trade, air and water pollution in several large cities, land degradation and water pollution caused by improper mining, wetland degradation, and severe oil spills (CIA 2012).

Society and Government

Brazil has an estimated population of 203,429,773. Its society is mainly

composed of three ethnic groups: white (53.7 percent), mulatto (38.5 percent), and black (6.2 percent). Sixty-seven percent of the population is between the ages of 15 and 64, with a total median age of 29.3 years. The population growth rate is 1.13 percent per year. The birth rate is 17.79 per thousand; the death rate, 6.36 per thousand. Life expectancy at birth for the total population is 72.53 years. The total fertility rate is 2.18 children born per woman (CIA 2012).

Eighty-seven percent of Brazil's population is considered urban. The net migration rate is -0.09 migrants per thousand of population (CIA 2012). Nearly 89 percent of the population is literate. Predominant religions in Brazil are Roman Catholic (73.6 percent), Protestant (15.4 percent), and spiritualist (1.3 percent) (CIA 2012). In 2009, the country spent 9 percent of GDP on health services; and in 2007, it spent 5.08 percent of GDP on education.

Once a colony of Portugal, Brazil obtained its independence on September 7, 1822. Today the country has a federal republic type of government, with its capital at Brazilia and Portuguese as its official language. Brazil's current constitution entered into effect on October 5, 1988. The country has a civil law legal system (the civil law code of 2002 replaced the 1916 code). For administrative purposes, Brazil is divided into twenty-six states and one federal district.

Brazil's government has executive, legislative, and judicial branches. The executive branch consists of the chief of state (president), the head of government (vice president), and the cabinet, which is appointed by the president. The president and vice president are elected by popular vote for a single four-year term. The legislative branch, or National Congress, consists of the Federal Senate, with 81 seats (i.e., 3 members from each state and federal district) and the Chamber of Deputies, with 513 seats (elected by

proportional representation). The judicial branch consists of the Supreme Federal Tribunal, with 11 ministers appointed for life by the president and confirmed by the Senate; the Higher Tribunal of Justice; and the Regional Federal Tribunals, with judges appointed for life. All federal employees, including judges, have a mandatory retirement age of 70.

Brazil has many political parties. Among them are the Brazilian Democratic Movement Party (PMDB), the Brazilian Labor Party (PTB), the Brazilian Renewal Labor Party (PRTB), the Brazilian Republican Party (PRB), the Brazilian Social Democracy Party (PSDB), the Brazilian Socialist Party (PSB), the Communist Party of Brazil (PCdoB), and the Party of the Republic (PR). Labor unions and federations, large farmers' associations, and religious groups are organizations that exercise political pressure (CIA 2012).

Brazil's international standing is not only related to its growing economy, but also to its involvement in environmental and human rights agencies. Such activities have made it one of the major candidates for a permanent seat on the UN Security Council (Barbosa 2011).

Brazil is member of the following international organizations: Community of Latin American and Caribbean States (CELAC), Community of Portuguese Language Countries (CPLC), Group of 15 (G-15), Inter-American Defense Board (IADB), International Atomic Energy Agency (IAEA), International Bank for Reconstruction and Development (IBRD), International Criminal Police Organization (Interpol), Organization of American States (OAS), United Nations (UN), World Trade Organization (WTO) and many others (CIA 2011).

Economy

Brazil has long been considered a developing economy. However, over

the last decade, the country has transformed itself into a fast-growing economy. That change has been attributed to successful privatization programs, economic stability, and a strong banking system—all, according to some, the work of two presidential administrations, those of Fernando Henrique Cardoso (1995–2003) and Luiz Inacio Lula da Silva (2003–2010). It was they who maintained the economic policies—the fiscal austerity, inflation targets, and a fluctuating exchange rate—that resulted in an increase in foreign investment and economic growth and a decrease in inflation (Barbosa 2011).

Brazil has a labor force of 104.7 million (2011 est.). The country's 2011 unemployment rate was estimated to be 6.1 percent. In 2009, 26 percent of the population lived below the poverty line (CIA 2012).

Economically, Brazil surpasses all other South American countries. Its large and well-developed agricultural, mining, manufacturing, and service sectors are the main reason for the steady improvement of its economy, which has expanded into world markets (Economy Watch 2010).

Brazil is one of the BRICS countries (i.e., Brazil, Russia, India, China, and South Africa). The BRICS group has greatly benefited Brazil by facilitating access to information and techniques to cope with endemic problems and issues of international scope. As a group, for example, they are implementing programs that improve the lives of poorer people. With their help, Brazil has invested in education and provided wages set above inflation levels. These changes have made it possible for 40 million Brazilians to move from the lower class to the middle class, making the middle class about 50 percent of Brazil's total population (Barbosa 2011).

The year 2003 marked a new beginning for Brazil's economy. The

government began to work on gradually improving the country's macroeconomic solidity by building up its foreign reserves, reducing its debt profile by shifting its debt burden toward real denominated and domestically held instruments, adhering to an inflation target, and committing to fiscal responsibility (Wolbers 2010). In addition, the domestic market was expanded to increase consumer lending (Barbosa 2011). In 2008, as proof of its progress, Brazil became a net external creditor, and two ratings agencies awarded investment-grade status to its debt.

In 2007 and for the first eight months of 2008, Brazil reported record growth. However, by September 2008, the global economic crisis began to impact the country. Its economy experienced two quarters of recession as a result of reduced global demand for commodity-based exports and its external credit burden (Economy Watch 2010).

Brazil's real growth rate for 2011 was estimated to be 2.8 percent as a whole; while its GDP per capita (PPP) was $11,800. In terms of GDP, 5.5 percent was in agriculture, 27.5 percent was in industry, and 67 percent was in services. Gross fixed investment was about 19 percent of GDP, with budget revenues of $1.01 trillion and expenditures of $901.6 billion. In addition, taxes and other revenues constituted 39.9 percent of GDP. Brazil had a budget surplus of 3.1 percent of GDP, a public debt of 54.2 percent of GDP, and an inflation rate of 6.6 percent of GDP. Its stock of narrow money was estimated to be $152.1 billion; its stock of broad money, $1.87 trillion; and its stock of domestic credit, about $2.24 trillion. In 2011, its at-home stock of direct foreign investment was estimated to be about $539.2 billion; its abroad stock, about $171.7 billion (CIA 2012).

Brazil's major agricultural products are coffee, soybeans, wheat, rice,

corn, sugarcane, cocoa, citrus, and beef. Its main industrial products are textiles, shoes, chemicals, cement, lumber, iron ore, tin, steel, aircraft, and motor vehicles and parts, in addition to other machinery and equipment. It is estimated that its industrial production growth rate for 2011 was 4 percent.

Brazil produces oil, natural gas, and electricity, mostly for its own consumption. In 2009, for example, Brazil exported about 1.08 billion kilowatt-hours of electricity, but it imported 39.67 billion. In that same year, estimates indicated that Brazil produced 2.75 million barrels of oil per day and consumed 2.65 million. It exported 699,000 barrels of oil per day, and imported 720,000 barrels. In 2010, Brazil consumed 25.13 billion cubic meters of natural gas. Of that amount, it produced 12.41 billion cubic meters and imported 12.72 billion cubic meters. It did not export any natural gas. Estimates at the beginning of 2011 showed proven reserves of natural gas amounting to 366.4 billion cubic meters.

Brazil's main export commodities are transport equipment, iron ore, soybeans, footwear, coffee, and automobiles. In 2011, Brazil's major export partners were China with 17.3 percent, the United States with 10.1 percent, Argentina with 8.9 percent, the Netherlands with 5.3 percent, and Germany with 4 percent. The value of Brazil's exports was estimated to be $250.6 billion.

Brazil's main imported products were machinery, electrical and transport equipment, chemical products, oil, automotive parts, and electronics. In 2011, Brazil's main import partners were the United States with 15 percent, China with 14.5 percent, Argentina with 7.5 percent, Germany with 6.7 percent, and South Korea with 4.5 percent. The value of Brazil's imports was estimated to be $226.2 billion.

Brazil has a current account balance of about -\$52.48 billion (CIA 2012).

From 1996 through 2012, Brazil's average quarterly GDP growth rate was 0.76 percent, with a record high of 4.2 at the end of the third quarter of 1996 and a record low of –4.2 at the end of the fourth quarter of 2008. There is no doubt that Brazil is one of the fastest-growing developing economies in the world (Trading Economics 2012). Perhaps the most impressive evidence supporting this view is the fact that over the last ten years, Brazil has been able to move 10 million of its people out of extreme poverty (Barbosa 2011). More recently, it was one of the first developing markets to recover from the global recession. By 2010, as a reflection of the confidence of consumers and investors, Brazil reported a GDP growth of 7.5 percent, the highest since 1986 (Trading Economics 2011).

In 2011, however, Brazil's growth began to slow, the result of a faltering industrial sector and a rapidly strengthening currency. In response, the government raised taxes on some foreign investments, due to large capital inflows, and increased foreign investments (Trading Economics 2011). Brazil was also likely feeling the effects of Europe's debt crisis. The fourth quarter of 2011 showed no growth; so the government took further steps to revive the economy. It cut taxes, reduced interest rates, and loosened loan requirements. By October 2011, the growth in bank lending had dropped off drastically (Trading Economics 2011).

By November 2011, Brazil's international reserves exceeded \$350 billion, which was sufficient to protect the country's economy from an economic crisis like the one in 2008 or the current one in Europe. Its foreign trade had increased as well, reaching a half trillion dollars

in 2011, thanks to China, its principal economic partner, and greater international demand in general for its exports. It was estimated that Brazil's GDP (PPP) for 2011 would be $2.28 trillion, with an official exchange rate (GDP) of $2.52 trillion (Trading Economics 2011). The country, which back in 2010 was considered the seventh-largest economy in the world in terms of economic output, seemed poised to displace the United Kingdom as the sixth largest (Barbosa 2011).

Despite its great success, however, Brazil faces challenges in the near future. In order to maintain its economic policies, experts recommend that the Brazilian Congress approve structural reforms in the areas of taxes, social security, labor relations, and politics. Overall these changes would reduce high investment costs (such as interest rates, currency values, and energy costs) and increase infrastructure. They would also promote Brazil's taking a major international role in aiding poorer countries (Barbosa 2011).

In January 2012, Brazil's president Dilma Rousseff restated his government's intention to reach at least 4 percent economic growth by year's end (by comparison, the United Nations expects about 2.7 percent GDP growth). Experts indicate that given even the most favorable conditions, such growth seems unlikely, if not impossible. Rousseff declared that the government would implement tax incentives for manufacturers struggling with high costs and an overvalued currency. In addition, he requested that the largest publicly owned bank implement new programs to stimulate consumer consumption by using credit cards or reducing interest rates.

Such practices are the stuff of real estate bubbles and injudicious lending. The truth is that industrial production has slowed in the last three years as a result of overvalued currencies, high taxes, and other

costs. They will transform Brazil from a paradise for new businesses to a place to avoid. If export prices stagnate or decline in the coming year, experts indicate that the only resort for Brazil's economy will be consumer demand.

Thus far, however, indications are that Brazilians are not taking the bait. They are not taking out loans; instead they are spending less and paying off their debts. If they stick to their own sound economic principles, there is little risk of a credit bubble. The first six months of 2012 are crucial, however, because that is when Europe's crisis is expected to be at its worst (The Daily Herald 2012).

Russia

The Russian Federation is the largest country in the world. Russia is located in northern Asia and borders the Artic Ocean from Europe to the northernmost portions of the Pacific Ocean. The country covers a total land area of 17,098,242 square kilometers. It shares borders with Azerbaijan, Belarus, China, Estonia, Finland, Georgia, Kazakhstan, North Korea, Latvia, Lithuania, Mongolia, Norway, Poland, and Ukraine. Russia has a coastline of 37,653 kilometers.

Russia's climate varies from temperate and semiarid in the southern steppes to humid and cold in European Russia to subartic in Siberia. Winters range from cool along the Black Sea to freezing in Siberia, while summers vary from warm in the steppes to cool along the artic coast.

Russia's terrain ranges from plains with low hills west of the Ural Mountains, forest and tundra in Siberia, and uplands and mountains along southern border regions. Russia's natural resources are extensive and include oil, natural gas, coal, strategic minerals, reserves of rare earth elements, and timber.

Despite its large territory, only 7.17 percent of Russia's land is arable

and permanent crops cover only 0.11 percent of the total. The permafrost covering extensive areas in Siberia is a major barrier to development. In addition, the country faces a number of environmental challenges, including air pollution from heavy industry; emissions from coal-fired electric plants and transportation in major cities; industrial, municipal, and agricultural pollution of inland waterways and seacoasts; deforestation; soil erosion; soil contamination; areas of intense radioactive contamination; and groundwater contamination from toxic waste, urban solid waste management, and abandoned stocks of obsolete pesticides.

Russia is party to a number of international environmental agreements, including those dealing with air pollution, climate change, biodiversity, and the Antarctic. The country does not have access to major sea-lanes. It also lacks proper soil and climate for agriculture (CIA 2012).

Society

It is estimated that by July 2012 Russia will have a population of 138,082,178, with a population growth rate of -0.48 percent and a birth rate of 10.94 births per 1,000 of population. The death rate is estimated to be 16.03 deaths per 1,000 of population.

About 71.8 percent of the population is between the ages of 15 and 64; 15.2 percent is 14 or younger; and 13 percent is 65 or older. Total population life expectancy at birth is 66.46 years. The total fertility rate is 1.43 children per woman.

Russia has only 0.29 migrants per every 1,000 of population. Approximately 73 percent of the population is urban.

According to the 2002 census, Russia has several ethnic groups, including Russian (79.8 percent), Tatar (3.8 percent), Ukrainian (2 percent), Bashkir (1.2 percent), Chuvash (1.1 percent), and other (12.1 percent). The predominant religions are Russian Orthodox (15

to 20 percent), Muslim (10 to 15 percent), and Christian (2 percent). The country's official language is Russian.

In 2009, Russia's health expenditures were 5.4 percent of GDP, up from 3.9 percent in 2006. According to the 2002 census, 0.6 percent of the population15 and over is illiterate (CIA 2012).

Government

Russia is a federation with its capital at Moscow. The country is administratively divided into forty-six provinces, twenty-one republics, four autonomous *okrugs* (districts), nine *krays* (territories), and two federal cities.

Russia's independence from the Union of Soviet Socialist Republics (USSR) was attained on August 24, 1991. The constitution was adopted on December 12, 1993. The legal system is based on a civil law model and incorporates judicial review of legislative acts.

There are three branches of government. The executive branch is composed of the chief of state, or president; the head of government, or premier; two first deputy premiers; and five deputy premiers. There is a cabinet composed of the premier, his deputies, and his ministers. All are appointed by the president; the premier is also confirmed by the lower house of the legislature.

The legislative branch is a bicameral federal assembly. It consists of an upper house, the Federation Council, and a lower house, the State Duma. The Federation Council's 166 members are appointed by the top executive and legislative officials in each of the eighty-three administrative units. The Duma's 450 members are elected by proportional representation from Communist Party lists winning at least 7 percent of the vote; members are elected by popular vote.

The judicial branch consists of the Constitutional Court, the Supreme

Court, and the Supreme Arbitration Court. Judges for all courts are appointed for life by the Federation Council on the recommendation of the president (CIA 2012).

Russia is a member of the following international organizations: Arctic Council, Association of Southeast Asian Nations (ASEAN) (dialogue partner), Council of the Baltic Sea States (CBSS), European Organization for Nuclear Research (CERN), Group of 20 (G-20), International Monetary Fund (IMF), International Criminal Police Organization (Interpol), United Nations (UN), and many others (CIA 2011). For some reason, Russia has not been able to join the WTO. Applications have been submitted since 1993 (Autonomous Non-profit Organization 2012).

Economy

Russia's agricultural products are limited to grain, sugar beets, sunflower seeds, vegetables, fruit, beef, and milk. On the other hand, industry has great variety. Mining and extractive enterprises produce coal, oil, gas, chemicals, and metals. A diversity of defense industries produce military equipment, including high-performance aircraft and space vehicles. Machine-building enterprises turn out equipment for various fields including road and rail transportation, agriculture, construction, electrical power generation and transmission, communications, medicine, and scientific research. Consumer industries produce durable goods, textiles, foodstuffs, and handicrafts (CIA 2012).

From 1917 to 1989, Russia's economy was centrally planned, as were the other economies of the USSR. The state controlled most of the investment, production, and consumption in the country (Autonomous Non-profit Organization 2012). Since the collapse of the Soviet Union, however, Russia has become a market-based and globally integrated economy.

In the 1990s, the country enacted economic reforms that privatized most industries, the notable exceptions being energy and defense (CIA 2012). The transition, directed by the Communist Party (Autonomous Non-profit Organization 2012), was not easy and was plagued by many social problems, including crime and corruption.

In 1998 Russia faced a financial crisis rooted in its inability to pay back the foreign debt acquired during the Soviet Union era. In 1996 the government had rescheduled payment of that debt with the assistance of the IMF. But just when the economy had begun to improve, in late 1997, the Central Bank of Russia was forced to defend the ruble against speculative attacks. The effort cost the bank about US$6 billion in foreign exchange reserves. To stabilize the investment environment, the government reformed the tax code, but officials could agree on little else to solve the revenue shortfall. President Boris Yeltsin fired his entire government, and the central bank warned of a looming debt crisis. On August 13, 1998, the Russian stock, bond, and currency markets collapsed. From January to August, the markets lost more than 75 percent of their value. On August 17, the government floated the exchange rate, devalued the ruble, and defaulted on its domestic debt. It froze payment on ruble-denominated debt and declared a ninety-day moratorium on payment by commercial banks to foreign creditors (Chiodo and Owyang 2002).

It took nearly ten years for the country's economy to recover, but recover it did. By the end of 2007, Russia had the fastest-growing economy among the industrialized nations of the world, with an average annual growth rate of 7 percent (Autonomous Non-profit Organization 2012). Russia managed this remarkable turnaround by growing its high-technology sector (CIA 2012); exporting weapons (Russia is in fact the world's major weapons exporter); and developing a domestic social plan to stimulate housing, agriculture,

health care, and education (Autonomous Non-profit Organization 2012). In the process, the country also managed to repay its Soviet Union debt to the Paris Club creditors and the IMF.

Many give credit for the turnaround to Vladimir Putin (2000–2008). Putin was the first Russian president to talk openly about poverty and focus on reducing it as one of the priorities of social policy. In fact, during the eight years of his presidency, Russian incomes grew rapidly. According to the Russian Monitor of the Economic Situation and Public Health (RMEZ), "the average income of the Russian family almost doubled between 2000 and 2006, from 6,807 rubles to 11,425 rubles." Also, for the first time the private sector contributed to the prosperity of the country: about 32.6 percent of families received income from the private sector in 2006 (Fedyukin 2007). In terms of the overall economy, Russia's GDP increased 70 percent. The country paid off nearly all of its foreign sovereign debts and, as of March 2008, had accumulated foreign currency reserves of $402 billion. Its GDP in current dollar amounts rose from $200 billion in 1999 to $1.26 trillion in 2007. According to the World Bank, by 2006 Russia's gross national income (GNI) was $823 billion, with an estimated per capita GNI of $5,780. All of this growth pulled Russia from the twentieth-largest economy in the world to the seventh largest (Ruthland 2008).

The 2008–2009 global economic crisis greatly affected Russia, mainly because of the drop in oil prices that it precipitated. The government's rescue package reached 6.7 percent of GDP. The government expended $200 billion alone in a rescue plan to increase liquidity in the banking sector and to aid Russian firms with foreign debts. To slow the devaluation of ruble, the Central Bank of Russia also spent one-third of its $600 billion in international reserves. The economy did not show signs of recovery until the third quarter of 2009.

In 2010, the inflation rate began to fall. Then in 2011, high oil prices spurred Russian growth and helped to reduce the budget deficit it incurred as a result of the global financial crisis. In the same year, Russia became the world's leading oil producer, surpassing Saudi Arabia (CIA 2012).

Russia is the world's largest exporter of natural gas, nickel, and palladium (Trading Economics 2012). It has the world's largest natural gas reserves (CIA 2012), second-largest coal reserves, and eighth-largest crude oil reserves. Furthermore, it is the third-largest exporter of steel and primary aluminum (CIA 2012).

According to the World Bank, Russia's GDP per capita (PPP) for 2009 was US$18,878, while for 2010 it was US$19,840 (Trading Economics 2012). For 2011, it is estimated that Russia's GDP (PPP) was $2.38 trillion, with an official exchange rate of $1.79 trillion. The real growth rate was about 4.3 percent, with 4.2 percent of GDP being derived from agriculture, 37 percent from industry, and 58.9 percent from services.

It is estimated that in 2011 Russia had 75.41 million people in its labor force. In 2010, 62.7 percent worked in services, 27.5 percent in industry, and 9.8 percent in agriculture (CIA 2012).

Recently, Russia has reported lower unemployment. Over the three years from 2009 to 2011, average annual unemployment fell 1 percent, from 7.7 to 6.7 percent (Trading Economics 2012). The most recent report indicates that the unemployment rate in Russia in January 2012 was 6.6 percent. From 1999 through 2010, the unemployment rate averaged 8.37 percent, with the historical high reported in February 1999 and record low in May 2008 (Trading Economics 2012).

Estimates indicate that for 2011, Russia's budget showed revenues

of $382.8 billion and expenditures of $376.2 billion, with a budget surplus of 0.4 percent of GDP. About 20 percent of GDP was derived from taxes and other revenues (CIA 2012). According to the Federal State Statistics Service, Russia's annual average inflation rate for 2009 was 12 percent. For 2010, it was 6.9 percent; for 2011, 9.43 percent; and for the first three months of 2012, 3.9 percent (Trading Economics, 2012).

Industrial production for 2009 was also affected by the 2008–2009 global financial crisis. The average growth rate for 2009 was -10.8 percent. Only the month of December reported a gain—4.9 percent—but it marked the beginning of the recovery. In 2010, all twelve months reported gains ranging between 5.9 and 12.6 percent; the average annual growth rate for 2010 was 8.36 percent. The following year, 2011, also reported gains for all months, ranging between 3.6 and 6.7 percent, with an average annual growth rate of 5.1 percent. The most recent reports indicate that January 2012 had a 3.8 percent growth rate and February, a 6.5 percent rate (Trading Economics 2012).

In 2010, Russia's oil production was 10.27 million barrels per day, while consumption was only 2.2 million barrels. It was estimated that Russia exported 5.01 million barrels per day for the same year. As of January 2011, Russia had an estimated 60 billion barrels in oil reserves.

In 2010, Russia's natural gas production was 588.9 billion cubic meters, with a consumption of 414.1 billion. Estimated exports were 199.9 billion cubic meters, while imports were 38.2 billion. Estimates indicate that as of January 1, 2011, Russia had 44.8 trillion cubic meters of natural gas reserves (CIA 2012).

According to the Central Bank of Russia, in 2009 Russia exported $298.06 billion in goods and services, with December's total of $30.85 billion being the highest. In 2010, the total value of exports was $391.82 billion, with December's figure of $35.35 billion again being the highest. In 2011, total exports were valued at $513.31 billion; once again, December's figure, $47.4 billion, was the highest. The most recent report indicates that exports in January 2012 were valued at $40.1 billion (Trading Economics 2012).

Russia's main export commodities are petroleum and petroleum products, natural gas, metals, wood and wood products, chemicals, and a wide variety of civilian and military manufactures (CIA 2012). Metals and energy account for more than 80 percent of Russia's total exports (Trading Economics 2012). In 2010, Russia's main export partners were Germany with 8.2 percent, the Netherlands with 6 percent, the United States with 5.6 percent, China with 5.4 percent, and Turkey with 4.6 percent.

As for imports, according to the Central Bank of Russia, in 2009 Russia imported $194.21 billion in goods and services, while for 2010 the total was $243.18 billion and for 2011 it was $319.6 billion. For the first month of 2012, the figure was $19.6 billion (Trading Economics 2012). The main imported commodities were machinery, vehicles, pharmaceuticals, plastics, semi-finished metal products, meat, fruits and nuts, optical and medical instruments, iron, and steel. For 2010, Russia's main import partners were Germany with 14.7 percent, China with 13.5 percent, Ukraine with 5.5 percent, Italy with 4.7 percent, and Belarus with 4.5 percent (CIA 2012).

Of all of the BRICS nations, Russia has the largest consumer class, the highest per capita GDP, and the lowest debt. Moreover, according

to *Forbes*, in 2011 Moscow had more billionaires (a total of 79) than any other city in the world (New York had only 58). Russia has 15 of the world's 100 hundred richest people. Retail sales in Moscow surpass those in Paris and London. Russia's consumer market is about 142 million. Estimates indicate that by 2025 it will be larger than Germany's. Furthermore, average Russians have higher disposable incomes than their Western (U.S. and Canadian] counterparts. That is because most Russians obtained their homes at no cost from the government. As a result, they do not have mortgage payments. Instead they spend their money on consumer goods, thereby boosting both the regional and the national economies (Thomas 2012).

Despite all of its strong points, however, even Russia's new economy has its vulnerabilities. For one, its reliance on exports makes it susceptible to the boom-and-bust cycles that follow the highly volatile swings of global commodities prices. For another, its development has been uneven: Urban areas have prospered and grown rapidly, while rural areas have not. Large energy-related enterprises have flourished, while small non-energy businesses have found capital inaccessible. Finally, Russia's new economy faces a number of problems endemic to the old USSR, namely a shrinking workforce, high levels of corruption, and poor infrastructure.

India

The Republic of India is a country located in southern Asia, between the Arabian Sea and the Bay of Bengal. The country covers a total area of 3,287,263 square kilometers and has 7,000 kilometers of coastline. India shares borders with Bangladesh, Bhutan, Burma, China, Nepal, and Pakistan (CIA 2011).

India has a varied climate, from tropical in the south to temperate in the

250

north. Likewise, its terrain varies, from upland plains in the south to flat to rolling plains along the Ganges, deserts in the west, and mountains (the Himalayas) in the north (CIA 2011).

India's natural resources are coal (the country has the fourth-largest reserves in the world), iron ore, manganese, mica, bauxite, rare earth elements, titanium ore, chromite, natural gas, diamonds, petroleum, limestone, and arable land. India's natural hazards are droughts, flash floods, monsoonal rains, thunderstorms, earthquakes, and volcanic eruptions (on Barren Island in the Andaman Sea). India has environmental issues of deforestation, soil erosion, overgrazing, desertification, air pollution, water pollution, and insufficient potable water (CIA 2011).

India dominates the southern Asian subcontinent. The country is located near important Indian Ocean trade routes and has one of the tallest mountains in the world, along the border with Nepal (CIA 2011).

Society and Government

As of July 2012, India had an estimated population of 1,205,073,612. The population growth rate is about 1.31percent, with a birth rate of 20.6 births per thousand. The country has a death rate of 7.43 deaths per thousand. Life expectancy at birth for the total population is 67.14 years, with a fertility rate of 2.58 children born per woman (CIA 2012).

In 2010, 30 percent of the total population was urban, with an annual rate of change of 2.4 percent and an immigration rate of -0.05 migrants per thousand. In 2009, the capital, New Delhi, had a population of 21.72 million; Mumbai, 19.695 million; Kolata, 15.294 million; Chennai, 7.416 million; and Bangalore, 7.079 million (CIA 2011).

India's population is composed of three major ethnic groups: Indo-Aryan (72 percent), Dravidian (25 percent), and Mongoloid and other (3 percent). The country has fifteen official languages. Hindi is the primary language

and is spoken by 41 percent of the population. The other languages are, in order, Bengali (8.1 percent), Telugu (7.2 percent), Marathi (7 percent), Tamil (5.9 percent), Urdu (5 percent), Gujarati (4.5 percent), Kannada (3.7 percent), Malayalam (3.2 percent), Oriya (3.2 percent), Punjabi (2.8 percent), Assamese (1.3 percent), Maithili (1.2 percent), and others (5.9 percent). English is considered a subsidiary official language and is the most important language for national, political, and commercial communication (CIA 2011).

Hinduism is the most widely practiced religion in India. Its followers constitute 80.5 percent of the population. Islam is practiced by 13.4 percent of the population, Christianity by 2.3 percent, the Sikh religion by 1.9 percent, other faiths by 1.8 percent, and unspecified faiths by 0.1 percent (CIA 2011).

India is a developing country with a federal republic type of government. It achieved independence from the United Kingdom on August 15, 1947. Its capital is New Delhi. For administrative purposes, the country is divided into twenty-eight states and seven union territories (CIA 2011).

The constitution of January 26, 1950, has been amended several times. It provides for a common law legal system based on the English model, but with separate personal legal codes that apply to Muslims, Christians, and Hindus. The constitution also provides for judicial review of legislative acts (CIA 2011).

India's government has executive, legislative, and judicial branches. The executive branch consists of a chief of state (the president), a head of government (the prime minister), and a cabinet, which is appointed by the president on the recommendation of the prime minister. The legislative branch, or Parliament (Sansad), consists of two bodies. The first is the Council of States (Raija Sabha), which has 245 members (up to 12 of whom

are appointed by the president, with the remainder chosen by the elected members of the state and territorial assemblies). The second body is the People's Assembly (Lok Sabha), which has 545 members (543 of whom are elected by popular vote, with the remaining 2 appointed by the president). The council members serve six-year terms; the assembly members, five-year terms. The judicial branch is the Supreme Court, consisting of a chief justice and 25 associate justices, all appointed by the president. The justices serve until they reach age of 65 or are removed for "proved misbehavior" (CIA 2011).

India has dozens of political parties. The main ones are the All India Anna Dravida Munnetra Kazhagam (AIADMK) and the All India Trinamool Congress (AITC) (CIA 2011).

India participates in the following international organizations: Association of Southeast Asian Nations (ASEAN) (dialogue partner), European Organization for Nuclear Research (CERN) (observer), Food and Agricultural Organization (FAO), Group of 15 (G-15), Group of 20 (G-20), International Atomic Energy Agency (IAEA), International Monetary Fund (IMF), International Criminal Police Organization (Interpol), United Nations (UN), World Trade Organization (WTO), and many others (CIA 2011).

In 2009, India expended 2.4 percent of GDP **[on what?]**. The country has many social and public health issues demanding attention. For example, India is a place with a high degree of risk of major infectious diseases, such as food or waterborne diseases, animal contact diseases, and others. The country has a literacy rate of only 61 percent, yet in 2006 it spent only 3.1 percent of its GDP on education (CIA 2011).

Economy

India is considered a developing open-market economy. However, prior

1991, the economy was considered *autarky*, which means "self-sufficient." In other words, the government considered it unnecessary to engage in any kind of international trade (Farlex 2011). In 1991, India's *autarky* economy changed when the government decided to open the country to international trade and investment. It carefully preserved a large role for the private sector and restructured its own role in the nation's economy (Ahluwalia 2008). Economic reforms such as industrial deregulation, privatization of state-owned enterprises, and reduced controls on foreign trade and investment became the foundation of the economic liberalization (CIA 2011). According to Dr. Sanjaya Baru (2011), the economic reforms derived from a combination of factors: the collapse of the Soviet Union, which left India without any reliable trading partner; China's growth, which imposed some restrictions on India's strategic options; and the demands of an emerging middle class.

The new reforms benefited India's economy. The average annual growth rate in the first ten-year period after the reforms showed an increase of 6 percent. This ranked India among the fastest-growing developing countries in the 1990s. In addition, records indicated that poverty declined at a faster rate during the post-reform period (Ahluwalia 2008).

Since 1997, India has had an average growth rate of 7 percent per year. The country now has a diversity of economic resources, from traditional village farming to modern industries. However, services are the main source of its economic growth, contributing more than half of the country's output with only one-third of its labor force. India has capitalized on this trend and is becoming a major exporter of information technology services and software workers (CIA 2011).

India's powerful economic recovery in 2010 from the global financial crisis was largely attributed to strong domestic demand. Growth exceeded

8 percent year-on-year in real terms (CIA 2011). By 2011, India was considered the tenth-largest economy in the world.

In 2012, however, India's economic growth slowed, triggered by persistent high inflation and eleven interest rate increases in eighteen months. Inflation rates reached double-digit levels, which was a double-edged sword: it diminished demand from abroad while raising food prices already impacted by supply shortages, consumer demand, and wage increases (Frangos, India's Inflation Is a Lesson for Fast-growing Economies 2011). Another factor contributing to the slowdown was the increase in international crude prices, which raised the Indian government's fuel subsidy expenditures, thereby contributing to a higher fiscal deficit and increasing the current account deficit (CIA 2011). To complicate matters further, corruption scandals delayed economic reforms.

The Reserve Bank of India [RBI] has made several efforts to reduce inflation; although Duvvuri Subbarao, governor of that organization, has stated, "Monetary policy is an ineffective instrument for reining in inflation emanating from supply pressures. . . . It is unrealistic under these circumstances to expect the Reserve Bank to deliver on an inflation target in the short-term." Furthermore, Deepak Mohanty, executive director of the Reserve Bank, admitted back in September 2011 that inflation had become "generalized" in the economy. However, he expected that inflation would start to subside by the end of 2011 or the beginning of 2012 (Frangos Who's to Blame for India's Inflation? 2011).

Estimates for 2011 indicated that for GDP (PPP), India had about $4.46 trillion, with a GDP (official exchange rate) of $1.84 trillion, an estimated real rate of growth of 7.8 percent, and a GDP per capita (PPP) of $3,700. GDP composition included agriculture (17.2 percent), industrial (26.4 percent), and services (56.4 percent). India had a labor force of approximately

487.6 million. iThe unemployment rate was about 9.8 percent. Fixed gross Investment was 29.5 percent of GDP, with revenues of $172.3 billion and expenditures of $283 billion. Taxes and other revenues were 9.6 percent GDP. India had a public debt of 50.5 percent of GDP and an inflation rate of approximately 8.9 percent. The stock of narrow money was estimated at $305.7 billion, while the stock of broad money was estimated to $1.29 trillion. In addition, the stock of domestic credit was about $1.45 trillion. It was estimated that during 2011 the industrial production growth rate was 6.7 percent (CIA 2011).

India's main agricultural products are rice, wheat, oilseed, cotton, jute, tea, sugarcane, lentils, onions, potatoes, dairy products, sheep, goats, poultry and fish. India's main industrial products are textiles, chemicals, processed food, steel, transportation equipment, cement, mining, petroleum, machinery, software, and pharmaceuticals. India's major export commodities are petroleum products, precious stones, machinery, iron and steel, chemicals, vehicles, and apparel. India's major imports are crude oil, precious stones, machinery, fertilizer, iron and steel, and chemicals.

By the beginning of 2011, it was estimated that India had natural gas reserves of 1.074 trillion cubic meters. In 2011, India's exports were estimated to be about $298.2 billion and its imports, $451 billion. In 2010, India's major export partners were the United States (12.6 percent), the United Arab Emirates (12.2 percent), China (98.1 percent), and Hong Kong (4.1 percent); while its major import partners for 2010 were China (12.4 percent), United Arab Emirates (6.5 percent0, Saudi Arabia (5.8 percent), and Australia (4.5 percent). India shows a stock of direct foreign investment at home of $225 billion, while abroad it shows $114.2 billion (CIA 2011).

In mid-2010, Morgan Stanley estimated that India would become the world's fastest-growing economy by 2013 or 2015. According to its report, several

factors make this a genuine possibility: "India has one of the lowest median ages among the major economies. When an economy prospers, first its death rate, then its birth rate, falls. As this trend proceeds, there is a big bulge in the working-age population, while the nonworking population shrinks as a share of total population. The lowering of the ratio of dependent population to working-age population has twin effects. [First] it allows people to save a large portion of their income, raising the country's rate of savings. [Second] it boosts the number of people who work and contribute to growth" (ET Bureau 2010).

However, Morgan Stanley revised its growth forecast of 7.8 percent downward and predicted that India's economic growth for 2012 would be only 7.4 percent. The adjustment was attributed to the developed market slowdown, higher oil prices, higher inflation rates, slowing growth, and alleged corruption scandals adversely impacting global markets. However, the Morgan Stanley forecast noted factors working in India's favor, such as surging corporate activity and good agricultural progress that will contribute to rural incomes and ease food inflation (The Hindu 2011).

Fitch Ratings also expects a cyclical slowdown for India. India's government expects a GDP of 6.9 percent for the 2010–2011 period and believes the cyclical downturn will help to ease inflation. Fitch estimates a potential growth rate between 7.5 to 8.5 percent. This would be the slowest pace of growth since the 2008 financial crisis. India's slowdown would be a consequence of the euro zone crisis, tough monetary policies, and political scandals. However, by December 21, headline inflation will have slowed to 7.47 percent, although this would mainly be due to a reduction in food inflation that is widely seen as unsustainable. The RBI governor urged the government to use the March budget to reflect a fiscal consolidation (Woo 2012).

According to other authorities, "the medium-term growth outlook seems bright due to a young population and corresponding low dependency ratio, stable savings and investment rates, and increasing integration into the global economy. Still, India must work on several long-term issues, such as reducing poverty, facilitating the proper physical and social infrastructure, providing better employment opportunities for nonagricultural employees, increasing access to quality basic needs and higher education, and accommodating rural-to-urban migration (CIA 2011).

Singapore

The Republic of Singapore is located in the southeastern part of Asia. Singapore consists of a set of islands, the largest of which is Singapore itself, located between Malaysia and Indonesia. A city-state, the country has a total land area of only 697 square kilometers and a coastline of 193 kilometers (CIA 2012).

Singapore's climate is tropical—hot, humid, and rainy. Its terrain is lowland, and only 1.47 percent of the land is arable. The country's natural resources are fish and deepwater ports. Singapore is, in fact, the focal point of Southeast Asian maritime routes (CIA 2012).

Founded in 1819 as a British trading colony, Singapore joined the Malaysian Federation in 1963, but only two years later became independent. Since that time, the country has become one of the most prosperous in the world, having strong international trading links and a per capita GDP similar to that of the leading nations of Western Europe. However, Singapore faces several major environmental challenges, including limited natural freshwater, limited land availability for proper waste disposal, seasonal smoke/haze from Indonesian forest fires, and industrial pollution. The country has signed but not ratified several international environmental agreements, including those pertaining to biodiversity, climate change, desertification,

endangered species, hazardous wastes, maritime law, and both atmospheric and shipping pollution (CIA 2012).

Society

According to its 2000 census, Singapore has three predominant ethnic groups: Chinese (76.8 percent of the total population), Malay (13.9 percent), and Indian (7.9 percent). There are four official languages: Mandarin spoken by 35 percent of the population, English spoken by 23 percent, Malay spoken by 14.1 percent, and Tamil spoken by 3.2 percent. The main religions practiced are Buddhism (42.5 percent), Islam (14.9 percent), Taoism (8.5 percent), Catholicism (4.8 percent), Hinduism (4 percent), and other Christian (9.8 percent) (CIA 2012).

It is estimated that by July 2012, Singapore will have a population of 5,353,494. Approximately 77 percent of the population is of productive age (15–64 years). Of the remainder, 13.8 percent is between infancy and 14 years of age, while only 9.2 percent is over the age of 65. The estimated population growth rate is 1.99 percent, with a birth rate of 7.72 births per one thousand of population, a death rate of 3.41 deaths per one thousand of population, and a net migration rate of 15.62 per one thousand of population. Life expectancy at birth for the total population is 83.75 years (CIA 2012). Singapore has a 100 percent urban population. In 2009, the country expended 3.9 percent of GDP on health care (CIA 2012).

Government

Singapore has a parliamentary republic form of government with no administrative subdivision (into states, districts, etc.). Its constitution was signed on June 3, 1959, and amended upon independence from the Malaysian Federation (August 9, 1965). The country's legal system is based on English common law (CIA 2012).

Singapore's government is divided into executive, legislative, and judicial

branches. The executive branch consists of a chief of state (president), a head of government (prime minister, along with two deputy prime ministers and a senior minister), and a cabinet (appointed by the president and responsible to the parliament). The president is elected by popular vote for a six-year term. The leader of the majority party or majority coalition is usually determined by a consensus of the prime minister, the president, and the deputy prime ministers. The legislative branch is a unicameral parliament whose eighty-seven members are elected by popular vote for a five-year term. The judicial branch is composed of a supreme court and a court of appeals. The chief justice is appointed by the president with the advice of the prime minister and advises the president on the appointment of other judges (CIA 2012).

Singapore has several political parties such as the National Solidarity Party (NSP), the Reform Party, and the People's Action Party (PAP). There are no political pressure groups or leaders. Singapore's military consists of an army, a navy, and an air force. In 2005, Singapore invested about 4.9 percent of GDP in military expenditures (CIA 2012).

Singapore is member of the following international organizations: Alliance of Small Island States (AOSIS), Asia-Pacific Economic Cooperation (APEC), Association of Southeast Asian Nations (ASEAN), International Atomic Energy Agency (IAEA), International Bank for Reconstruction and Development (IBRD), International Criminal Police Organization (Interpol), International Trade Union Confederation (ITUC), United Nations (UN), World Trade Organization (WTO), and many more.

Economy

While Singapore is a small country in territory, it has a well-managed and successful free-market economy that is corruption-free, with stable prices and a per capita GDP higher than that of many developed countries. Its economy depends mainly on exports such as consumer electronics,

information technology products, pharmaceuticals, and financial services. Real GDP growth between 2004 and 2007 was 8.6 percent. In 2009 the economy contracted by 1 percent, affected by the global financial crisis; but in 2010 and 2011, it surged back with increases of 14.8 percent and 4.9 percent, respectively. Now Singapore's government is focused on establishing a new path to growth by raising productivity and becoming a financial and high-tech center. (The country is already a preferred place for major investments in pharmaceuticals and medical technology.) (CIA 2012) Singapore's estimated GDP for 2011 was $314.5 billion (compared with $298.7 billion in 2010 and $260.9 billion in 2009). Its real growth rate for 2011 was estimated to be 5.3 percent. Its labor force for 2011 was estimated to be 324 million people, with 0.1 percent in agriculture, 19.6 in industry, and 80.3 percent in service. The estimated unemployment rate was 2 percent. Gross fixed income was 23.4 percent of GDP. Singapore's 2011 budget showed revenues of $40.53 billion, expenditures of $37.18 billion, a surplus of 1.3 percent of GDP, and taxes and other revenues of 15.9 percent of GDP. The nation's public debt for 2011 was estimated to be 118.2 percent of GDP; the consumer price inflation rate, 5.2 percent (CIA 2012).

Singapore's agricultural products are orchids, vegetables, poultry, and fish. Its industrial products include electronics, chemicals, financial services, oil drilling equipment and petroleum refining, rubber processing and rubber products, processed foods and beverages, ship repair, offshore platform construction, life sciences research, and entrepôt trade. The industrial production growth rate in 2011 was estimated to be 3.4 percent (CIA 2012).

Singapore's export commodities are machinery and equipment,

pharmaceuticals and other chemicals, and refined petroleum products. The value of its exports was estimated to be about $432.1 billion for 2011. Its main export partners (2010) were Malaysia with 11.9 percent, Hong Kong with 11.7 percent, China with 10.4 percent, Indonesia with 9.4 percent, the United States with 6.5 percent, Japan with 4.7 percent, and South Korea with 4.1 percent (Department of Statistics Singapore 2012).

Singapore's import commodities are machinery and equipment, mineral fuels, chemicals, foodstuffs, and consumer goods. The value of its imports was estimated to be about $386.7 billion for 2011. Its main import partners (2010) were Malaysia with 11.7 percent, the United States with 11.5 percent, China with 10.8 percent, Japan with 7.9 percent, South Korea with 5.8 percent, and Indonesia with 5.4 percent (CIA 2012). During January 2012, imports showed an increase of 1.4 percent; exports, an increase of 1.8 percent (Department of Statistics Singapore 2012).

In February 2012, non-oil domestic exports increased by 6.2 percent on a month-on-month seasonally adjusted basis. Retail sales also showed an increase on a seasonally adjusted basis—1.7 percent for January 2012 (Department of Statistics Singapore 2012).

Despite all of these strong numbers, Singapore faces at least a few challenges, among them criminal justice problems. The country's geographic location, combined with its economic success, makes it susceptible to crimes such as money laundering, armed robbery, and high seas piracy (CIA 2012).

Still, Singapore 's positives far outweigh its negatives, and one positive in particular stands out among the rest: Singapore is a country with a history of low unemployment rates. From 1996 through 2012, its unemployment

rate was on average about 2.48 percent. (Overall the historic high was 6 percent in June 1990; the historic low, 1.3 percent in September 1997.) The unemployment rate during last quarter of 2011 was 2 percent (Trading Economics 2012).

That same quarter, employment increased by 37,600, raising the job growth figure for the year to 122,600—a growth rate of 3.9 percent. The December 2011 total employment figure was 3.23 million (Department of Statistics Singapore 2012).

According to some experts, the low rates of unemployment in Singapore are partly the result of an increase in the educational level of young people (BBC News 2011). Others attribute it to an extremely skilled and disciplined workforce (Global Maverik 2011). In addition, according to the Ministry of Manpower, all service industries expanded their workforces over the period of time studied. This was a result of the growing business confidence produced by a strong market, which also motivated new foreign companies to establish themselves in Singapore (Chan 2011). This means that Singapore is becoming a strong candidate for many companies that are looking for a stable market that offers a skilled workforce. As the establishment of new foreign businesses increases, so do employment opportunities.

In 1998 Russia faced a financial crisis rooted in its inability to pay back the foreign debt acquired during the Soviet Union era. In order to restore investor confidence, in 1996 the government had rescheduled payment of that debt with the assistance of the IMF. But just when the economy had begun to improve, in late 1997, the Central Bank of Russia was forced to defend the ruble against speculative attacks. The effort cost the bank about US$6 billion in foreign exchange reserves. To stabilize the investment

environment, the government reformed the tax code, but officials could agree on little else to solve the revenue shortfall. President Boris Yeltsin fired his entire government, and the central bank warned of a looming debt crisis. On August 13, 1998, the Russian stock, bond, and currency markets collapsed. From January to August, the market lost more than 75 percent of its value. On August 17, the government floated the exchange rate, devalued the ruble, and defaulted on its domestic debt. It froze payment on ruble-denominated debt and declared a ninety-day moratorium on payment by commercial banks to foreign creditors (Chiodo and Owyang 2002).

It took nearly ten years for the country's economy to recover, but recover it did.

CHAPTER 35

Who Controls the U.S. Economy?

Corporate Elites and the Upper Class

Up until the first half of the twentieth century, the American government and economy were mainly influenced by the upper class; however, after the Great Depression of the 1930s, the federal government became more independent. Today the majority of experts agree that by comparison upper-class power over the American government has lessened, but some still believe that the group has major control of the country's economy and politics (Kerbo 2009).

According to G. William Domhoff, a sociology professor, a governing or ruling class has dominated the United States since its founding in 1776. The group's present-day power over the nation's economy derives from its control of the primary means of production through stock ownership. Upper-class families have accumulated extensive holdings of stock in major corporations; and most of the remaining stock is controlled by large financial corporations over which the upper class has major influence (Domhoff 2012).

By 2009, the upper class represented about 0.5 percent, or about 1 million, of the total U.S. population (Kerbo 2009). According to economist Edward N. Wolff, the top 1 percent of households (which is considered the upper class) includes, but is not limited to, doctors, executives, lawyers, and politicians. Wolff reported that as of 2007 the group owned 34.6 percent of all privately held wealth, while their financial wealth (total net worth minus the value of the primary residence) was 42.7 percent (Domhoff 2012).

In March 2012, *Forbes Magazine* reported that the average annual income of the top 1 percent of the American population was $717,000 (with a net value of $8.4 million), while 1 percent of that group (the top 0.01 percent of the total population) had average incomes of over $27 million.

Furthermore, the top 1 percent paid approximately 25 percent of their income in taxes. However, within the group, the people with higher incomes paid less, and the top 400 earners in the country paid only 18 percent.

Since 1979, the upper class has gained financially compared to the bottom 90 percent. Between 2007 and 2009 alone, Wall Street profits increased by 720 percent (Dunn 2012).

Economic elites often come from upper-class families, a fact that influences both their way of thinking and whose interests they serve in making decisions (Kerbo 2009). In 2010 the Center for Responsive Politics noted that 261 members of Congress were millionaires. Furthermore, the median average

266

income of a member of the House Tea Party Caucus was $1.8 million. The group included 33 millionaires and 6 members whose individual net worth was over $20 million (Cline 2012). A more recent report indicated that there were 250 members of Congress who were millionaires, with a median net worth of about $891,000. In addition, 57 members of Congress, or about 11 percent, were members of the financial elite (Dunn 2012). Not surprisingly then, when issues like taxation are under discussion, such individuals vote repeatedly for tax cuts for the wealthy. Faced with a conflict, they vote in their own interest rather than that of their constituents. The need to fund regular reelection campaigns reinforces this behavior. For most politicians, seeking financial support from the wealthy (including corporations and their well-compensated executives) is the most efficient form of fund raising (Dunn 2012).

The political power of the upper class is used to maintain its influence over the state as well as the economy (Domhoff 2012). Cabinet positions are of special importance in this regard. Cabinet members are in a position to steer presidential policy decisions in a way that will ensure that upper-class interests are preserved (Kerbo 2009). Domhoff, Kerbo, and Della Fave, after examining the backgrounds of secretaries of state, treasury, and defense between 1932 and 1964, concluded that 63 percent of the secretaries of state, 62 percent of the secretaries of defense, and 63 percent of the secretaries of the treasury could be classified as members of the upper class (Kerbo 2009). Campaign contributions are another way that the group protects its interests. The recipients usually adhere to a political philosophy supportive of the upper class. They also have direct influence on the policy-formation process and lobbying organizations.

The influence of corporate elites, on the other hand, is not based on personal wealth (although many are wealthy), but on control of corporate resources.

One of the most important means of influence within a corporation is the ownership or control of a large amount of the corporation's stock. Access to information can be a factor as well. Chief executive officers from the biggest corporations and high-status people who work or socialize with them have ready access to information that can be used to economic advantage (suggests *insider trading,* an illegal practice). The globalization of the economy amplifies these influences. Today, top executives of multinational corporations comprise a whole new international corporate class. Many of these top officers, in turn, are members of an inner group of the corporate class who represent large banks. This inner group functions to link larger corporations to the point where they have common interests that they act upon in an arrangement not unlike a system of *interlocking directorates* (another arguably illegal practice) (Kerbo 2009).

The power that all of these individuals wield, however, is not absolute. The upper class, the corporate elite, or the capitalist class—whatever it is called, it does have a major influence on the economy; and compared to other groups, it is able to ensure that its interests are protected even in the face of opposition. However, in a democracy, when a strongly united population opposes the interests of such a powerful group, that population can carry the day. But usually, because of their power, the elites are able to minimize their losses and maintain their position of relative dominance. One tactic they frequently use is to invoke the spirit of American "rugged individualism" in opposing any regime that would result in less inequality and exploitation (Kerbo 2009). Ladd and Bowman illustrated how this works (1998): "People in the United States are much more likely to reject government intervention to help the poor and reduce inequalities, and show by far the highest percentage believing [in] equality of opportunity."

The Israel Lobby

According to the late Sen. J. William Fulbright (D-AR), Zionism has had a major direct and indirect influence on both the politics and the economy of the United States (Senate Foreign Relations 2007). According to some experts, there is evidence to support Fulbright's statement. Former Rep. Paul Findley (R-IL) (1980) has stated that the influence of Israel's supporters is pervasive in almost every government and social institution. They are considered one of the strongest political campaign contributors. Their unity allows them to have access to people in key positions from the lowest to the highest levels of government, ensuring that their interests are protected (Findley 2003).

Moreover, Jews have major interests in and influence on foundations and organizations directly affecting U.S. politics and government. Their control over media has been a key factor in managing the politics, government, and economy of the United States. Allegedly, the Clinton Administration was greatly influenced by so-called warm Jews, key persons involved in politics on whom Israel could rely for support (Bar-Yosef 1994).

Oil Companies

On February 12, 1998, the House Subcommittee on Asia and the Pacific held a hearing on U.S. interests in the central Asian republics. Among the topics discussed were first the need for U.S. support for international and regional efforts to achieve lasting political settlements to the conflicts in the region and second the need for structured assistance to encourage economic reforms and the development of an appropriate investment climate in the region. At that hearing, John J. Maresca, vice president for international relations of Unocal Corporation, expressed his company's interest in assisting the U.S. government in undertaking a promising pipeline construction project that involved central Asian oil and gas reserves. Specifically, Unocal supported the repeal or removal of section 907 of the Freedom Support Act, which

restricted U.S. assistance to the government of Azerbaijan and limited U.S. influence in the region (House of Representatives, 1998).

The economic interest in central Asian oil and gas resources was more than obvious. Detailed information about the Caspian region's energy reserves was provided. According to the report, there were proven natural gas reserves equal more than 236 trillion cubic feet. The region's total oil reserves were put at more than 60 billion barrels, with some estimates as high as 200 billion barrels. In 1995, the region had produced only 870,000 barrels per day; it was estimated that by 2010, Western companies could increase production to about 4.5 million barrels daily, a more than 500 percent increase. That would mean that in about fifteen years, 5 percent of the world's total oil production would come from the region.

In his testimony, Maresca emphasized the geographic and political constraints, such as the fact that each of the central Asian countries had governmental, political, and armed conflict issues. The main concern, however, was transporting the oil. The region's existing pipeline infrastructure, which was constructed during the USSR period, headed north and west toward Russia, although that country was not a competitor for the project because it lacked the capacity to manage the area's oil production (House of Representatives, 1998).

The plan was for the Caspian Pipeline Consortium, a group of eleven foreign oil companies, including four American firms (Unocal, Amoco, Exxon, and Pennzoil) and sponsored by the Azerbaijan International Operating Company, to meet the need for additional export capacity. However, the project as planned would not provide enough capacity to handle the oil flow or to move it to markets. Therefore, additional pipelines would be required. Maresca suggested that they be located near prospective energy markets, such as western, central, and eastern Europe and the independent states of the

former Soviet Union. Moreover, since Asia's energy demands were expected to double by 2010, he suggested two additional projects—one with the Turkish Company Koc Holding to take competitive gas supplies to Turkey and another with the Central Asia Gas Pipeline Consortium (CentGas) to link Turkmenistan's vast Dauletabad gas field with markets in Pakistan and possibly India. (Not coincidentally, Unocal held an interest in CentGas.) After reviewing all the possible routes and taking into consideration the net profits and investments, the only option left was to build the pipelines across Afghanistan, which was then still torn by civil war. So it was understood that the pipeline projects would not become a reality until that country had a stable regime that other nations, governments, and oil companies could trust (House of Representatives 1998).

Unocal had one other partner in mind for the project: the University of Nebraska at Omaha. The school was to develop a training program for Afghan nationals that would operate in the north and south of the country and benefit the nation's economy by creating new jobs. Maresca noted that central Asia and the Caspian region were blessed with abundant oil and gas, resources that could be used to enhance the lives of the region's residents as well as provide energy for growth in both Europe and Asia. He also mentioned the significant impact on the U.S. commercial interests and foreign policy. He urged the administration and Congress to provide support by using their influence to help find solutions to the region's conflicts. A few months after this statement—and as result of sharply deteriorating political conditions in the region—Unocal issued a suspension of all activities involving the proposed pipeline projects in Afghanistan (House of Representatives 1998). Clearly the company's interest in region was motivated by "black gold" and the benefit that other countries could obtain from it. True, it would have created some jobs for local people, but the real benefits were the profits to

be made by corporate people.

In order to have a better understanding of the reasons behind the international interest in central Asian oil, one must focus on the importance of oil to industrialized countries. Oil production is fundamental to a healthy modern economy; therefore, governments must protect any interests involving oil. Experts believe that the global oil peak was reached in 2005 and that by 2030 oil production will have dropped to levels comparable to 1980. However, global demand will increase as the population and industrialization grow (Savinar 2006). In other words, demand will outpace production, leading to a major increase in oil prices, an economic crisis for industrialized, oil-dependent countries, and resource wars. In the case of the United States, a 10–15 percent increase would be the tipping point.

Experts predict that the future oil crisis will be long lasting, even permanent, beginning with a gradual drop in oil production, but later resulting in geological problems, war, and terrorism. The crisis will lead to a decline in economic growth rates of about 10 percent per year (Goodchild 2011).

Former vice president Dick Cheney supported this view. In 1999 he stated that, based on estimates, by 2010 the United States would need an additional 50 million barrels of oil per day. Many experts believed that the rate of decline would be steeper—about 13 percent per year, which would be the equivalent of a global production drop of 75 percent over a decade (Savinar 2006). If this were to happen, the future of industrialized nations would be uncertain. However, the Great Recession intervened, curbing oil consumption. In 2000, the United States consumed 19.6 million barrels of oil per day; by 2009 consumption was down to 18.7 million barrels per day (CIA 2012).

Central Asian hatred of the United States is nothing new. During the Eisenhower administration, the president asked the National Security

Council why the United States was so hated. The answer was straightforward: from the point of view of the general population, the United States supports corrupt and oppressive governments and opposes political or economic progress because of its interest in controlling the region's oil resources (Chomsky 2002). Moreover, on August 14, 1998, the former Vice-Chairman of the National Intelligence Council at the CIA, Graham E. Fuller, stated that it was more efficient for Washington to support dictators, as long as they complied with certain foreign policy needs—specifically, the demands of powerful corporations (Fuller 2001). Therefore, to the general population in central Asia, U.S. promises of democracy are convenient fallacies used to facilitate access to and management of oil resources. Democracy and the region's improvement are not priorities.

The interest of the U.S. government in the Middle East's oil resources dates from the middle of the last century, when it was described by the State Department as a great source of strategic power, a "material prize in world history, and the richest economic prize in the world of foreign investment." President Eisenhower described the area as the most strategically important in the world. The idea was sustained by oligarchs who facilitated access to resources and then outsourced the projects to American oil companies for ease of control. The profit obtained from the oil of the region secured the interests of both the American government and investing oligarchs. The economic power obtained from the Middle East's oil ensured that the United States continued to be the strongest nation in the world. The greatest threat to this control was independent economic nationalism, which focuses on the prosperity of national developers to benefit the region's economic growth (Burchill 2003).

In the past, the priority of the United States was geopolitical control over resources as proof of supremacy. Now the priority is control over resources

to maintain a healthy economy. U.S. intelligence projections suggest that in coming years the United States will rely primarily on Western Hemisphere resources (i.e., Venezuela, Mexico, Brazil and probably Colombia, plus Canada if it becomes economically competitive). In 2000, imported oil accounted for 50 percent of U.S. oil consumption, and it is expected that by 2020 the percentage will rise to 66 percent. By obtaining power over the oil resources of the region, the United States could obtain the major material prize of world history. (Representative Press 2003).

But most prizes are mixed blessings, and oil resources are no exception. The April 2010 oil spill in the Gulf of Mexico put a spotlight on the company that worked the site. BP, or British Petroleum, adopted its name back in 1954 (Mufson 2010). Forty-five years later, during the Clinton administration, the U.S. government allowed BP to purchase Amoco, founded in 1889. Then, during (George W.) Bush Administration, BP purchased Atlantic Richfield. These were two of the most important strategic domestic energy companies, and they made BP the largest producer of oil and natural gas in the United States.

The explosion of the Deepwater Horizon well exposed BP's operating practices for the world to see. The Schlumberger (SLB) employees had told BP that the well was a danger, but the company refused to shut it down. On April 20, 2010, it exploded, killing eleven people. BP was faulted for contracting out the technology services in order to increase production and profit (Fitzsimmons 2010). In the process, it violated standard operating procedures to reduce maintenance and equipment expenses; disregarded safety guidelines, warning signs, and advice from one of the most respected energy services companies; minimized the magnitude of the leak; and failed to deploy the most effective oil spill technology to mitigate the damage.

At the root of all these failures was one thing: money. President Bush

had reduced the royalty rates on deep-water drilling, with the intention of increasing corporate profit margins (House of Representatives 2010). President Obama had appointed a former BP executive to head the Minerals Management Service (MMS). As a consequence, BP had an automatic green light both to drill in deeper water and to ignore environmental safety considerations in order to maximize profits (Madrak 2010).

It has been estimated that total damages for the Deepwater Horizon disaster in the Gulf of Mexico will exceed $1 billion. Who will pay? Matthew Wald of the *New York Times* provided a troubling review of the options in 2010. The Oil Spill Liability Trust Fund was created by Congress in 1986. After the Exxon Valdez ran aground in Alaska in 1989, the fund was replaced by a new $1.6 billion reserve. Under the terms of the Oil Pollution Act of 1990, the new fund was to be financed in two ways: (1) by fines and civil penalties on companies that spilled oil and (2) by an eight cent per barrel tax on oil to be paid by oil companies in exchange for limits on their liability. According to the 1990 law, the operators of an offshore rig would face a maximum liability of $75 million for damages claimed by individuals, companies, or governments as a result of an accident or spill. (However, they would be fully responsible for the costs of containing and cleaning up a spill.) Unfortunately, since the law took effect, there have been fifty-one cases in which the damages have exceeded the liability cap. BP's Deepwater Horizon spill was the fifty-second case.

So the oil companies win again. They pass the tax on to consumers, but keep their billions in profits. The environmental and economic damage they cause may be incalculable, but their liability is fixed at a maximum of $75 million. According to Wald, it will continue to be this way until the current law is amended.

<a>Military-Industrial Complex

The collapse of the USSR in the late 1980s left the United States the world's sole superpower, having a both far-flung military and the revenues to support it. A decade later, after the 9-11 terrorist attacks, the United States went to war in Iraq and Afghanistan; and its already large military expenditures grew by magnitudes. The defense budget for 2002 increased $32.6 billion over the previous year, to a total of $343.2 billion. Military spending accounted for more than half of discretionary spending, and most of it was funneled into the weapons industry. Terrorism proved to be the perfect pretext for funding any project related to war. By 2012, the defense budget had swelled to $687 billion (U.S. Department of Defense 2012). On Wall Street, the prices of defense stocks saw a similar run-up (Berrigan 2001).

Despite fighting on two fronts, the Bush administration decided to forego a military draft and make up for any personnel shortages by resorting to a practice prevalent in the private sector—outsourcing. However, according to Michael E. Milakovich and George J. Gordon, outsourcing as used in Iraq and Afghanistan was controversial. The usual justifications for outsourcing included increased productivity, efficiency, and competition, as well as reduced costs. At the time, the Pentagon was spending over $300 billion annually on goods and services. About half of that amount was awarded through *no-bid contracts,* contracts awarded with limited or no competition. This left the motivations for selecting a given contractor suspect. The effect on citizen confidence in the fairness and efficacy of public administration was devastating.

For example, outsourcing was initiated to save money, but in Iraq and Afghanistan, costs escalated sharply when companies like Blackwater Worldwide (formerly known as Blackwater USA) and Halliburton started providing goods and services for the U.S. State Department and military

forces under no-bid contracts. The Congressional Budget Office (CBO) estimated that the conflicts in Iraq and Afghanistan would eventually cost the nation thousands of lives and as much as $3.6 trillion in total economic losses. Some of the companies benefiting from the contracts had close connections to high-ranking members of the (George W.) Bush administration: Halliburton's former CEO was Vice-President Dick Cheney; a former member of Bechtel's board of directors was Secretary of Defense Donald Rumsfeld; and Blackwater's CEO, Erick Prince, had strong ties to *both* Bush administrations and a host Republican luminaries, including Sen. Tom Coburn (R-OK), Sen. Rick Santorum (R-PA), Rep. Duncan Hunter (R-CA), and former House Majority Leader Tom DeLay (R-TX) (Milakovich and Gordon 2009).

Eventually, modifications in the military procurement system were required to promote greater accountability and transparency. In the course of this process, Blackwater's security contract in Iraq was scrutinized and its performance found wanting in terms of meeting the basic goals of outsourcing. The company neither reduced costs nor increased the quality of services provided.

Deals (and results) like these are not the province of any one political party. Milakovich and Gordon (2009) were careful to point out that politicians from across the political spectrum have rewarded their supporters with multimillion-dollar contracts.

There is, however, a remarkable consistency among the corporate players. During fiscal year 2002, three of the major weapons companies—Lockheed Martin, Boeing, and Northrop Grumman—received a total of more than $42 billion in Pentagon contracts. This represented an increase of nearly one-third compared to 2000. The firms received one out of every four dollars the Pentagon spent for armament.

The Pentagon, however, was not their only source of funding. The Bush nuclear buildup was funded through the Energy Department budget. One of the three firms had a $2 billion-per-year contract to run the nuclear test site in Nevada and Sandia National Laboratories, a nuclear weapons design and engineering facility. The contract was significant because at the end of 2003 Congress lifted a ban on research into "mini-nukes" and authorized funds for a nuclear "bunker buster" project, as well as a multibillion-dollar facility to supply plutonium for a new generation of nuclear weapons. In addition, the three companies had access to other federal contracts, such as airport security and domestic surveillance. The annual cost in 2004 for these services was about $20 billion.

Lucrative projects like these reached the Senate thanks to aggressive lobbyists and the support of several influential senators. Some of the companies even offered employment opportunities to officials to induce them to grant contracts for their projects (Hartung 2004).

The Defense Contract Management Agency (DCMA) is an independent body that administers and supervises the funding of contracts for the Department of Defense (DOD). The agency is responsible for 321,270 active contracts that provide aircraft, space launch vehicles, spacecraft, medical supplies, electronic equipment, military vehicles, munitions, petroleum, chemicals, and lumber, among other things. In total, these contracts have a face value of $1.81 trillion.

During fiscal 2007, the DOD spent $312 billion. The top contractors (and their contract totals) were as follows: Lockheed Martin Corporation ($27.89 billion); the Boeing Company ($22.54 billion); Northrop Grumman Corporation ($14.68 billion); General Dynamics Corporation ($13.36 billion); Raytheon Company ($11.24 billion); Bae Systems ($9.13 billion); L-3 Communications Holdings, Inc. ($5.97 billion); United Technologies

Corporation ($5.3 billion); KBR, Inc. ($4.78 billion); and SAIC, Inc. ($3.55 billion) (Wallechinsky 2009).

According to the Stockholm International Peace Research Institute's 2010 yearbook, the United States accounts for almost half of the world's total military expenditures—46.5 percent. The Pentagon's fiscal 2009 spending request was nearly $826 billion, and Congress approved $700 billion in supplemental funding for operations in, among other places, Afghanistan (Committee on Foreign Affairs 2008). The truth is that U.S. military spending is seven times more than China's and thirteen times more than Russia's. Indeed, U.S. military spending is greater than the next top fourteen countries combined. Eight "potential enemies" together spend about $169 billion, or 24 percent of the U.S. military budget (Peace Action 2011).

"Some senators and representatives [have] introduced proposals and bills calling for 4 percent of GDP to be guaranteed as the military budget; however, critics stated that that would add $1.4–$1.7 trillion in deficits over the next decade and provide more defense funding than was forecast to be necessary," a situation that was deemed untenable given the budgetary conditions and economic environment in the United States. Using GDP is an important method for determining how much the United States can afford to spend on defense, but it does not provide any insight into how much the United States should spend. Defense planning is a matter of matching limited resources to achieve carefully scrutinized and prioritized objectives (Shah 2012).

The Obama administration indicated that for the 2010 fiscal year the defense budget would be reduced. Reductions would be achieved by, among other things, cutting some unnecessary high-tech weapons programs. Opposition to this proposal was immediate and intense, even though spending limits had been escalating for over a decade. The Friends Committee on National

Legislation acknowledged that discontinuing such projects would cause job losses in the short term, but argued that manufacturing unnecessary weapons should not be considered a jobs program. Also, research showed that such jobs could be successfully transferred to other sectors of the economy (Shah 2012). The approved defense budget for 2010 was $636.3 billion (U.S. Senate 2009).

According to Anna Rich, the United States is the world's major arms trade profiteer, often threatening nations with loss of trade privileges or entrance into alliances if they do not buy high-tech U.S. weaponry that they can ill-afford. In regions of conflict, such sales serve to stimulate destabilization (Rich 2000).

The three largest defense companies in the world are located in the United States (Stanford University). In the 1990s, over two million defense workers were laid off in an effort to downsize as the demand for weapons fell and competition for a share of the shrinking defense market intensified. Many firms chose to merge, and the consolidated companies began to sell a vast array of weapons to nations unaffected by trade restrictions and outright embargoes. Middle East chaos provided many defense firms with a hefty windfall that ensured their survival.

By the end of the 1990s, the United States had exported more than $200 billion worth of weapons. Arms merchants had used their enormous financial clout to secure the influence of politicians in brokering deals abroad and acquiring subsidies and tax breaks to help their industry. For example, William Cohen, secretary of defense in the Clinton administration, benefited from the generosity of arms lobbyists when he signed a letter recommending the lifting of the de facto ban on sales of high-tech weaponry to Latin American countries. There are records indicating that he received $42,600 from arms exporters. Such payments manipulate the decisions of politicians

at the expense of lives and regional security (Hartung REPORTS—Peddling Arms, Peddling Influence Update 1997).

According to John Tirman, in 1997 there were 221 weapons manufacturers located near the White House and the Pentagon so that they could have easy access to high-ranking individuals in the executive branch. The lobbyists' campaigns included expensive gifts to those in office who were considered pro-trade. Weapons firms spent millions in campaign contributions in an attempt to elect a Republican Congress sympathetic to the industry's needs. They also aided the campaigns of Democrats who had arms manufacturers in their districts, like Sen. Joseph Lieberman of Connecticut, home of Pratt & Whitney.

In 1997 the weapons industry spent $49.5 million to lobby legislative and administration decision makers (Rothenburger 1999). In 1998, major defense contractors alone (Boeing, Lockheed Martin, Northrop Grumman, and Raytheon) spent about $22 million on lobbying. In addition, former government officials working on behalf of defense firms used their connections to influence current officials to award contracts. They also represented foreign governments interested in expanding their militaries. Alexander Haig is an example of the latter. He has lobbied on behalf of corporations seeking foreign investments and represented the governments of China and Indonesia (Greenspan 2000).

According to the Center for Responsive Politics (CRP), during the Clinton administration, political action committees (PACs) of the major defense companies made direct contributions to federal candidates of about $14.2 million. The investment paid off: "arms exporters won tax breaks, guaranteed loans for arms-importing countries, an end to the ban on arms exports to Latin America, expansion of NATO to include former Warsaw Pact enemies, and the defeat of bills that would have restricted arms exports

based on buyers' human-rights records" (Rothenburger 1999).

The Defense Trade Advisory Group (DTAG) is an elite group appointed by the State Department to advise the Pentagon on arms exports. In 1999, its forty members represented the most powerful arms export and industry trade group in the United States. It included such firms as Boeing, United Technologies, Lockheed Martin, Hughes, Allied Signal, Litton Industries, Raytheon, General Dynamics, Loral Space Systems, the Electronic Industries Association, and the Aerospace Industries Association (Rothenburger 1999). In 2010, President Obama and Pentagon chief Robert Gates agreed that it was unnecessary to spend $485 million to develop a second engine for the F-35 jet fighter. At the end of May 2010, however, the House restored funding for the project, ostensibly because it would generate jobs at a time when they were greatly needed. It was a measure of how irresistible the opportunity was that among those voting for the project was Barney Frank (D-MA), one of the House's most fervent fighters against military spending (he had once proposed a 25 percent reduction in the Pentagon budget). Frank supported the program because it would generate jobs in his Congressional district.

That same year, the United States officially passed the trillion-dollar mark in spending on the wars in Iraq and Afghanistan. Several months ago, those costs surpassed expenditures for the Vietnam War—$738 billion in inflation-adjusted dollars. It is expected that by the end of 2012, federal spending on the fighting in Iraq and Afghanistan will reach $823 billion. The amount is fast approaching the cost of the most expensive conflict in the history of the United States—World War II, with a cost of $4.1 trillion in current dollars (Dorning 2012).

What can be done to halt these spiraling costs? The fact is that the only ones who profit from war on terror are the weapons manufacturers. Politicians

and bureaucrats who have a monetary interest in weapons procurement must be penalized, and all presidential and congressional candidates must be prohibited from accepting campaign contributions from companies involved in the war.

Pharmaceuticals Firms

The pharmaceuticals industry began to expand rapidly in the 1980s. Today it is a $700 billion business. About 48 percent of its total sales are made in the United States, while Europe accounts for 29 percent and Japan for 11 percent. Pharmaceuticals sales have been increasing at an average annual rate of 8.4 percent, which means that the industry has been growing more robustly than the world economy in general (Hashemi 2011).

A number of factors have contributed to this growth. First, drugs developed by pharmaceuticals companies had strong patent protection. Over the last decade, companies exploited this protection by making minimal changes in existing drugs and patenting the resulting ones as something entirely new, thereby effectively doubling the duration of their patent protection. Second, starting in the mid-1980s, large pharmaceuticals companies began consolidating by buying out small biotechnology firms that were struggling to compete on their own. Such transactions were mutually beneficial because they allowed both companies to hold a more dominant position in the marketplace. Third, whole new categories of drugs were developed to fight contemporary health problems ranging from heart disease to AIDS. Also, as health maintenance organizations (HMOs) took hold in an effort to control rising medical costs, they spurred demand for preventive and maintenance medications. Finally, in the 1990s, the pharmaceuticals industry entered a new phase marked by the use of *contract research organizations* for clinical development and even for basic research and development. While

expensive, this practice expanded the range of new products that a given firm could develop at any one time.

Although the pharmaceuticals industry took off in the 1980s, it was not until the 1990s that it actually flourished. Marketing evolved, vastly expanding the ways consumers learned about and purchased pharmaceuticals. The Internet became a major information source for consumers, many of whom followed up with on-line purchases. In 1997, as a result of new FDA regulations, *direct-to-consumer advertising* proliferated on radio and television. The required listing of side effects and product risks in such advertising initially had a negative effect on sales, but it was not sufficient to induce the drug companies to give up the practice. Today direct-to-consumer ads are commonplace both on television and in print. Finally, demand for nutritional supplements and alternative medicines created new opportunities and increased competition in the industry.

The success of the pharmaceuticals industry was not without controversy. Beyond drug side effects and marketing tactics, such companies were often implicated in situations involving over-medication, addiction, or other social problems (Whaley Products 2007). However, the most contentious and high-profile issue by far was drug pricing.

According to apologists for the pharmaceuticals industry, drug prices are determined by what the buyer can pay. In some countries, that figure is below the actual cost of the drug. As a result, those costs plus profit must be recovered in another way, typically from consumers in richer markets. The United States is the richest market of all—and the most fragmented, which virtually guarantees that its negotiated prices will always be higher than those in other countries. Other industrialized nations have national health care systems that negotiate on behalf of whole populations (Caldera and Zarnic 2008). According to a recent report, Americans pay about 77 percent

more for drugs than Canadians and about 76 percent more than Germans (NorthwestPharmaceuticals.com 2012). Moreover, the U.S. government, lobbying on behalf of pharmaceuticals companies, is trying to convince other nations that their affordable health care systems are mistaken and that they should allow the rise of drug prices. The implication is that U.S. drug prices will go down if prices abroad go up, but that is neither guaranteed nor likely. The government is letting the pharmaceutical industry influence decisions about health care issues (Reinhardt, Hussey, and Anderson 2004). In 2005, Pfizer, the largest pharmaceuticals company in the world, had a profit of 470 percent. The actual figure was $2.83 billion, more than four times the $602 million reported in the same period in 2004. What was even more remarkable, the company achieved that result despite that fact the some of its medications, such as Celebrex (which had been linked to heart attacks), caused a drop in sales. At the deepest point of the current economic recession, Pfizer managed to report six consecutive quarters of better-than-expected earnings, despite declining revenues, by implementing cost-cutting strategies, including merging with other corporations and laying off workers. Pfizer placed forty-sixth in the 2009 Fortune 500 rankings. It was a plan that worked, but at the expense of 50,400 Americans—30,900 whose jobs were eliminated from 2005 through 2012, plus 19,500 more whose jobs were lost in a merger with Wyeth Corporation (Ostergard and Sweeney 2011).

The goals of the officers and board members of the major pharmaceuticals firms will not change. They will continue influencing government to make decisions concerning health care issues based on the best interests of Big Pharma. They have enough key people in strategic positions to ensure that their interests will be safeguarded vis-à-vis those of patients, constituents, and taxpayers.

Health Insurance Companies and Hospitals

Unfortunately, capitalism encompasses anything that makes a profit, from prisons to war and hospitals. "For-profit hospitals are generally structured as corporations and governed by a board of directors; as such, their primary goal, as with any other business, is to return a yield on shareholder investment" (Seattle University).

Reports from the American Hospital Association indicate that in 2010, there were 1,030 hospitals and other health care facilities that were investor owned (American Hospital Association 2012). The typical hospital has become a money-making system. The largest hospital chain in the United States is HCA, founded by the family of former Senate Majority Leader Bill Frist, who was investigated for illegal selling of HCA stocks (Dreyfuss 2005).

In the 1980s, deregulation swept through the financial, airline, and medical industries, ostensibly with the goals of reducing costs and improving care. For-profit corporations took control of the nation's health care system. Estimates indicated that in 1980 medical care consumed 9.1 percent of the nation's GDP. Thirty years later, taking into consideration that health care costs had doubled, it was estimated that medical care consumed 18 percent of GDP, and a third that was wasted on bureaucracy (Wang 2010). "Although health spending in the amount of $3.36 trillion in 2013 may seem alarming, the nonhealth GDP projected to be available to Americans in that year would still be $5.6 trillion larger than it was in 2003. This implies that in 2003 U.S. dollars, Americans are projected to have 16.4 percent more nonhealth GDP per capita in 2013 than they had in 2003. While nonhealth GDP's share of total GDP is projected to fall over the decade (from 85.1 percent in 2003 to 81.6 percent in 2013), in absolute real dollars Americans are projected to have more of everything, besides health care" (Reinhardt, Hussey, and Anderson 2004).

The fact is, however, that with or without health insurance, health care is becoming more and more inaccessible. Thanks to all the advances in science, health care has become so expensive that it is considered a luxury. There are critics and supporters of the new health care reform law, which will obligate insurance companies to provide coverage even when patients have preexisting conditions. The Patient Protection and Affordable Care Act (PPACA) has a provision that will streamline the process by which doctors and health care providers request approvals from health insurance companies to provide treatment. Unfortunately, even after the PPACA is fully implemented, health insurance companies will continue to manage medical care and to be traded on Wall Street. Taking into consideration that Wall Street has been running health care for the last thirty years, it should not be a surprise that Wall Street manages all the aspects of American society, including medical care (Wang 2010).

The health-care bill continues to be controversial. For conservatives, having medical insurance is an independent decision of each citizen, one in which the government should not be involved. For liberals, affordable health care is both a right and an individual responsibility, something every person needs and should have available to him at a reasonable cost. Because the issue affects everyone, a solution must be found; but that solution must not exhaust the available funds or bankrupt state governments. Conservatives, on the other hand, feel that many states over-regulate insurance companies, and so they want insurers to be able to cluster in the states with the least regulation and still be able to offer policies nationwide (similar to the way credit card companies are treated). Moreover, while the PPACA is a private-market plan, it cannot be managed as the companies wish because they must adhere to the regulations established by the government (Mears 2012).

Banks and Financial Institutions

Banks and financial institutions are the motor of every society. In the United States, they have existed since the nation's founding. For instance, the Bank of Pennsylvania was founded 1780 to fund the American Revolutionary War. A year later, the Congress of the Confederation established the Bank of North America, which was granted a monopoly on the issuance of bills of credit as currency at the national level (Federal Reserve Bank of Philadelphia 2009). The early leaders of the U.S. government struggled over the form of the nation's banking system. Alexander Hamilton supported one central bank, while Thomas Jefferson supported local control (Todd 2009).

After the U.S. Constitution was ratified, commercial banking had an opportunity to emerge. It was the perfect arrangement for wealthy people willing to get involved in entrepreneurial projects for a guarantee of a return on their investment. Banks were for-profit institutions. They were privately owned (generally by stockholders) and earned an average over 1 percent on assets (Conference of State Bank Supervisors [CSBS] 2012). In fact, the early banks were reliable; failures were minimal, which encouraged the financial evolution of the United States (Mason 2010).

In 1831, the first savings and loan association was formed. It accepted savings deposits and made mortgage and other personal loans to individual members. Initially, S&Ls operated in only few states in the Midwest and the East.

The thrift industry, or building and loans (B&Ls), were for-profit businesses formed by bankers and/or industrialists. They, in turn, employed promoters to form local branches and sell shares to prospective members. In the 1880s, a new type of B&L was created. It promised to pay savings rates that were up to four times greater than those of other financial institutions.

In the 1980s and early 1990s, the savings and loan industry experienced a

crisis that resulted in the failure of 747 savings and loans. Total losses were estimated to be about $160.1 billion. Of that amount, about $124.6 billion was directly paid by the U.S. government via a financial bailout under the leadership of George H. W. Bush. In other words, taxpayers funded the bailout, either directly through charges on their S&L accounts or indirectly through increased taxes, which contributed to the budget deficits of the early 1990s (Mason 2010).

On the eve of the most recent economic crisis, in October 2008, President George W. Bush announced that the United States would spend up to $250 billion in taxpayer money to buy stocks in banks across the country. It was the first time the federal government had involved itself in banking since the Great Depression. The healthy banks would have their reserves increased, while the weaker banks would have their losses covered so that they would be able to lend again. According to President Bush, the move was "designed to directly benefit the American people by stabilizing our overall financial system and helping our economy recover." To emphasize that this was not a "no-strings-attached bailout," he noted that the stocks were expected to pay a dividend of about 5 percent (Associated Press 2008).

According to Timothy J. Kehoe and Edward Prescott, this latest bailout was just more evidence that "bad government policies are responsible for causing great depressions." They argued that at best it provided only temporary relief from the economic crisis. In their opinion, government should avoid implementing policies that stifle productivity by providing bad incentives to the private sector, meaning that unproductive firms (i.e., banks) must be allowed to fail (Cordoba and Kehoe 2009).

Tyler Cowen agreed that the bailout was a bad idea, but for a different reason. He and others like Simon Johnson and James Kwak (see below) saw it as proof of a direct link between political power and the major banks.

As evidence he cited three decades of either weak or lax tax regulation, hundreds of billions in bailouts, massive and undeserved CEO bonuses, and the rapid return of record bank profitability after the latest crisis. The most overt evidence, however, was the persistent political opposition (mainly Republican) to any kind of meaningful financial reform, a position Cowan believed to be rooted in large campaign contributions from the banks (Cowen 2011).

Simon Johnson and James Kwak had a similar point of view, with one important difference. They too saw the political dimensions of the financial crisis, and they also indicated their belief in an unholy alliance between banks and the U.S. government. However, they believed that the *banks* controlled the government through lobbying; so they suggested breaking up the big banks to prevent this (Johson and Kwak 2010). Cowan, on the other hand, believed that the *government* controlled the banks.

In support of his contention, Cowan offered two different ways to look at the bank bailout. The first was literally: it was the U.S. government that rescued the banks, and not the other way around. By extension, it is the IMF, an international organization created and largely dominated by the United States, that does the same thing for nations with debt problems (Cowan 2011).

Cowan's second way of looking at the bailout is broader and emphasizes the pervasive nature of U.S. influence. Picture the U.S. government as standing at the center of a giant nexus of funding, almost all to be used to finance the U.S. government budget deficit and to keep the economy running. The United States requires (1) the dollar as a reserve currency, (2) New York City as a major banking center with major banks, (3) fully credible governmental guarantees behind every Treasury auction, and (4) liquid financial markets more generally. However, the international trade presence

290

of the United States requires that the federal government ally itself with major commercial interests (e.g., the government sides with Hollywood in trademark and intellectual property disputes).

In other words, the U.S. government has decided to assemble a cooperative ruling coalition, which includes banks. It decides who belongs to the coalition, mostly for reasons of political expediency and according to what is perceived to be best for American voters.

Under such circumstances, it is unlikely that tougher banking regulations will ever be implemented. The government will simply not allow it. Why? Because if the government were to abandon the banks, it would send a broader message to the world, namely, that the United States is a nation in decline with major financial and political problems. Portraying the nation this way would not be acceptable, at least not according to the standards of the real Washington consensus (Cowen 2011).

Besides, as Cowen has stated, breaking up the major banks would only serve as a palliative; it would not eliminate the cause of the problem. In fact, the ongoing growth of political power and the reliance of that power upon an ongoing inflow of capital is the major cause. If a break-up of the banks were to occur, Washington would just find another way to assemble privileged financial institutions. The only real way out, according to Cowan, is to run a balanced budget. This would mean that the government would no longer need to favor banks in order to finance its activities. However, such a result is unlikely, mostly because Americans accept and support relatively high government spending and relatively low taxes (Cowen 2011).

CHAPTER 36
China and the United States: Competing World Strategies

China's Strategy: Worldwide Economic Power

China has a fast-growing economy and a specific strategy for achieving its economic goals. It is now actively integrating itself into the global economy, a surprising turn events, given its history.

When the People's Republic of China was established in 1949, it lacked capital and was internationally isolated. Following in the steps of the Soviet Union, it tried to industrialize rapidly in an effort to reach the level of developed nations. In the service of this goal, it suppressed the procurement price for grains, restricted rural migration, and set up barriers between rural and urban residents. This strategy led to nearly thirty years of stagnation in per capita income in the more labor-intensive sectors of the economy—initially agriculture and eventually export-oriented rural industries (Headey, Kanbur, and Zhang 2008).

The economic reforms of the late 1970s changed this approach. The open-door policy of that period attracted foreign direct investment and offered low-cost labor. As demands for continued growth increased, the reforms were modified. Fiscal decentralization allowed local governments to receive incentives to increase productivity; the governments, in turn, provided protection to investors' property rights (usually at the expense of the property rights of others). Other factors, such as ethnic homogeneity, land equality, and strong central governance, contributed as well (Headey, Kanbur, and Zhang 2008).

Successful political reforms of this sort also often required persuasion.

Prior to the implementation of economic reforms, the Chinese government had to modify people's preferences so that those involved would be more open to change. This was also true at the political level, where leaders were encouraged to take educational tours overseas and to invite other nations' leaders to speak about economic reforms. The fact that the Chinese media was run by the government virtually guaranteed that the economic reforms would be well publicized. Taken together, all of these factors ensured that the Chinese people, in the end, believed that China was doing the correct thing to benefit everyone (Headey, Kanbur, and Zhang 2008).

All of the above was preparation for the "big jump" to the economic level of developed nations. China used two strategies in making this transition: reforms at the margin and explicit experimentation.

Reforms at the margin were dual-track price reforms that allowed state-owned enterprises to sell unused input quota at market prices to township and village enterprises (TVEs) outside the command economy. This provided a functional pricing mechanism that benefited both the hierarchical and market systems. Eventually, the dual-track unified and became a market price (Headey, Kanbur, and Zhang 2008). Another example of reform at the margins involved the urban housing system. Apartment residents were allowed to buy their own units at discounted prices, while employees were permitted to buy new homes at market prices with a contribution from their employers. Arrangements like these, led to the emergence of a semiprivate real estate market (Headey, Kanbur, and Zhang 2008).

Before the implementation of a policy, the government could also have a trial period in which they would evaluate the effects of the policy. Such explicit experimentation was usually conducted in isolated, poor areas. Afterwards, the government would keep the most effective policies and discard the ones that caused problems. In this way, experimentation has

successfully functioned as a proving ground for reforms. In addition, China joined the World Trade Organization (WTO), a move that became part of the external pressure to implement reforms within state banks (Headey, Kanbur, and Zhang 2008).

Like most nations with developing economies, China has an insufficient infrastructure, but a fast-growing potential to rectify that situation. By offering a skilled workforce at very low wage levels and developing the capacity to adjust to a rapidly changing marketplace, the country has become one of the world's main product manufacturers. However, it still maintains several state-owned enterprises over which it has a major influence, although now often through regulation rather than direct management (Denlinger 2003).

China is also developing increased purchasing potential. In 2007, China became the second-largest economy in the world. By that same year, the country had already become the world's most important auto market and its biggest energy consumer.

Having achieved those distinctions, China began focusing on more than just GDP growth; it started looking to build a more harmonious society. Both objectives have been integrated into the government's economic policies. Local demand is now being factored into the economic equation that previously had included only China's foreign-owned manufacturers and domestic exporters (Zhang, Reuer, and Zhang 2012).

The 2008 global economic crisis affected China's economy as well. To continue the country's economic growth, Chinese firms were encouraged to expand into global markets. For example, such firms became strategic investors in the natural resources sector, mainly in Australia, Africa, and Latin America. Chinese companies have also acquired Western companies, such as Sweden's Volvo (2010) (Zhang, Reuer, and Zhang 2012).

Now, Western multinationals are focusing on and tailoring products,

294

services, and strategies to the Chinese market. Many of these companies conduct research and development activities in China, and the subsequent innovations are used for both domestic and global markets. Chinese firms are simultaneously competing and cooperating with their Western counterparts at a global level (Zhang, Reuer, and Zhang 2012).

Many economists have attributed China's economic growth to labor, capital, technology, and other components of institutional change. However, the structural change from low-productivity agriculture to the far more productive industrial and service sectors has also contributed to rapid economic growth.

Today, however, after almost thirty years of economic success, China faces a new challenge: how to continue growing while effectively managing the consequences of growth, like inequality, environmental degradation, and social tension. In other words, China must work to create reforms that sustain both rapid growth and social equity. That, according to experts, will require a level of policy-making objectivity that can only be achieved by maintaining practical reforms and focusing on innovation (Headey, Kanbur, and Zhang 2008).

Experts indicate that for sustainable development in the future, China needs to restructure its economy. This will mean, first, focusing on its domestic market because, despite the economic recovery of the U.S. and western European economies, exports are not likely to be as strong as they were in the past. Second, it will mean increasing the role of the private sector in job creation in order to generate new sources of domestic demand. And third, it will mean investing in strategic industries that will contribute to economic growth—industries like new materials, new energy, energy conservation, environmental protection, biomedicine, information networks, and high-end manufacturing (Xinhua 2011).

Note, however, that experts also see an important and ongoing role for China's state-owned enterprises in the development of a domestically driven economy. That is because of the Chinese government's knowledge of problems like growth inequality among regions. The government has been working for more than a decade through a variety of regional plans to reduce the gap between urban and rural development and to ensure coordinated regional growth. The ideal restructuring plan will include a balance of regional development and solid urbanization strategies to achieve economic growth for the coming decades (Xinhua 2011).

<a>U.S. Strategy: Worldwide Military Power

In its early years as a nation, the United States was a strong opponent of imperialism. This was understandable, since the country had been a colony of England and fought a war to achieve its independence. In 1823 the country's fifth president, James Monroe, proclaimed the doctrine that bears his name, and successive presidents have enforced it ever since. The Monroe Doctrine threatened with war any European country that ventured into Latin America to interfere with an existing government or to try to establish a colony. However, by the turn of the century (and thanks to the Spanish-American War in 1898), the United States had its own empire of Pacific and Caribbean islands (Reeves 2012).

After World War I, President Woodrow Wilson tried to form the League of Nations as a way to avoid such costly conflicts in the future. He received the support of all the countries that had signed the treaty ending the war; however, the U.S. Senate rejected the proposal. Thereafter, the United States retreated into isolationism, until it was drawn into World War II. At the end of that war, Europe was in ruins. To help rebuild it, the United States provided billions of dollars in aid under the Marshall Plan and created the North Atlantic Treaty Organization (NATO) to protect against the rise of

another power like Germany. Also, to ensure that Germany would not violate the military strictures imposed upon it, the United States deployed 500,000 troops in Europe, the majority of them stationed in Germany. Likewise Japan was placed under military command; and to ensure that it would not rearm, American and Allied troops were stationed in both Japan and South Korea. In addition, the United States was charged with countering the postwar rise of Communism (Reeves 2012).

The United States managed to maintain peace, keep Germany and Japan from rearming, and forestall Communist expansion—all of which was attributed to the presence of American forces. However, with the Vietnam War some twenty years later, the reputation of the United States as both defender against Communism and peacekeeper vanished (Reeves 2012).

Today U.S. military forces are deployed in nearly 149 countries worldwide, performing a variety of duties from combat operations to training foreign militaries to peacekeeping (U.S. Department of Defense 2011). Some of these troops (those in Germany, Japan, and South Korea) have been stationed abroad for more than five decades. (Note: The troops in South Korea are considered part of a UN command and deterrence operation [GlobalSecurity 2005]).

Some experts refer to the U.S. armed forces' deployment worldwide as an empire. According to Laurence M. Vance, the U.S. hegemony is unique because it not only controls great land masses and population centers, but also has a global presence, which no other country has or has had. The 2003 Base Structure Report issued by the Department of Defense declared that the department's physical assets consisted of over 600,000 individual buildings and structures at more than 6,700 locations, situated on more than 30 million acres, and divided into 115 large installations, 115 medium installations, and 6,472 small installations or locations; however, the

number could be greater than indicated because small installations are only considered if the plant replacement value (PRV) is less than $800 million. Most of the locations are in the continental United States; but 96 are in U.S. territories around the world, and 702 are in foreign countries. However, the last figure did not include installations in Afghanistan, Iraq, Israel, Kosovo, Kuwait, Kyrgyzstan, Qatar, and Uzbekistan. Chalmers Johnson, a specialist in political science and economics, estimated that the real total would be close to 1,000 (Vance 2004).

By 2003, the number of countries in which the United States had a presence was staggering. The Independent States in the World List issued by the U.S. Department of State reported that there were 192 sovereign countries in the world; the United States had troops in 135 of them, or about 70 percent of the total. However, places like the Indian Ocean territory of Diego Garcia, Gibraltar, the Atlantic Ocean island of St. Helena, Greenland, Kosovo, and Hong Kong also had a U.S. military presence. Furthermore, Guam, Johnson Atoll, Puerto Rico, the Trust Territory of the Pacific Islands, and the Virgin Islands had a U.S. military presence. By September 30, 2003, there were 252,764 troops deployed abroad, not including the U.S. troops in Iraq. The total number of military personnel rose to 1,434,377 (Vance 2004).

By January 2005, there were about 250,000 soldiers, sailors, airmen, Marines, and Coast Guardsmen deployed; although forces normally present in Germany, Italy, the United Kingdom, and Japan were not included in that total. They would count only if they were in active combat; these forces totaled about 100,000 soldiers (GlobalSecurity 2005).

According to the U.S. Department of Defense, by March 31, 2011, there were 1,435,450 military personnel. This figure did not include forces in Iraq, Kuwait, and Afghanistan, which combined would have totaled 203,800; the figure for Korea was unknown. Once again, the forces in Germany, Italy, the

United Kingdom, and Japan would count only if they were in active combat; those troops totaled 16,870. Putting all of these figures together resulted in a grand total of 1,656,120 military personnel deployed around the world, not including Korea. The total number of locations other than the continental United States was 156, including Hawaii, Alaska, Guam, the North Mariana Islands, Puerto Rico, the U.S. Virgin Islands, and the Wake Islands. This means that beyond the territory of the continental United States, the U.S. military has a presence in 149 different places (U.S. Department of Defense 2011).

Chalmers Johnson, an American author, consultant for the CIA (1967–73), and political and economic analyst, has predicted that the era of American Empire will end by 2045. In an article written in August 2010, he questioned whether the United States could maintain its position with wars in the Middle East, sanctions on Iran and North Korea, and military interventions in other countries, when the country itself was incapable of paying for basic services. Referring to the United States as "imperial America," he suggested that if the country were to diminish its profile overseas, it would also diminish its risk of another 9/11 attack. Furthermore, he stated his belief that if the United States were to leave the countries it occupies, some of them would follow the path of democracy if the United Nations oversaw them or if the neighboring states influenced them. According to Johnson, however, even if the United States were to bring all of its the military personnel home, it would still face the same internal and external issues, ranging from immigration and drug trafficking south of the border, a fragile educational system, and a host of economic problems. In Johnson's opinion, these will not disappear as long the United States continues to spend its wealth on "armies, weapons, wars, global garrisons, and bribes for dictators." In Johnson's opinion, without the intervention of the United States, the Middle East will continue to export

oil, and if China continues to consume large amounts of it, then this might present an opportunity to develop alternative energy sources. He believes, however, that the United States "has begun to look like England at the end of its imperial run, with an aging infrastructure, declining international clout, and sagging economy" (Johnson 2010).

The only way for the United States to continue as a powerful nation, in Johnson's opinion, is for the country to reinvent itself as a productive, normal nation. To achieve this goal will take dismantling its military bases abroad, using military force primarily to defend the U.S. territory, and developing a productive economy by investing in infrastructure, education, health care, and savings. However, this seems a remote possibility. Furthermore, Johnson, accused the CIA of being "politically tainted, with clandestine operations that [have] created a climate . . . in which the U.S. can assassinate, torture, and imprison people at will worldwide" (Johnson 2010).

Nevertheless, the United States keeps playing the role of world protector. In early October 2011, the United States deployed 100 troops to central Africa. According to the Obama administration, this was done to advise in the fight against the Lord's Resistance Army (LRA), a guerrilla group accused of widespread violence across several countries; however, some experts said that it was "political payback for the quiet sacrifices of Uganda's troops in Somalia." In other words, it might have been a reward for the service of U.S.-funded Ugandan troops in Somalia. Experts questioned the decision, especially because the LRA does not represent a national security threat to the United States and because the Obama administration was planning to disengage from conflict in Iraq and Afghanistan (Johnson 2010).

However, this was not the first time that the United States had tried to dismantle the LRA. The George W. Bush administration authorized sending seventeen counterterrorism advisers to train Ugandan troops for this purpose

and provided millions of dollars in aid to the Ugandan Army. In November 2010, the Congress passed legislation that authorized the coordination of U.S. diplomatic, economic, intelligence, and military support to combat the LRA. (NBC and AP 2011).

Worldwide, dislike for the United States is growing, and all too often the reason is that people disagree with the way the country is conducting its military occupations. Satur C. Ocampo, a journalist in the Philippines, has asserted that the new U.S. defense plan includes expanding the American role and military presence in the Philippines. In response, Kenneth A. Fenwick, an Australian, wrote, "The U.S., in its belt tightening, has a new strategy to use other people's and countries' assets to continue its hegemony the best it can. My country, Australia, which may as well be another star on the U.S. flag, has fallen to U.S. pressure and is allowing them to use our military bases here—for our own benefit of course." Ocampo has suggested that the proposed changes in the U.S. defense plan include rebalancing towards the Asia-Pacific region simultaneously with the withdrawals from Iraq and Afghanistan (Ocampo 2012).

In addition, he cited a specific plan called Global SOF Alliance, which was designed to improve the elite U.S. Special Operations Forces to be sent on special missions to any crisis area in the world. The Special Operations Command (SOCOM) proposed expanding its troop presence in regions such as Asia, Africa, and Latin America. The SOCOM chief, Admiral William H. McRaven, had requested additional authority to position SOF units and their equipment where they were most needed. However, U.S. ambassadors in crisis zones believed that this could be prejudicial, because the host governments would see it as a violation of their sovereignty (Ocampo 2012). During the last decade, 80 percent of SOF units were deployed in the Middle East; the other 20 percent were dispersed throughout seventy countries. The

SOCOM budget rose to $10.5 billion, and at least 12,000 SOF personnel were stationed around the world (Ocampo 2012).

Bernie Reeves disagrees with Johnson about the consequences of withdrawing U.S. troops from around the world. Reeves believes that in those circumstances "sea lanes would be endangered; unstable regimes would rise, creating regional warfare; weak nations would be dominated by stronger rivals; world oil supply would be shortened; and U.S. borders would be tested, which includes the possibility of suffering an attack with nuclear weapons" (Reeves 2012).

<p align="center">***THE END***</p>

Works Cited

PART 1 Two Nations Profiled
Chapter 1 Histories of the United States and China
(United States)

A&E Television Networks. (2011). *This day in History: Civil War*. Retrieved from History.com: http://www.history.com/this-day-in-history/house-passes-the-13th-amendment

Central Intelligence Agency. (2011, September). *The World Factbook: The United Sates of America*. Retrieved from Central Intelligence Agency: https://www.cia.gov/library/publications/the-world-factbook/geos/us.html

Every Culture. (2011, September). *United States of America* . Retrieved from Countries and their Cultures: http://www.everyculture.com/To-Z/United-States-of-America.html

Faragher, J. M., M. J. Buhle, D. Czitrom, and S. H. Armitage (1995). *Out of Many: A History of the American People.* Englewood Cliffs, NJ: Prentice Hall. Frater, J. (2007, November 20). *History: Top 15 Most Famous Native Americans.* Retrieved from Listverse.com: http://listverse.com/2007/11/20/top-15-most-famous-native-americans/

Goodyear A. (2012, November 13). Seeking a Scientific Summary of Clovis in the Southeast. Retrieved from http://www.clovisinthesoutheast.net/confocus.htm

Independence Hall Association . (2011). *American History: From Pre-Columbian to the New Millennium*. Retrieved from U.S. History: http://www.ushistory.org/us/1b.asp

International Monetary Fund. (2011, August). *Data and Statistics :
United States of America.* Retrieved from International Monetary Fund:
http://www.imf.org/external/pubs/ft/weo/2010/02/weodata/weoseladv.
aspx?a=&c=924&s=NGDP_R%2cNGDP_RPCH%2cNGDP%2cNGDPD%2cN
GDP_D%2cNGDPRPC%2cNGDPPC%2cNGDPDPC%2cPPPGDP%2cPPPPC%
2cPPPSH%2cPPPEX%2cPCPI%2cPCPIPCH%2cPCPIE%2cPCPIEPCH%2cLU
R%2cLP%2cGGR%2cGGR_NGDP%2cGG

U.S. Census Bureau, Statistical Abstract of the United States. (2011). Expectation
of Life at Birth, 1970-2007, and Projections, 2010–2020. Retrieved from census.
gov:http://www.census.gov/compendia/statab/2011/tables/11s0:03.pdf

U.S. Department of Interior/National Park Service. (2011, September 12). *Denali.*
Retrieved from National Park Service: http://www.nps.gov/dena/index.htm

U.S. Department of the Interior/National Park Service. (2010, September 29).
Death Valley. Retrieved from National Park Service: http://www.nps.gov/deva/
naturescience/index.htm

U.S. Department of State. (2011, September). *U.S. History.* Retrieved from U.S.
Department of State: http://countrystudies.us/united-states/history-4.htm

(China)

BBC News. (2008). *BBC on this day: December 19.* Retrieved from BBC
News: http://news.bbc.co.uk/onthisday/hi/dates/stories/december/19/
newsid_2538000/2538857.stm

Chaos at University of Maryland. (2011, August). *Republic of China.* Retrieved
from History Timelime: http://www-chaos.umd.edu/history/republican.
html#republic

Chinatouristmaps.com. (2011, August 25). *Location of China on the World Map.* Retrieved from China Tourist Maps: http://www.chinatouristmaps.com/china-maps/china-in-world.html

Chinese Government's Official Portal. (2007, June 14). *Full Text of Sino-British Joint Declaration.* (L. Hui, Editor) Retrieved from Chinese Government's Official Portal: http://www.gov.cn/english/2007-06/14/content_649468.htm

Economy Watch. (2011, August). *The Chinese Economy.* Retrieved from Economy Watch: http://www.economywatch.com/world_economy/china/

EconPost. (2011, February 21). *Top 10 world economy ranking.* Retrieved from EconPost: http://econpost.com/worldeconomy/world-economy-ranking

HistoryofChina.com. (2010). *About History of China.* Retrieved from History of China: http://www.history-of-china.com/

Hong Kong Baptist University. (1996, November 7). *Sino-British Joint Declaration.* Retrieved from Sino-British Joint Declaration: http://www.hkbu.edu.hk/~pchksar/JD/jd-full1.htm

International Monetary Fund. (2011, August). *Data and Statistics : China.* Retrieved from International Monetary Fund: http://www.imf.org/external/pubs/ft/weo/2010/02/weodata/weoseladv.aspx?a=&c=924&s=NGDP_R%2cNGDP_RPCH%2cNGDP%2cNGDPD%2cNGDP_D%2cNGDPRPC%2cNGDPPC%2cNGDPDPC%2cPPPGDP%2cPPPPC%2cPPPSH%2cPPPEX%2cPCPI%2cPCPIPCH%2cPCPIE%2cPCPIEPCH%2cLUR%2cLP%2cGGR%2cGGR_NGDP%2cGG

Ministry of Culture RR China. (2003). About China>Sci-Tech>Ancient>Scientists>Zu Chongzhi. Retrieved from China Culture: http://www.chinaculture.org/gb/en_aboutchina/2003-09/24/content_26294.htm

People's Daily Online. (2007, June 15). *The Sino-British Joint Declaration*
. Retrieved from People's Daily Online: http://english.peopledaily.com.
cn/200706/15/eng20070615_384581.html

U.S. Department of State. (2010, August 5). *Background Note: China.* Retrieved
from U.S. Department of State: http://www.state.gov/r/pa/ei/bgn/18902.htm

Chapter 2 China's Centralized Government

Chen, A., and S. Song (2006). *China's rural economy after WTO: problems and
strategies.* Burlington, VT: Ashgate Publishing Company.

Chu, R., D. Lau, S. Moriah, and A. Schallich (2012, January 12). *Communism in
China.* Retrieved from Communism and Computer Ethics: http://www-cs-faculty.
stanford.edu/~eroberts/cs181/projects/communism-computing-china/china.html

Columbus, F. (Ed.). (2003). *Asian Economic and Political Issues* (Vol. 8).
Hauppauge, New York: NOVA.

Dorn, J. A., and W. Xi (Eds.). (1990). *Economic reform in China: problems and
prospects.* Chicago: The University of Chicago Press.

Encyclopedia Britannica. (2012, January 12). *economic Systems: Centralized
states*. Retrieved from Encyclopedia Britannica: http://www.britannica.com/
EBchecked/topic/178493/economic-systems/61115/Centralized-states

Hitt, M. A., R. D. Ireland, and R. E. Hoskisson (2009). *Strategic management:
competitiveness and globalization : cases.* Mason, OH: South-Western.

Houghton Mifflin Company. (1996). *The American Heritage College Dictionary.*
Boston, MA: Houghton Mifflin Company.

Merriam-Webster. (2012, January 12). *Communism*. Retrieved from Merriam-Webster: http://www.merriam-webster.com/dictionary/communism

Sachs, J. (2005). *The end of poverty: economic possibilities for our time.* London, England: Penguin Books LTD.

Theobald, U. (2000). *Han Dynasty: government, administration and law.* Retrieved from Chinese History: http://www.chinaknowledge.de/History/Han/han-admin.html

UN ESCAP (2012, January). *Local Government in Asia and the Pacific: A Comparative Study.* Retrieved from United Nations Economic and Social Commisssion for Asia and the Pacific: http://www.unescap.org/huset/lgstudy/country/china/china.html

Wei, Y. D. (2000). *Regional development in China: states, globalization, and inequality.* New York: Routledge.

Zhou, J. (2003). *Remarking China's Public Philosophy for the Twenty-first Century.* Westport , CT: Greenwood Publishing.

Chapter 3 Public Policy and Social Organization

(United States)

Dictionary.com. (2011, September). *Social Organization*. Retrieved from Dictionary.com: http://dictionary.reference.com/browse/social%20organization

Hunt, E. F., and D. C. Colander (2008). *Social Science: An introduction to the study of society.* Boston: Pearson Education Inc.

Kerbo, H. R. (2009). *Social Stratification and Inequality.* New York: McGraw Hill Co.

Kilpatrick, D. G. (2000). *Definitions of Public Policy and the Law* .
Retrieved from Medical University of South Carolina: http://www.musc.edu/
vawprevention/policy/definition.shtml

Milakovich, M. E., and G. J. Gordon (2009). *Public Administration in America.*
Boston: Wadsworth Cengage Learning.

O'Neil, D. (2008). *SOCIAL ORGANIZATION: An Overview of How We Create
and Maintain Social Groups*. Retrieved from Palomar.edu: http://anthro.palomar.
edu/status/stat_1.htm

Rushefsky, M. E. (2008). *Public Policy in the United States: At the Dawn of the
Twenty-First Century* . Armond, New York: M.E. Sharpe, Inc.

Sociology Guide. (2011). *Basic Concepts: Social Groups*. Retrieved from
Sociology Guide: http://www.sociologyguide.com/basic-concepts/Social-Groups.
php

Stanford University. (2011). *Law and Public Policy*. Retrieved from Stanford
University: http://www.law.stanford.edu/program/degrees/joint/public_policy/

Theodoulou, S.Z. and C. Kofinis (2004). *Definition of Public Policy Evaluation.*
Retrieved from https://courses.worldcampus.psu.edu/welcome/plsc490/
lesson05_07.html

(China)

China Culture. (2008, February). *Social Organization in China.* Retrieved from
China Culture: http://www.chinaculture.org/library/2008-02/14/content_22259.
htm

Gustafsson, B., S. Li, and T. Sicular (2008). *Inequality and Public Policy in
China.* New York, NY: Cambridge University Press.

Harding, H. (1981). *Organizing China: the problem of bureaucracy, 1949-1976*. Standford, CA: Standford University.

Wood. (2011, September). *Sources Of Public Authority and Political Power*. Retrieved from Sources Of Public Authority and Political Power: http://phs.prs.k12.nj.us/ewood/China2/change.htm

Yi, L. (2005). *The Structure and Evolution of Chinese Social Stratification*. University Press of America.

Chapter 4 Culture, Diversity, and Wealth

(United States)

Adams, D., & Goldbard, A. (1995). *New Deal Cultural Programs: Experiments in Cultural Democracy*. Retrieved from The Institute for Cultural Democracy: http://www.wwcd.org/policy/US/newdeal.html

Domhoff, G. W. (2011, July). *Wealth, Income, and Power*. Retrieved from Who Rules America?: http://sociology.ucsc.edu/whorulesamerica/power/wealth.html

Every Culture. (2011, September). *United States of America*. Retrieved from Countries and their Cultures: http://www.everyculture.com/To-Z/United-States-of-America.html

Hunt, E. F., & Colander, D. C. (2008). *Social Science: An Introduction to the Study of Society*. Boston.

Kerbo, H. R. (2009). *Social Stratification and Inequality: Class Conflict in History, Comparative, and Global Perspective*. New York: McGraw-Hill Companies.

Rubenstein, J. M. (2008). *An Introduction to Human Geography.* Upper Saddle River: Prentice Hall.

The New York Times. (2007, August 12). *Opinion: World's Best Medical Care?* . Retrieved from The New York Times: http://www.nytimes.com/2007/08/12/ opinion/12sun1.html?pagewanted=all

U.S. Census Bureau. (2011). *United States Census 2010.* Retrieved from U.S. Census Bureau: http://2010.census.gov/2010census/data/

(China)

Advameg. (2011). *Introduction to China - Unity and Diversity in China Today.* Retrieved from Countries and their cultures: http://www.everyculture.com/ Russia-Eurasia-China/Introduction-to-China-Unity-and-Diversity-in-China-Today.html

Lee, S. (2010, June 28). *China's unequal wealth-distribution map causing social problems.* Retrieved from The China Post : http://www.chinapost.com.tw/ commentary/the-china-post/special-to-the-china-post/2010/06/28/262505/Chinas-unequal.htm

Li, C. (2008, July). *China's Fifth Generation: Is Diversity a Source of Strength or Weakness?* Retrieved from AsiaPolicyNBR.org: http://www.nbr.org/publications/ asia_policy/Free/AP6/AP6_D_Li.pdf

Meng, X. (2007, January). *Wealth Accumulation and Distribution in urban China.* Retrieved from Iza.org: http://ftp.iza.org/dp2553.pdf

Monan, Z. (2010, January 21). *China needs a wealth distribution revolution*. Retrieved from China Daily: http://www.chinadaily.com.cn/thinktank/2010-01/21/content_9354134.htm

Stepan, M. (2009, September 6). *The development of the Chinese Welfare State and the prospects of EU Policy*. Retrieved from eucss.org: http://www.eucss.org.cn/fileadmin/research_papers/policy/Unemployment_Insurance/090902_Stepan_The_Development_of_the_Chinese_welfare_State.pdf

Weisenthal, J. (2011, March 11). *The Biggest Peace Time Wealth Distribution In China's History*. Retrieved from Business Insider: http://articles.businessinsider.com/2011-03-11/markets/29961200_1_housing-program-subsidized-housing-government-spending

Xinjua. (2009, March 5). *China to boost spending on welfare, education, health care*. Retrieved from China Daily: http://www.chinadaily.com.cn/china/2009-03-05/content_7542377.htm

Yunlong, S. (2008, November 2). *Report: China to become a welfare state by 2049*. Retrieved from Xinhua News Agency: http://news.xinhuanet.com/english/2008-11-02/content_10295173.htm

Chapter 5 Poverty—Its Challenges and Solutions

(United States)

AARP. (2006, December 14). *Income, Poverty, and Health Insurance in the United States in 2005*. Retrieved from AARP: http://assets.aarp.org/rgcenter/econ/fs133_income.pdf

Fredix, E. (2010, April). *Yahoo Finance*. Retrieved from Forecasters Optimistic About Economy, Job Creation: http://news.yahoo.com/s/ap/20100426/ap_on_bi_ ge/us_nabe_survey

Goodman, P. (2010, February). *Despite Signs of Recovery, Chronic Joblessness Rises.* Retrieved from The New York Times: http://www.nytimes. com/2009/11/07/business/economy/07jobs.html?hp

Haq, H. (2010, March). *Who's Poor in America? US leaks hwo it defines poverty.* Retrieved from CS monitor: http://www.csmonitor.com/USA/2010/0303/Who-s-poor in-America-US-tweaks-how-it-defines-poverty

Hunt, E., and D, Colander. (2008). *Social and Economic Stratification. Social Sciente: An Introduction to the Study of Society.* Boston: Pearson Education, Inc.

Irons, J. (2009, February). *Economic Scarring: The Long-term Impacts of the Recession.* Retrieved from Economic Policy Institute: http://www.epi.org/ publications/entry/bp243/

Kvaal, J., and B. Furnas. (2009, February). *Recession, Poverty, and the Recovery Act; Millions Are at Risk of Falling Out of the Middle Class.* Retrieved from Center for American Progress: http://www.americanprogress.org/issues/2009/02/ middle_class_report.html

Maierhofer. (2010).

Maierhofer, S. (2010, April). *5 Bull Market Game Changers.* Retrieved from Yahoo Finance: http://finance.yahoo.com/news/5-Bull-Market-Game-etfguide-1886653744.html?x=0

Tavernise, S., and R. Gebeloff. (2011, November 7). *New Way to Tally Poor Recasts View of Poverty.* Retrieved from The New York Times: http://www. nytimes.com/2011/11/08/us/poverty-gets-new-measure-at-census-bureau.html

The University of Michigan. (2011, November 30). *National Poverty Center*. Retrieved from Frequently Asked Questions: http://www.npc.umich.edu/poverty/

U.S. Bureau of Labor Statistics. (2010).

U.S. Bureau of Labor Statistics. (2010). *Labor Force Statistics from the Current Population Survey*. Retrieved from U.S. Bureau of Labor Statistics: http://data.bls.gov/PDQ/servlet/SurveyOutputServlet?series_id=LNS14000000

U.S. Census Bureau. (2008, August). *Income, Poverty, and Health Insurance Coverage in the United States: 2007*. Retrieved from U.S. Census Bureau: http://www.census.gov/prod/2008pubs/p60-235.pdf

U.S. Census Bureau. (2007, August). *Income, Poverty, and Health Insurance Coverage in the United States: 2006*. Retrieved from U.S. Census Bureau: http://www.census.gov/prod/2007pubs/p60-233.pdf

U.S. Census Bureau. (2011, December 5). *Poverty*. Retrieved from U.S. Census Bureau: http://www.census.gov/hhes/www/poverty/data/historical/people.html

U.S. Courts. (2011, December 5). *Bankrupcy Statistics*. Retrieved from U.S. Courts: http://www.uscourts.gov/Statistics/BankruptcyStatistics.aspx

U.S. Courts. (2009). *Bankruptcy Filings Up 34 Percent over Last Fiscal Year*. Retrieved from U.S. Courts: http://www.uscourts.gov/Press_Releases/2009/BankruptcyFilingsSep2009.cfm

United States Courts. (2009).

Versace, C. (2009, December 4). *Unemployment Signals Lackluster U.S. Recovery*. Retrieved from The Washington Times: http://www.washingtontimes.com/news/2009/dec/04/unemployment-signals-lackluster-us-recovery/

Yen, H. (2011, November 7). *U.S. Poverty: Record 49.1 Million Americans Are Poor According To New Census Measures* . Retrieved from The Huff Post : http://www.huffingtonpost.com/2011/11/07/supplemental-poverty-measure_n_1080160.html

(China)

ET. (2011, November 29). *China increases rural poverty limit to $1 a day.* Retrieved from BBC News China: http://www.bbc.co.uk/news/world-asia-china-15956299

Park, A., and S. Wang. (2002, January 17). *China's poverty statistics.* Retrieved from China Economic Review: http://ihome.ust.hk/~albertpark/papers/povstats. pdf

Ravallion, M., and D. v. Walle. (2008, September). *Land and Poverty in Reforming East Asia.* Retrieved from International Monetary Fund: http://www. imf.org/external/pubs/ft/fandd/2008/09/ravallion.htm

Reuters. (2011, November 29). *China eyes boost in poverty line to $1 a day* . Retrieved from The Global Exchange: http://www.theglobeandmail.com/report-on-business/international-news/global-exchange/international-roundup/china-eyes-boost-in-poverty-line-to-1-a-day/article2253143/

Rigby, B. (2011, April 17). *Banking to Lift Poverty in China.* Retrieved from Iowaiblog: http://laowaiblog.com/banking-for-the-poor-2/

Rural Survey Organization of National Bureau of Statistics, China. (2004, September). *Poverty Statistics in China.* Retrieved from nscb.gov: http://www. nscb.gov.ph/poverty/conference/papers/4_poverty%20statistics%20in%20china. pdf

S.C. (2011, December 2). *Life at the bottom of the middle kingdom* . Retrieved from The Economist: http://www.economist.com/blogs/freeexchange/2011/12/chinas-poverty-line

Zhu, J. (2010, October 28). *China to raise its poverty line.* Retrieved from China Daily: http://www.chinadaily.com.cn/china/2010-10/28/content_11467561.htm

PART 2 Two Economies Profiled

Chapter 6 Recessions and Depressions in the United States and China

(United States)

Albert, S. (2008, December 16). *The Great Recession 2008-2009.* Retrieved from AFL-CIO Housing Investment Trust: http://www.aflcio-hit.com/user-assets/Documents/Economic_analysis/2008_great_recession.pdf

Amadeo, K. (2011, September 24). *U.S Economy: The History of Recessions in the United States.* Retrieved from About.com: http://useconomy.about.com/od/grossdomesticproduct/a/recession_histo.htm

Dieli, R. F. (2011, September 1). *Overview and Outlook.* Retrieved from nospinforecast.com: www.nospinforecast.com/getfile.php?code...cf=1

Fabricant, S. (1972). The Recession of 1969-1970. In V. Zarnowitz, & V. Zarnowitz (Ed.), *Economic Research: Retrospect and Prospect Vol 1: The Business Cycle Today.*

ING-USA. (2009, July 20). *Recession 101.* Retrieved from Ingretirementplans.com: https://www.ingretirementplans.com/3013471.X.G_Recession_FINAL.pdf

Khimm, S. (2011, September 13). *The Great Recession in five charts* . Retrieved from The Washington Post: http://www.washingtonpost.com/blogs/ezra-klein/post/the-great-recession-in-five-charts/2011/09/13/gIQANuPoPK_blog.html

Labonte, M., and G. Makinen. (2002, January 10). *The Current Economic Recession:How long, how deep and how different from the past?* Retrieved from fpc.state.gov: fpc.state.gov/documents/organization/7962.pdf

Merriam-Webster. (2011). *Stagflation.* Retrieved from Merriam-Webster: http://www.merriam-webster.com/dictionary/stagflation

Romer, C. D. (2008). *Business Cycles.* Retrieved from Economics Library: http://www.econlib.org/library/Enc/BusinessCycles.html

US History Project. (2011). *US History: Economics 1960.* Retrieved from elcoushistory.tripoid.com: http://elcoushistory.tripod.com/economics1960.html

Verick, S., and I. Islam. (2010, May). *The Great Recession of 2008–2009: Causes, Consequences and Policy Responses.* Retrieved from http://ftp.iza.org/dp4934.pdf

(China)

Arabian Money. (2011, June 10). *Marc Faber forecasts recession in China and big looses for the rich.* Retrieved from Arabian Money: http://www.arabianmoney.net/us-dollar/2011/06/10/marc-faber-forecasts-recession-in-china-and-big-losses-for-the-rich/

Eckstein, A. (1978). *China's economic revolution.* Cambridge University Press.

The Economic Times. (2011, August 9). *Recession 2011: Inflation surges in China amid US downgrade worries.* Retrieved from The Economic Times: http://articles.economictimes.indiatimes.com/2011-08-09/news/29867137_1_inflation-surges-china-s-consumer-price-index-national-bureau

Fewsmith, J. (1994). *Dilemmas of reform in China: political conflict and economic debate.* M.E. Sharpe Inc.

Garnaut, R., L. Song. (2006). *The turning point in China's economic development.* ANU E Press and Asia Pacific Press.

Reuvid, J. (2011). *Business Insights: China: Practical Advice on Operational Strategy and Risk Management.* Kogan Page.

Wall Street Journal. (2009, January 22). *What does Recession in China look like?* Retrieved from Wall Street Journal: http://blogs.wsj.com/economics/2009/01/22/what-does-recession-in-china-look-like/

Chapter 7 U.S. Trade Agreements

Barnes and Richardson. (2011, October 21). *President Signs FTAs, GSP/TAA Legislation* . Retrieved from Barnes/Richardson Global Trade Law: http://www.barnesrichardson.com/?t=40&an=9917&format=xml&p=3731

Department of Homeland Security. (2011). *North American Free Trade Agreement (NAFTA)* . Retrieved from Department of Homeland Security: http://www.cbp.gov/xp/cgov/trade/trade_programs/international_agreements/free_trade/nafta/

export.gov. (2011, March 31). *Dominican Republic-Central America-United States Free Trade Agreement (CAFTA-DR)* . Retrieved from export.gov: http://export.gov/FTA/cafta-dr/index.asp

export.gov. (2011, October 11). *The U.S.-Australia Free Trade Agreement.* Retrieved from export.gov: http://export.gov/FTA/australia/index.asp

Free Trade Area of the Americas - FTAA. (2006, June 21). *Free Trade Area of the Americas - FTAA*. Retrieved from http://www.ftaa-alca.org/View_e.asp

International Trade Administration. (2011). *Free Trade Agreements*. Retrieved from International Trade Administration: http://trade.gov/fta/

MacLeod, I. (2000, June). *Foreign Trade Zones*. Retrieved from Trade Information Center: http://ia.ita.doc.gov/ftzpage/tic.html

Nanto, D. K. (2006, November 22). *U.S. International Trade: Trends and Forecasts*. Retrieved from The Library of Congress: http://fpc.state.gov/documents/organization/77717.pdf

Public Citizen. (2011). *North American Free Trade Agreement (NAFTA)*. Retrieved from Public Citizen: http://www.citizen.org/Page.aspx?pid=531

S.B. (2011, October 15). *The Colombia-United States free-trade agreement.* Retrieved from The Economist: http://www.economist.com/blogs/americasview/2011/10/colombia-united-states-free-trade-agreement

U.S. Department of Commerce. (2011, October 13). *U.S. Census Bureau/U.S. Bureau of Economic Analysis*. Retrieved from U.S. Census Bureau-Foreign Trade: http://www.census.gov/foreign-trade/Press-Release/current_press_release/ftdpress.pdf

United States Department of Agriculture. (2011, June 30). *North American Free Trade Agreement*. Retrieved from Foreign Agricultural Services: http://www.fas.usda.gov/itp/policy/nafta/nafta.asp

United States International Trade Commission. (2011, November). *United States International Trade Commission*. Retrieved from United States International Trade Commission: http://www.usitc.gov/

United States Trade Representative. (2011, November). *North American Free Trade Agreement* . Retrieved from United States Trade Representative: http://www.ustr.gov/trade-agreements/free-trade-agreements/north-american-free-trade-agreement-nafta

United States Trade Representative. (2011, November). *United States Trade Representative*. Retrieved from United States Trade Representative: http://www.ustr.gov/

United States Trade Representative. (2012, November). *Free Trade Agreement KORUS-FTA*. Retrieved from ustr.gov:http://www.ustr.gov/trade-agreements/free-trade-agreements/korus-fta

Chapter 8 China's Reforms

China Daily. (2009, January 12). *A good first step in China's health care reform*. Retrieved from China.org.cn: http://www.china.org.cn/health/2009-01/12/content_17094730.htm

China Daily. (2009, January 15). *Reform 'must be pushed forward'*. Retrieved from china.org.cn: http://www.china.org.cn/government/news/2009-01/15/content_17109985.htm

Hannum, E. (2009). *Education and Reform in China*.

Hu, Z., and M. S. Khan. (1997, April). *Why is China Growing So Fast?* Retrieved from International Monetary Fund: http://www.imf.org/external/pubs/ft/issues8/issue8.pdf

Ji, L. (2003, September 5). *The Reform of Chinese Political System.* Retrieved from China Europe International Business School: http://www.ceibs.edu/ase/Documents/EuroChinaForum/liuji.htm

Kaye, J. (2011, April 14). *China Struggles With Health Care Reform Amid Growing Demand.* Retrieved from PBS Newshour: http://www.pbs.org/newshour/bb/health/jan-june11/china_04-14.html

U.S. Library of Congress. (1987). *The First Wave of Reforms 1979-1984.* (R. L. Worden, A. M. Savada, & R. E. Dolan, Editors) Retrieved from China: A country study: http://countrystudies.us/china/117.htm

Weiguang, W. (2008, April 18). *China's Reform, Opening up and its Path of Development.* Retrieved from The Institute of Latin American Studies Chinese Academy of Social Sciences: http://ilas.cass.cn/uploadfiles/ens/%7BED7B5A7A-AB19-4962-B321-007EDFD1E13F%7D.pdf

Xinhua News Agency . (2009, May 17). *China reforms all life aspects.* Retrieved from China.org.cn: http://www.china.org.cn/china/reform-opening-up/2009-05/17/content_17788337.htm

Chapter 9 Twenty Years of U.S. and Chinese GDP

Bureau of Economic Analysis. (2011, November 9). *National Economic Accounts.* Retrieved from U.S. Department of Commerce- Bureau of Economic Analysis:

China.org. (2005, September 3). *Change of China's GDP Over 20 Years*. Retrieved from Crienglish.com: http://english.cri.cn/855/2005/09/03/192@16626. htm

Gongloff, M. (2003, October 30). *U.S. economic growth sizzles* . Retrieved from CNN Money: http://money.cnn.com/2003/10/30/news/economy/gdp/index.htm

International Monetary Fund. (2011, November 9). *Data and Statistics*. Retrieved from International Monetary Fund: http://www.imf.org/external/pubs/ft/ weo/2011/02/weodata/weoseladv.aspx?a=&c=924%2c111&s=NGDP_RPCH%2c NGDPD%2cNGDP_D%2cNGDPDPC%2cNGAP_NPGDP%2cPPPGDP%2cPP PPC%2cPPPSH%2cNID_NGDP%2cNGSD_NGDP%2cGGR_NGDP%2cGGX_ NGDP%2cGGXCNL_NGDP

International Monetary Fund. (2011, November 10). *Data and Statistics*. Retrieved from International Monetary Fund: http://www.imf.org/external/pubs/ ft/weo/2010/02/weodata/weoseladv.aspx?a=&c=924&s=NGDP_R%2cNGDP_ RPCH%2cNGDP%2cNGDPD%2cNGDP_D%2cNGDPRPC%2cNGDPPC%2cN GDPDPC%2cPPPGDP%2cPPPPC%2cPPPSH%2cPPPEX%2cPCPI%2cPCPIPC H%2cPCPIE%2cPCPIEPCH%2cLUR%2cLP%2cGGR%2cGGR_NGDP%2cGG

Pettis, M. (2011, January 31). *How Big Is Chinese GDP*. Retrieved from Financial Sence: http://www.financialsense.com/contributors/michael-pettis/how-big-is-chinese-gdp

Smith, J. F. (2004, October 29). *Strong Economic Growth in China and the United States means a more balanced World Economy*. Retrieved from siordata. com: http://www.siordata.com/publications/Smith%20fall%202004.pdf

Subramanian, A. (2011, January 13). *Is China Already Number One? New GDP Estimates*. Retrieved from Peterson Institute for International Economics: http://www.iie.com/realtime/?p=1935

The World Bank. (2011, November 10). *GDP growth (annual %)* . Retrieved from The World Bank: http://data.worldbank.org/indicator/NY.GDP.MKTP. KD.ZG?page=4

PART 3 Trade Partners and Competitors

Chapter 10 The Trade War Between the United States and China

Bradsher, K. (2012, October 11). *For Solar Panel Industry, a Volley of Trade Cases*. Retrieved from The New York Times: http://www.nytimes. com/2012/10/12/business/global/us-places-tariffs-on-imports-of-chinese-solar-panels.html?pagewanted=all&_r=0

Bradsher, K. (2011, November 9). *Trade War in Solar Takes Shape*. Retrieved from The New York Times: http://www.nytimes.com/2011/11/10/business/global/us-and-china-on-brink-of-trade-war-over-solar-power-industry.html?pagewanted=all

China Global Trade. (2012, May 17). *Commerce Dept. Assesses 31% Anti-Dumping Tariff in US-China Solar Trade Case*. Retrieved from China Global Trade.Com: http://www.chinaglobaltrade.com/article/commerce-dept-assesses-31-anti-dumping-tariff-us-china-solar-trade-case

Ikenson, D. (2012, February 29). *Congress Poised to Escalate U.S.-China Trade War*. Retrieved from Forbes: http://www.forbes.com/sites/danikenson/2012/02/29/congress-poised-to-escalate-u-s-china-trade-war/

Morath, E. (2012, March 5). *US Senate Unanimously Passes China Tariff Bill*. Retrieved from Nasdaq: http://www.nasdaq.com/article/us-senate-unanimously-passes-china-tariff-bill-20120305-01250

Shah, J. (2012, March 5). *Viewpoint: Growing U.S. Solar Industry Doesn't Need New Tariffs and a Trade War with China* . Retrieved from Industry Week: http://www.industryweek.com/articles/viewpoint_growing_u-s-_solar_industry_doesnt_need_new_tariffs_and_a_trade_war_with_china_26746.aspx?Page=2&SectionID=2

Chapter 11 U.S. and Chinese Trade Deficits

Bloomberg News . (2012, April 9). *China Unexpectedly Reports Trade Surplus*. Retrieved from Bloomberg News : http://www.bloomberg.com/news/2012-04-10/china-unexpectedly-reports-trade-surplus.html

Bloomberg News. (2011, March 10). *China's Surprise Trade Deficit May Help Nation Parry U.S. Yuan Criticism*. Retrieved from Bloomberg News: http://www.bloomberg.com/news/2011-03-10/china-unexpectedly-posts-7-3-billion-trade-deficit-as-export-growth-slows.html

Chandra, S. (2012, February 10). *Trade Deficit in U.S. Rose in December to Six-Month High on Import Growth*. Retrieved from Bloomberg: http://www.bloomberg.com/news/2012-02-10/trade-deficit-in-u-s-rose-in-december-to-six-month-high-on-import-growth.html

Edwards, N. (2012, April 9). *China surprises with export-led March trade surplus*. Retrieved from Reuters: http://www.reuters.com/article/2012/04/10/us-china-economy-trade-idUSBRE83903H20120410

Trade Economics. (2012, April). *China Balance of Trade*. Retrieved from Trade Economics: http://www.tradingeconomics.com/china/balance-of-trade

Tung, R. (2011, November 22). *China may post trade deficit next year: adviser*. Retrieved from Reuters: http://www.reuters.com/article/2011/11/22/us-china-economy-xia-idUSTRE7AL0MK20111122

Zarathustra, W. (2011, March 10). *China: Trade Balance Went Negative In Feb 2011*. Retrieved from Business Insider: http://articles.businessinsider.com/2011-03-10/markets/30037191_1_trade-deficit-february-exports-general-administration

Chapter 12 U.S. Debt and Who Holds It

Bureau of the Public Debt. (2012, April 4). *Monthly Statement of the Public Debt of the United States*. Retrieved from treasurydirect.gov: http://www.treasurydirect.gov/govt/reports/pd/mspd/2012/opds032012.pdf

Bureau of the Public Debt. (2011, November 23). *The Debt to the Penny and Who Holds It*. Retrieved from TreasuryDirect: http://www.treasurydirect.gov/NP/BPDLogin?application=np

Defeat the Debt. (2012, April). *A Snapshot of our National Debt:*. Retrieved from Defeat the Debt: http://www.defeatthedebt.com/understanding-the-national-debt/how-much-do-we-owe/

Department of the Treasury/Federal Reserve Board. (2012, April 16). *Major Foreign Holders Of Treasury Securities*. Retrieved from treasury.gov: http://www.treasury.gov/resource-center/data-chart-center/tic/Documents/mfh.txt

Geiger, J., and W. Fiske. (2011, April 26). *Randy Forbes says the U.S. pays China $73.9 million per day in debt interest*. Retrieved from Politifact Virginia: http://www.politifact.com/virginia/statements/2011/apr/26/randy-forbes/randy-forbes-says-us-pays-china-739-million-day-de/

Kruger, D. (2011, November 17). *China Long-Term Treasury Holdings Rise Most Since March 2010*. Retrieved from Bloomberg Businessweek: http://www. businessweek.com/news/2011-11-17/china-long-term-treasury-holdings-rise-most-since-march-2010.html

Pollock, A. J. (2011, JUly 13). *The Government's Four-Decade Financial Experiment*. Retrieved from The American: http://american.com/archive/2011/july/the-government2019s-four-decade-financial-experiment

TreasuryDirect. (2012, April 5). *Managed by the Bureau of the Public DebtFor the period from September 30, 2011 through March 31, 2012 - Unaudited*. Retrieved from TreasuryDirect: http://www.treasurydirect.gov/govt/reports/pd/feddebt/feddebt_mar12.pdf

TreasuryDirect. (2012, April 26). *The Debt to the Penny and Who Holds It*. Retrieved from TreasuryDirect: http://www.treasurydirect.gov/NP/BPDLogin?application=np

Tucker, P. (2004). *Analytical Perspectives: Budget of the United States Government, Fiscal Year ...* Claitors Publishing Division.

U.S. Department of the Treasury. (2011, November 22). *Daily Treasury Yield Curve Rates* . Retrieved from U.S. Department of the Treasury: http://www. treasury.gov/resource-center/data-chart-center/interest-rates/Pages/TextView. aspx?data=yieldYear&year=2011

U.S. Treasury Department. (2011, November 6). *Major Foreign Holders Of Treasury Securities*. Retrieved from U.S. Treasury Department: http://www. treasury.gov/resource-center/data-chart-center/tic/Documents/mfh.txt

U.S. Treasury Department. (2009, February 27). *Preliminary Report On Foreign Holdings Of U.S. Securities at end of June 2008*. Retrieved from U.S. Treasury Department: http://www.treasury.gov/press-center/press-releases/Documents/ticreport02272009.pdf

U.S. Department of the Treasury, Bureau of the Public Debt. (2011, May 16). *General Information*. Retrieved from Trerasury Direct: http://www.treasurydirect.gov/govt/resources/faq/faq_publicdebt.htm

U.S. Department of the Treasury, Bureau of the Public Debt. (2012, April 3). *Debt Position and Activity Report*. Retrieved from treasurydirect.gov: http://www.treasurydirect.gov/govt/reports/pd/pd_debtposactrpt_0312.pdf

U.S. Government Accountability Office. (2011, November). *Bureau of the Public Debt's Fiscal Years 2010 and 2011 Schedules of Federal Debt*. Retrieved from treasurydirect.gov: http://www.treasurydirect.gov/govt/reports/pd/feddebt/feddebt_ann2011.pdf

Chapter 13 China's Total Trade Value

(Imports and Exports)

Back, A. (2011, December 12). *Exclusive Holiday Offers from the Journal See today's Offers* . Retrieved from The Wall Street Journal: http://online.wsj.com/article/SB10001424052970203413304577089292425553450.html

International Monetary Fund. (2011, September 20). *Data and Statistics: China*. Retrieved from International Monetary Fund: http://www.imf.org/external/pubs/ft/weo/2011/02/weodata/weorept.aspx?sy=2012&ey=2012&scsm=1&ssd=1&sort=country&ds=.&br=1&c=924&s=NGDP_R%2CNGDP_RPCH%2CNGDP%2CNGDPD%2CNGDP_D%2CNGDPRPC%2CNGDPPC%2CNGDPDPC%2CPPPGDP%2CPPPPC%2CPPPSH%2CPPPEX%2CNID_NGDP%2CNGSD_NGD

Lee, D. (2008, January 12). *China's global trade surplus up 47%.* Retrieved from Los Angeles Times: http://articles.latimes.com/2008/jan/12/business/fi-chinatrade12

Lum, T., and D. K. Nanto. (2006, March 14). *China's Trade with the United States and the World.* Retrieved from U.S. Department of State: http://fpc.state.gov/documents/organization/64475.pdf

Morrison, W. M. (2011, September 30). *China-U.S. Trade Issues.* Retrieved from Federation of American Scientists: http://www.fas.org/sgp/crs/row/RL33536.pdf

Rohwer, J. (1996). *Asia Rising.* New York, NY: Simon & Schuster.

Ruan, V. (2011, November 21). *China Trade Surplus May Be Gone in Two Years, Adviser Says.* Retrieved from Bloomberg Businessweek: http://www.businessweek.com/news/2011-11-21/china-trade-surplus-may-be-gone-in-two-years-adviser-says.html

Trademark Southern Africa. (2011, December 7). *China's foreign trade: white paper.* Retrieved from Trademark Southern Africa: http://www.trademarksa.org/news/chinas-foreign-trade-white-paper

Trading Economics. (2011, December 14). *China Balance of Trade.* Retrieved from Trading Economics: http://www.tradingeconomics.com/china/balance-of-trade

Winning, D., and C. W. Yap. (2010, January 11). *China's Exports Turn Upward in December.* Retrieved from Wall Street Journal: http://online.wsj.com/article/SB126310314103423521.html

Zhongxiu, Z., and S. Jingying. (2011, November 24). *China's trade surplus not due to global economic imbalance .* Retrieved from China Insight: http://www.chinainsight.info/business/95-economy/751-chinas-trade-surplus-not-due-to-global-economic-imbalance.html

(Foreign Direct Investment)

Chinability. (2011). *The rise of foreign direct investment (FDI)*. Retrieved from FDI inflows into China 1984-2009: http://www.chinability.com/FDI.htm

Fung, K., H. Iizaka, and S. Tong. (2002, June). *Foreign Direct Investment in China: Policy, Trend and Impact* . Retrieved from Hong Kong Institute of Economics and Business Statistics: http://www.hiebs.hku.hk/working_paper_updates/pdf/wp1049.pdf

International Monetary Fund . (1993). *Foreign Direct Investment*. Retrieved from United Nations Conferance on Trade and Development: http://www.unctad.org/Templates/Page.asp?intItemID=3147&lang=1

Panckhurst, P. (2011, September 15). *China's August Foreign Direct Investment Rises 11.1% on Year, MOFCOM Says*. Retrieved from Bloomber.com: http://www.bloomberg.com/news/2011-09-15/foreign-direct-investment-in-china-rises-11-1-in-august-to-8-45-billion.html

Webfinance Inc. (2012). Businessdictionary.com

The World Bank Group. (2008, April). *Special Economic Zones*. Retrieved from National Association of Foreign Trade Zones: http://www.naftz.org/docs/news/Special%20Economic%20Zones%20report_April2008.pdf
World Trade Organization. (2011, November 15). *Members and Observers*. Retrieved from World Trade Organization: http://www.wto.org/

Zhan, J. J. (2006, October). *FDI Statistics*. Retrieved from World Association of Investment Promotion Agencies: http://www.waipa.org/pdf/SurveyResults/Problems_with_FDI_statistics.pdf

PART 4 Aspects of U.S. Economic Policy

Chapter 14 U.S. Economic Trends

Bland, M. (2012, January 25). *FOMC statement from January 24-25 meeting.* Retrieved from Reuters: http://www.reuters.com/article/2012/01/25/us-usa-fed-text-idUSTRE80O1V220120125

Dunstan, P. (2012, Janaury 25). *A Fed First: Central Bankers to Unveil Forecasts.* Retrieved from Fox Business: http://www.foxbusiness.com/economy/2012/01/25/fed-likely-to-leave-interest-rates-unchanged/

Fergunson, B. M. (2012, January 24). *The GDP Growth Deception, Central Bank Manipulated Fake Economic Statistics .* Retrieved from The Market Oracle: http://www.marketoracle.co.uk/Article32768.html

Lowrey, A. (2012, January 23). *U.S. on track — for now — to meet higher export goal.* Retrieved from PostBulletin: http://www.postbulletin.com/news/stories/display.php?id=1483356

Spence, M. A. (2011, December 27). *Five Economic Trends to Watch in 2012.* Retrieved from Council on Foreing Relations: http://www.cfr.org/economics/five-economic-trends-watch-2012/p26903

WebFinance Inc. (2012, January 20). *Economic Trend.* Retrieved from Business Direct: http://www.businessdictionary.com/definition/economic-trend.html

Wieseman, T. (2012, January 24). *Review and Preview.* Retrieved from Mogan Stanley: http://www.morganstanley.com/views/gef/

Chapter 15 U.S. Exports

Association of Equipment Manufacturers (AEM). (2011, August 29). *U.S. agricultural equipment exports up 15 percent at midyear 2011.* Retrieved from AgriPulse: http://agri-pulse.com/AEM_Exports_8292011.asp

Department of Commerce. (2012, January 12). *Trading Economics.* Retrieved from United States Exports: http://www.tradingeconomics.com/united-states/exports

Dorish, J. (2010, July 30). *United States Main Exports and Trade Partners .* Retrieved from Factoidz: http://internationaltrade.factoidz.com/united-states-main-exports-and-trade-partners/

International Trade Administration. (2009, February). *Agricultural Equipment: Industry Assessment.* Retrieved from International Trade Administration: http://trade.gov/static/doc_Assess_Ag_Equip.asp

International Trade Administration. (2011, May 11). *U.S. Export Fact Sheet.* Retrieved from trade.gov: http://trade.gov/press/press-releases/2011/export-factsheet-may2011-051111.pdf

Investor Glossary (n.d.). http://www.investorglossary.com/capital-goods.htm

Phillip, D. J. (2011, December 31). *In a first, gas and other fuels are top U.S. export.* Retrieved from USA Today: http://www.usatoday.com/money/industries/energy/story/2011-12-31/united-states-export/52298812/1

U.S. Census Bureau. (2011, August 19). *Agricultural Exports—Value by Selected Countries of Destination: 1990 to 2010.* Retrieved from census.gov: http://www.census.gov/compendia/statab/2012/tables/12s0855.pdf

U.S. Department of Agriculture. (2012, January 17). *Foreign Agricultural Trade of the United States (FATUS).* Retrieved from U.S. Department of Agriculture: http://www.ers.usda.gov/Data/FATUS/

U.S. Department of Commerce. (2011, May 25). *On the Road: U.S. Automotive Parts Industry Annual Assessment.* Retrieved from trade.gov: http://trade.gov/static/2011Parts.pdf

U.S. Department of Commerce. (2012, January 13). *U.S. INTERNATIONAL TRADE IN GOODS AND SERVICES November 2011.* Retrieved from Census. gov: http://www.census.gov/foreign-trade/Press-Release/current_press_release/ft900.pdf

Chapter 16 Is Outsourcing Damaging the U.S. Economy?

Deb, S. (2012, January 14). *Rock Center with Brian Williams: Made in America: Trend against outsourcing brings jobs back from China.* Retrieved from MSNBC: http://rockcenter.msnbc.msn.com/_news/2012/01/14/10156162-made-in-america-trend-against-outsourcing-brings-jobs-back-from-china

Hassan. (2008, September 16). *How Outsourcing Affects The U.S. Economy!* Retrieved from Directory Journal: Business Journal: http://www.dirjournal.com/business-journal/how-outsourcing-affects-the-us-economy/

Investopedia. (2012, March). *Outsourcing.* Retrieved from Investopedia: http://www.investopedia.com/terms/o/outsourcing.asp#axzz1pma5a5CW

Levine, L. (2011, January 21). *Offshoring (or Offshore Outsourcing) and Job Loss among U.S. Workers.* Retrieved from House.gov: http://forbes.house.gov/UploadedFiles/CRS_-_Offshoring_and_Job_Loss_Among_U_S__Workers.pdf

Mohr, A. (2012, March 6). *4 Ways Outsourcing Damages Industry.* Retrieved from Investopedia: http://finance.yahoo.com/news/4-ways-outsourcing-damages-industry-155733127.html

U.S. House of Representatives. (2012, January 31). *McNerney Takes Lead On Outsourcing Bill.* Retrieved from McNerney house.gov: http://mcnerney.house.gov/index.php?option=com_content&view=article&id=688:mcnerney-takes-lead-on-outsourcing-bill&catid=8:latest-news

Chapter 17 U.S. Addiction to Debt

Barboza, D. (2011, August 6). *China Tells U.S. It Must 'Cure Its Addiction to Debt'*. Retrieved from The New York Times: http://www.nytimes.com/2011/08/07/business/global/china-a-big-creditor-says-us-has-only-itself-to-blame.html

Elliott, L. (2011, July 31). *US economy needs to rid itself of debt addiction*. Retrieved from The Guardian: http://www.guardian.co.uk/business/2011/jul/31/us-economy-debt-addiction

Grant, T. (2011, July 26). *Like the U.S., consumers also 'addicted to debt'*. Retrieved from Pittsburgh Post-Gazette: http://www.post-gazette.com/pg/11207/1162899-28-0.stm

Investor's Journal. (2011, November). *Lessons from the Dot-com bubble*. Retrieved from The Investor's Journal: http://www.theinvestorsjournal.com/lessons-from-the-dot-com-bubble

Macedonian International News Agency. (2011, March 1). *US Owes $1.16 Trillion to China, $882 Billion to Japan...* . Retrieved from Macedonian International News Agency: http://macedoniaonline.eu/content/view/17661/56/

Chapter 18 Is the United States Bankrupt?

Duncan, R. (2012, March 1). *Is The US Government Bankrupt?* Retrieved from RichDad: http://www.richdad.com/Resources/Rich-Dad-Financial-Education-Blog/March-2012/Is-The-US-Government-Bankrupt-.aspx

Kotlikoff, L. J. (2006, July/August). *Is the United States Bankrupt?* Retrieved from Federal Reserve Bank of St. Louis Review: http://research.stlouisfed.org/publications/review/06/07/Kotlikoff.pdf

Kotlikoff, L. (2010, August 11). *U.S. Is Bankrupt and We Don't Even Know It: Laurence Kotlikoff*. Retrieved from Bloomberg: http://www.bloomberg.com/news/2010-08-11/u-s-is-bankrupt-and-we-don-t-even-know-commentary-by-laurence-kotlikoff.html

Chapter 19 Sustainable Capitalism

Future Generations Party. (n.d.). *Capitalism and Sustainability*. Retrieved from Future Generations Party: http://www.future-generations-party.org/capitalism-and-sustainability.html

Generation Investment Management LLP. (2012, February 15). *Sustainable Capitalism*. Retrieved from socialk.com: http://blog.socialk.com/wp-content/downloads/gore-blood-paper.pdf

Gies, E. (2012, February 21). *How To Achieve Sustainable Capitalism*. Retrieved from Forbes: http://www.forbes.com/sites/ericagies/2012/02/21/five-ways-to-rein-in-rogue-capitalism/

Gore, A., and D. Blood. (2011, December 14). *A Manifesto for Sustainable Capitalism*. Retrieved from The Wall Street Journal: http://www.generationim.com/media/pdf-wsj-manifesto-sustainable-capitalism-14-12-11.pdf

Ikerd, J. (n.d.). *Sustainable Capitalism*. Retrieved from Missouri.edu: http://web.missouri.edu/~ikerdj/papers/WI-Madison%20Sustain%20Capitalism.htm

Chapter 20 Billions Wasted in Afghanistan

Crawford, N. C. (2011, June 13). *Civilian Death and Injury in Afghanistan, 2001-2011*. Retrieved from costofwar.org: http://costsofwar.org/sites/default/files/articles/14/attachments/Crawford%20Afghanistan%20Casualties.pdf

Farmer, B. (2011, August 19). *US troops may stay in Afghanistan until 2024*. Retrieved from The Telegraph: http://www.telegraph.co.uk/news/worldnews/asia/afghanistan/8712701/US-troops-may-stay-in-Afghanistan-until-2024.html

Khan, R. M. (2012, March 23). *A failing US strategy in Afghanistan*. Retrieved from uruknet.info: http://www.uruknet.info/?new=86768

Miklaszewski, J. (2012, March 13). *Officials: US soldier in Afghanistan shooting spree said 'I did it'*. Retrieved from MSNBC: http://worldnews.msnbc.msn.com/_news/2012/03/13/10670935-officials-us-soldier-in-afghanistan-shooting-spree-said-i-did-it

National Priorities Project. (2012, april 23). *Cost of war Afghanistan*. Retrieved from costofwar: http://costofwar.com/en/

New York Times. (2012, April 22). *TLP Quik Hits: US To Intervene In Afghanistan Until 2025*. Retrieved from The Libertarian Patriot: http://www.thelibertarianpatriot.com/2012/04/tlp-quik-hits-us-to-intervene-in.html

Riegert, B. (2012, April 20). *NATO seeks funding for Afghan security forces*. Retrieved from Deutsche Welle : http://www.dw.de/dw/article/0,,15898538,00.html

Rogers, S., and A. Sedghi. (2012, March 12). *Datablog: Afghanistan civilian casualties: year by year, month by month*. Retrieved from The Guardian: http://www.guardian.co.uk/news/datablog/2010/aug/10/afghanistan-civilian-casualties-statistics

Seervai, S. (2012, March). *Leave Af4ghanistan, But Not In Haste* . Retrieved from Polimic: http://www.policymic.com/articles/5552/leave-afghanistan-but-not-in-haste

Shah, T., and G. Bowley. (2012, March 11). *U.S. Sergeant Is Said to Kill 16 Civilians in Afghanistan*. Retrieved from The New York Times: http://www.nytimes.com/2012/03/12/world/asia/afghanistan-civilians-killed-american-soldier-held.html?pagewanted=all

Tirman, J. (2012, January 3). *The Forgotten Wages of War*. Retrieved from The New York Times: http://www.nytimes.com/2012/01/04/opinion/the-forgotten-wages-of-war.html

UNAMA. (2012, February). *Afghanistan: Annual Report 2011*. Retrieved from umissions.org: http://unama.unmissions.org/Portals/UNAMA/Documents/UNAMA%20POC%202011%20Report_Final_Feb%202012.pdf

Washington Post. (2012, April 25). *How not to abandon Afghanistan* . Retrieved from The Salt Lake Tribune: http://www.sltrib.com/sltrib/opinion/53978692-82/afghanistan-afghan-nato-deal.html.csp

Watson Institute. (2011). *Human Costs: Civilian Killed and Wounded* . Retrieved from Costs of War: http://costsofwar.org/article/afghan-civilians

PART 5 Aspects of Chinese Economic Policy

Chapter 21 Chinese Economic Trends

Huang, Y. (2011, December 27). *China's Rise Under Stress* . Retrieved from Council on Foreign Relations: http://www.cfr.org/economics/five-economic-trends-watch-2012/p26903

Ross, J. (2012, January 13). *China and developing economies will determine the chances for world growth in 2012* . Retrieved from Key Trends in the World Economy: http://ablog.typepad.com/key_trends_in_the_world_e/

Shedlock, M. (2012, January 20). *Chinese Manufacturing Recession Continues 3rd Straight Month; Romney's Tough China Talk May Fall Flat in South Carolina* . Retrieved from MISH Global Economic Trend Analysis: http://globaleconomicanalysis.blogspot.com/2012/01/chinese-manufacturing-recession.html

Chapter 22 China's Exports

Bloomberg News. (2012, April 5). *Chinese Export Machine Upgraded as Cranes Replace Toys*. Retrieved from businessweek: http://www.businessweek.com/news/2012-04-05/chinese-export-machine-upgraded-as-cranes-replace-toys

DG Trade Statistics. (2012, March 21). *China's Trade with Main Partners (2010)*. Retrieved from Trade.ec.euro: http://trade.ec.europa.eu/doclib/docs/2006/september/tradoc_113366.pdf

Ernst & Young. (2012). *Changes in geography, supply, sectors*. Retrieved from Ernst and Young: http://www.ey.com/GL/en/Issues/Business-environment/Trading-places--Changes-in-geography--supply--sectors

ETCN. (2012, April). *China's Total Value of Imports and Exports by Major Country (Region) Jan. 2012*. Retrieved from ETCN: http://www.e-to-china.com/customsinfo/latestdata/2012/0210/99942.html

European Commission. (2012, March 15). *Trade: China*. Retrieved from European Commission: http://ec.europa.eu/trade/creating-opportunities/bilateral-relations/countries/china/

Hong Kong Trade Development Council. (2012, April 16). *Top 10 export countries/regions and 5 major products*. Retrieved from Hong Kong Trade Development Council: http://info.hktdc.com/hktdc_offices/mi/ccs/index_static_type/Top10countriesn5MajorProducts012012exeng.htm

International Monetary Fund. (2012, April 16). *World Economic Outlook Databases*. Retrieved from International Monetary Fund: http://www.imf.org/external/ns/cs.aspx?id=28

Simpfendorfer, B. (2009, June 29). *Chinese exports could crush fragile markets*. Retrieved from Financial Times: http://www.ft.com/cms/s/0/48d4f4f8-64d8-11de-a13f-00144feabdc0.html#axzz1sKaKPG6G

starmass. (2011). *China exports by main countries*. Retrieved from starmass.com: http://www.starmass.com/china_review/imports_exports/china_top_export_market.htm

The Middle East Information Network. (2012, April 17). *Countries*. Retrieved from The Middle East Information Network: http://www.mideastinfo.com/countries.html

The US-China Business Council. (2012, April). *US-China Trade Statistics and China's World Trade Statistics*. Retrieved from The US-China Business Council: https://www.uschina.org/statistics/tradetable.html

Trading Economics. (2012, April). *China Exports*. Retrieved from Trading

Economics: http://www.tradingeconomics.com/china/exports

U.S. Census Bureau. (2012, April 13). *Trade in Goods with China* . Retrieved from Census.gov: http://www.census.gov/foreign-trade/balance/c5700.html

Chapter 23 China's Currency

Bloomberg News. (2012, April 15). *China Widening Yuan Band Shows Confidence in Economy*. Retrieved from Bloomberg News: http://www.businessweek.com/news/2012-04-15/china-widening-yuan-ban-shows-confidence-in-strength-of-economy

CNBC. (2012, April 17). *Widening of Yuan band to lead to volatility: Andy Xie*. Retrieved from CNBC: http://www.moneycontrol.com/news/rupee/wideningyuan-ban-to-lead-to-volatility-andy-xie_693324.html

International Monetary Fund. (2012, April 17). *World Economic Outlook*. Retrieved from International Monetary Fund: http://www.imf.org/external/pubs/ft/weo/2012/01/index.htm

Katz, I. (2012, April 18). *Geithner Calls China's Changes on Yuan Very Significant*. Retrieved from Bloomberg News: http://www.businessweek.com/news/2012-04-18/geithner-calls-china-s-yuan-ban-widening-very-significant

Xinhua. (2012, April 17). *Widening yuan band bittersweet for exporters*. Retrieved from China Daily: http://www.chinadaily.com.cn/business/2012-04/17/content_15072489.htm

Zhang, Y. (2012, April 16). *China Commerce Ministry: Yuan Band Widening Key Step In Exchange Rate Reform* . Retrieved from The Wall Street Journal: http://online.wsj.com/article/BT-CO-20120416-718838.html

Chapter 24 China's Inflation

Bloomberg. (2012, April 10). *China's inflation rises more than forecast in March*. Retrieved from The Sydney Morning Herald: http://www.smh.com.au/business/world-business/chinas-inflation-rises-more-than-forecast-in-march-20120410-1wlm6.html#ixzz1rweEQzK6

Qing, K. G., N. Edwards, L. Hornby, and N. Shuping. (2012, April 9). *China inflation data keeps policy bias on growth*. Retrieved from Reuters:

http://www.reuters.com/article/2012/04/09/us-china-economy-inflation-idUSBRE83801T20120409

Chapter 25 China's Economic Growth

Hu, Z., and M. S. Khan. (1997, June). *Why Is China Growing So Fast?* Retrieved from IMF: http://www.imf.org/external/pubs/ft/issues8/index.htm

Komo, A. (2011, October). *The factors of China's rapid growth*. Retrieved from Gary J. Wolff: http://www.garyjwolff.com/the-factors-of-chinas-rapid-growth.html

National Bureau of Statistics China. (2011, October 18). *China's GDP Growth Slows to 9.1% in Q3*. Retrieved from TradingEconomics.com: http://www.tradingeconomics.com/china/gdp-growth

Reuters. (2012, January 17). *China 2011 FDI up 9.7 pct to record $116 bln*. Retrieved from Reuters: http://www.reuters.com/article/2012/01/18/china-economy-investment-idUSB9E7NB00H20120118

Reuters. (2012, January 17). *China's Economy Expands 8.9% in Q4*. Retrieved from Trading Economics: http://www.tradingeconomics.com/china/gdp-growth

Sunday Independent. (2011, October 10). *Is China's rapid growth costing them?* Retrieved from The Sunday Independent: http://www.iol.co.za/sundayindependent/is-china-s-rapid-growth-costing-them-1.1153844

Chapter 26 China's Acquisitions

The American Dream. (2011, June 18). *The Chinese Government Is Buying Up Economic Assets And Huge Tracts Of Land All Over The United States.* Retrieved from The American Dream: http://endoftheamericandream.com/archives/the-chinese-government-is-buying-up-economic-assets-and-huge-tracts-of-land-all-over-the-united-states

Blodget, H. (2009, July 2009). *China's New Plan To Take Over The World.* Retrieved from Business Insider: http://articles.businessinsider.com/2009-07-25/wall_street/29989939_1_china-telecom-china-s-cnooc-chinese-companies

Czaja, J. (2012, May 10). *American Affairs: Does China Plan to Buy the World?* Retrieved from suite101: http://jeanine-czaja.suite101.com/does-china-plan-to-buy-the-world-a407411

Long, C. (2011, December 5). *Foreigners want America's public assets.* Retrieved from Reuters: http://blogs.reuters.com/muniland/2011/12/05/foreigners-want-americas-public-assets/

Sands, N. (2012, May 7). *Purchase of dairy farm group sparks fears of land grab in New Zealand.* Retrieved from China Post: http://www.chinapost.com.tw/china/china-business/2012/05/07/340199/Purchase-of.htm

Scissors, D. (2012, July 9). *China Global Investment Tracker: 2012.* Retrieved from The Heritage Foundation: http://www.heritage.org/research/reports/2012/01/china-global-investment-tracker-2012

UCLA Asian American Studies Center. (2009). *U.S./China Trade*. Retrieved from UCLA Asian American Studies Center: http://www.aasc.ucla.edu/uschina/trade_investment.shtml

Xu, W., and D. Durfee. (2012, February 27). *China's State Grid in talks to buy AES' U.S. wind assets:sources*. Retrieved from Yahoo News: http://news.yahoo.com/exclusive-chinas-state-grid-talks-buy-aes-u-083850080.html

Chapter 27 China and North Korea

arirang.co.kr. (2012, May 1). *China and North Korea Trade Hits Record High in the First Quarter*. Retrieved from arirang.co.kr: http://www.arirang.co.kr/News/News_View.asp?nseq=129037&code=Ne2&category=2

Bajoria, J. (2010, October 7). *The China-North Korea Relationship*. Retrieved from Council on Foreign Relations: http://www.cfr.org/china/china-north-korea-relationship/p11097

Buckley, C. (2012, April 23).*China lauds North Korea friendship despite tensions*. Retrieved from Reuters: http://www.reuters.com/article/2012/04/23/us-china-korea-north-idUSBRE83M00020120423

Buckley, C. (2012, April 23). *Chinese President Hu lauds North Korea ties despite tension*. Retrieved from Reuters: http://www.reuters.com/article/2012/04/23/us-china-korea-north-idUSBRE83M0R720120423

Royce, E. (2012, May 1). *Our North Korean policy has become based on blind trust* . Retrieved from The Hill's Congress Blog: http://thehill.com/blogs/congress-blog/foreign-policy/224803-our-north-korean-policy-has-become-based-on-blind-trust

PART 6 Crises to Come

Chapter 28 Does Europe Need Help from China?

BBC News. (2011, December 9). *Timeline: The unfolding eurozone crisis* . Retrieved from BBC News: http://www.bbc.co.uk/news/business-13856580

Fedyashin, A. (2012, January 10). *Europe needs diet therapy to survive.* Retrieved from Journal of Foreign Relations: http://www.jofr.org/2012/01/10/europe-needs-diet-therapy-to-survive/

Gosset, D. (2012, January). *China and Europe: Towards a Meaningful Relationship.* Retrieved from China Europe International School of Business: http://www.ceibs.edu/ase/Documents/EuroChinaForum/gosset_meaningful.htm

Mattich, A. (2011, November 7). *Europe Doesn't Need Chinese Finance.* Retrieved from The Wall Street Journal: http://blogs.wsj.com/source/2011/11/07/europe-doesnt-need-chinese-finance/

Peaple, A. (2011, November 6). *China Needs Help from Europe.* Retrieved from The Wall Street Journal: http://blogs.wsj.com/overheard/2011/11/09/china-needs-help-from-europe/

Whitney, P. (2006, April 25). *China Needs Design That Sells.* Retrieved from Bloomberg Businessweek: http://www.businessweek.com/innovate/content/apr2006/id20060425_526874.htm

Xinhua. (2011, November 30). *Europe needs China investment to solve debt crisis.* Retrieved from China Daily: http://www.chinadaily.com.cn/bizchina/2011-11-30/content_14187687.htm

Zhongping, F. (2009, May 3). *Lecture by Feng Zhongping on the EU-China relations* . Retrieved from Brussels Institute of Contemporary China Studies: http://www.vub.ac.be/biccs/site/index.php?id=158

Chapter 29 Will China Face an Economic Crisis?

Article Snatch. (2011). *Financial Crisis: A Great Opportunity For E-commerce*. Retrieved from articlesnatch: http://www.articlesnatch.com/Article/Financial-Crisis--A-Great-Opportunity-For-E-commerce/468943

Chunshan, M. (2012, March 12). *How China Can Prevent Collapse*. Retrieved from The Dipllomat: http://the-diplomat.com/china-power/2012/03/12/how-china-can-prevent-collapse/

Daniels, R. (2012, March 18). *Why China Will Have an Economic Crisis*. Retrieved from linkendin: http://www.linkedin.com/news?viewArticle=&articleID=5587205103024087059&gid=82210&type=member&item=105082209&articleURL=http%3A%2F%2Fdadycandoit%2Ecom%2Fbusiness-economy%2Fwhy-china-will-have-an-economic-crisis%2F&urlhash=ZJMh&goback=%2Egmp_82210%2Egde_82

Davis, B., and A. Back. (2012, March 11). *China Trade Deficit Spurs Concern* . Retrieved from the Wall Street Journal: http://online.wsj.com/article/SB10001424052702303717304577274922208015862.html?mod=googlenews_wsj

Elliott, L. (2012, January 11). *China's collapse 'will bring economic crisis to climax in 2012'*. Retrieved from the Guardian: http://www.guardian.co.uk/business/2012/jan/11/china-economic-collapse-global-crisis

Hui, L. (2012, March 10). *China Focus: China posts vast trade deficit as imports jump*. Retrieved from Xinhuanet: http://news.xinhuanet.com/english/china/2012-03/10/c_131458680.htm

Phneah, E. (2012, March 29). *China aims for $2.8T e-commerce sales by 2015*. Retrieved from ZDNet: http://www.zdnetasia.com/china-aims-for-2-8t-e-commerce-sales-by-2015-62304334.htm

Ran, D. (2011). *China New Legal Approaches to E-Commerce: Prosperity and Challenge*. Retrieved from IPEDR: http://www.ipedr.com/vol3/36-M00063.pdf

Rosen, D. H. (2012, March 26). *China's Economic Watch: China's Economic Outlook in 2020 and Beyond*. Retrieved from Peterson Institute for International Economics: http://www.piie.com/blogs/china/?p=1188

Chapter 30 Will the World Economy Falter in the Next Decade?

MSNBC. (2012, January 28). *Economist who foresaw '08 crash warns conflict could cause global recession*. Retrieved from MSNBC: http://www.msnbc.msn.com/id/46172944/ns/business-stocks_and_economy/t/economist-who-foresaw-crash-warns-conflict-could-cause-global-recession/

O'Sullivan, J. (2011, September 24). *A game of catch-up*. Retrieved from The Economist: http://www.economist.com/node/21528979

Salomon, R. (2011, October 18). *Special Report on Developing Country Growth*. Retrieved from Robert Salomon: http://blog.robertsalomon.com/2011/10/18/special-report-on-developing-country-growth/

Chapter 31 Is the United States Committing Superpower Suicide?

Amanpour, C., M. Drake, I. Zoric, and D. Miller (2012, February 22). *Is U.S. Committing Superpower Suicide Against China?* Retrieved from Yahoo News: http://news.yahoo.com/blogs/around-the-world-abc-news/u-committing-superpower-suicide-against-china-013525522.html

Ignatius, D. (2012, March 23). *Book-club picks for Election 2012*. Retrieved from The Washington Post: http://www.washingtonpost.com/opinions/book-club-picks-for-election-2012/2012/03/23/gIQAYemIWS_story.html

Zakaria, F. (2011, July 14). *China vs. USA: Who will win the 21st Century?* Retrieved from CNN World: http://globalpublicsquare.blogs.cnn.com/2011/07/14/china-vs-the-u-s-who-will-win-the-21st-century/

PART 7 The Future

Chapter 32 Is China an Emerging Superpower

Schofield, J. (2012, March 9). *China: the new tech superpower*. Retrieved from PC Pro: http://www.pcpro.co.uk/features/373483/china-the-new-tech-superpower

Shaikh, T. (2011, June 10). *When will China become a global superpower?* Retrieved from CNN World: http://articles.cnn.com/2011-06-10/world/china.military.superpower_1_superpower-military-spending-military-dominance/2?_s=PM:WORLD

SPIEGELnet GmbH . (2011, December 9). *The Geopolitics of Climate Change: Will China Become the Green Superpower?* Retrieved from Spiegel Online International : http://www.spiegel.de/international/world/0,1518,802814-2,00.html

Chapter 33 China: Powerhouse of the World Economy?

Bonar, J. (2011, October 4). *Siberia looks to China as the economic powerhouse* . Retrieved from BSR Russia: http://www.bsr-russia.com/en/regions/item/1886-siberia-looks-to-china-as-the-economic-powerhouse.html

Chang, G. G. (2011, November 27). *Can China Rescue Its Economy?* Retrieved from Forbes: http://www.forbes.com/sites/gordonchang/2011/11/27/can-china-rescue-its-economy/2/

Elliott, K. (2011, November 28). *And You Thought China was An Economic Powerhouse: Wait to Read This!* Retrieved from World Net Daily: http://www. wnd.com/index.php?fa=PAGE.view&pageId=372457

Finance Twitter. (2011, April 28). *China to become New Economic Powerhouse by 2016?* Retrieved from Finance Twitter: http://www.financetwitter. com/2011/04/china-to-become-new-economic-powerhouse-in-2016.html

Gardner, D. (2010, November 11). *China could overtake U.S. as the world's economic powerhouse within two years, says think tank.* Retrieved from Mail Online: http://www.dailymail.co.uk/news/article-1328625/China-overtake-US-worlds-economic-powerhouse-2-years.html

Reuters. (2011, October 18). *World's economic engine slows.* Retrieved from FP Investing: http://business.financialpost.com/2011/10/18/worlds-economic-engine-slows/

Rohwer, J. (1996). *Asia Rising.* New York: Touchstone.

Saad, L. (2009, February 16). *U.S. Surpasses China in Forecast for Economic Powerhouse.* Retrieved from Gallup: http://www.gallup.com/poll/114658/surpasses-china-forecast-economic-powerhouse.aspx

Xinhua. (2011, December 12). *Opening up - China's answer to the past and future.* Retrieved from China Daily: http://www.chinadaily.com.cn/china/2011-12/11/content_14246147.htm

Chapter 34 Other BRICS Economies

(Brazil)

Barbosa, R. (2011, November 30). *Viewpoint: Brazil - steady growth for America's only Bric.* Retrieved from BBC: http://www.bbc.co.uk/news/business-15964808

CIA. (2012, February). *The World Fact Book - Brazil.* Retrieved from Central Intelligence Agency: https://www.cia.gov/library/publications/the-world-factbook/geos/br.html

Economy Watch . (2010, June 30). *Fastest Growing Economy.* Retrieved from Economy Watch: http://www.economywatch.com/world_economy/fastest-growing-economy/

The Daily Herald. (2012, January 23). *Rousseff wants fast growth, will stimulate economy* . Retrieved from The Daily Herald: http://www.thedailyherald.com/business/33-business/24608-rousseff-wants-fast-growth-will-stimulate-economy.html

Trading Economics. (2011, December 6). *Brazil GDP Growth Rate.* Retrieved from Trading Economics: http://www.tradingeconomics.com/brazil/gdp-growth

(Russia)

All-Russia State Television and Radio Company. (2012, March 20). *Russia's fast growing economy important to Denmark.* Retrieved from english.rurvr.ru: http://english.ruvr.ru/2012_03_20/68984833/

Autonomous Non-profit Organization. (2012, March). *Basic facts about Russia: Economy.* Retrieved from Russiapedia: http://russiapedia.rt.com/basic-facts-about-russia/economy/

Chiodo, A. J., and M. T. Owwyang. (2002, October 23). *A Case Study of a Currency Crisis: The Russian Default of 1998.* Retrieved from stlouisfed.org: http://research.stlouisfed.org/publications/review/02/11/ChiodoOwyang.pdf

CIA. (2012, March 20). *The World Fact Book: Russia.* Retrieved from CIA: https://www.cia.gov/library/publications/the-world-factbook/geos/rs.html

Desai, R. (2012, April 1). *The west must wake up to the growing power of the Brics*. Retrieved from The guardian: http://www.guardian.co.uk/commentisfree/2012/apr/02/west-power-brics-world-bank

Fedyukin, I. (2007, September 18). *Putin's Eight Years*. Retrieved from Kommersant: http://www.kommersant.com/p804651/Putin_Eight_Years/

Ruthland, P. (2008). *PUTIN'S ECONOMIC RECORD: IS THE OIL BOOM SUSTAINABLE?* Retrieved from Europe Asia Studies: http://prutland.web.wesleyan.edu/Documents/Putin's%20record.pdf

The New York Times. (2012, March 29). *BRICS Group*. Retrieved from The New York Times: http://topics.nytimes.com/topics/reference/timestopics/organizations/b/bric_group/index.html

Thomas, D. (2012, February 21). *Building with New BRICs*. Retrieved from Think Global with David Thomas: http://bricandchina.com/storage/White%20Paper%20FINAL2.pdf

Trading Economics. (2012, April). *Russia Exports*. Retrieved from Trading Economics: http://www.tradingeconomics.com/russia/exports

TRading Economics. (2012, April). *Russia GDP per Capita PPP*. Retrieved from Trading Economics: http://www.tradingeconomics.com/russia/gdp-per-capita-ppp

Trading Economics. (2012, April). *Russia Imports*. Retrieved from Trading Economics: http://www.tradingeconomics.com/russia/imports

Trading Economics. (2012, April). *Russia Inflation Rate*. Retrieved from Trading Economics: http://www.tradingeconomics.com/russia/inflation-cpi

Trading Economics. (2012, April 3). *Russia Unemployment Rate*. Retrieved from Trading Economics: http://www.tradingeconomics.com/russia/unemployment-rate

(India)

Ahluwalia, M. S. (2008). *Economic Reforms in India since 1991: Has Gradualism Worked?* Retrieved from Planningcommisssion.nic.in: planningcommission.nic.in/aboutus/speech/spemsa/msa008.doc

Baru, S. (2011, February 21). *India and the World – the Economic Dimension.* Retrieved from Institute for Defence Studies and Analysis: http://www.idsa.in/ event/GeoeconomicDimensionsofIndiasRise

CIA. (2011, December 30). *Central Intelligence Agency.* Retrieved from The World Fact Book - India: https://www.cia.gov/library/publications/the-world-factbook/geos/in.html

ET Bureau. (2010, August 17). *India to become world's fastest growing economy by 2013-15: Morgan Stanley.* Retrieved 2010, from The Economic Times: http:// articles.economictimes.indiatimes.com/2010-08-17/news/27599478_1_china-s-gdp-real-gdp-growth-savings-rate

Farlex . (2011). *autarky.* Retrieved from Farlex Financial Dictionary: http:// financial-dictionary.thefreedictionary.com/autarkic

Frangos, A. (2011, September 12). *India's Inflation Is a Lesson for Fast-Growing Economies .* Retrieved from The Wall Street Journal: http://online.wsj.com/ article/SB10001424053111904836104576560780387580752.html

Frangos, A. (2011, September 12). *Who's to Blame for India's Inflation?* Retrieved from The Wall Street Journal: http://blogs.wsj.com/ indiarealtime/2011/09/12/whos-to-blame-for-indias-inflation/

The Hindu. (2011, August 19). *Morgan Stanley lowers India's 2012 GDP forecast to 7.4 p.c.* Retrieved from The Hindu: http://www.thehindu.com/business/ Economy/article2373336.ece

Woo, A. (2012, February 7). *Indian slowdown confirmed, but cyclical not structural*. Retrieved from Reuters: http://www.reuters.com/article/2012/02/07/idUSWNA957620120207

(Singapore)

BBC News. (2011, December 11). *Why Singapore's youth unemployment rate is so low*. Retrieved from BBC News: http://www.bbc.co.uk/news/business-16134451

Chan, J. (2011, June 15). *S'pore unemployment rate falls to three-year low*. Retrieved from Channel News Asia: http://www.channelnewsasia.com/stories/singaporelocalnews/view/1135224/1/.html

CIA. (2012, March 14). *The World Fact Book: Singapore*. Retrieved from CIA: https://www.cia.gov/library/publications/the-world-factbook/geos/sn.html

Department of Statistics Singapore. (2012, March). *Department of Statistics Singapore*. Retrieved from Latest Statistics News: http://www.singstat.gov.sg/

Global Maverik. (2011, November 2). *Singapore's Soaring Economy*. Retrieved from GlobalMaverik: http://www.globalmaverick.org/57/singapore%E2%80%99s-soaring-economy/

Trading Economics. (2012). *Singapore Unemployment Rate*. Retrieved from Trading Economics: http://www.tradingeconomics.com/singapore/unemployment-rate

Chapter 35 Who Controls the U.S. Economy?

American Hospital Association. (2012, January 3). *Facats on US Hospitals*. Retrieved from aha.org: http://www.aha.org/research/rc/stat-studies/fast-facts. shtml

Associated Press. (2008, October 14). *Despite 'regret,' U.S. to pour money into banks*. Retrieved from MSNBC: http://www.msnbc.msn.com/id/27161138/ns/ business-stocks_and_economy/t/despite-regret-us-pour-money-banks/

Bar-Yosef, A. (1994, September 2). *The Jews Who Run Clinton's Court*. Retrieved from Radio Islam: http://www.radioislam.org/islam/english/toread/ collect.htm

Berrigan, F. (2001, December 18). *The War Profiteers: How Are Weapons Manufacturers Faring in the War?* . Retrieved from Common Dreams: http:// www.commondreams.org/views01/1218-03.htm

Blumm, W. (n.d.). *U.S. Corporate Interests in Controlling Middle East's Oil*. Retrieved from Representative Press: http://oilcontrol.tripod.com/

Burchill, S. (2003, January 28). *U.S. corporate interests in control of Middle East Oil*. Retrieved from Representatives Press: http://www.representativepress.org/ Oil.html

C.Ladd, E., & Bowman, K. H. (1998). *What's Wrong: A survey of American Satisfaction and Complaint*.

Caldera, A., & Zarnic, Z. (2008, January 23). *Affordability of Pharmaceutical Drugs in Developing Countries*. Retrieved from http://www.econ.kuleuven.be/ public/ndcalc9/Caldera_Zarnic_WP_IFW.pdf

Chomsky, N. (2002, January 26). *The Campaign of Hatred Against Us*. Retrieved from Chomsky.info: http://www.chomsky.info/interviews/20020126.htm

Cline, S. (2012, January 4). *Tea Party House Members Even Wealthier Than Other GOP Lawmakers*. Retrieved from OpenSecrets.org: http://www.opensecrets.org/news/2012/01/tea-party-house-members-wealthy-gop.html

Committee on Foreign Affairs. (2008, February 13). *International Relations Budget for fiscal Year 2009*. Retrieved from house.gov: http://foreignaffairs.house.gov/110/40747.pdf

Conference of State Bank Supervisors (CSBS). (2012). *Bank and Our Economy*. Retrieved from ct.gov: http://www.ct.gov/dob/cwp/view.asp?a=2235&q=297884

Cordoba, G. F., & Kehoe, T. J. (2009, May 1). *The Current Financial Crisis: What Should We Learn From the Great Depressions of the 20th Century?* Retrieved from Minneapolisfed.org: http://m.minneapolisfed.org/article.cfm?id=4225

Cowen, T. (2011, February). *The Inequality That Matters*. Retrieved from The American Interest: http://www.the-american-interest.com/article-bd.cfm?piece=907

Domhoff, G. W. (2012). *Who Rules America? Power, Politics, and Social Change*. Retrieved from ucsc.edu: http://www2.ucsc.edu/whorulesamerica/

Dorning, M. (2012, January 3). *Iraq War Lives on as Second-Costliest U.S. Conflict Fuels Debt*. Retrieved from Bloomberg Business Week: http://www.businessweek.com/news/2012-01-03/iraq-war-lives-on-as-second-costliest-u-s-conflict-fuels-debt.html

Dreyfuss, R. (2005, September 28). *Frist Things First*. Retrieved from The American Prospect: http://prospect.org/article/frist-things-first

Duke, D. (2012, March 4). *Israel Media Says What American Media Won't Dare: Israel Controls America!* Retrieved from David Duke: http://www.davidduke.com/?p=27376

Dunn, A. (2012, March 21). *Average America vs the One Percent*. Retrieved from Forbes: http://www.forbes.com/sites/moneywisewomen/2012/03/21/average-america-vs-the-one-percent/

Federal Reserve Bank of Philadelphia. (2009, June). *The First Bank of the United States*. Retrieved from philadelphiafed.org: http://www.philadelphiafed.org/publications/economic-education/first-bank.pdf

Findley, P. (2003). *They Dare to Speak Out: People and Institutions Confront Israel's Lobby.*

Fitzsimmons, M. (2010, June 13). *The Saga of the Oil Company (Better known as BP)* . Retrieved from blogspot.com: http://thefitzman.blogspot.com/2010/06/saga-of-anglo-iranian-oil-company.html

Fuller, G. E. (2001, October 5). *Muslims Abhor the Double Standard*. Retrieved from Los Angeles Times: http://articles.latimes.com/2001/oct/05/local/me-53771

Goodchild, P. (2011, January 26). *Oil Decline Rate And Population*. Retrieved from Countercurrents.org: http://www.countercurrents.org/goodchild260111.htm

Greenspan, P. (2000, November 14). *Government And Industry Running Amuck*. Retrieved from cephasministry: http://www.cephasministry.com/nwo_private_warriors.html

Hartung, W. D. (2004, February 5). *Making Money on Terrorism* . Retrieved from The Nation: http://www.thenation.com/article/making-money-terrorism

Hartung, W. D. (1997, April). *REPORTS - Peddling Arms, Peddling Influence Update*. Retrieved from World Policy Institute: http://www.worldpolicy.org/projects/arms/reports/papirel.html

Hashemi, F. (2011, December 16). *Industry Dynamics in Pharmaceuticals*. Retrieved from Swiss Federal Institute of Technology: http://www.SciRP.org/journal/pp

House of Representatives. (2010, July 19). *Supplemental Information Regarding Federal Regulation of Deepwater Drilling*. Retrieved from house.gov: http://democrats.energycommerce.house.gov/documents/20100719/Supplemental.Memo.Deepwater.07.19.2010.pdf

House of Representatives. (1998, February 12). *U.S. Interests in the Central Asian Republics*. Retrieved from House.gov: http://commdocs.house.gov/committees/intlrel/hfa48119.000/hfa48119_0.htm

Johson, S., & Kwak, J. (2010). *13 Bankers: The Wall Street Takeover and the Next Financial Meltdown*. New York: Pantheon Books.

Kerbo, H. R. (2009). *Social Stratification and Inequality*. New York, NY: McGarw-Hill Higher Education.

Liptak, A. (2010, January 21). *Justices, 5-4, Reject Corporate Spending Limit*. Retrieved from The New York Times: http://www.nytimes.com/2010/01/22/us/politics/22scotus.html?pagewanted=all

Madrak, S. (2010, May 25). *Why Were BP Executives Hired For MMS? Fox, Meet Henhouse*. Retrieved from Crooks and Liars: http://crooksandliars.com/susie-madrak/why-were-bp-executives-hired-mms-fox

Mairesse, M. (2012, April 22). *Double-Dealing Drug Companies*. Retrieved from hermess-press.com: http://www.hermes-press.com/drugweb.htm

Mason, D. (2010, June 10). *Savings and Loan Industry (U.S.)*. Retrieved from EH.net: http://eh.net/encyclopedia/article/mason.savings.loan.industry.us

Mears, B. (2012, March 27). *Supreme Court divided over health care mandate*. Retrieved from CNN: http://www.cnn.com/2012/03/27/justice/scotus-health-care/index.html

Milakovich, M. E., & Gordon, G. J. (2009). *Public Administration in America*. Boston: Wadsworth Cengage Learning.

Mufson, S. (2010, April 27). *Gulf of Mexico oil spill creates environmental and political dilemmas*. Retrieved from Washingtonpost: http://www.washingtonpost.com/wp-dyn/content/article/2010/04/26/AR2010042604308.html

NorthwestPharmacy.com. (2012, August 29). *See How Much More Americans Pay for Prescription Drugs*. Retrieved from businessinsider.com:http://www.businessinsider.com/see-how-much-more-americans-pay-for-prescription-drugs-2012-8

Ostergard, R. L., & Sweeney, S. E. (2011). Give Me Property or Give Me Death: Reconciling Intellectual Property Rights and the Right to Health. *Journal of Human Rights* , 339-357.

Peace Action. (2011, March 28). *Does our country needs to spend so much money to protect us from adversaries?* Retrieved from Peace Action: http://www.peace-action.org/system/files/PeaceActionPentagonFacts%2526Figures_LegalSize.pdf

Reinhardt, U. E., Hussey, P. S., & Anderson, G. F. (2004, May). *U.S. Health Care Spending In An International Context*. Retrieved from Health Affairs: http://content.healthaffairs.org/content/23/3/10.full

Representative Press. (2003). *U.S. corporate interests in control of Middle East's Oil*. Retrieved from Representative Press.

Rich, A. (2000). *U.S. Exports Arms to the World*. Retrieved from Federation of American Scientists: http://www.fas.org/asmp/library/articles/resist.html

Rothenburger, A. (1999, August). *Arms Makers' Cozy Relationship with the Government.* Retrieved from Third World Traveler: http://www. thirdworldtraveler.com/Weapons/ArmsMakers_cozy.html

Savinar, M. (2006, February). *Matt Savinar featured in Salon.com Peak Oil article.* Retrieved from Life After the Oil Crush: http://www.latoc.net/ AboutMattSavinar.html

Seattle University. (n.d.). *The American Hospital in the 21st Century.* Retrieved from seattleu.edu: fac-staff.seattleu.edu/kwing/web/AHLCH42006.doc

Senate Foreign Relations. (2007). *Ninetieth Congress - First Session 1967.* Retrieved from fas.org: http://www.fas.org/irp/congress/2007_hr/1967executive. html

Shah, A. (2012, May 6). *World Military Spending.* Retrieved from Global Issues: http://www.globalissues.org/article/75/world-military-spending

Stanford University. (n.d.). *The U.S. Defense Industry and Arms Sales.* Retrieved from Stanford.edu: http://www.stanford.edu/class/e297a/U.S.%20Defense%20 Industry%20and%20Arms%20Sales.htm

Stockholm International Peace Research Institute. (2010). *SIPRI Yearbook 2010: Armament, Disarmament and International Security.* Retrieved from Stockholm International Peace Research Institute: http://www.sipri.org/yearbook/2010

Tirman, J. (1997). *Spoils of War: The Human Cost of America's Arms Trade.* New York: The Free Press.

Todd, T. (2009). *The Balance of Power.* Retrieved from kansascityfed: http:// www.kansascityfed.org/publicat/balanceofpower/balanceofpower.pdf

U.S. Department of Defense. (2012, February). *Fiscal Year 2013 Budget Request.* Retrieved from defense.gov: http://comptroller.defense.gov/defbudget/fy2013/FY2013_Budget_Request_Overview_Book.pdf

U.S. Senate. (2009, September 14). *Committee Approves FY 2010 Defense Appropriations Bill.* Retrieved from Defence Talk: http://www.defencetalk.com/committee-approves-fy-2010-defense-appropriations-bill-21870/

Wald, M. L. (2010, May 1). *Tax on Oil May Help Pay for Cleanup.* Retrieved from The New York Times: http://www.nytimes.com/2010/05/02/us/02liability.html

Wallechinsky, D. (2009). *Defense Contract Management Agency.* Retrieved from allgov.com: http://www.allgov.com/agency/Defense_Contract_Management_Agency

Wang, D. C. (2010, July 27). *Is Wall Street Making Life or Death Decisions on Your Behalf?* Retrieved from AlterNet: http://www.alternet.org/economy/147646/is_wall_street_making_life_or_death_decisions_on_your_behalf

Whaley Products. (2007). *The History of The Pharmaceutical Industry.* Retrieved from Whaley Products: http://www.pharmaceuticalchiller.com/historical.html

Zakaria, F. (2012, March 29). *Natural gas, fueling an economic revolution.* Retrieved from Washington Post: http://www.washingtonpost.com/opinions/shale-gas-an-alternative-to-oil-that-is-bolstering-the-us-economy/2012/03/29/gIQAkIc7iS_story.html

Chapter 36 China and the United States: Competing World Strategies

(China's Strategy)

Denlinger, P. M. (2003). *7 Secrets to Business Success in China.* Retrieved from China Business Strategy: http://www.china-ready.com/articles/ SevenSecretsToBusinessSuccessInChina.htm

Headey, D., Kanbur, R., and Zhang, X. (2008, August). *China's Growth Strategies.* Retrieved from Cornell.edu: http://www.arts.cornell.edu/poverty/ kanbur/China'sGrowthStrategies.pdf

Xinhua. (2011, March 13). *China seeks balanced economic growth in post-crisis era* . Retrieved from China Embassy: http://vu.china-embassy.org/eng/jjmy/ t805869.htm

Zhang, Y., Reuer, J., and Zhang, S. (2012, January). *China.* Retrieved from Strategic Management Society: http://china.strategicmanagement.net/welcome. php

(U.S. Strategy)

GlobalSecurity. (2005). *Where are the Legions? [SPQR] Global Deployments of US Forces.* Retrieved from Global Security: http://www.globalsecurity.org/ military/ops/global-deployments.htm

Johnson, C. (2010, August 17). *It's the Beginning of the End for the American Empire.* Retrieved from TomDispatch.com: http://www.alternet.org/story/147880/ it's_the_beginning_of_the_end_for_the_american_empire/?page=entire

NBC and AP. (2011, October 15). *Political payback behind US special forces deployment to Uganda?* . Retrieved from NBC News: http://www.msnbc.msn. com/id/44912923/ns/world_news-africa/t/political-payback-behind-us-special- forces-deployment-uganda/

Ocampo, S. C. (2012, February 18). *US Special Forces want wider global operations.* Retrieved from PhilStar: ttp://www.philstar.com/Article.aspx?articleI d=778665&publicationSubCategoryId=64

Reeves, B. (2012, January 21). *Why the U.S. Has Troops around the World.* Retrieved from American Thinker: http://www.americanthinker.com/2012/01/ Why_the_US_has_troops_around_the_world.htm

U.S. Department of Defense. (2011, June 19). *Active Duty Military Personnel Strenghts By Regional Area and by Country.* Retrieved from GlobalSecurity: http://www.globalsecurity.org/military/library/report/2011/hst1103.pdf

Vance, L. M. (2004, March 16). *The U.S. Global Empire.* Retrieved from LewRockwell: http://www.lewrockwell.com/vance/vance8.html

CPSIA information can be obtained at www.ICGtesting.com
Printed in the USA
BVOW031230210313

316062BV00003B/3/P